WORLD HERITAGE, URBAN DESIGN AND TOURISM

To my mother Yusrā and my nephews: Hāshem, 'Alī, Ja'far and Jawād

World Heritage, Urban Design and Tourism
Three Cities in the Middle East

LUNA KHIRFAN
University of Waterloo, Canada

LONDON AND NEW YORK

First published 2014 by Ashgate Publishing

Published 2016 by Routledge
2 Park Square, Milton Park, Abingdon, Oxon OX14 4RN
711 Third Avenue, New York, NY 10017, USA

Routledge is an imprint of the Taylor & Francis Group, an informa business

Copyright © Luna Khirfan 2014

Luna Khirfan has asserted her right under the Copyright, Designs and Patents Act, 1988, to be identified as the author of this work.

All rights reserved. No part of this book may be reprinted or reproduced or utilised in any form or by any electronic, mechanical, or other means, now known or hereafter invented, including photocopying and recording, or in any information storage or retrieval system, without permission in writing from the publishers.

Notice:
Product or corporate names may be trademarks or registered trademarks, and are used only for identification and explanation without intent to infringe.

British Library Cataloguing in Publication Data
A catalogue record for this book is available from the British Library

Library of Congress Cataloging-in-Publication Data
Khirfan, Luna.
 World heritage, urban design and tourism : three cities in the Middle East / by Luna Khirfan.
 pages cm
 Includes bibliographical references and index.
 ISBN 978-1-4094-2407-9 (hardback) -- ISBN 978-1-4094-2408-6 (ebook) -- ISBN 978-1-4094-7201-8 (epub) 1. World Heritage areas--Conservation and restoration--Middle East. 2. Historic sites--Conservation and restoration--Middle East. 3. Urban landscape architecture--Conservation and restoration--Middle East. 4. City planning--Middle East. 5. Heritage tourism--Middle East. 6. Sustainable tourism--Middle East. 7. Aleppo (Syria)--Antiquities. 8. Salt (Jordan)--Antiquities. 9. Acre (Israel)--Antiquities. 10. Middle East--Antiquities. I. Title.
 DS56.K445 2014
 363.6'90956--dc23
2014016683

ISBN 13: 978-1-4094-2407-9 (hbk)

Contents

List of Figures *vii*
List of Plates *ix*
List of Tables *xi*
List of Abbreviations *xiii*
Note on Transliteration *xv*
List of Foreign Words *xvii*
Acknowledgements *xix*

PART I THE CONTEXT

1. Historic Urban Landscapes: World Heritage and the Contradictions of Tourism 3
2. Historic and Morphological Review 13

PART II PLACE-MAKING

3. Documentation and Value Assessments: The Identification of Local and Global Significance 37
4. Place-making Strategies 61
5. Public Participation in World Heritage Planning: From Evolution to Implementation 99

PART III PLACE EXPERIENCE

6. Place Experience 121
7. Conclusions 149

Bibliography *153*
Index *169*

List of Figures

2.1	The Citadel of Aleppo is at the centre of the historic urban landscape surrounded by the residential quarters and the main *sūq*	17
2.2	The monumental corridor leading to the Citadel of Aleppo	18
2.3	The contemporary automobile roads that traversed the historic quarters of Aleppo as a result of contemporary planning initiatives	18
2.4	The centre of al-Salt	20
2.5	Plan of *'Aqabet al-Ḥaddādīn* (stairway) and adjacent houses showing semi-private courtyards or *ḥūsh*	22
2.6	The Crusader and the Ottoman layers of Acre	27
4.1	A comparison between the existing traditional and the proposed land uses in Aleppo	72
4.2	The proposed tourist trails along the *'aqabāt* of al-Salt	80
4.3	The visitor management and land use policies in Acre	94
6.1	The proposed framework and its three processes for a distinctive place experience: cultural, social and spatial and their measurable elements	124

List of Plates

1	The entrance to the Citadel – or *Qal'a* – of Aleppo and its fortifications rendered it inaccessible to the general public	17
2	The *Ḥammām* Street in al-Salt	21
3	The semi-private *ḥūsh* of the Mu'ashsher complex in al-Salt	23
4	The seemingly superimposed buildings of al-Salt and the *'aqabāt*	23
5	The intricate detailing of the mustard-yellow stone typical of al-Salt	24
6	The ruins of the *ḥammām* in al-Salt	25
7	The spectacular *al-Jazzār* Mosque of Acre	29
8	The defensive walls or *al-aswār* surrounding Acre as seen from the Mediterranean	29
9	The *Bahá'í* Palace or *Qasr 'Abbūd* in Acre	58
10	An example of the additions and modifications in the courtyard houses of Aleppo	67
11	The dilapidated houses in Aleppo	68
12	The courtyard houses in Aleppo became storage facilities for small industries	69
13	Signs advertising the traditional courtyard houses for sale can be seen around Aleppo	69
14	The courtyard of the Mansouriya Palace Hotel in *Bāb Qinnasrīn* in Aleppo	70
15	A worker unloads material into a small industry workshop in an historic house in Aleppo	73
16	The urban design interventions in *Sāḥet al-Ḥaṭab* in *Jdēide* in Aleppo	74
17	The shop facades in *al-Farāfra* quarter in Aleppo, which have not yet been subjected to the new standardization regulations	74
18	The standardized shop façades in *al-Jdēide* quarter in Aleppo yield a homogenized urban landscape	75
19	An art exhibition at the gallery of the *Shībani* Church in Aleppo	76
20	The Historic Old Salt Museum was housed in the *Abū Jāber* mansion in the centre of al-Salt with the plaza or *sāḥa* in the forefront	78
21	Some of the *'aqabāt* in al-Salt had been excluded from the rehabilitation	80
22	*Sāḥet al-'Ain* (the Spring Plaza) in al-Salt became a wide stretch of glaring white stone pavement	81
23	A newly introduced plaza and water fountain along one of the *'aqabāt* in *al-Jad'a* in al-Salt	81
24	The mix of new materials in al-Salt included black basalt and white limestone which contrast with the local yellow stone	82
25	The pavements of the *'aqabāt* in al-Salt were built to the same level as some of the houses, creating drainage problems for the local inhabitants	83
26	The newly standardized signage in al-Salt yields a homogenized urban landscape	84
27	The newly standardized shop façades in al-Salt yield a homogenized urban landscape	84
28	The contemporary civic structures (the Directorate of Education and the Police Headquarters) are disproportionate to the townscape of al-Salt	85
29	Vandalism and littering along the *'aqabāt* of al-Salt	86
30	A dilapidated residence in Acre	87
31	A level C house in Acre where the façade is significant	89
32	A level D housing complex in Acre where the composition is significant	90
33	Illegal additions to the residences in Acre	91
34	Legal additions to the residences in Acre following the new design guidelines	91
35	New street pavements in Acre	92
36	The moat or *khandaq* in Acre had been adapted into a sports field for the local community	92
37	The Templar tunnel in Acre	93

38	A fresh fish shop in Acre's *sūq*	95
39	*Shukran*, or *shūk run*, at *Emm Mḥammad*'s home in Acre	96
40	The notes made by the planners and the tourism entrepreneurs during a workshop specifically mentioned the local inhabitants as part of the tourism product	107
41	The fencing of *Ḥammām al-Bāsha* in Acre	116
42	A sketch of Aleppo's urban elements by one of its inhabitants	127
43	Dilapidated buildings in the core of al-Salt	135
44	Donkeys are used for garbage collection along the winding *'aqabāt* of al-Salt	136
45	The harbour of Acre	140
46	A snippet of local particularisms in Acre's *sūq*	145
47	A snippet of local particularisms in Acre's residential *ḥārāt* (singular *ḥāra*)	146
48	A fresco representing Acre in one of the houses that exemplifies Bacon's (1982: 30) notion of the representations of local particularisms that became 'the means by which spatial concepts are reduced to tangible images'	147

List of Tables

3.1	The inscription criteria for Aleppo, al-Salt and Acre	57
5.1	A summary of the participatory processes in Aleppo, al-Salt and Acre	118
6.1	Some of the comments by the local inhabitants of Aleppo on the most beautiful elements of their city	128
6.2	The comments offered by the international tourists as they made their choices regarding the most distinctive urban elements of Acre	138

List of Abbreviations

AA	Action Areas
CAD	Computer-aided design
GIS	Geographic information systems
GPS	Global positioning system
GTZ	Gesellschaft für Technische Zusammenarbeit meaning Agency for Technical Cooperation. It was renamed GIZ which stands for Gesellschaft für Internationale Zusammenarbeit on 1 January 2011
HUL	Historic urban landscape
ICOMOS	International Council of Monuments and Sites
ICCROM	International Centre for the Study of the Preservation and Restoration of Cultural Property
IUCN	International Union for the Conservation of Nature
JICA	Japan International Cooperation Agency
NGO	Non-governmental organization
OUV	Outstanding universal value
The Committee	World Heritage Committee
The Convention	UNESCO Convention Concerning the Protection of the World Cultural and Natural Heritage
UNESCO	United Nations Educational, Scientific and Cultural Organization
USAID	United States Agency for International Development
USP	Unique selling preposition

Note on Transliteration

Arabic words and names used throughout this book have been transliterated into the Latin alphabet according to the system used by *International Journal of Middle East Studies*. Those unfamiliar with Arabic transliteration can simply read the words as they are in English – disregarding the bars and dots. For definitions of the Arabic (and other foreign) words, please refer to the List of Foreign Words on page xvii.

List of Foreign Words[1]

Aghrāb	Foreigners
'Akkā	The Arabic name of Acre
'Akkō	The Hebrew name of Acre
'Amidār	The Israel National Housing Company for Immigrants, Ltd
'Aqabe, another form (plural: *'aqabāt*)	Public stairway
Aswār	Defensive city walls
Āthār	Either archaeological remains and/or remaining impacts
'Atiqot	Hebrew for Antiquities, and used locally to refer to the Israel Antiquities Authority
Balgāwiyye	The inhabitants of the Balgā region
Bilād ash-Shām	Greater Syria/the Levant
Bimaristān	Clinic or hospital
Dabkeh (plural: *dabkāt*)	Traditional line dance
Dār	Residential complex, typically houses an extended family
Darwīsh	Typically, a Sufi aspirant, however, in the colloquial Levantine Arabic, it refers to someone who discards material pleasures
Ḍiyāfe	Hospitality
Ḥakawāti	Storyteller
Ḥammām (plural: *ḥammāmāt*)	Bathhouse
Ḥāra, also *ḥāret* (plural: *ḥārāt*)	Neighbourhood
Ḥūsh (plural: *aḥwāsh*)	Small, private or semi-private courtyard
Jallābiyye	Traditional long dress, typically worn by men
Karam	Generosity
Khān (plural: *khānāt*)	Caravanserai
Khandaq	Moat
Madrasah (plural: *madāris*)	School
Maḥalla, another form *Maḥallat* (plural: *maḥallāt*)	Neighbourhood
Manāra	Lighthouse
Masjid	Mosque
Masjid al-jāmi'	The main Friday mosque
Mdīneh	The city
Minḥāl	Israel Land Administration
Mukhtār	Neighbourhood leader
Mushāwara	Consultation
Mustashfā	Hospital
Mwāzīn (singular: *mīzān*)	Scales
Qal'a	Citadel
Qasr	Palace
Sabīl	Water fountain
Sāḥa (also: *Sāḥet*)	Plaza
Salālem	Stairways and the name of a residential neighbourhood in al-Salt

1 All foreign words are in Arabic unless otherwise noted.

Salṭiyye	The inhabitants of al-Salt
Sarāi	Government palace
Sarsariyye	Rascals
Sharī'a	Islamic law
Shukran	Thank you
Shūk	Hebrew for marketplace
Sūq (plural: *aswāq*)	Main marketplace
Thōb	Traditional long dress, typically worn by women
'Urf	Traditional law
Waqf	Religious endowment
Zamān	Olden

Acknowledgements

This book evolved from a research project that was initially conducted for a doctoral dissertation at the University of Michigan in Ann Arbor, the USA. For nearly a decade since the inception of this research project in 2004, it has expanded, drawing in the process on additional resources. Throughout the evolution of the research project that paved the way for this book, I have been fortunate to receive support and assistance from various sources. Several organizations and institutions provided financial support that proved crucial for conducting the fieldwork in the three case study cities in three different countries. I am deeply grateful for the Taubman College of Architecture and Urban Planning, the Horace H. Rackham School of Graduate Studies and the Museum Studies Program at the University of Michigan; the Fulbright program at the Jordanian American Commission for Educational Exchange; and the American Association of University Women. The Columbia University Middle East Research Center in Amman allowed me, through a visiting fellowship (between 2010 and 2012), to spend an extensive period of time in the Middle East region, hence facilitating my access to information and allowing me to dedicate the time necessary for embarking on this book. Both UNESCO and Australia ICOMOS kindly enabled me to access part of their archives not available to the public, and for this, I am thankful. The University of Waterloo's Lois Claxton Humanities and Social Sciences Award, through the Humanities and Social Sciences Endowment Fund, kindly supported the indexing costs of this book.

A number of individuals around the world – in the UK, USA, Canada, Syria, Jordan and Israel – also provided valuable intellectual and moral support and, also, facilitated the fieldwork in numerous ways. I begin with Dymphna Evans at Ashgate in the UK who first approached me about writing this book and whose continuous support and constructive feedback encouraged me to persevere in this task. The team at Ashgate has been extremely supportive, efficient and gracious in every interaction, and for this I am thankful. At the University of Michigan, Jonathan Levine, Linda Groat, Andrew Shryock and Robert Fishman provided guidance, advice and valuable insights. Doug Kelbaugh, Mary Anne Drew, Carol Kent and the staff of the Taubman College of Architecture and Urban Planning provided moral and administrative support as I conducted my fieldwork. In Canada, I thank Zahra Jaffer and Mojgan Rasouli for their help with some of the background research. I am also thankful for Mohamed al-Huneidī and Barry Levely for their help with some of the illustrations. My special thanks go to my colleague Pierre Filion for reading the manuscript and offering valuable insights and to my former student Matt Perotto for his help and support in preparing and in refining the illustrations. In Aleppo, Syria, my sincere gratitude goes to Ma'an Shiblī, Sakher Ulabī, Ammār Ghazāl, Dalyā Mokayed and Nihād al-Amirī who, through their official posts and genuine interest, opened many a closed door in Aleppo. I am especially grateful to my friend Nouha Attār for her wonderful generosity and hospitality –typical traits of Aleppians. In al-Salt and in Amman, Jordan, my gratitude goes to Līnā Abū Salīm, Ansām Malkāwī, Hāla al-Asīr, Akihiro Iwasaki, Sana' al-Bo'bo', 'Uhūd 'Arabiyyāt, Muhannad Ḥirzallah, Usaid Khdēir and Randā 'Arabiyyāt who have all offered their help unconditionally. In Israel, I thank Rachelle Alterman and Naomi Carmon for their assistance with the visa process, and Dany Ben-Shahar, Michael Turner, Hanā Abū Uqsā and Eliazer Stern for facilitating my access to information. I am also deeply grateful to Yael Namaan, Rawyā and 'Abdū Matta, 'Ammō Abū Adnān, el-Ḥajjeh Emm Mḥammad, the late Yussef Hawwari and, lastly, but not least, the members of al-Jarrāḥ family including the late judge Sahel al-Jarrāḥ – all of whom took me under their wing and made me feel very much at home.

Throughout the past decade, friends and family provided support in ways that are indeed inexplicable. In Ann Arbor, Michigan, I am grateful for the van Deventer, the Champoux and the Ammari families who adopted me as their own and who provided a home away from home. In Waterloo and in Toronto, Ontario, the wonderful friendship of Rosemary and Howard Pell, Patricia Dimeck, Fadi Masoud, Matthew Austin John Brown and Laura and Bob Johnson sustained me through challenging times. To my own family, including my brother Loai and his wife Samāḥ, my youngest brother Moḥamed-Wāel, my sister and best friend Lamā and

her husband Bashār al-'Amad and of course to my wonderful mother Yusrā al-Zu'bī: I thank each and every one of you for your unwavering support and boundless love.

Lastly, but certainly not least, the lovely people in Aleppo, al-Salt and Acre who welcomed me into their homes and shops, shared their problems and aspirations and taught me valuable lessons in modesty, adaptation, co-existence and hopes for a better tomorrow – lessons that will stay in my heart and dreams forever.

PART I
The Context

Chapter 1
Historic Urban Landscapes: World Heritage and the Contradictions of Tourism

The Evolution of World Heritage

An awareness of the value of the built heritage was heightened following the First World War and the destruction of numerous historically significant monuments in Europe and beyond. The notion of what came to be known as 'world heritage' evolved in 1959 when Egypt appealed to the international community, represented by the United Nations Educational, Scientific and Cultural Organization (UNESCO), to save numerous archaeological monuments in Nubia between Sudan and Egypt that were threatened by imminent flooding due to the construction of the Aswan High Dam. UNESCO spearheaded the international efforts to relocate the temple of Abu Simbel in which experts from around the globe participated. These experts also contributed to the excavation and the documentation of multiple other sites affected by the flooding (Hassan, 2007: 89). In addition, UNESCO garnered international financial support from nearly 50 countries that collectively contributed half of the total US $80 million required for these efforts (UNESCO World Heritage Centre, 2008). This incident 'established a precedent in which the concept of "world heritage" has emerged as a principal notion in archaeological circles' (Hassan, 2007: 89). Simultaneously, however, this same notion of a collective world heritage also created a sense of entitlement among the donor countries that demanded to acquire half of all the archaeological finds in Nubia. Consequently, entire structures were dispersed across museums around the world, including the Temple of Dandur that is exhibited in the Metropolitan Museum of Art in New York and the Temple of Ellesiya that sits in the Egyptian Museum of Turin (Säve-Söderberg, 1987). Several other international campaigns followed at other sites such as Venice in Italy and Mohenjodaro in Pakistan (Hassan, 2007; UNESCO World Heritage Centre, 2008) throughout which the notion of world heritage gained further prominence until it was eventually cemented through the UNESCO Convention Concerning the Protection of the World Cultural and Natural Heritage (henceforth the Convention). The General Conference – UNESCO's governing body – adopted the Convention in November of 1972 (UNESCO, 1972). Thereafter, UNESCO established the World Heritage Center and entrusted it to coordinate with the State Parties – that is member states that had ratified the Convention – on all matters related to the World Heritage List. The World Heritage Center directs the preparation of tentative lists; the nomination and inscription on the World Heritage List; the management of international and emergency assistance; the organization of training courses; and the monitoring activities (UNESCO, 1992–2014a). Three advisory bodies offer expert assistance to UNESCO and the World Heritage Center: the International Council on Monuments and Sites (ICOMOS) and the International Centre for the Study of the Preservation and Restoration of Cultural Property[1] (ICCROM) advise on issues related to the conservation of cultural heritage including training (UNESCO 2008) while the International Union for the Conservation of Nature (IUCN) evaluates the nominations of natural heritage.

A committee known as the World Heritage Committee[2] (henceforth, the Committee) was entrusted with establishing and defining the criteria for inscription on the World Heritage List (UNESCO, 1972: Articles 11.2 and 11.5). At the request of this Committee, the conservation experts at ICOMOS prepared in 1976 a document titled the Operational Guidelines for the Implementation of the World Heritage Convention (henceforth, the Operational Guidelines). In this document, two sets of criteria were specified for inscription on the World

1 UNESCO established ICCROM in 1964 at the Second International Congress of Architects and Technicians of Historic Monuments.

2 The World Heritage Committee is composed of representatives of 21 State Parties who are elected on six-year terms by the General Assembly. The Committee meets annually.

Heritage List: six for cultural heritage and four for natural heritage (Jokilehto et al., 2008; UNESCO, 1977: Article 5.ii). Between 1977 and 2013 the Operational Guidelines underwent 16 revisions, and they continue to play a significant role in regulating all the procedures pertaining to world heritage (UNESCO, 1977; UNESCO, 1978). Each State Party is encouraged to generate an inventory – a tentative list – of all the properties that it may potentially seek to inscribe on the World Heritage List (UNESCO, 2008: Article 17.62). Only properties that have been on the Tentative List for at least one year may be nominated for the World Heritage List (UNESCO, 2008: Articles 62.67 and 62.128).

AlSayyad has observed that the term heritage 'derives from the Old French *eritage*, meaning property which devolves by right of inheritance in a process involving a series of linked hereditary successions' (AlSayyad, 2001: 2). Indeed, UNESCO translated this notion of inherited property when it defined 'cultural heritage' as consisting of one or a combination of 'monuments, groups of buildings and sites' (UNESCO World Heritage Centre, 2008: 3). The Convention offered detailed definitions for each of these three elements whereas monuments refer to 'architectural works, works of monumental sculpture and painting, elements or structures of an archaeological nature, inscriptions, cave dwellings and combinations of features which are of outstanding universal value from the point of view of history, art or science'. Likewise, groups of buildings refer to 'groups of separate or connected buildings which, because of their architecture, their homogeneity or their place in the landscape, are of outstanding universal value from the point of view of history, art or science'. And lastly, sites are the 'works of man or the combined works of nature and man, and areas including archaeological sites which are of outstanding universal value from the historical, aesthetic, ethnological or anthropological point of view' (UNESCO, 1972: 3). Historic towns were typically included within the 'groups of buildings' category until the 1987 Operational Guidelines, which, under 'groups of buildings' distinguished between abandoned historic towns, inhabited historic towns and contemporary towns (UNESCO, 1987: Article 24.i, ii and iii). Then in 2011 the Records of the General Conference of UNESCO proposed a Recommendation for Historic Urban Landscapes (UNESCO, 2011a), which eventually yielded 'A New International Instrument: the proposed UNESCO Recommendation on the Historic Urban Landscape (HUL)' (UNESCO, 2011b).

The World Heritage List and the Historic Urban Landscape

While a successful inscription on the World Heritage List is a significant feat, the world heritage status brings about a profound effect on the historic city, bringing to bear interventions that significantly affect it physically, morphologically and socio-culturally. Most notably is the attention that world heritage destinations attract from the tourism industry especially, the influx of tourists and the irreversible negative impacts of tourism development (Di Giovine, 2009; Rakić and Chambers, 2007). Unmanageably large tourist numbers are especially problematic for historic cities, where entry controls such as fees are difficult to impose (Frey and Steiner, 2010: 10). Furthermore, sites that are inscribed on the World Heritage List receive only minimum funding from UNESCO[3] (UNESCO World Heritage Centre, 2008). Given that thus far 238 cities have been inscribed on the World Heritage List (The Organization of World Heritage Cities, 2011), there is a dire need to address the financial challenges of urban conservation and development and devise methods that balance the needs of the local communities and the international tourists (Rakić, 2007). Indeed, one can detect such a need by tracing the activities of numerous institutions and organizations that have been founded to aid cities inscribed on the World Heritage List, including the Organization for World Heritage Cities[4] (The Organization of World Heritage Cities, 2011). Also, because UNESCO was 'concerned by the multitude of World Heritage Cities facing difficulties in reconciling conservation and development', it founded in 1996 the World Heritage Cities Programme (UNESCO, 1992–2014a; also personal correspondence with Kirsten Manz from the World Heritage Cities Programme). These concerns had surfaced in the wake of the debates over the Wien-Mitte

3 This funding, which can also be used in cases of emergency, ranges between US $5,000 and US $75,000 and is authorized by the director of the World Heritage Centre or the Chairperson of the Committee. In the cases where higher amounts are requested, the approval of the Committee becomes imperative (UNESCO World Heritage Center, 2008).

4 It was founded in 1993 at Fez in Morocco following the recommendation of the 1991 Quebec City Declaration.

train station in Vienna, Austria – a city on the World Heritage List – where a contemporary structure was designed (van Oers, 2010). Consequently, the World Heritage Center organized a conference titled 'World Heritage and Contemporary Architecture – Managing the Historic Urban Landscape' in Vienna in May 2005. The participants adopted what came to be known as the Vienna Memorandum that outlined the 'principles and guidelines that promoted an integrated and harmonious relationship between conservation and new urban developments in order to preserve the integrity of the historic urban landscape' (van Oers, 2010: 3). However, because UNESCO also recognized that it has been over 30 years since its 1976 Recommendation Concerning the Safeguarding and Contemporary Role of Historic Areas (van Oers, 2010), it decided in 2005[5] that the Vienna Memorandum should constitute the draft for a new recommendation that would 'complement and update the existing ones on the subject of conservation of historic urban landscapes, with special reference to the need to link contemporary architecture to the urban historic context' (UNESCO, 2005b: Decision 29 COM 5D). This new recommendation, with the provisional title 'Recommendation on the Historic Urban Landscape' was adopted at the 36th General Conference of UNESCO in the Fall of 2011 (UNESCO, 1992–2014a, UNESCO, 2011b).

The following section addresses the conflicts that arise from planning for tourism in historic cities in general, and in World Heritage cities in particular.

The Contradictions of Tourism and the Historic Urban Landscape

The World Tourism Organization defined tourism as 'the activities of persons traveling to and staying in places outside their usual environment for not more than one consecutive year for leisure, business and other purposes'[6] (World Tourism Organization, 1995: Article 1.1–19). While this definition focused on the demand side, tourism nevertheless is an important economic activity for the supply side as well – in this case, for historic cities particularly, as their cultural heritage constitutes an important resource that attracts the international tourists (Graham, 2002: 1007). Therefore, and especially in developing countries with limited choices for economic growth combined with an abundance of cultural heritage, tourism constitutes an important economic sector for some cities, regions and even nations (Ashworth and Tunbridge, 1990). For example, tourism ranks second among the national sources of revenue after foreign aid for Jordan (ANSAmed, 2013), where Petra, a World Heritage Site famous for its rock-carved façade from the second to third century BC, is considered the 'oil of Jordan' (Gray, 2002).

De-industrialization and the subsequent deteriorating economic situation in the developed and developing worlds respectively gave rise to a global shift towards the service industries – tourism included (Chang et al., 1996; Harvey, 2001). Tourism creates direct and indirect employment opportunities, generates a multiplier effect through the recycling of tourists' expenditure in the local economy and stimulates local products such as souvenirs and crafts (Bosselman et al., 1999; Graham et al., 2000). Similar to other industries, however, tourism is susceptible to cycles, competition and trends. One such contemporary trend is alternative tourism that marks a shift from mass tourism (that is, organized guided tours) toward experience-based tourism in historic urban landscapes (Mieczkowski, 1995). The latter, as Chapter 6 discusses, produces complex relations between the hosts and the tourists, more so than in confined resorts for example, because the hosts and tourists share the same urban space and simultaneously avail themselves of its amenities and services (Chang et al., 1996; Law, 1996). The consequences of this shift are identifiable both at the demand side (that is, the tourists), and at the supply side (that is, the historic urban landscape).

To begin with, the tourists, who constitute the demand side, seek urban heritage destinations with distinctive local identities, preferably destinations that represent the 'other' that differs from their own socio-cultural backgrounds (MacCannell, 1999). Echtner and Prasad (2003) have identified three types of such 'otherness' that are specifically based on tourism demand from the developed to the developing world. These

5 This happened during the Committee's 29th session in July 2005, which was held in Durban, South Africa (van Oers, 2010).

6 Tourism is distinguished from hospitality whereby the latter is the business of hosting tourists, and includes conventions, trade shows and business meetings (Kotler et al., 1993).

are known as the 'three "Un"-myths' namely, the unchanged, the unrestrained and the uncivilized (Echtner and Prasad, 2003). Historic urban landscapes in developing countries, with their distinctively local aura, are perceived as timeless and static in past times in a typical manifestation of the myth of the unchanged[7] (Echtner and Prasad, 2003: 668–9). Experience-based urban heritage tourism intimates that the sense of place ensues from both contemporary and historic processes, which, combined, contribute to a distinctive place experience. Interestingly, planning thus far lacks the tools that enable us to define what elements constitute a distinctive experience of the historic urban landscape, and by extension, what tools enable us to evaluate these experiential elements. Such gaps in the analytical capacity render it difficult to plan for the future sustainability of these experiences. These challenges act in concert with additional limitations on the supply side, as historic urban destinations strive to differentiate their distinctiveness in an increasingly competitive global market through deploying a triad of place-making strategies that includes image marketing, urban rehabilitation and tourism development (Gold and Gold, 1995). Collectively, these strategies fashion place distinctiveness either prior to or after the arrival of the tourists at the historic city. Prior to their arrival, image marketing influences the destination choices of potential tourists by demonstrating the historic urban landscape's unique selling preposition (USP) or its distinctiveness. Once these tourists arrive at the historic city, their experiences are shaped through interventions that include historic conservation, urban design and urban rehabilitation as well as tourism development. Thus, as I argue throughout this book, experience-based tourism in the historic urban landscape bears two normative planning implications. John Friedmann and Barclay Hudson (1974: 3) had explained that normative planning traditions pose 'prescriptive concerns' and tend 'to assume explicit value positions'. Accordingly, the implications of experience-based tourism on the historic urban landscape – that is, the supply side – necessitate that planning provides the tourists with a distinctive place experience that includes, in addition to the built heritage, the various processes of the local inhabitants' lives and their relationship to their historic urban landscape. These implications also entail that planning must integrate, and cater for, the expectations and needs of the international tourists in tandem with those of the local communities. Once converted into planning practices, these implications generate four inherent yet contradictory and often mutually exclusive conditions.

The first of these conditions arises from the high fixed costs associated with the various place-making efforts in an attempt to develop tourism in historic cities, including the conservation of historic structures, the rehabilitation of historic urban landscapes and the provision of tourism infrastructure. To begin with, image marketing, which targets potential tourists prior to their arrival at the destination, capitalizes on the destination's unique selling preposition – its distinctive identity (Holloway and Robinson, 1995; Kotler et al., 1993). Image marketing seeks to increase the tourists' numbers, their length of stay and eventually their spending (Bosselman et al., 1999). Next, and in order to cater for the expectations and needs of tourists within the historic urban landscape, tourism infrastructure is developed to provide an array of services such as accommodation, catering and attractions. Concurrently, historic conservation, urban design and urban rehabilitation attempt to ensure a visually engaging and distinctive experience of the historic urban landscape. But due to the difficulty in establishing entry fees for wider historic urban landscapes, the ensuing externalities are mostly borne not by the tourists, but by the local inhabitants (Graham, 2002: 1013–14). In a continual cycle, these costs are then partly offset through a profit-motivated planning approach that aims to further increase the tourists' numbers, their length of stay and, eventually, their spending (see for example: Ashworth and Voogd, 1990; Ashworth and Tunbridge, 1990; Bosselman et al., 1999; Chang et al., 1996; Fyall and Rakić, 2006; Nuryanti, 1996; Rakić and Chambers, 2007; Robinson, 1999; Tunbridge and Ashworth, 1996; Wahab and Pigram, 1997).

The second condition stems from the contradictory nature of urban heritage tourism as an industry that depends on global demand for distinctively local products (Harvey, 2001). In response to market demand, the aforementioned triad of place-making strategies is deployed to commodify cultural items, the historic urban

7 According to Echtner and Prasad (2003), the other two 'un'-myths refer to the myth of the unrestrained and the myth of the uncivilized. The former is related to beach destinations such as Cuba, Fiji and Jamaica that are resort-based whose remarkable weather and landscape represent paradise where tourists indulge without restrain in the pleasures of life. The latter refers to primordial places that lack any form of civilization manifest in the absolute absence of built environment, and where nature is savage and untamed especially, in frontier countries like Ecuador, Kenya and Namibia.

landscape in this case, as tourism products (Judd and Fainstein, 1999). Such commodification transforms the historic urban landscape into an economic good – that is, a tourism product – that is subject to market exchange and exploitation (Ashworth and Voogd, 1990; Fainstein and Gladstone, 1999). When transferred to the urban heritage tourism realm, commodification becomes 'the process whereby ways of life, traditions and the complex symbolism which supports these, are imaged and transformed into saleable products' (Robinson, 1999:11). The resulting image, which usually highlights the unique selling preposition of the historic urban landscape as 'unchanged', is then communicated through image marketing (Beriatos and Gospodini, 2004; Ward, 1998). But while these saleable products must demonstrate local distinctiveness, they must simultaneously comply with the expectations and needs of tourists who come from diverse backgrounds (Grunewald, 2002). The results are twofold, a need for legitimization and Disneyfication. The former requires local representations to be both comprehensible and acceptable to international tourists (Dahles, 2001). The latter entails standardization and quality control that homogenize historic urban landscapes across the globe, hence erasing all signs of place distinctiveness (Boniface and Fowler, 1993). This is evidenced by the international standardization of historic conservation interventions and urban design measures that are producing similar outcomes across different historic urban landscapes, thus eliminating their individually local qualities (Beriatos and Gospodini, 2004; Graham, 2002). Indeed, UNESCO considers standard-setting to be one of its most important mandates in the management of cultural heritage (UNESCO, 2011c). Others have critiqued the World Heritage List as the material outcome of a 'metacultural production' of heritage that overlooks local particularities (Kirshenblatt-Gimblett, 2004). Together, legitimization and Disneyfication shape the historic urban landscape – and eventually its experience – according to the expectations and needs of the international tourists rather than according to its local reality, and, hence, they incorporate a level of staging and lack of authenticity (see for example: Graham et al., 2000; Nuryanti, 1996; Sternberg, 1999; Taylor, 2001; Upton, 2001). Legitimization and Disneyfication also alienate the local inhabitants of these historic urban landscapes especially when their socio-economic and cultural realities differ significantly from the objectives of the economically driven planning process that prioritizes the needs of the international tourists at the expense of their own needs. Ultimately, this leads the local inhabitants and the international tourists to differently experience the historic urban landscape.

The third condition is brought on by the fact that, in developing countries in particular, it is the national entities that control the development and the marketing of tourism resources – that is the primary attractions – which inherently excludes, or at best minimizes, the input of the local inhabitants in the processes of tourism planning and place production (Harvey, 2001; Robinson, 2001). This condition is particularly relevant for cities inscribed on the World Heritage List where the nomination, inscription and management processes underscore their status as national property (Scholze, 2008: 216–17). Nation-states thus view their World Heritage assets, particularly historic cities, as symbols of national identity (Shackley, 2000) and market them as representations of a collective identity – overlooking in the process the complex diversity within them (Scholze, 2008). Ideally, in order to gain a competitive edge in the global tourism market, marketing succeeds when it communicates the diversity of local self-representations, which collectively shape the unique character of an historic urban landscape – a challenging feat for nation-states that typically suppress those local self-representations that do not comply with their agendas (Herzfeld, 2004; Mitchell, 1995). Thus dissonance arises between two representations: the collective universalisms that represent the imagined communities of the nation-state on the one hand (Anderson, 1991), and the particularisms that represent the local values on the other (Chatterjee, 1993). The representations of local particularisms become 'the means by which spatial concepts are reduced to tangible images' (Bacon, 1982: 30), where such images are 'variants or an interpretation of an underlying reality' (Stanley, 1998: 116) that articulate a distinctively local identity. Tourists, therefore, often seek these genuine representations of local particularisms, and in this book I argue that planning for tourism in historic cities succeeds when it integrates the universalisms and the particularisms in the place-making initiatives. For example, the Maori of New Zealand underscore what they dub 'the four Hs' in the tourism development and place-making initiatives, which are their habitat, handicrafts, history and heritage that emphasize the Maoris' ancestral roots and thus link their history and heritage to the place (Ryan, 1999). Image marketing also capitalizes on the image of the four Hs as the unique selling preposition of Rotorua's historic urban landscape.

The fourth and last condition arises when the nation-state perceives the local inhabitants of historic urban landscapes through the lens of assets and liabilities. Even in the rare cases when the local inhabitants are considered as 'an important part of the product' (Kotler et al., 1993: 135), the national entities ground their agendas on the degree to which these local inhabitants contribute to the historic city's competitiveness in the global tourism market. This 'outside-in' approach to planning tailors the place-making strategies to cater for the needs and the expectations of the international tourists – further exacerbating the alienation of the local inhabitants (Arefi and Triantafillou, 2005). While some level of commodification of the cultural heritage may be acceptable, and even required for the purposes of place-making, it nonetheless becomes questionable when carried out to the exclusion – and often the disapproval and alienation – of the local inhabitants (Boniface and Fowler, 1993). In the long run, the conservation of historic buildings and the rehabilitation of historic urban landscapes, combined with the contemporary urban design interventions and the development of tourism infrastructure, collectively impose irreversible changes on the physical and the socio-cultural characteristics of the historic urban landscape. These actions jeopardize this landscape's distinctive identity – what Graham dubs its *'raison d'être'* – the very quality that motivates the tourists' choices and the one which attracts them to the historic city in the first place (Graham, 2002: 1007; also see: Ahn et al., 2002; Bryden, 1996; Nasser, 2003). Orbaşli's (2000) study of Antalya in Turkey represents but one example of how these conditions lead to a loss of the distinctiveness of the historic urban landscape.

The combination of these conditions and the situations that ensue from them – including but not limited to the increase in the numbers of tourists, the uncontrolled tourism development, the legitimization and the Disneyfication and the alienation of local communities – collectively jeopardize the physical and the social carrying capacity of the historic urban landscape (see for example: Bryden, 1996; Swarbrooke, 1999; Wahab and Pigram, 1997). They also stretch the historic urban landscape's limits of acceptable change (Ahn et al., 2002; Bosselman et al., 1999). These consequences strain the ability to sustain the distinctive identity of the place, deteriorate the quality of the experience of the place – for the local communities as well as for the international tourists – and challenge the competitive edge of the historic urban landscape in the global tourism market (Graham, 2002; Russo, 2002).

The recurring theme in these contradictory conditions is the exclusion of the local inhabitants of historic cities from the planning processes. The main argument in this book stipulates that the historic city as a destination is both a perishable and a critical 'capital resource' (Cooper, 1996), therefore planning needs to steer away from purely economically driven development. Rather, throughout this book, I argue that the life within the historic urban landscape plays a significant role in shaping and in sustaining its distinctive identity. Consequently, the historic urban landscape becomes the interface between the local inhabitants and the international tourists, hence it is imperative to understand the underlying processes that shape its production (that is, place-making) and its consumption (that is, place experience) for each of the local inhabitants and the international tourists. Such an understanding becomes particularly crucial for cities inscribed on the World Heritage List whose status as national symbols and whose protection and management often collide with the constituents of its distinctive identity, with the needs of the local communities and with the development of the tourism infrastructure.

The Premise of this Book

This book addresses the complexities of planning for the cities that are either inscribed on the World Heritage List or that seek such a status. The research that led to this book adopted an interdisciplinary approach in order to elucidate the intertwined relationships in historic urban landscapes between the aforementioned conditions that practitioners and researchers grapple with in such cities around the globe. This book seeks to contribute to the ongoing discussions through an in-depth investigation of three Middle Eastern historic cities, each with its own set of challenges, namely, Aleppo in Syria, al-Salt in Jordan and Acre in Israel.[8] The planning initiative in each of these cities offers a different scenario for addressing the intertwining, in

8 Throughout this book, the discussion specifically pertains to the historic cores of these cities and not to their contemporary districts unless otherwise noted.

historic urban landscapes, of urban conservation and rehabilitation, contemporary urban design and tourism development. Specifically, this book offers insights on the processes of place-making and place experience from the perspectives of the planners and policy-makers, the local inhabitants and the international tourists. This book is divided into three parts. As a preamble to the subsequent parts on place-making and place experience, Part I provides the context for the contemporary plans and projects whereby Chapter 2 offers the historic context through an historic and morphological overview of the three case study cities. By tracing their histories, this overview also offers the setting for the contemporary place-making plans and projects in Aleppo, al-Salt and Acre and which the subsequent chapters delve further into. Moreover, from the general characteristics of cities in *Bilād ash-Shām* – that is, the Levant – to the specific qualities of each of Aleppo, al-Salt and Acre, this chapter provides an insight into some of the aspects that contribute to these cities' distinctiveness whether architectural, morphological or socio-cultural and economic traits. Chapter 3 builds on this discussion by introducing the notions of heritage value, significance and the outstanding universal value pertaining to the World Heritage List. Through archival research, this chapter traces the evolution of these notions in the heritage debate in general and the world heritage discourse in particular. It then discusses the onset of the contemporary plans and projects in Aleppo, al-Salt and Acre and specifically highlights the initial documentation phase in each. In particular, this chapter presents the links between the documentation approach in each city's contemporary plans and the ultimate goals and objectives of these plans. This chapter also revisits each city's outstanding universal value and its criteria for inscription on the World Heritage List in light of the documentation approach and the findings it yielded.

Part II of this book delves into the place-making processes. Chapter 4 discusses the plans and their associated projects in Aleppo, al-Salt and Acre. In particular, this chapter situates the contemporary plans within the world heritage discourse and highlights the choices for intervention strategies. It then follows with a detailed investigation of the choices made in each city's plans and projects. Chapter 5 expands on this discussion and traces the evolution of the public participation in the world heritage discourse vis-à-vis the urban planning discourse. It then relates this discussion to how public engagement and participatory planning were tackled in each city's place-making plans and strategies. Lastly, Part III of this book explores the place experience aspects that ensue from a combination of these cities' histories, values and significance and place-making initiatives whether historic or contemporary. In particular, Chapter 6 attempts to define place experience and to identify the various elements that contribute to it. It distinguishes the Experience and Experiential modes of tourism from the other modes and links them to historic urban landscapes. In order to identify and assess the elements of place experience, I develop a theoretical framework that draws on the theories of urban design, environmental psychology and humanistic geography. The proposed theoretical framework identifies three processes – cultural, social and spatial – that contribute to a distinctive place experience, and it also identifies their measurable elements. This proposed theoretical framework considers the historic urban landscape as the interface between the tourists and the local inhabitants hence, through determining the variables for each of the three processes it is possible to compare the simultaneous experience of the historic city as a tourist destination and as a living place. Thus, for each city, Chapter 6 compares the place experiences for the local inhabitants, the international tourists and the planners and then contrasts them with the objectives and goals of the recent plans and projects. Finally, Chapter 7 offers the conclusions as well as a postscript on the current situation in Aleppo given the ongoing conflict in Syria. Prior to delving into the following parts and chapters, the next section presents a summary of the methodology and the research design that were deployed in conducting the research project that led to this book.

The Methodology and the Research Design

In order to facilitate a comprehension of the complex processes within – and the meanings of – place, a qualitative method was embedded within the general analytical framework of case study design (Groat and Wang, 2002). Several reasons provided the rationale for selecting Aleppo in Syria, al-Salt in Jordan and Acre in Israel. Firstly, they are all part of the Levant hence their histories and the characteristics of their historic urban landscapes are comparable. Secondly, and to some extent, they all fall under the myth of the unchanged (Echtner and Prasad, 2003) and depend on their 'otherness' to attract international tourists

(MacCannell, 1999). Thirdly, Aleppo and Acre have been inscribed on the World Heritage List in 1986 and 2001 consecutively, while al-Salt was placed on the Tentative List in 2004 and has yet to be inscribed. Fourthly, from a place-as-product planning perspective, the three case study cities varied in their product's lifecycle at the time of the fieldwork between 2005 and 2006. Aleppo represented a mature cultural heritage tourism product that enjoyed a widely acclaimed reputation for its citadel and historic urban landscape; al-Salt was at the development stage during the fieldwork and currently remains at the introduction stage; while Acre was at the growth stage of its lifecycle (Russo, 2002). Fifthly, at the time of the fieldwork, each of Aleppo, al-Salt and Acre was subject to plans and projects that varied in their approach whereby the Project for the Rehabilitation of the Old City of Aleppo prioritized in its objectives and goals the residential function of the historic urban landscape. Conversely, the three Tourism Development Projects in al-Salt focused primarily on tourism development with hardly any mention of the needs of the local inhabitants. At its inception, the Development Plan in Acre underscored tourism development by seeking to convert the historic urban landscape into a museum city; however, as the project progressed, several factors obliged the planners to shift the planning and implementation approach to account for the needs of the local inhabitants. Lastly, given my family roots in the Levant, my ability to speak the Arabic language, and especially the local dialects, as well as my knowledge of the nuances of the local culture bestowed on me the advantage of easy access to the local communities in Aleppo, al-Salt and Acre.

Thus in order to delve into the specifics surrounding the planning initiatives in each of the three case study cities, a primary explanatory approach to the case study analysis is combined with a secondary exploratory one (Yin, 1994; Yin, 2003). The questions that this book investigates include: how did these planning initiatives and their projects embark on achieving their place-making objectives? How did they identify the significant elements of the historic urban landscape that warranted intervention? How were the place-making policies and implementation strategies formed? How did these place-making initiatives consider the needs of the local inhabitants and the needs of the international tourists? What types of challenges emerged during the planning processes and how did planning respond to them? And lastly, how did the planning initiatives, their challenges and the responses to these challenges shape the place experience for the local inhabitants and for the international tourists?

In addressing these questions, the comparative case study analysis adopted a theoretical as opposed to a literal replication (Yin, 2003). Where the former seeks 'contrasting results for predictable reasons', the latter 'predicts similar results' (Yin, 2003: 5). For example, through the literal replication of the comparative case study analysis, I seek to explain how the different documentation methods had impacted the subsequent policy-making and planning decisions in these cities albeit in different ways (Sartori, 1994). The comparison also investigates how the globally endorsed guidelines, such as ICOMOS's conservation charters and UNESCO's Convention, have been adapted differently to suit the local conditions. Such an approach allows a balance between the particularities of Aleppo, al-Salt and Acre and the generalizable outcomes through which it is possible to draw lessons for other contexts beyond the Levant and the Middle East.

The data collection tactics comprised a variety of primary and secondary sources of data. To begin with, the secondary sources of data included, among others, the documents and archives pertaining to each of the plans and projects in Aleppo, al-Salt and Acre; relevant publications in academic journals, books and public media; and the archives of UNESCO, ICOMOS and ICCROM on heritage in general and world heritage in particular. Certainly, Luisa de Marco (2009) has observed that UNESCO and ICOMOS documents 'orient their [conservation] "discipline"' and as such, 'reflect the debate and the modifications of perspective within conservation' (De Marco, 2009: 13). Therefore, throughout this book, I conduct a content analysis of the Convention and other UNESCO documents on world heritage, and 14 revisions of the operational guidelines which have been published between 1977 and 2013. Included in this analysis as well are the 39 charters, resolutions and doctrinal texts that ICOMOS had issued or had endorsed and through which it continues to be involved, whether directly or indirectly, in the regulation of heritage planning worldwide. These include: 14 ICOMOS International charters; 14 ICOMOS International resolutions and declarations; seven ICOMOS National Committees charters that have been endorsed by ICOMOS; and four documents and texts listed by ICOMOS as 'Other International Standards' (ICOMOS, 2011a).

The primary sources of data included primarily in-depth interviews with the planners and policy-makers; semi-structured interviews with the local inhabitants; and semi-structured interviews with the international

tourists in Aleppo and Acre.[9] These primary sources also included in-situ observations and visual analyses of the historic urban landscapes of Aleppo, al-Salt and Acre, as well as observations during special events in each city such as concerts, meetings and workshops, all of which contributed pivotal data. More specifically, the interviews with the planners and policy-makers sought to incorporate the perspectives of all those involved in the decision-making process, including government employees, private-sector developers and the staff of the various non-governmental organizations (NGOs) active in each city. These interviews lasted anywhere from one to two hours. In total, nine interviews were conducted in Aleppo, 12 in al-Salt and 11 in Acre. The questions posed to the planning officials concerned three main topics, particularly the current management plans and the associated projects; each city's distinctive characteristics; and the measures taken to involve the local inhabitants in the planning and implementation processes.

The semi-structured interviews with the local inhabitants and the international tourists were limited to the areas where the plans and projects were being implemented in each city. As such, the study in Aleppo focused on three action areas (AA), which corresponded to three quarters, namely: *Bāb Qinnasrīn* (AA-1), *al-Farāfra* (AA-2) and *al-Jdēide* (AA-3). In al-Salt the study included the downtown core and the historic neighbourhoods abutting the public stairways, while in Acre the study covered the entire historic urban landscape bounded by the city's walls. The local inhabitants were defined as anyone who lived and/or worked within these areas of each city's historic urban landscape. The structured interviews with the local inhabitants lasted anywhere between 60 and 90 minutes and elicited 36 respondents in Aleppo, 39 in al-Salt and 38 in Acre. Accurate sampling was rendered difficult because of the non-geometric urban forms of these cities combined with a lack of telephone directories or house numbering systems. Accordingly, a quasi-random sampling method was developed that accounted for the division of the historic urban landscape into residential quarters, whereby using a map of each historic city, the tenth unit – whether residential or commercial – along each street or alleyway was selected and the available and willing adults were interviewed: an average of seven interviews were conducted in each historic quarter.

As for the tourists, English-speaking international tourists were recruited in person at the primary tourist attractions such as historical monuments, major plazas and museums within the aforementioned boundaries. These tourists were approached and whoever agreed to participate was interviewed. Each interview lasted anywhere between 30 and 60 minutes, however, because Acre as a destination attracts day-trippers for the most part, the international tourists were generally pressed for time. This, combined with the fact that upon entering Israel the immigration officers limited my stay to one month, compounded the time limitations. Eventually, a new approach was devised whereby if a tourist was interested but was also rushed, then after their initial approval, they were given the questions in pre-paid envelopes which they filled out and mailed at their convenience. In total, 80 copies of the interview questions were distributed and 28 tourists mailed back their responses with a response rate of 35 per cent. For the most part, the respondents among the international tourists were generous with their feedback and remarks in the mailed-in paper copies. Quite a few of them followed up by email to share additional insights and to pose inquiries about the research project, which, naturally, triggered email conversations during which these individuals shared further insights and ideas. The data from the open-ended questions with the local inhabitants and the international tourists and their comments on the closed-ended questions yielded themes that were tabulated to facilitate the analysis of the place-making and place experience processes. Most importantly, and in line with the ethics protocols, anonymity was guaranteed to every participant in this study.

Needless to say that the research design also considered the political situation in the Middle East whereby the fieldwork in Aleppo had to be completed before commencing in Acre because it would have been impossible to enter Syria after entering Israel. Therefore, between 26 May and 18 June 2005, I lived in Aleppo and followed this with a trip to Acre from 13 December 2005 until 11 January 2006. The fieldwork in al-Salt took place between 1 and 23 May 2005 and again between 20 June and 20 July 2005. Since then, and almost annually, several other trips to Jordan followed that included regular visits to al-Salt during which it was possible to monitor the progress of the tourism development projects and to meet with the local planners for follow-up discussions. During the fieldwork, immersion in each city was crucial. In Aleppo, I stayed

9 As a tourism product still in its initiation stage, al-Salt receives a nominal number of international tourists compared to the other tourist destinations in Jordan such as the ruins of Nabataean Petra or Greco-Roman Jerash.

with friends who lived at the edge of the Old City of Aleppo; in Acre, I stayed with a family in the heart of Old Acre; and I commuted daily from Amman to al-Salt. Thus, I immersed myself in these historic cities and spent my days roaming around, conducting interviews, sitting at cafés and benches, chatting with the local inhabitants and the international tourists and simply observing both my physical surroundings and the activities around me. On many occasions in the three cities, I was fortunate to be invited to local events from Christmas celebrations in the historic churches of Acre, to concerts in the archaeological ruins of Aleppo's *Shēibānī* Church, to lectures and even weddings in al-Salt. I was invited into people's homes, shared their food and drink and was fortunate to enjoy a firsthand experience of their ways of life – allowing me insights that enriched my research project but, most importantly, enriched my personal experience.

Chapter 2
Historic and Morphological Review

This chapter introduces the general characteristics that distinguish the urban form of cities in *Bilād ash-Shām* – that is, Greater Syria – which later came to be known as the Levant, and which includes contemporary Syria, Lebanon, Palestine and the western parts of Jordan. This chapter then discusses the socio-cultural, political and economic factors that shaped the distinctive characteristics of the contemporary urban form for each of Aleppo, al-Salt and Acre. This is followed by a review of each city's experiences with urban planning since the beginning of the twentieth century. The goal is, firstly, to address the sources of these cities' otherness as tourist destinations (MacCannell, 1999) and the rationale behind their labelling under the myth of the unchanged (Echtner and Prasad, 2003). Secondly, this chapter's discussion establishes the links between the recent history of urban planning in these cities and the choice of a planning approach in each. The argument contends that the history of urban planning in Aleppo, al-Salt and Acre had strongly influenced the more recent place-making initiatives as we shall see in Chapters 3, 4 and 5.

The General Urban Characteristics of Cities in *Bilād ash-Shām*

Claims abound of urban centres in *Bilād ash-Shām* that had supposedly thrived as early as recorded history. While Damascus claims to be the oldest continuously inhabited city in the world (Pitard, 1987), archaeological excavations have proved that Jericho was the first walled city in history, dating to around 9000 BC (Kenyon, 1957; Gates, 2003). Fertile soils, moderate climate and rare minerals, among other factors, have contributed to this region's attractiveness, but mostly it is its strategic location between Mesopotamia, the Nile Valley and Asia Minor that transformed it into a multi-cultural hub.

In the wake of Alexander's campaign around 333 BC, several urban centres in the region adopted the Hellenistic urban traditions that emerged from a fusion of the local and the Greek cultures (Green, 1996: 54). Urban centres like the Decapolis Cities, a league of ten city-states, adapted the Greco-Roman grid and architectural orders (Jeffers, 2009: 51; Chancey, 2005: 95). Even the Nabataean Arabs who ruled over Petra in southern Jordan, and who were never subjugated to Alexander or his successors, had rulers like Aretas III who dubbed himself 'Philhellen' for his love of the Hellenistic culture (Horsfield, 1930). The Nabateans' distinctive urban and architectural traditions, particularly in Petra, emerged from a synthesis of local, regional and Classical Greek customs (Wenning, 2001: 85). Under both the Roman rule, which began in 64 BC, and the subsequent transition into the Eastern Roman Empire (the Byzantine Empire) around AD 330, Levantine urban centres continued to fuse the Greco-Roman architectural and urban traditions with their own. This was witnessed in cities such as Dionysias (*Swēida*) and Palmyra (*Tadmor*) in Syria, Gerasa (*Jerash*) and Gadara (*Umm Qais*) in Jordan and Caesarea (*Kaysaría*) and Scythopolis (*Bēisan*) in Palestine. However, the transfer of power from the Byzantine Empire to Muslim rule around AD 634–5 brought significant changes to the form of urban centres in the region. The regularity of the Greco-Roman plan gradually and almost entirely disappeared and was replaced by a more organic morphology that reflected the new political and administrative divisions. In accordance with these new divisions – which later became known as *dār*, *ḥāra* (plural: *ḥārāt*) or *mahalla* (plural: *maḥallāt*) – the land was distributed among the leaders of the local tribes, clans and even among the leaders of the Jewish and Christian communities (Hakim, 1986).

Over the following centuries the land was subdivided among the members of the same group in line with the Islamic *sharī'a* law, and these divisions developed gradually into a segregated *ḥāra* system. Eventually, each *ḥāra* became a complete community that boasted its own civic and public structures, including a mosque or *masjid* (a synagogue or church in the non-Muslim quarters), a school or *madrasah*, a water fountain or *sabīl* and a clinic or *bimaristān* among others. These structures were usually placed along the main street of each *ḥāra*, which typically ended with a gate that was closed at night. Smaller streets branched from this main

street, while, in turn, further smaller lanes branched from these smaller streets and so on until the gradual hierarchy ended with the quieter, semi-private residential cul-de-sacs. This urban morphology, characterized by a street network akin to 'a tree with branches' (Lewcock, 2002: 41), also lacked public open spaces due to the decreased level of public engagement compared to the Greco-Roman ethos of civic life that created spaces like the agora and the forum (see Hakim, 1986, Kostof, 1991; Philipp, 2001). The main Friday mosque or *al-masjid al-jāmi'* was customarily the primary civic structure and occupied a central location in the city in close proximity to the main market, or *sūq*. Most economic activities concentrated in the *sūq*, in which shops assembled according to either craft or goods and which was occasionally roofed to provide shade against the hot sun, as was the case in Aleppo. Several caravanserais or *khānāt* (singular *khān*) dotted the areas around *al-masjid al-jāmi'* where the travelling merchants, their goods and even their camels stayed (Lewcock, 2002). In contrast to the public nature of the *sūq*, the privacy of the residential areas was paramount; therefore each residence had only one door that opened onto the semi-private dead-end lane. Further, the simplicity of the external façades of the houses contrasted with the intricacy of their internal façades that surrounded the private and central courtyard (Hakim, 1986; Kostof, 1991; Lewcock, 2002).

Two concurrent factors shaped the urban morphology of these cities during the Islamic periods. On the one hand, the rulers were responsible for the macro-scale interventions through the major urban development projects and the construction of civic monuments, while on the other hand the Arab-Islamic traditional laws and the local building practices informed the micro-scale interventions. The merging of the Islamic or *sharī'a* law and the traditional Arab laws produced the local *'urf* laws that regulated the construction of ordinary buildings such as the relationships between adjacent buildings; the windows and door openings; and the building heights (Hakim, 1986). Simultaneously, the building practices, whether in the use of materials like the local stone, or in the design of architectural elements like the courtyards and the small openings, responded to local environmental conditions (Ettinghausen et al., 2001).

Urban Histories and Urban Forms: Aleppo, al-Salt and Acre

Although Aleppo, al-Salt and Acre currently belong to three different political entities, they are nonetheless geographically and culturally part of *Bilād ash-Shām*, which later became known as the Levant. Thus, they share the same historical periods and major events. These three cities were inhabited from the earliest millennia, with written records referring to them either in Egyptian hieroglyphs or Assyrian cuneiform tablets (see Abū Tālib et al., 2000 on al-Salt; Kesten, 1993 on Acre; and Tabbaa, 1997 on Aleppo). Some historians claim that since its inception in the 2nd millennium BC Aleppo had never been abandoned, which makes it among the oldest continuously inhabited cities of the world (Meyer, 2005). Both al-Salt and Acre, however, underwent periods of severe population decline and abandonment at least at one point in their histories.

The urban forms of these three cities as we know them today were shaped over the Islamic periods, most prominently during the Crusades which took place between the eleventh and the thirteenth centuries. Acre's strategic location along the Mediterranean shores contributed to its pivotal role as a link between the East and the West, to the extent that it became the capital of the Second (Crusader) Kingdom after Saladin captured Jerusalem in AD 1187 (Makhkhūl, 1979). Unlike Acre, Aleppo defied the Crusaders who were never able to conquer it, although they besieged it twice – in AD 1098 and again in AD 1124. A major earthquake in AD 1138 followed these sieges and killed nearly 230,000 of Aleppo's inhabitants and this damage was compounded when the Mongolians attacked it in AD 1260 and destroyed most of the city (Tabbaa, 1997). Although the combination of these events resulted in a severe population decline, Aleppo's inhabitants nevertheless managed to reinstate their city as a major urban and trade centre by the end of the *Mamlūk* period (AD 1260–1517) – a status that it continued to enjoy under the rule of the Ottomans (AD 1517–1918) (Tabbaa, 1997; Zeitlian Watenpaugh, 2004).

In contrast to the prosperity of Aleppo, al-Salt remained a provincial town after the Mongolian attack in AD 1260, despite successive attempts to reconstruct it (Abū Tālib et al., 2000). Likewise, Acre lost its prominent status in AD 1291 when the *Mamlūk* conquest against the Crusaders destroyed it almost entirely, and was subsequently abandoned except for a few families (Hartal, 1997; Maalouf, 1985; Philipp, 2001). While Aleppo thrived throughout the first two centuries of the Ottoman period (AD 1517–1918), al-Salt and Acre declined but were both able to reverse this decline during the eighteenth century when, along with Aleppo,

they prospered again mostly due to the expansion of their economic activities (on Aleppo see Davis, 1967 and Zeitlian Watenpaugh, 2004; on al-Salt see Abū Tālib et al., 2000; and on Acre see Philipp, 2001). The agents of well-known French and English merchant families – dubbed 'factors' – were permanently stationed in the caravanserais of those cities that were located along the trade routes, and, thus, at the time linked these cities to the world economy. Aleppo dominated the global silk trade, and acquired particular significance among the English merchants[1] (Sutton, 1979: 169; Davis, 1967: 3, 27). Likewise, during the Napoleonic wars, Acre dominated the cotton and grain trade and thrived to become the third largest urban centre in *Bilād ash-Shām* after Damascus and Aleppo, with a population that reached 25,000 in AD 1785. Acre's location and geographic formation provided both natural shelter against storms and formidable protection against attack – factors that transformed its port into the largest among all the Levantine ports on the Mediterranean (Philipp, 2001: 1, 9).

While al-Salt never achieved the prominent status of either Aleppo or Acre, it nonetheless experienced a similar trend, particularly influenced by its location along the pilgrimage routes to Mecca and along the trade routes between the East and the West. Therefore, the Ottoman rulers who sought to endear themselves among their local Arab populations empowered al-Salt's local leaders – among others in the region – to protect the pilgrimage and trade routes from Bedouin attacks. The improved status of al-Salt enticed the immigration of several merchant families from other parts in the Levant – especially from Nablus in Palestine – during the nineteenth century (Abū Tālib et al., 2000). While al-Salt and Aleppo were thriving during the last decades of the nineteenth century, a combination of events caused Acre's population to dwindle again that included several military attacks, the Napoleonic siege in 1799 and the British bombardment in 1840 as well as a plague, famine and a few earthquakes (Philipp, 2001).

In 1920, only two years after the end of the Ottoman rule over *Bilād ash-Shām*, France and Britain divided the region and established the French Mandate over Syria and Lebanon, and the British Mandate over Jordan, Palestine and Iraq (Shorrock, 1970; Smith, 1968). The decision to designate nearby Amman (30km to the south) as the capital of Jordan in 1923, and to pass the *Ḥijāz* Railway through it instead of al-Salt, decreased the latter's importance and diverted trade routes away from it (Rogan, 1996; Royal Scientific Society, 1990a). Acre faced a similar fate when the secondary line of this *Ḥijāz* Railway meandered from Darʻa in Syria to Haifa in Palestine, which is less than 30km south of Acre. Consequently, Haifa's port rose to prominence marginalizing Acre's port in the process (Mansour, 2006; Kushner, 1997: 607). Likewise when in 1939 France gave the Syrian *Iskandarūn* governorate, including the major city of Antioch, to Turkey, Aleppo's trade connections were negatively impacted (Jørum, 2004).

The following sections present the histories of the urban forms of Aleppo, al-Salt and Acre in order to elucidate the various factors that shaped the distinctiveness of their urban forms as we know them today. The overview stops at the mid-1990s, right when the contemporary projects, which are the subject of this book, commenced.

The Evolution of Aleppo's Urban Form

As soon as they diffused the Crusader threats over Aleppo, the *Zangid* and *Ayyūbid* princes who ruled over Aleppo between the twelfth and the sixteenth centuries focused their attention on large-scale urban revitalization projects. Firstly, they enlarged Aleppo's Great Mosque, then expanded the water network and constructed dozens of religious and civic structures, such as mosques, schools, clinics and water fountains. They constructed defensive elements such as towers and gates and reinforced the wall fortifications, which, combined, re-emphasized Aleppo's enclosure. Eventually, their efforts yielded a unique urban form among contemporary Islamic cities where Aleppo's Citadel – or *Qalʻa* – became contained within the city's walls, instead of occupying a corner along them. Official institutions that were built to the south of the Citadel and linked to it augmented its superiority and rendered it inaccessible to ordinary people (Plate 1) (Ettinghausen

1 According to Sutton (1979: 169), Shakespeare mentioned Aleppo twice in his plays: 'Her husband to Aleppo gone …' (Macbeth, Act I Scene III), and 'In Aleppo once, where a maligned and a turban'd Turk [Aleppoan] beat a Venetian …' (Othello, Act V, Scene II). Keeping in mind that Shakespeare's plays were not limited to the upper classes, this meant that Aleppo was known among ordinary English folk at the time (Sutton, 1979).

et al., 2001; Tabbaa, 1997). This separation of political and administrative activities from the other aspects of civic life resulted in a decreased level of public engagement, which in turn led to the aforementioned dearth of public open space (Tabbaa, 1997). The Great Mosque and the main *sūq* were placed to the west of the Citadel and, collectively, these three civic structures and their surroundings became the heart of the city and created a city within a city, to the extent that this area was dubbed by Aleppo's inhabitants as *al-Mdīneh* – literally, the city. The monumentality and activity of the city's centre gradually disintegrated into the quieter residential *ḥārāt*, such as *al-Farāfra* quarter north-west of the Citadel where the aristocratic Muslims lived, and into zones further to the north of the Citadel where the non-Muslim *ḥārāt* were located – that is, the Jewish and Christian quarters. Aleppo's *ḥārāt* thus remained ethnically and religiously divided, as the lack of municipal organization precluded any unity among them (Figure 2.1) (Tabbaa, 1997).

Once they assumed control of Aleppo, the Ottomans continued the macro-scale urban projects. Also, once the ownership of civic structures such as the baths, mosques and schools was shifted from private or semi-private ownership to a religious endowment or *waqf*,[2] the Ottomans empowered their affiliated religious and administrative institutions to carry out their own urban schemes (Zeitlian Watenpaugh, 2004). Be it through the construction of new religious and secular monuments or through the renovation of existing ones, these new projects blended well with Aleppo's urban fabric (Ettinghausen et al., 2001; Zeitlian Watenpaugh, 2004). Therefore, in common with earlier macro-scale urban developments, the Ottomans' spatial organization of Aleppo centred in the civic core around the main *sūq*, and concentrated mainly on economic activities as a natural response to Aleppo's prominent position as a cosmopolitan centre of trade at the time (Zeitlian Watenpaugh, 2004: 236). However, because this civic core of Aleppo did not undergo the land divisions imposed by *sharī'a* law on privately owned property, it continued to follow the pre-existing Roman grid and thus formed a 'monumental corridor' in the heart of the city (Figure 2.2) (Zeitlian Watenpaugh, 2004: 236).

The main *sūq* area, or *al-Mdīneh*, was surrounded by and contrasted highly with the residential neighbourhoods, which continued to be regulated through the common laws or *'urf* (Figure 2.1) (Zeitlian Watenpaugh, 2004). It was not until the end of the nineteenth century that building legislation of a Western fashion was introduced in Aleppo (Windelberg et al., 2001).

As early as the eighteenth century, Western visitors to Aleppo perceived it as an attractive and pleasant place (Davis, 1967) and described it as 'the prettiest town in the Turkish Empire' (Hasselquist, 1766: 398). In 1743, Perry offered a more detailed portrayal, describing Aleppo as:

> ... a pretty large and well-built city; and though remote from the sea, is second to few others, except Damascus, for the beauty and advantage of situations. Its houses in common are large, built with a handsome sort of stone, and in a good taste. Some of its streets are spacious and handsome (a rarity in this country) and are well paved with flag stones (Perry, 1743: 141).

The end of the Ottoman rule over Aleppo marked the beginning of the French Mandate over Syria and Lebanon, which lasted for 26 years (1920–46) (Shorrock, 1970). During this period, several plans were proposed for Aleppo that were either not implemented or had a minimal and indirect effect on it, such as directing growth and expansion toward the edges (Windelberg et al., 2001). Thus unlike their approach in Cairo where they demolished significant parts of the non-geometric historic fabric and replaced it with more organized grids, the French planners did not heavily intervene in Aleppo and instead concentrated their urban development in the new parts of the city. Similar to their strategy in Cairo, however, they left an empty zone between the old and the new parts of Aleppo, which they dubbed the 'hygiene belt' (Mitchell, 1991; Windelberg et al., 2001). This belt probably reflected the French perception of the old and traditional non-geometric parts of the colonized cities as unorganized and unsanitary, hence the need to separate them from the modern, geometrically arranged areas (Mitchell, 1991).

Once Syria gained its independence from the French in 1946, two major planning initiatives significantly impacted Aleppo, the first of which was the 1954 Master Plan, known as the Gutton Proposal,[3] and the second

2 This regulatory arrangement in Aleppo, like in many other cities, began during the *Ayyūbid* period and continued throughout the Ottoman period (Zeitlian Watenpaugh, 2004).

3 Named after the French architect who designed the plan.

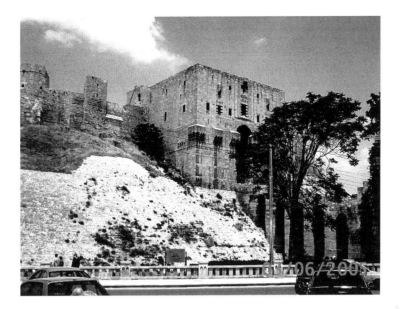

Plate 1 The entrance to the Citadel – or *Qal'a* – of Aleppo and its fortifications rendered it inaccessible to the general public

Source: The author.

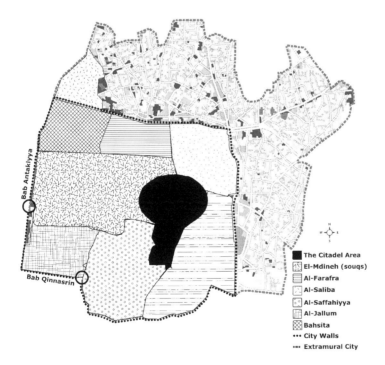

Figure 2.1 The Citadel of Aleppo is at the centre of the historic urban landscape surrounded by the residential quarters and the main *sūq*

Source: The author.

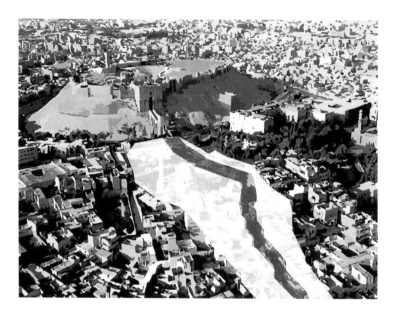

Figure 2.2 The monumental corridor leading to the Citadel of Aleppo
Source: The author.

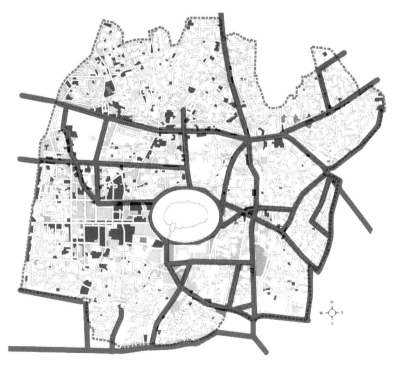

Figure 2.3 The contemporary automobile roads that traversed the historic quarters of Aleppo as a result of contemporary planning initiatives
Source: The author.

was the 1974 Master Plan, known as the Banchoya and David Plan.[4] The Gutton Proposal imposed two main roads running along the west-east axis, and two ring roads: one around the old quarter and the other around the main *sūq* or market (Figure 2.3). These roads sought to 'expose' the major monuments of the Old City of Aleppo. Although the Gutton Proposal was only partially implemented, its devastating impacts triggered several problems that Aleppo continues to face. In particular, the execution of the axial and ring roads destroyed over one tenth of the intramural fabric, in addition to entire extramural neighbourhoods and historic monuments (Windelberg et al., 2001: 7). Subsequently, the 1974 Banchoya and David Plan initially sought to counter the effects of the Gutton Plan and to prevent further damage to the historic *ḥārāt*, but ultimately continued the two west-east axes and also proposed an additional north-south axis. Had it been implemented, this latter axis would have cut through the historic fabric, demolished more monuments and further segregated the historic quarters from each other.

In recognition of these impending consequences, several public and private parties in Aleppo joined forces to stop the Banchoya and David Plan, until the Syrian General Directorate of Antiquities yielded to public pressure in 1979 and halted its implementation. Most importantly, the Directorate of Antiquities registered all of Aleppo as an historic monument and then recruited the assistance of UNESCO in planning for the city. A team of five experts from UNESCO headed by Stefano Bianca conducted a lengthy research study and produced a report in 1980 which included policy recommendations that focused primarily on issues of traffic management and accessibility in Aleppo (Bianca et al., 1980). The combined efforts of several international experts and local activists culminated with Aleppo's inscription on UNESCO's World Heritage List in 1986 (Windelberg et al., 2001). In the words of one of the individuals who played a key role in halting the Banchoya and David Plan and in involving UNESCO:

> … what exacerbated matters more was that [the Banchoya and David Plan] opened some streets. There was a group of three to four individuals who tried their best to stop the organizational plan and they succeeded in stopping it. There were interferences on behalf of UNESCO and others. We included UNESCO and the [Syrian] central government and there were fights because the Municipality did not want to change its policies, but then later the Municipality switched positions and adopted conservation (interview on 30 May 2005).

Shortly after Aleppo was inducted into the World Heritage List, the Syrian government requested the support of the German government to preserve Aleppo. The German government responded positively and in 1994 delegated the German Technical Cooperation Agency, then known as GTZ[5] to represent it on the Project for the Rehabilitation of the Old City of Aleppo as an official partner (Windelberg et al., 2001). This project received the 2005 Veronica Rudge Green Prize in Urban Design from the Harvard School of Design (Busquets, 2005). It stressed the imperative to 'Promote social and economic development, and improve housing and living conditions within the Old City. [And to] Preserve the urban fabric and functional pattern where it is unique and valuable according its character and structure' (Windelberg et al., 2001: 16). Indeed, during a meeting in the Old City Directorate on 6 June 2005, which was attended by a select group of stakeholders – mostly tourism entrepreneurs – the mayor of Aleppo announced that, using his control over licensing, he would continue to curb tourism development in the residential quarters of the Old City: 'What we [the municipality] decide will be implemented, and if we decide [there will be] no tourism, then no tourism'. At the same meeting, the Director of the Old City Directorate added, 'tourism is a tool not a goal for developing the Old City and improving the quality of life within it'. These views were echoed during interviews with the planners:

> The project, in its very early inception, somehow regarded tourism in a rather nonchalant way – for lack of a better word – in that the main attention of the project was still, and to a certain extent still is, the preservation of the residential function of the city. In that sense working too much in the favour of tourism was seen as somehow endangering the probability of a continuous residential function in the city, so it was mostly an idea of mitigating tourists' presence rather than opening up the city for tourism (interview on 9 June 2005).

4 Named after the Japanese architect and French urban geographer who proposed it.
5 GTZ stands for *Gesellschaft für Technische Zusammenarbeit*, meaning Agency for Technical Cooperation. It was renamed GIZ which stands for *Gesellschaft für Internationale Zusammenarbeit* on 1 January 2011.

Al-Salt's Urban Morphology

The *Ayyūbid* princes constructed two citadels in the southern part of *Bilād ash-Shām* in what is now contemporary Jordan, one in Ajlūn and the other in al-Salt. These fortifications were meant to ward off the ambitions of the Crusaders in the areas east of the River Jordan. At the time, Ajlūn was the more important centre and continued to be so throughout the later Islamic periods, while al-Salt remained the smaller town that contained only one main *masjid al-jāmi'* and the famous *al-Madrasah al-Sayfiyah*. The *Ayyūbid* citadel or *Qal'a* of al-Salt was destroyed twice, first by the Crusaders in the twelfth century then by the Mongols in 1260 (Abū Tālib et al., 2000). Although the *Ayyūbids*, and later the *Mamlūks* who ruled between the thirteenth and sixteenth centuries subsequently rebuilt the citadel, al-Salt's population dwindled to only 2,500 inhabitants from the *Mamlūk* period until the first half of the Ottoman period, which lasted from 1517 until 1918 (Royal Scientific Society, 1990a, Royal Scientific Society, 1990b). At the beginning of the Ottoman period, the town constituted of only two residential *hārāt* known as *al-Akrād* at the western foot of the Citadel hill, and *al-'Awāmleh* at its southern foot. Ibrahim Pasha, who was the Ottoman Governor of Damascus, destroyed al-Salt's citadel in 1840, when the leader of an anti-Ottoman revolt fled from Nablus in Palestine and hid in it. Simultaneously, and in an attempt to endear himself to the local communities, Ibrahim Pasha empowered al-Salt's elites to protect the caravans travelling along the pilgrimage routes on their way to Mecca from the attacks of the Bedouin tribes. His decision was no doubt influenced by al-Salt's location along trade and pilgrimage routes; its close proximity to major urban centres like Damascus, Jerusalem, Nablus and Cairo; its plentiful water supplies, agricultural land and mild climate; and the natural fortifications of its hilly topography. Consequently, Ibrahim Pasha re-established the Governorate of al-Salt and ordered the construction of a government palace or a *sarāi* (Abū Tālib et al., 2000). As al-Salt gradually became stable in an otherwise volatile region, several merchant families from Nablus and Damascus flocked to it, as well as Latin Anglican missions. These groups brought with them a rich repertoire of Near Eastern and European architectural expressions that fused with the various regional influences and were reflected in the new private and civic structures (Royal Scientific Society, 1990a; Royal Scientific Society, 1990b).

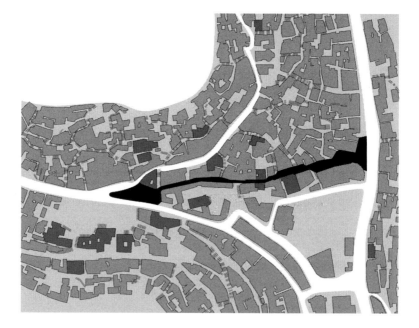

Figure 2.4 **The centre of al-Salt**
Source: The author.

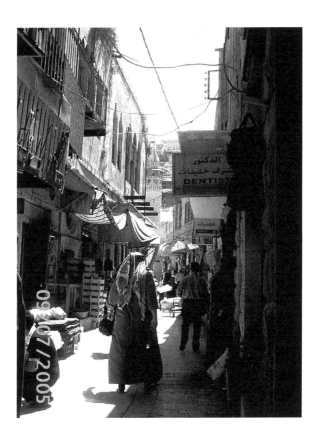

Plate 2 **The *Ḥammām* Street in al-Salt**
Source: The author.

With the increase of al-Salt's population, the *ḥārāt* at the foot of the Citadel hill – also known as the *Qal'a* – expanded. New *ḥārāt* evolved, where just like in Aleppo's quarters, members of the same group congregated together. For example, *Ḥārat al-Akrād* referred to the Kurdish families, while *al-Jad'a* was also called either *Maḥallat al-Aghrāb* – literally, the foreigners' neighbourhood – or *Maḥallat al-Nābulsiyyeh* in reference to Nablus in Palestine where the families that inhabited originated from (Khuraysāt, 1997; Abū Tālib et al., 2000). These *maḥallāt* spread from the feet of the three mountains, the *Qal'a* (Citadel), *al-Jad'a* and *al-Salālem* (stairways) toward the valley where the main water spring[6] was located. Politico-administrative, economic and socio-cultural activities thrived in the valley, creating a central area that came to be known as the plaza or *sāḥa* (Figure 2.4). In addition to a new *sarāi*, other structures sprung around *al-sāḥa*, including the Telegraph Building, the *Sukkar* dealership or *Wakālet al-Sukkar*,[7] the bathhouse or *ḥammām*, the English Hospital or *al-Mustashfā al-Inglīzi*, the Big and the Small Mosques, several churches (Latin, Catholic, Orthodox and English) and the Catholic Monastery. Construction expanded along the *Ḥammām* and *Maydān* streets, which together formed the major commercial centre (Plate 2) (Royal Scientific Society, 1990a).

In contrast to the civic and commercial activity around *al-sāḥa*, the residential *ḥārāt* enjoyed more privacy and tranquillity. These residential developments spread along the city's steep foothills where al-

6 The main water spring constituted of three parts known as the *'ain al'dawāb*, *'ain al-banāt*, and *'ain al-rijāl* referring to the water springs for livestock, women and men respectively. The first two were covered while the third, which was the public one that provided the entire city with water, was not covered (Abū Tālib et al., 2000).

7 Named after the *Sukkar* merchant family that constructed it (Khuraysāt, 1997).

Salt's natural topography influenced their urban form and architectural vocabulary. Specifically, the city's morphology is formed by a series of horizontal streets that followed the natural surface contour lines and which functioned as main movement arteries. A series of stepped terraces developed in between these arteries on which the residential units were built. Several steep and winding alleys that also contained public stairways and which were known as 'aqaba (singular) or 'aqabāt (plural) and provided the vertical connections between these terraces and the residences that lay within them. The 'aqabāt in al-Salt differed from the alleys of contemporaneous cities in that they became stairways at the steep locations, but similar to the typical alleys, these 'aqabāt branched hierarchically (both horizontally and vertically) into a maze of smaller 'aqabāt that led to the more private residential cul-de-sacs. Most of the cul-de-sacs contained a small, semi-private courtyard known locally as ḥūsh onto which several houses opened. Typically, each ḥūsh belonged to the members of the same extended family (Figure 2.5, Plate 3) (Khuraysāt, 1997; Royal Scientific Society, 1990a). The local mustard-yellow limestone, which is abundant in the region constituted the dominant construction material for the structures and 'aqabāt, and was used with a high level of craftsmanship and detail. The combination of horizontal arteries, terraces, yellow buildings and vertical alleys collectively bestowed on al-Salt a distinctive townscape whose visual effect is that of superimposed buildings along the city's steep foothills (Plates 4 and 5) (Khuraysāt, 1997; Royal Scientific Society, 1990b).

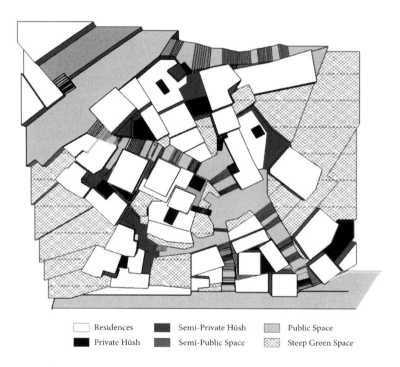

Figure 2.5 **Plan of 'Aqabet al-Ḥaddādīn (stairway) and adjacent houses showing semi-private courtyards or ḥūsh**

Source: The author.

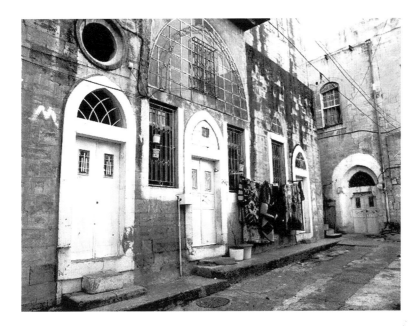

Plate 3 The semi-private *ḥūsh* of the Muʻashsher complex in al-Salt
Source: The author.

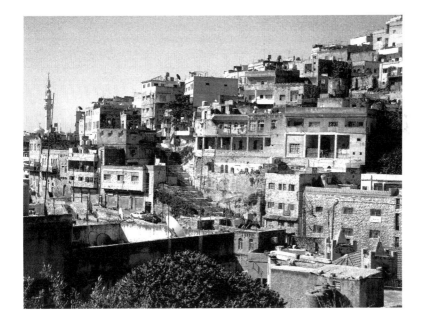

Plate 4 The seemingly superimposed buildings of al-Salt and the *ʻaqabāt*
Source: The author.

Plate 5 The intricate detailing of the mustard-yellow stone typical of al-Salt
Source: Khirfan 2013. This plate, along with other plates and some quotes that appear in subsequent chapters have been published in the *International Journal of Islamic Architecture*, 2, 307–25. The article was titled:' Ornamented Facades and Panoramic Views: The Impact of Tourism Development on al-Salt's Historic Urban Landscape'.

As was the case with Aleppo, several travellers to al-Salt during the nineteenth century reported their experiences. Laurence Oliphant offered one of the more detailed descriptions:

> Salt is situated on a high projecting spur formed by the junction of two gorges. It is surmounted by an old castle, still in tolerable repair, and the houses cluster one above another from the margin of the streams which meet in the valley to the crest of the hill. In fact, one might possibly climb from one flat roof to another, so tightly packed are they, and so narrow are the muddy lanes by which they are divided […] there is a quarter of the town built on the opposite side of one of the gorges which gives it quite a civilised aspect; with two storeys and verandas; here, too, is the Serai or Government building, and the residence of the Caimakam, and a Greek monastery, and several schools […] Salt now contains a population which is estimated at 6000 souls, and is the only center of population to the east of the Jordan. In the days of Burckhardt it only contained about 3000 inhabitants, but it has increased principally during the last ten years, owing to the establishment here of a seat of government (Oliphant, 1880: 199–200).

Historic records from the end of the nineteenth and the beginning of the twentieth century reveal that the Municipality of al-Salt enjoyed a high level of organization and power. It provided public services including infrastructure such as water and sewerage; organization and management such as the numbering of houses; and beautification like the planting of trees (Khuraysāt, 1997). These golden days however ended when, in 1923 under the British Mandate, Amman was chosen as the capital of the Emirate of Transjordan, which later became the Hashemite Kingdom of Jordan. Some of al-Salt's affluent inhabitants also moved to Amman in the wake of the destruction caused by the 1927 earthquake. Nevertheless, the period between 1935 and the mid-1950s did not see any major changes in al-Salt's urban form apart from the introduction of contemporary structural solutions that were used in conjunction with traditional building materials. For example, this period witnessed the introduction of railway beams that were used as load-bearing structural elements instead of arches and vaults. The local yellow limestone remained in use with all the new façades adopting the same traditional styles and maintaining the same high level of craftsmanship and detailing of the previous decades.

The high quality of stonemasonry in al-Salt declined significantly toward the end of the 1950s, when concrete was introduced to the region (Royal Scientific Society, 1990b).

This architectural decline paralleled a socio-economic one that ensued following the Arab-Israeli conflict of 1948 and the closure of the ports in Haifa and Jaffa. Al-Salt did not receive the large number of displaced Palestinian refugees that other Jordanian cities like Amman, Zarqa and Irbid received. On the contrary, it lost a significant portion of its population in the 1940s, who either moved to Amman or to the newer spaces around al-Salt itself, thus abandoning in the process many of the houses in the historic core. Furthermore, the Antiquities Law in Jordan protected only those historic remains that pre-dated 1700 leaving anything built after this date unprotected – a situation that lasted until the approval of the temporary Heritage Law by the Parliament in 2004 (Hashemite Kingdom of Jordan 1988). Due to the absence of protective legislation for architectural heritage, several of the historic buildings in al-Salt were either entirely demolished or mutilated with contemporary concrete additions. The area around *al-sāḥa* suffered the most – all three branches of the water spring completely disappeared, and what was once a garden in that area became a stretch of asphalt and concrete. To exacerbate matters, during the 1960s and 1970s, successive governments demolished most of the Ottoman civic structures around *al-sāḥa* and replaced them with concrete structures including the Big Mosque, the *sarāi* and *Wakālet al-Sukkar* (Abū Tālib et al., 2000; Royal Scientific Society, 1990b). The *ḥammām* is also currently in ruins (Plate 6).

Plate 6 **The ruins of the *ḥammām* in al-Salt**
Source: The author.

Sensing the threat during the 1980s, Salt Development Corporation, which is a local non-profit non-governmental organization (NGO), contracted the Royal Scientific Society, which is another non-profit NGO based in Amman, to document all the architectural urban heritage of al-Salt. The collaboration resulted in two publications, the first of which was a volume that documented all the architectural heritage of the city (Royal Scientific Society, 1990a), and the other consisted of a three-volume report that classified all the heritage buildings typologically and proposed design and budgetary guidelines for their rehabilitation (Royal Scientific Society, 1990b). During interviews, however, several of the local planners shared that a lack of funding combined with bureaucratic procedures precluded the implementation of these rehabilitation plans and only sporadic renovations of important buildings took place. Nevertheless, the combined efforts of these two NGOs first drew national attention to the need for

protective legislation for the architectural heritage in Jordan, leading to a temporary version of the Law on the Protection of Traditional Architecture and Heritage that was passed in 2004 and then ratified by the parliament in 2005 (The Hashemite Kingdom of Jordan, 2005). Their efforts also raised international awareness regarding al-Salt's urban heritage, and in the early 1990s the Japan International Cooperation Agency (JICA) included al-Salt in its comprehensive study for tourism development at six sites in Jordan[8] as part of the Jordanian-Japanese cooperation agreements (JICA, undated). This study, which sought 'to understand tourism in Jordan as a result of interaction between demand and supply under the prevailing socio-economic and institutional setting' (Nippon Koei Co. et al., 1996a: 2), concluded that 'Economically, tourism is the "oil" of Jordan', and that 'the basic character of tourism in Jordan will remain centered around its rich history and culture' (Nippon Koei Co. et al., 1996a). JICA thus proposed a tourism development project for al-Salt that would also serve as a model for other Jordanian towns (Nippon Koei Co. et al., 1996a). JICA's project, which was dubbed the First Tourism Development Project, was followed by the Second and the Third Tourism Development Projects, the funding for which came from the United States Agency for International Development (USAID) and the World Bank consecutively (United States Agency for International Development, 2011; World Bank, 2005). But, most importantly, while Salt Development Corporation and the Royal Scientific Society did not fully succeed in implementing their urban rehabilitation and architectural conservation plans, they at least succeeded in raising public awareness toward al-Salt's cultural heritage. Eventually this cultural awareness culminated in the attempts to inscribe al-Salt on UNESCO's World Heritage List. A group of local experts who worked at the time for Salt Development Corporation and the Greater Salt Municipality prepared the nomination package that resulted in al-Salt's inscription on the Tentative List (UNESCO, 1992–2014a).

Acre's Overlaid Cities

The natural peninsula that is Acre protrudes into the Mediterranean and connects to land at its north-eastern side (Figure 2.6). A breakwater at the southern end of this peninsula that was probably constructed by the Phoenicians around 1500 BC historically provided protection and created a safe harbour (Kesten, 1993). Acre's unique natural setting and its location along the eastern Mediterranean shores transformed it into a gateway between the East and the West. Furthermore, Acre flourished as a result of the relative peace between the Crusaders and the Muslims, and Saladin's encouragement of commercial exchange between the Christians and the Muslims (Maalouf, 1985; Salāmah, 1998). Eventually, Acre thrived as a base for pilgrimage en route to the Holy Land and as a centre of production and trade for sugar cane, grapes and olives as well as silk, wine, shipbuilding and weaponry. Several European communities, mostly of Italian origin, who were based in Acre influenced its urban character. Acre was therefore comprised of 17 residential quarters, each of which belonged to one European community, such as the Venetian, Genoese and Pisan quarters (Kesten, 1993; Makhkhūl, 1979; Salāmah, 1998). During the Second Crusader Kingdom, and under the rule of Count Henry De Champaign, each one of these quarters was governed akin to an autonomous European colony that had its own consul or viscount who reported directly to the respective authorities in Europe. As such, each quarter had its own consular court council, church, grain mill and bathhouse among other civic amenities. A committee assisted the consul/viscount in running each quarter's housing, services, trade and industry affairs. Several *khānāt* (plural for *khān*) were constructed during this period, and several specialized *aswāq* (plural for *sūq*) were established that concentrated on a particular trade or industry so as to facilitate their administration (Salāmah, 1998). Peace did not last long, however, and war erupted again between the Crusaders, who persisted in their attempts to recapture Jerusalem, and the *Mamlūks* – the new Muslim rulers in the region – until the Crusaders lost the pivotal siege of Acre in AD 1291. The *Mamlūks* destroyed Acre completely until its population declined to only a few dozen Arab families. A major shift occurred in the fifteenth century when the silk trade between the East and the West began to flourish in Aleppo, and *Bilād ash-Shām* witnessed the first signs of economic revival. At this point in time, the competition between the French and British Factors

8 The six sites in Jordan: the Amman Downtown Tourist Zone, the National Museum, the Dead Sea Parkway, the Dead Sea Panoramic Complex, the Karak Tourism Development and Historic Old Salt (Japan International Coorperation Agency, 2011).

resulted in the former's control over the Syrian coast from Jaffa (130km south of Acre) to Tripoli (190km north of Acre). By AD 1700, the French Factors had founded a Consulate in Acre as they received permission from the Ottomans to trade in silk and cotton.

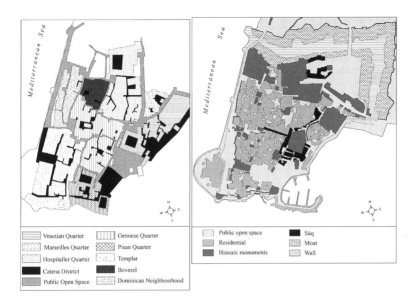

Figure 2.6 **The Crusader and the Ottoman layers of Acre**
Source: The author.

The turning point in Acre's history came when *Zāhir al-Omar al-Zeidānī* made Acre his capital in AD 1751. *Zāhir al-Omar*'s decision marked the rapid revival of Acre's Crusader glory, and by AD 1785, only a couple of decades later, it was transformed into 'the third largest city in Syria – after Aleppo and Damascus – and the largest port on the Syrian coast' (Philipp, 2001: 1). The scarce archival sources from this period[9] reveal that most probably it was the readily available building materials from Acre's Crusader ruins that had influenced *Zāhir al-Omar*'s choice to make the city his capital. Not only was the eighteenth century city constructed over the Crusader one, but also, for the most part, it followed the Crusader city's layout particularly in the southern and western areas where the Genoese, Pisan and Rectangular quarters were located (Figure 2.6) (Philipp, 2001). Furthermore, Acre's new layout reflected clear functional divisions where, on the one hand, the residential one- or two-story buildings dominated the central, western and southern parts of the city. Most residences had their own private courtyards and the two-story houses were often divided into separate apartments to accommodate the extended family. On the other hand, the religious structures, such as the churches and mosques, were distributed evenly among the neighbourhoods and only the spectacular *al-Jazzār* Mosque stood out as a symbol of 'representation and political legitimization' (Philipp, 2001: 26) (Plate 7). The commercial structures revealed Acre's rising economic status and included five major *khānāt* as well as the three major *aswāq* that spread along the eastern part of the city adjacent to the harbour (Philipp, 2001: 26). The civic structures and public utilities included *ḥammāmāt* (plural for *ḥammām*) and an aqueduct that delivered fresh water into the city from nearby water springs (Philipp, 2001; also see Rustum, 1926). And finally, the military-political structures of Acre concentrated in the northern parts of the city and included the Crusader Citadel, which the Ottoman rulers rehabilitated to serve as their palace and headquarters. After Napoleon's siege and eventual retreat, *al-Jazzār*, who was the Ottoman ruler at the time, re-fortified Acre's

9 The records may have been destroyed during any of the wars that the city suffered from beginning with the internal strife among Ottoman rulers in 1775 and ending with the Arab-Israeli war in 1948 (Philipp, 2001).

walls or its *aswār* with additional defence structures like towers (Hartal, 1997; Philipp, 2001) (Plate 8). The evolution of Acre during this period is better detected from accounts like the one by Maundrell, who was a French Factor in Acre during 1700, and who described Acre as nothing but a ruin: 'Besides a large Khān in which the French factors have taken up their quarters and a mosque, and a few poor cottages, you see nothing here but a vast and spacious ruin' (Philipp, 2001, after Maundrell, 1848). Conversely, Rogers, who visited in 1880, described his entry to Acre – or *'Akkā* using its Arabic name – from the sea:

> From every point of view, the external appearance of *'Akka* is pre-eminently picturesque, and especially so from the deck of a yacht or steamer approaching the shore on a calm bright moonlight night, or, as an Arab would say, 'when God's lantern is in the sky'. The bold western front of the city appears suddenly to rise up before us out of the sea, with its loopholed battlemented walls, its square towers, and its serviceable lighthouse at its southern extremity. In the northern division of the city, the lofty and curiously buttressed dome of the great mosque of Jezzar Pasha vividly reflects the moonlight, and near to it the formidable-looking citadel is conspicuous. No city in Syria or Palestine completely carries one back in fancy to Crusading and feudal times as does this city of *'Akka* especially when thus beheld from the sea; if the tall minaret of the great mosque were not there to remind us of the local supremacy of the followers of the prophet Mohammed, we might easily imagine ourselves to be steering towards a stronghold still occupied by Crusading kings and by those Knights of St. John to whom the place owes its familiar European name of St. Jean d'Acre (Rogers, 1975: 73–4).

Like Aleppo, the new urban expansion during the British Mandate period, which lasted between 1918 and 1946, took place outside Acre's *aswār*. The only major change to Acre's historic fabric was one opening carved in the north-east side of *al-aswār* to allow cars to enter, but apart from this, the intramural parts remained almost intact. The British also conducted extensive surveys of Acre that were documented in an unpublished report known as the Winter Report (Kool, 1997). On 5 July 1933, the Antiquities Department of the British Mandate declared Acre's *aswār* along with the Citadel, the Prison and the extant aqueduct between Acre and Kabri as antiquities (Wass, 2010: 4).

Only two years after the end of the British Mandate, the State of Israel was established over parts of Palestine. Although at the time Acre was designated as part of the Arab state in Palestine according to the United Nations Partition Plan, the political unrest and the military activities of 1948 displaced the majority of Acre's inhabitants who fled either to the countryside or to neighbouring countries. Concurrently, several Arab Palestinian families also fled from Haifa and its environs to Acre through the Mediterranean Sea. Thinking that their displacement would be temporary, these newcomers crowded into Acre's houses, sometimes dividing the one unit into several smaller ones[10] (Abu Shanab, 2004). The newly established Israeli government confined the displaced Palestinian Arabs and what remained of Acre's original inhabitants within the *aswār* of Acre and declared the area 'under military administration', claiming security reasons (Torstrick, 2000: 54; Morris, 2004: 228–32). Simultaneously, the Israeli government created the new post of 'Custodian of Absentee Property' in order to manage the businesses, land and property of those Arab Palestinians who were declared as absentees – in reference to all who were displaced from their property, even if their displacement was within the boundaries of Israel (Fischbach, 2003). The Custodian of Absentee Property in turn leased this property to the new Jewish immigrants or, as in the case of Acre, to other displaced Palestinian Arabs. But five years later – in 1953 – the Custodian of Absentee Property appointed the Israel National Housing Company for Immigrants, Ltd, also known as *'Amidār*, to administer the residential and commercial property on behalf of the Israel Land Administration which is locally known as *Minḥāl* (Fischbach, 2003: 77; Cohen et al., 2000). *'Amidār* assumed the role of an agent for the Custodian of Absentee Property, and to this day retains a similar leasing policy according to which internally displaced Arab Palestinians rent property in Acre and other places within the State of Israel (Cohen et al., 2000; Fischbach, 2003, and personal interviews with Acre's inhabitants during December 2005 and January 2006, and also, with planners on 20 December 2005 and 6 January 2006). In total, the property that is currently administered by *'Amidār* amounts to 85 per cent

10 Also, during an interview on 27 December 2005, one of the planners in Acre referred to these events. Likewise, most of the local inhabitants who were interviewed also referred to these events.

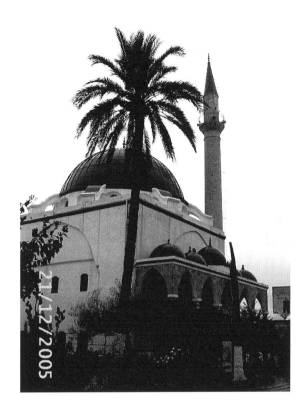

Plate 7 **The spectacular *al-Jazzār* Mosque of Acre**
Source: The author.

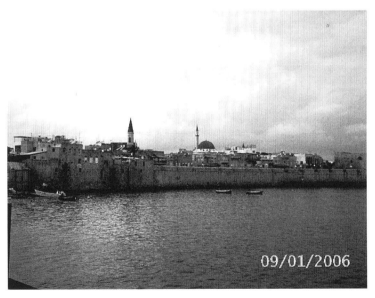

Plate 8 **The defensive walls or *al-aswār* surrounding Acre as seen from the Mediterranean**
Source: The author.

of the property within the walls of Acre, while 10 per cent of what remains either belongs to the Muslim *waqf* or to the Church, and the other 5 per cent is privately owned (Cohen et al., 2000).

The government of Israel realized the historic value of Acre and its potential for international tourism, and as early as 1950, Israel's Antiquities Authority, also known as *'Atiqot*, began archaeological excavations to expose the Crusader layer (see Hartal, 1997; Kedar, 1997; Kesten, 1993). The government of Israel hired Alex Kesten, an Israeli Architect, in 1962 to put forward a plan to develop and manage Acre as a tourism resource (Kesten, 1993). Then in 1967, the government also established Old Acre Development Company, a private company under the auspices of the Ministry of Tourism, and entrusted it with the development of Acre as a tourism resource. By 1978, the entire walled city became protected under the Israeli Antiquities Law.

Through implementing the Kesten Plan, Old Acre Development Company sought to convert Acre into a 'museum city' (Kesten, 1993: 6), while simultaneously other decision-makers and planners within the Municipality of Acre campaigned to Judaize the largely Arab Acre (Torstrick, 2000: 184, 188). Old Acre Development Company therefore sought to transfer the nearly 5,000 inhabitants who lived within the walls of Acre to *al-Makr*, a nearby village (Hecht, 1997; Torstrick, 2000). Initially, the government of Israel justified this course of action by referencing the precedent of Old Jaffa where it had also established Old Jaffa Development Company that had transferred Jaffa's entire Palestinian Arab population from Old Jaffa and transformed it into a museum and tourist city where only artists were allowed to reside (Old Jaffa Development Company, 2014; Coplans, 2009). Further, the government of Israel and Old Acre Development Company also sought to justify their motivations by citing Acre's Arab inhabitants as a liability to tourism development, given their association with the city's nefarious reputation derived largely from claims of a multitude of socio-economic problems including unemployment, substance abuse and violence (Hecht, 1997). According to one source:

> For many years the Israeli government did not know how to handle the situation. As you know, the population is 5,000 to 7,000 inhabitants, and practically all of them are Arabs. Now, for many years, the Israeli government thought that the condition for developing Acre was to transfer the population, and in fact they built a village – *al-Makr*. The purpose of the construction of the village was to transfer the inhabitants of Old Acre to it (interview on 10 January 2006).

Despite the unsubstantiated claims of the placeless nature of Acre's Palestinian Arab inhabitants, which implied a lack of a sense of place – let alone place attachment (Cohen et al., 2000; Creighton, 2007: 349–50), the numerous attempts to relocate them were deemed unsuccessful. Once they established the parallels between their own situation and the past transfer of Old Jaffa's inhabitants, Acre's Palestinian Arab inhabitants who had acquiesced to the transfer pressure immediately returned to their homes in Old Acre (Galili and Nir, 2001). One of the planners in Acre relayed:

> I don't know if anyone informed you about the experiment – that the government constructed a whole neighbourhood in a nearby village – *al-Makr* – so as to transfer Old Acre's inhabitants to it. And even with that, the houses were not vacated. The majority stayed, and a lot of the inhabitants came back. If a residence had a few families leaving it, they all came back to live in the same houses because it was not easy[11] (interview on 6 January 2006; also see Khirfan, 2010a: 42).

Nevertheless, Old Acre Development Company persisted in implementing the Kesten Plan. This continued until a pivotal event in the 1990s brought Acre into the international spotlight when, based on *'Atiqot*'s recommendation, UNESCO selected Acre from among 100 sites worldwide that best represent medieval heritage – in this case, Crusader heritage (Torstrick, 2000). Immediately thereafter, Old Acre Development Company, *Minḥāl* and *'Amidār* hired Arie Rahamimoff and Saadia Mandel, both of whom are considered among the leading Israeli architects and urban planners (Forester et al., 2001), to develop a proposal for a $100 million five-year Development Plan for Acre (Hecht, 1997; also interviews with several planners). The end

11 This quote, along with some other quotes and some plates that appear in subsequent chapters have been published in *Traditional Dwellings and Settlements Review*, Spring 2010, volume XXI, Issue II, pages 35–54. The article was titled: From Documentation to Policy-Making: Management of Built Heritage in Old Aleppo and Old Acre.

of this five-year Development Plan in 2001 coincided with Israel's ratification of the Convention Concerning the Protection of the World Cultural and Natural Heritage. The government of Israel at the time chose the Old City of Acre and the Masada National Park as its first sites to be nominated for the World Heritage List (UNESCO, 1992–2014). The Development Plan hence became the crux of a nomination package that was submitted to UNESCO to inscribe Acre on the World Heritage List. Given its tangible positive outcomes, the plan has since been renewed for at least two additional five-year terms.

The Contemporary Challenges

The original inhabitants of the three cities for the most part had abandoned their homes, albeit with varying motivations – ranging from the socio-economic in Aleppo, to the political in Acre, to a combination of both in al-Salt. The affluent inhabitants of Aleppo moved to the newer parts of the city, while Acre's inhabitants fled in the aftermath of the 1948 Arab-Israeli war and al-Salt's inhabitants moved either to the new capital Amman, or to the newer suburbs of their city. The ensuing effects were similar across all three cities as new inhabitants, who were of a lower socio-economic class than their predecessors, moved into the historic quarters from the surrounding villages and towns.

Viewed through an urban planning lens, the problems in Aleppo, al-Salt and Acre appear to stem from a lack of clear strategies for adapting the historic fabric of these cities to the needs of their contemporaneous inhabitants. They were also aggravated by a combination of maltreatment by their local inhabitants and prolonged neglect on the part of public institutions, leading these historic cities to spiral into additional physical and socio-economic decline. The contemporary challenges to urban development are discussed here under three key themes, namely, the socio-economic conditions, the spatial concerns and the architectural and aesthetic elements.

The Socio-economic Conditions

The French Mandate over Syria (1920–46) and the British Mandate over Palestine (1918–46) ended without significant changes to the urban form of Aleppo, al-Salt or Acre. While the colonizers focused on developing newer districts in these cities, the historic urban landscapes were neglected, adding a layer to the decline of these cities, wherein the municipal authorities channelled their efforts toward the emerging zones of each city and in the process overlooked the maintenance and refurbishment of infrastructure in the historic quarters. Consequently, the historic fabrics of Aleppo, al-Salt and Acre became dilapidated and many residential areas suffered from deteriorating living standards due to overcrowding in Aleppo and Acre, and to abandonment in al-Salt (personal observations in the three cities and also, on Aleppo see Busquets, 2005; Windelberg et al., 2001; on al-Salt see Royal Scientific Society, 1990b; and on Acre see Abu Shanab, 2004; Rahamimoff, 1997).

Significant demographic changes also occurred during this period. In Aleppo, the affluent inhabitants moved to the new parts of their city, to be replaced in the old districts by poorer, less educated rural migrants. Gradually, the residential quarters of Aleppo also became overcrowded, and houses were subdivided into smaller units to accommodate extended families. More recently, sweatshops and commercial storage facilities, attracted by low rental rates, have begun to occupy many of the historic houses (Khechen, 2005: 55). In the same vein, the political events of 1948 caused the majority of Acre's Arab inhabitants to flee to neighbouring countries or to the countryside, becoming 'absentees from their property' (Fischbach, 2003). Simultaneously, Palestinian Arab families from Haifa and its environs converged onto Acre and were confined with the remainder of Acre's original inhabitants within the *aswār* of Acre. During almost all the interviews with Acre's inhabitants, they referred to their current living conditions, and many insisted on showing intimate details of their daily hardships, such as dilapidated structures and crowded residential spaces. Several planners in Acre also highlighted the poor living conditions there. According to one: 'some of the houses in Acre are inhumane. Some underground houses in Acre do not get sunshine and are not suitable for human habitation'. Another shared that: 'A lot of the buildings [and] structures are not fitting appropriate for dwelling [sic]. It is not healthy to live there. They all suffer from high humidity without the circulation of the air. There is thick

air within the structures'. In the case of al-Salt, several residential abodes remain to this day abandoned, while an additional number are rented out either to poorer local families or to groups of immigrant workers from neighbouring countries – primarily single males, who often crowd in large numbers inside these dwellings for cheap rent (personal observations).

Lastly, the inhabitants in the three cities complained during the interviews about the lack of social infrastructure. They repeatedly referred to the lack of clinics, vocational schools, public libraries, youth centres, elderly services, children's playgrounds and kindergartens.

The Spatial Concerns

The adaptation of infrastructure to accommodate the use of the automobile posed a major challenge given the traditional street hierarchy in the three cities in general, but in al-Salt, in particular, there was the additional challenge of navigating its steep topography. Moreover, while the main arteries in Aleppo could accommodate vehicular traffic, the smaller branches in the network could not, which led to the demolition of significant parts of the historic urban landscape. Also, in the three cities, the small branches and cul-de-sacs impeded the continuous flow of traffic, leading to traffic congestion which was worsened by the concentration of administrative, economic and religious activities in the central areas of these cities (on Aleppo see Windelberg et al., 2001; on Acre see Kesten, 1993; and on al-Salt see Royal Scientific Society, 1990b).

Most of the damage to Aleppo's spatial organization actually resulted from planning initiatives between the 1950s and the 1970s that imposed automobile roads over the traditional street network (Vincent and Sergie, 2005: 49), such as the effects of the Gutton Proposal described earlier in this chapter. The neglectful attitude of the Municipality of Acre, *Minḥāl* and *'Amidār* toward Acre had resulted in ongoing problems, including a lack of basic infrastructure where, for example, one planner reported that up until the early 1990s, Acre lacked even the most elemental necessity of a functioning sewer system. Al-Salt lost a significant portion of its historic urban landscape, especially in the downtown core, to urban development since the 1960s. Simultaneously, the abandonment of historic buildings combined with municipal neglect led to dilapidated urban infrastructure.

The Architectural and Aesthetic Elements

Due to their limited economic means, the contemporary inhabitants of Aleppo, al-Salt and Acre have often been unable to meet the costs to maintain their houses in their original condition. In Aleppo and al-Salt, the inheritance procedures practiced under *sharī'a* laws have subdivided most of the privately owned property among dozens of owners over several generations, resulting in ownership complications which precluded the maintenance of property: similarly, in Acre the establishment of *'Amidār* and the absentee laws created a complex ownership situation for the majority of its inhabitants who have been living there since 1948. Observations of the built fabric also reveal that as they subdivided and added to historic structures, the inhabitants have utilized incompatible contemporary materials, such as reinforced concrete, that interacted negatively with the traditional stone façades.

In summary, Aleppo, al-Salt and Acre were subject to planning initiatives that commenced in the mid-1990s and that varied significantly in their place-making approaches and strategies. Throughout this book, I delve into the differences across these three cities at various stages of the place-making process; my objective from the review of their planning histories is to establish the links between these histories and the selection of particular planning objectives, and, eventually, to tie in the planning approaches and the associated place-making strategies in each case. I argue that the choice of a planning approach in each city (as we shall see in Chapters 4, 5 and 6) was strongly influenced by its recent history of planning. In more specific terms, the Project for the Rehabilitation of Aleppo considered rehabilitation its ultimate objective – this it aimed to achieve by prioritizing the conservation of the residential function of Aleppo's historic landscape while adopting a spatial approach (Windelberg et al., 2001). These place-making choices stemmed from the city's recent history which witnessed the demolition of significant portions of its historic residential quarters for

the sake of contemporary development as well as from the history of spatial planning in Aleppo. In contrast, the three Tourism Development Projects for al-Salt and the Development Plan for Acre emphasized tourism development. The former, however, underscored the foreseeable economic benefits of developing a new type of tourism product – this is particularly lucrative for a country that prides itself on its rich repertoire of antiquities, albeit with a dearth of urban history that until recently was not protected through the legislative channels. The projects in al-Salt thus approached tourism development purely from a commercial perspective that commodified the historic city – literally – as a tourism product. In contrast, while the Development Plan for Acre also prioritized tourism development, it emphasized the picturesque in the historic urban landscape and strove for a museum-like city; however, the tensions between the authorities and Acre's inhabitants coerced a shift in the planning approach.

PART II
Place-making

Chapter 3
Documentation and Value Assessments: The Identification of Local and Global Significance

The First International Congress of Architects and Technicians of Historic Monuments yielded the 1931 Athens Charter for the Restoration of Historic Monuments which called for the protection of the 'character and historic values' of 'monuments of artistic, historic or scientific interest' (ICOMOS, 1931: Article 2.II). The Second International Congress in Venice followed in 1964 and yielded the Venice Charter according to which restoration's primary objective was to 'preserve and reveal the aesthetic and historic value of the monument' (ICOMOS, 1964: Article 9). The Venice Charter also furthered the notion of world heritage, grounding it in the rationale that 'people are becoming more and more conscious of the unity of human values and regard ancient monuments as a common heritage' hence it stressed the need for a 'common responsibility to safeguard [ancient monuments] for future generations' (ICOMOS, 1964). Thus this congress led to the establishment of ICOMOS (ICOMOS, 2011a), and to the emergence of three key notions that henceforth prevailed UNESCO's modus operandi, namely: heritage values and significance; world heritage; and shared responsibility.

Building on the discussion in Chapter 1, this chapter delves further into the world heritage and the shared responsibility notions, but highlights the values and significance of cultural heritage, particularly the concept of outstanding universal value (OUV). Fulfilling the requirement of outstanding universal value determines the inscription of a property on the World Heritage List (UNESCO, 1972) and sets forth the direction for the management and intervention strategies – in other words, the place-making strategies. As the first step in such place-making, value assessments consist of three stages that begin with the documentation of the historic urban landscape (see for example Pendlebury, 2009; Tyler, 2000; Ford et al., 1999; Pearson and Sullivan, 1999). The outcomes of the documentation then lead to the ranking and prioritization of the values, while the third and last stage is the actual planning for later intervention in the historic urban landscape (Mason, 2002: 14). Therefore, the discussion in this chapter addresses the challenges and the controversies associated with the assessment of values in general, and the outstanding universal value in particular. The discussion draws attention to the intensified complexity of value assessments at the urban scale where the cultural heritage in question encompasses the entire historic urban landscape. Through the case study cities, the discussion also presents the tensions between the values and significance associated with the world heritage status versus those associated with the local values.

World Heritage: the Outstanding Universal Value and the Inscription Criteria

The Convention introduced the tenet of 'outstanding universal value' as a prerequisite for the inscription of any heritage property on the World Heritage List (UNESCO, 1972: Article 11). However, the Convention did not define the outstanding universal value but instead linked it to specific 'points of view' such as the 'point of view of history, art or science' for monuments and groups of buildings and the 'historical, aesthetic, ethnological or anthropological' point of view for sites – inherently implying that these points of view pertain to the experts (see UNESCO, 1972: Articles 1, 2). In lieu of defining the outstanding universal value, the Committee requested from ICOMOS to prepare criteria that evaluate it. Thus, ICOMOS produced the Operational Guidelines for the Implementation of the World Heritage Convention (henceforth, the Operational Guidelines) that regulated all the procedures pertaining to world heritage from nomination to inscription (UNESCO, 1977, UNESCO, 1978). These Operational Guidelines proposed two sets of criteria: six for cultural heritage and four for natural heritage (Jokilehto et al., 2008; UNESCO, 1977: Article 5.ii). These criteria remained in principle unchanged throughout the 16 revisions of the Operational Guidelines between 1977 and 2013 except that in 2005 they were combined into one list instead of their separation

into criteria for cultural and for natural heritage (UNESCO, 2005a: Articles 77.i–77.x) (see Table 3.1). In conjunction with these criteria, the Operational Guidelines also stipulated that any nominated property 'must also meet the conditions of integrity and/or authenticity' (UNESCO, 2013: Article 78). Thus, in order to justify any property's inscription on the World Heritage List, the nomination package should compare this nominated property to similar sites, specify the applicable nomination criteria and assert the validity of these criteria through a 'Statement of Outstanding Universal Value' while simultaneously validating the claims of integrity and authenticity. ICOMOS and IUCN experts then evaluate all the nominations and make their recommendations to the Committee, which in turn makes the final decision.

Notwithstanding its importance, the documentation methods of cultural heritage have hitherto not been fully addressed in the world heritage documents or any other UNESCO, ICOMOS or ICCROM doctrinal texts except for a brief mention in the Convention for the need for complete documentation of any nominated property (UNESCO, 1972: Article 11.1). Likewise, the 2013 Operational Guidelines have very briefly stated that the nomination package should include 'carefully prepared documentation' (UNESCO, 2013: Article 23.a). These Operational Guidelines have also linked the documentation to intervention strategies when specifying that 'Reconstruction is acceptable only on the basis of complete and detailed documentation and to no extent on conjecture' (Ibid.: Article 86). Thus any future intervention in the nominated property would safeguard its values and significance whether through protection, conservation and/or management (UNESCO, 2008: Article I.3.i). As such, the statement of significance that ensues from the documentation becomes a 'prerequisite to making decisions about the future of a place' (Australia ICOMOS, 1999), rendering such documentation critical for the subsequent development of policies and plans (Feilden and Jokilehto, 1998). Without elaborating on the documentation methods, the Convention and the Operational Guidelines have considered that the inscription criteria and the outstanding universal value would provide a 'framework' for assessing the values of cultural heritage (Jokilehto et al., 2008: 8). This framework certainly underscored only the perspective of the heritage and conservation experts, particularly when statements such as 'from the point of view of history, art or science' have been appended to almost all the inscription criteria (UNESCO, 1972: Article 1).

Indeed, since its inception, the outstanding universal value and then its 10 assessment criteria had stirred debate within and beyond the world heritage institutions. The following discussion traces these debates and reveals that the first stab at defining the outstanding universal value happened only in 1998, and that the term was finally defined in 2005 – 33 years after its inception in 1972. The discussion also reveals that the world heritage documents and doctrinal texts had lagged behind the heritage debates in defining values and significance and in establishing their assessment tools.

The Evolution of Cultural Heritage Values and Significance

The word 'value' holds positive connotations that evoke worth and benefits (Mason, 2002: 6). When the definition of cultural heritage as a resource that is inherited from the past prevailed in the nineteenth century, the concern for the conservation of historic built fabrics was based on their 'intrinsic value' (Ashworth and Tunbridge, 1990: 24; Nasser, 2003: 467, 471). The resolution of the 1972 ICOMOS symposium on the 'introduction of contemporary architecture into ancient groups of buildings'[1] asserted 'that any historical monument or complex of buildings possesses an intrinsic value independently of its initial role and significance' (ICOMOS, 1972). Thus, it was historic conservation experts who judged the value of cultural heritage and claimed objectivity by depending solely on 'facts' and 'truths' (Wells, 2010). However, I argue that two events in 1972 led to a surge in the theoretical and empirical writings on heritage value and significance that subsequently triggered a paradigm shift in the definition of values and significance and in their assessment. The first was the National Parks Service's establishment of procedures for assessing the significance of material heritage[2] (Samuels, 2008), and the second was the ratification of the Convention which ensued in the

1 This symposium was held in 1972 during the Third ICOMOS General Assembly, in Budapest (ICOMOS 1972).

2 This was probably a response to the National Historic Preservation Act of 1966 that delegated such assessments to contracted archaeologists (Samuels, 2008: 74).

adoption of the Operational Guidelines in 1977 and the first inscriptions on the World Heritage List in 1978 (UNESCO, 1978).

Briuer and Mathers (1997) observed that prior to 1972 there were very few, if any, publications at all on heritage values and significance in the USA. Then, while only a handful of such publications appeared between 1972 and 1976, a plethora emerged from 1977 onward (Briuer and Mathers, 1997). These publications called for considering alternative modes for the evaluation of heritage significance other than the expert-attributed intrinsic value. Thus, in addition to the 'historical and scientific significance', new types appeared such as 'social and monetary values' (Briuer and Mathers, 1997: Ea-1, E-a2). Distinctions ensued between 'significance' and 'value' whereby the former was associated with expert-related interests and the latter with the public-related ones (Briuer and Mathers, 1997: Ea-1, E-a2). Others challenged significance assessments based on the fact that significance is inherently capricious and advocated for abandoning it altogether. Instead, as Lipe (1974: 228) argued, 'the guiding principle [...] should be representativeness' lending further credence to the experts' standpoint.

The first to break with the expert-based approach of heritage values were Michael J. Moratto and Roger E. Kelly (1976) who contested the claim of intrinsic significance for cultural heritage, questioned the experts' control over value assessments and advocated for diverse concepts of heritage significance that 'vary according to the attributes of the resources, the context of the assessment, and the perspective of the evaluation' (Moratto and Kelly, 1976: 201). By questioning the approach of setting criteria for significance assessments, they contended that 'there can be no universal or absolute measures of worth' (Moratto and Kelly, 1976: 193). Therefore, they proposed to overcome the limitations of existing criteria by combining them with a layered thematic approach such as the National Parks Services' classification of cultural heritage according to events and/or periods (Moratto and Kelly, 1976: 200–201).

In addition to representativeness and themed classifications, subsequent arguments also reasoned that heritage is a contemporary social construct. Thus, in contrast with the experts' view that intrinsic values define heritage, heritage is currently selected based on subjective values that are contingent upon and constantly interacting with contemporary factors such as historical events, social forces, cultural trends, economic opportunities and spatial forms (Graham, 2002: 1004; Mason, 2002: 5–6, 9). Value and significance are therefore bestowed on heritage and do not necessarily emanate from its materiality or physical status (Graham, 2002: 1004). Once it was established that heritage is inherently 'value-laden' (Boniface and Fowler, 1993: 158), it became possible to challenge the empiricist-positivist claim of objective expert assessments of heritage (Tainter and Lucas, 1983: 715). Also, because a diversity of factors influences heritage values, cultural heritage may then concurrently possess a complex array of contemporary values (Graham, 2002: 1006; Moratto and Kelly, 1976). Various factors further compound this complexity. Firstly, the varying perceptions of stakeholders who maintain different values for the same quality of cultural heritage (Mason, 2002: 9; Moratto and Kelly, 1976) and who, in the process, generate insider-outsider views of heritage values (Hayden, 1999) and create clusters of 'imagined communities' among those who share the same values toward cultural heritage (Anderson, 1991: 184). Secondly, the complexity of heritage values is exacerbated when their diversity entails overlap, competition, inconsistency and even conflict (Mason, 2002: 5), which more often than not evolve into dissonance (Tunbridge and Ashworth, 1996: 3, 8). For example, while the historic and the commercial values of heritage link the past and the present (Ashworth and Tunbridge, 1990: 24; Nasser, 2003: 471), they simultaneously generate dissonance when tourism development, motivated by the economic values, imposes irreversible changes on the historic urban landscape and on the quality of life of its inhabitants (Graham et al., 2000; Tunbridge and Ashworth, 1996). Thirdly, while the capricious nature of cultural heritage values manifests in multifarious ways, the decision-making processes typically fail to capture this diversity and prioritize the conservation of those values deemed essential at one particular point in time (Lipe, 1974: 227; Taylor and Cassar, 2008: 8). Heritage therefore is not only a varied, but also an evolving entity, where many 'heritages' co-exist, whose values – that is, contents and meanings – change through time and across space (see for example Graham, 2002: 1004; Mason, 2002: 9; Taylor and Cassar, 2008: 8). Lastly, and most importantly, these complexities and controversies surrounding the heritage value concept acquire additional dimensions when transposed onto historic urban landscapes – as opposed to a single monument, site or group of buildings. If we apply Moratto and Kelly's (1976: 210) view that a combination of attributes, context and perspective shape the values of heritage, then these values are indeed compounded at the scale

of the historic urban landscape where the urban fabric and its context are more intricate and where the stakeholders are greater in numbers and more varied in perspectives.

The Evolution of the Outstanding Universal Value

The world heritage movement, as represented by UNESCO and its advisory bodies, has failed to keep pace with the ongoing debates on heritage values in general, let alone to address their complexities at the urban scale in particular. The 1987 Operational Guidelines were the first to mention historic towns (UNESCO, 1987: Article 24.i, ii and iii), but they underscored their architectural rather than intellectual value (UNESCO, 1987: Article 26), highlighted the 'monumentality' of the nominated historic fabric (or parts of it) (UNESCO, 1987: Articles 27, 28) and recognized only the implications of the inscription on 'the fragility of their urban fabric' as opposed to the life within this fabric (UNESCO, 1987: Article 15.ii).

Likewise, the numerous ICOMOS international resolutions and charters, some of which were specifically dedicated to historic urban landscapes, overlooked the heritage values altogether including the Bruges Resolution 1975[3] and the Washington Charter 1987[4] (ICOMOS, 1975; ICOMOS, 1987). Both documents underscored the 'historic character' of the town/urban area and called for conserving its 'visual qualities', 'appearance' and its 'physical and spatial elements' (ICOMOS, 1987: Article 5.iii; ICOMOS, 1975: Article 2). Additionally, they highlighted the expert assessments of the morphological characteristics (for example, the street network, land parcels and public open spaces) and of the visual characteristics (for example, the architectural styles and the natural setting) (ICOMOS, 1987: Article 2). The 1979 Burra Charter[5] defined cultural significance as the 'aesthetic, historic, scientific or social value for past, present or future generations' (Australia ICOMOS, 1979: Article 1). The final iteration of this charter in 1999 added the 'spiritual' value and explicated that 'Cultural significance is embodied in the *place* itself, its *fabric, setting, use, associations, meanings*, records, *related places* and *related objects*'. But most importantly, this charter acknowledged the diversity of the stakeholders when it declared that 'places may have a range of values for different individuals or groups' (Australia ICOMOS, 1999, italics original). Notwithstanding the positive reception of the Burra Charter, many criticized its 'discursive' structure that signalled the superiority of the experts' point of view at the expense of the diversity of the stakeholders (Waterton et al., 2006). Nevertheless, the Burra Charter has been acclaimed for attempting – as early as 1979 – to be inclusive of both the diversity of stakeholders and of their temporality by addressing past, present and future generations – preceding in this process the 1987 Brundtland Report, which supposedly introduced the intra-generational concept of sustainability (Brundtland, 1987).

In contrast to the Burra Charter, the Convention and the subsequent operational guidelines were marked by the exclusion of the local communities from the identification of significance – as evident in the operational guidelines from 1977 until 1995 which, for the first time, acknowledged the need to involve the local communities in the early stages of the nomination phase. However, the 1995 Operational Guidelines still emphasized that such involvement was meant to ensure the experience of a 'shared responsibility' instead of ensuring that the stakeholders' opinions would be included in assessing the significance of their historic town (UNESCO, 1995: Article A.2.1).

The recent UNESCO proposal titled 'Recommendation on the Historic Urban Landscape' (UNESCO, 2011a) attempted to offer a framework for addressing the issues pertaining to urban conservation, including the identification of cultural values. This instrument admitted to the complexity of multiple stakeholders and encouraged the use of participatory methods in the identification of the values of the historic urban landscape, but it fell short of defining the outstanding universal value at the urban scale (Alsalloum, 2011) and it also failed to offer any practical suggestions for the documentation process. The ambiguity surrounding the outstanding universal value continued to incite debates that even extended to the inscription criteria. Through

3 The Bruges Resolution is the outcome of the International Symposium on the Conservation of Smaller Historic Towns, which was held at the Fourth ICOMOS General Assembly in 1975.

4 The Washington Charter is the ICOMOS Charter for the Conservation of Historic Towns and Urban Areas.

5 Australia ICOMOS published the first iteration of this charter in 1979. It is also known as the Charter for the Conservation of Places of Cultural Significance. Since 1979, it had undergone several subsequent revisions until 1999.

a content analysis of UNESCO's documents and archives, the following section reveals how the attempts to elucidate and to operationalize the outstanding universal value had lagged behind the contemporaneous heritage debates. This section also reveals how these attempts seemed reactionary to these debates and, for the most part, how they drew on the experiences of the National Parks Service in the USA instead of responding to the challenges emerging from the actual process of inscription on the World Heritage List.

Resolving Ambiguity or Inciting Debate?

The long trail of official UNESCO, ICCROM and ICOMOS records since the 1970s documents all the meetings, workshops and efforts by experts and commissioned consultants among many others. This trail thus provides tangible evidence of UNESCO's attempts to define, interpret, justify and operationalize the outstanding universal value and also to revise the inscription criteria accordingly (Jokilehto et al., 2008). At its third session in 1979,[6] the Committee conceded to the presence of 'a number of problems over the application of the criteria', and commissioned Michel Parent, a conservation expert, to 'define more precisely' these inscription criteria (UNESCO, 1979: Article 2). Parent produced a report that distinguished between the positive and negative values and associated the outstanding universal value with the qualities of rarity and uniqueness but simultaneously admitted that these were '(subjective) qualifications not objective criteria' (Parent, 1979: 18). Parent therefore attempted to counter this subjectivity primarily through expanding on the authenticity criterion, and through generating sub-classes for each of the Convention's three typologies of cultural heritage – monuments, groups of buildings and sites – and proposing possible combinations of applicable values for each (Parent, 1979: 2–7). Most importantly, Parent's report introduced 'comparative assessments' and 'representation' both of which became central to the methodological ethos of the World Heritage List inscription procedure. The tenet behind comparative assessment was that it would increase the objectivity by enabling the experts 'to compare like with like' (Parent, 1979: 25). Parent had indeed borrowed comparative assessments from Michael B. Schiffer and John H. House (1977) who had proposed, firstly, to categorize the different types of value and, secondly, to ascribe values to sites, allowing the assessors to establish a relative significance for each site by cross-comparing the sites that possess similar value categories. Similarly, Parent's report borrowed from Lipe's (1974) theory of a representative sample, whereby representation referred to 'a whole series of similar sites, whereas monuments or historic towns will inevitably form whole "families"' (Parent, 1979: 24). Accordingly, only 'the most remarkable' sites from each family – that is, that are both representative and unique – would be inscribed on the World Heritage List, and thus become 'unique symbols, each one standing for the whole series of similar events' (Parent, 1979: 24). This emphasis on uniqueness contradicted with this report's earlier criticism of the subjective nature of the rarity and uniqueness qualities and fell in line with earlier critiques of 'sliding scales' in determining the significance of cultural heritage (Raab and Klinger, 1977: 632).

Although the Committee initially dismissed Parent's report (UNESCO, 1983), his recommendation for a comparative assessment method was endorsed together with revising the criteria as necessary (UNESCO, 1979: Article 5; UNESCO, 1983: Article 7). Criticism, however, was mounting against the over-representation of European Judaeo-Christian sites on the World Heritage List (see for example critiques by: Beck, 2006: 522; Cameron, 2005: 72; Smith, 2006; Titchen, 1996). Such critique was attributed to the predominantly Eurocentric method of assessing the outstanding universal value, which was seen as exclusionary of other cultures (Cleere, 1996; de Cisari, 2010: 310; Frey and Steiner, 2010: 6–8). Thus, several following attempts sought to widen the representative net of the World Heritage List (Cameron, 2005: 72), but each new proposal attracted more criticism and controversy, and inevitably became the burden of its successor. For example, a 1988 Global Study proposed to combine Parent's classifications and the comparative assessments whereby all the cultural heritage of the world would be grouped into various lists based on considerations such as chronology, geography, function and religion in order to facilitate international comparisons. Had it been endorsed, this proposal would have led to an infinite number of inscriptions on the World Heritage List (see Cameron, 2005: 72; Frey and Steiner, 2010: 8; Rakić, 2007: 215).

6 This session was held in Luxor and Cairo in Egypt.

Mostly, the contradictions in defining the outstanding universal value resulted from the attempt to interpret this construct through combining 'uniqueness' and 'representativeness' (see for example Titchen, 1996) – overlooking in the process that these two qualities are mutually exclusive. In other words, by virtue of being unique, such as in the case of the carved-rock city of Petra in Jordan, a heritage property cannot simultaneously be representative. Therefore, decreasing the emphasis on the uniqueness quality was thought to resolve these controversies, and so, for the first time since the Convention, the outstanding universal value was defined in 1998 as 'an outstanding response to issues of universal nature common to or addressed by all human cultures. In relation to natural heritage, such issues are seen in bio-geographical diversity; in relation to culture in human creativity and resulting cultural diversity' (World Heritage Committee, 1998). The lingering ambiguity of the terms 'outstanding' and 'universal' in this definition, however, compelled the Committee to redefine the outstanding universal value in the 2005 Operational Guidelines as: 'cultural and/or natural significance which is so exceptional as to transcend national boundaries and to be of common importance for present and future generations of all humanity. As such, the permanent protection of this heritage is of the highest importance to the international community as a whole'[7] (UNESCO, 2005: Article 49).

Simultaneously, a 2005 World Heritage Expert Meeting in Kazan sought to elucidate this new definition and to improve the identification, nomination and sustainable management of those properties that possess this value (World Heritage Committee, 2005). This meeting's recommendations made two controversial claims. Firstly, these recommendations claimed that the outstanding universal value concept was deliberately 'widely drawn' so as to allow it to evolve over time (World Heritage Committee, 2005: Article II.7.b). This claim is contested on the grounds that the theoretical and empirical discussions that established the capricious and diverse nature of heritage values had occurred in the wake of the 1972 Convention (Briuer and Mathers, 1997). Also, the corporate history of UNESCO as reviewed in this chapter proves that the numerous attempts to define and operationalize the outstanding universal value continued as recently as 2008 with ICOMOS's report: 'What is OUV?' (Jokilehto et al., 2008).

Secondly, for the first time in the 30-odd years of official UNESCO discourse on world heritage, the Kazan meeting finally included the stakeholders' perspective, whereby the outstanding universal value is 'attributed by people and through human appreciation', and thus its identification stems from the 'wide participation' of stakeholders, who include local communities and indigenous people (World Heritage Committee, 2005: Articles II.7.a and k). These recommendations for inclusiveness at the local level however contradicted with the strong bias toward expert-based determination of 'outstanding' value as well as with the 'universal' quality of world heritage. On the one hand, the Kazan meeting put the onus on the experts who compile regional and global heritage databases that facilitate thematic studies and comparative assessments (World Heritage Committee, 2005: Article II.7.e). To this day, these are considered the only methods to evaluate the outstanding universal value by determining whether the site is unique or representative (Jokilehto et al., 2008: 8, 47). Ironically, Jokilehto et al'.s (2008) report concluded its discussion of these methods by endorsing a 1976 ICCROM report that stipulated: 'the fact that [the outstanding universal] value be recognized to an object or a cultural ensemble cannot be justified except when referred to specialized scientific literature on the subject, which is considered the most up-to-date expression of the universal consciousness on the issue' (Jokilehto et al., 2008: 47). This reversion to the 1970s rhetoric disregarded decades of evolution for the heritage value concept and returned to a post-positivist paradigm that re-established the hegemony of the conservation experts over the supposedly objective assessments of heritage values. Indeed, when this process is 'institutionalized in the state cultural agencies and amenity societies' (Smith, 2006: 11), as is the case for world heritage, then it eventually leads to an 'authorized heritage discourse' – albeit one that deviates from 'mediating cultural change' (Ibid.: 11, 300). Also, because the hegemonic control of professional elites typically excludes stakeholders, it thus precludes 'asserting, negotiating and affirming particular identities and values' (Smith, 2006: 300). This exclusionary approach contravenes the recommendations of the Kazan meeting, since it diminishes the possibility of a people-oriented participatory process in defining the outstanding universal value.

7 This definition remained unchanged in the 2008, 2011 and 2013 revisions of the Operational Guidelines (UNESCO, 2008; UNESCO, 2011b; UNESCO, 2013).

On the other hand, the universal value of world heritage entails shared responsibility and global accountability for the protection and conservation of heritage assets (Jokilehto et al., 2008: 8) and requires that the outstanding characteristics be concurrently 'shared by human cultures' and 'specific to' its local culture (Ibid., 2008: 47). In fact, this seems to be the reasoning offered by UNESCO at the finale of its debate over the outstanding universal value – as Christina Cameron summed up in Kazan: 'maybe it does not matter. Maybe what matters is that the objectives of the World Heritage Convention – protection and international cooperation – continue to be the catalyst for increased national actions to support a culture of conservation' (Cameron, 2005). But the international shared responsibility tenet conflicts with the fact that heritage generates an insider sphere and an imagined community, and by consequence an outsider sphere. David Lowenthal (1998: 230) argued that 'the very notion of a universal legacy is self-contradictory; [...] confining possession to some while excluding others is the *raison d'être* of heritage'. Empirical evidence from several countries including China, Vietnam, Thailand and Fiji, among others, reveals dissonance between the universal, national and local values at several World Heritage Sites[8] (Beck, 2006: 523). Notwithstanding the global shift in the heritage value paradigm which has forced policy-makers to address local concerns, the continued emphasis on the universality of world heritage inherently excludes the local narratives. Indeed, the report by Jokilehto et al. (2008) discounted the local perspective in the assessment of outstanding universal value when it confirmed that 'the nominations should be seen in a context that "goes beyond the national boundaries. Thus the reference framework will necessarily be international and in some cases even global"' (Jokilehto et al., 2008: 47). Furthermore, the 2013 Operational Guidelines contended that the World Heritage List is intended 'only for a select list of the most outstanding of these from an *international* viewpoint. It is not to be assumed that a property of national and/or regional importance will automatically be inscribed on the World Heritage List' (UNESCO, 2013: Article 52, italics mine). Thus in their attempt to explain the outstanding universal value, Jokilehto et al. (2008: 12) defined six criteria that included: uniqueness; rarity; outstanding importance for world architecture or human settlements; the best or most significant intellectual, social or artistic examples of cultural heritage; historicity or old age; and, lastly, association with persons, events, religions or philosophies that are globally significant. The outstanding universal value is therefore not only criticized for being 'an idealistic quest' (Beck, 2006: 522), which reduces all values in a statement of significance akin to a 'black box', but also for excluding in the process other types of values (Mason, 2002: 6) – mostly the local ones (Frey and Steiner, 2010). This exclusion is further exacerbated given the chasm between the international level of administering the World Heritage List (Lowenthal, 1998: 227), and the national and local levels of nominating and inscribing property (Graham, 2002: 1005). In sum the iterative attempts to define and interpret the outstanding universal value have eclipsed all other worthwhile pursuits, including the need to address the diversity of heritage values, to include local values and, above all, to operationalize value assessments at the scale of the historic urban landscape.

Notwithstanding these criticisms of the outstanding universal value, the inscription criteria and their implications, some have argued that these concepts have enriched the debate over heritage (Howard, 2006: 487), and have mobilized research that yielded the still-evolving discipline of heritage management. The following section addresses how the identification of the values and significance of historic urban landscapes constitutes the first among several that influence the outcomes of the place-making initiatives.

Alternative Conceptions of Values and their Assessment

In order to avoid the subjectivity and inherent capriciousness of heritage values, several classifications, measures and typologies have emerged over the years (Briuer and Mathers, 1997; Mason, 2002: 9; Mathers et al., 2005). Some classifications reflected the priorities of the assessors including the conservation experts' emphasis on the physical and intrinsic values (see for example Deeben et al., 1999; Tyler, 2000; Feilden and Jokilehto, 1998). Moratto and Kelly (1976) proposed one of the earliest classifications that sought to replace the intrinsic values by basing their typology on the historical, scientific, ethnic, public, geographic, monetary and legal and, lastly, managerial values. Others resolved to temporal distinctions that differentiated between

8 See for example Maddern's study of the World Heritage Site of the Statue of Liberty, Ellis Island (Maddern, 2004).

memorial and present-day values, where the former refers to the values of age, history and place memory while the latter includes the values of contemporary use, aesthetic, newness and relative art (Pendlebury, 2009). Among the contemporary values, some included the economic, functional, educational, socio-cultural and political values (Ashworth and Voogd, 1994; Graham et al., 2000; Olsson, 2008), and even the knowledge value of heritage (Graham, 2002: 1006).

Throughout, these classifications were motivated by an attempt to objectively and impartially identify the heritage values and significance and eventually yielded distinctions between the 'values' and their impartial 'assessment criteria' (Deeben et al., 1999: 181). Deeben et al. (1999: 181) further distinguished between the subjectively perceived values and the supposedly objective physical and intrinsic values whereby the criteria for assessing the former account for the perceiver's subjectivity while the criteria for assessing the latter resolve to expert assessments like comparative and typological studies. Such deconstruction identified the objective assessment criteria and matched them with impartial data collection tactics and assessment methods (Mason, 2002: 9). The complexity of historic urban landscapes renders this deconstruction especially relevant considering the multiplicity and overlapping of values and their corresponding assessment criteria. Recently, distinctions between two sets of interrelated values emerged, namely: the socio-cultural and the economic values of heritage (Ibid., 2002: 11).

On the one hand, the socio-cultural values have been considered 'at the traditional core of conservation' (Mason, 2002: 11), but unlike the intrinsic value standpoint, these socio-cultural values incorporate the stakeholders' perceptions since they are 'attached to an object, building, or place *because it holds meaning for people or social groups* due to its age, beauty, artistry, or association with a significant person or event or (otherwise) contributes to processes of cultural affiliation' (Mason, 2002: 11 emphasis mine). Accordingly, contemporary conservation experts have included the historical, cultural-symbolic, social, spiritual-religious and the aesthetic together with the intrinsic values under the umbrella of the socio-cultural values of heritage (Mason, 2002). While this and other more recent definitions of the socio-cultural values convey better awareness of the stakeholders than the earlier definitions of heritage values, contemporary experts still seem reluctant to relinquish their authority to identify all the heritage values to the purview of the stakeholders and, particularly, maintaining their authority through the historical and the intrinsic values of heritage. The historical values have been associated with the 'material age, associations with people or events, the rarity and/or uniqueness, the technological qualities, or the archival/documentary potential' (Mason, 2002: 11; also see Throsby, 2002: 101). The intrinsic value is 'represented by – inherent in – some truly old and thus authentic material (authentic in that it was witness to history and carries the authority of this witness). Thus, if one can prove authenticity of material, historical value is indelibly established' (Mason, 2002: 13). Even those values that are supposedly identified by the stakeholders, such as the cultural-symbolic values (that is, the meanings of heritage), the social values (that is, social relations, identities and networks) and the religious-spiritual values (Mason, 2002: 11), can become tools of socio-political and religious 'legitimization', particularly, under the influence of hegemony (Graham, 2002: 1006). This issue is of particular relevance to world heritage, where the nation-state controls the nomination, inscription and management of heritage property.

On the other hand, the contemporary heritage management experts have highlighted the economic value of heritage and thus have perceived heritage as a 'cultural capital' asset that 'gives rise to a flow of goods and services over time which may also have cultural value (i.e., which are themselves cultural goods and services)' (Throsby, 2002: 103). Accordingly, these experts have adapted the distinctions between the use and the non-use values,[9] whereby the use value is generated from present-day direct uses of heritage through means such as entry fees, while the non-use values are based on the perception of heritage as a public good whose mere existence is considered of value. Thus the non-use values encompass the option value, which maintains the choice for the future uses of heritage and, similarly, the bequest value which considers the right of future generations to inherit this heritage (World Commission on Protected Areas, 1998: 11; Throsby, 2002: 103). Some have cautioned that, more often than not, the economic values precede, as in favouring the perspective of tourism (Wells, 2010: 465; Tunbridge and Ashworth, 1996). For example, Marion Read's (2005) research in New Zealand has revealed that even seemingly objective measures might become subjective if they excluded the perspective of the local communities. Read's analysis of the assessment of beauty in the Otago Peninsula

9 The World Commission on Protected Areas first introduced these distinctions in 1998.

has found that the experts' definition of aesthetics favoured 'the outsider over the inhabitants, owners and users of the landscape' (Read, 2005: 340).

Many have argued that these various typologies should not be used normatively but should instead constitute a starting point whereby the various types of heritage values are gleaned from the context rather than imposed on it (see for example Mason, 2002: 10, who sums up these arguments). As it stands, the pre-set world heritage criteria and parameters for outstanding universal value conflict not only with this deduction-oriented perspective, but also with the complexity of inhabited historic towns and, most importantly, fail to adequately consider these towns' distinctive characteristics. Indeed, the assessments of significance for inscription on the World Heritage List, particularly at the urban scale, continue to emphasize the point of view of the professional conservation experts and the architectural historians. For example, the inscription criteria have clearly prioritized monumental architectural relics, at the expense of the other elements that distinguish the urban image, namely, the paths, edges, districts and nodes (Lynch, 1960). Most importantly, the inscription criteria have disregarded that experts like M.R.G. Conzen (1960) attributed the picturesque of an historic urban landscape – or what Gordon Cullen (1971) had later dubbed the 'serial vision' – to its morphological characteristics. Conzen (1960: 3) stipulated that 'Morphologically [a town's character] finds expression in the physiognomy or townscape, which is a combination of town plan, pattern of building forms, and pattern of urban land use'. Numerous theoretical and empirical findings have supported Conzen's claim (see for example Conzen, 1981; Lilley et al., 2005; Pendlebury, 2009; Samuels, 1990; Whitehand, 1990). Through highlighting the pattern of land use, Conzen's work influenced the understanding of the relationship between the spatial distribution and the urban form on the one hand, and the socio-economic processes and power relations on the other hand. Certainly, Edward W. Soja (2003: 155) asserted that 'space is not an empty dimension along which social groupings become structured, but has to be considered in terms of its involvement in the constitution of systems of interaction'. David Harvey (2001) pointed out the interconnections between economy, power and spatial distribution while Manuel Castells (Castells, 2002) addressed the links between information flows and the contemporary city. Further, Joseph Rykwert (1976) analysed the links between political and religious power and urban form whereby a city's cosmic form conveys its distinctive religious and political status. Conversely, Peter G. Rowe (1997) negated the notion that the design of urban civic spaces is a social, political and economic representation and instead considered it a cultural expression of an organized civic society that is divorced from the influences of market forces (Rowe, 1997: 204). In the context of Arabic-Islamic cities, Besim Hakim (1986) argued that the merging of religious rules (that is, the Islamic *sharī'a* law) and the socio-cultural norms (that is, the traditional *'urf* rules) had impacted the spatial and architectural organization of these cities.

The recent heritage frameworks in general and the world heritage frameworks in particular have attempted to encapsulate these expert views in addressing the values and significance of historic urban landscapes. UNESCO's Recommendation on the Historic Urban Landscape stressed that: 'This concept encompasses layers of symbolic significance, intangible heritage, perception of values, and interconnections between the composite elements of the historic urban landscape, as well as local knowledge including building practices and management of natural resources' (van Oers, 2010: 12; UNESCO, 2011b). Surely, building on the idea of multi-layered significance, the forthcoming chapters on place-making and place experience ground the distinctiveness of the historic urban landscape in the perspectives of the local communities, the foreign tourists and the conservation experts. But firstly, the next section discusses the documentation methods that lead to the identification of the values and significance of historic urban landscapes.

The Documentation of Historic Urban Landscapes

MacLean (1996: 12) has defined the documentation of the historic urban landscape simply as 'information'. Often compared to a medical exam (MacLean, 1996), documentation provides an in-depth understanding of all the aspects related to the historic urban landscape (Mason, 2002: 5). It entails gathering all the available information about this landscape by reviewing all written documents like historic accounts, historic and contemporary archives and specialized research (Tyler, 2000). Documentation typically precedes any planning or intervention thus ensures their soundness (Mason, 2002: 5). In order to establish continuous monitoring,

documentation continues throughout the management of, and intervention in, the historic urban landscape (MacLean, 1996).

Documentation assumes a particular importance for historic urban landscapes where the complexity of the overlapping – and often competing – values deems it difficult to single one documentation method that yields perfect or complete information (Mason, 2002: 5, 14). Accordingly, I distinguish between three distinct discourses in the documentation of the historic urban landscape: the documentation of the architectural and the visual qualities; the documentation of the spatial and morphological qualities; and the documentation of the socio-cultural qualities.

To begin with, the architectural and visual discourse underscores primarily those qualities of the cultural heritage that speak to its physical appearance and historic status including its age, architectural style and visual aesthetic. This discourse also incorporates the qualities of integrity and conservation, such as the altered or authentic status of the historic urban landscape. Field surveys and in situ measured drawings have been used to document the architectural and visual components. Additionally, the increased concern for the physical architectural authenticity led to the development of highly technical photographic methods that document intricate details like the decorative elements of building façades (Tyler, 2000). For example, rectified photography uses grids to define scales and to provide reference points for a more accurate documentation while photogrammetry pairs photos in a stereoscopic viewer to create a more precise realistic visual record (Nichols, 1997; Tyler, 2000).

Secondly, with the introduction of the concept of 'historic urban landscapes' in later statutes like the Bruges Resolution and the Washington Charter (ICOMOS, 1987, ICOMOS, 1975), a need for new value assessment methods that cater for the spatial and morphological values emerged. Conzen's (1960) seminal study of Alnwick in Northumberland, England, constituted the cornerstone for the evolution of a new spatial morphological method – one that considers the townscape qualities. Such a method accounts for an urban landscape's historical spatial arrangements and morphological characteristics through spatial recording and analytical techniques that include metrological and town-plan analyses (see for example Lilley et al., 2005; Lo, 2007; Whitehand, 2001). The metrological analysis is akin to the in situ measured drawings of architectural physical features in that it depends on field surveys with the objective of reconstructing the historical town plans (Lilley et al., 2005). The town-plan analysis investigates, according to Conzen, the 'topographical arrangement of an urban built-up area in all its man-made features' (Conzen, 1960: 4–5). Town-plan analysis is primarily concerned with three 'plan elements', namely, 'streets and their arrangement in a street-system; plots and their aggregation in street-blocks; and buildings or, more precisely, their block-plans' (Ibid.: 5). Conzen developed the town-plan analysis method during his studies of English medieval towns where he used later eighteenth- and nineteenth-century plans to trace the medieval and post-medieval developments of the streets, the plots and the building footprints. Thus the town-plan analysis bestows particular attention on inferring historical developments in the urban form from the more recent plans and from field observations (Conzen, 1960). In other words, the town-plan analysis is concerned with change over time (Vernez Moudon, 1997).

Contemporary spatial technologies build to some extent on Conzen's town-plan analysis (Koster, 1998; Lo, 2007). One of the pioneering adoptions of information technology in documenting historical urban morphology is the University of Pisa's study of Capri, Italy, where the team innovatively combined town-plan analysis and computer-aided design (CAD) applications. Later research in England and in continental Europe combined computerized technologies and early cadastral plans to provide accurate reconstructions of the plot boundaries at the time of these plans (Koster, 1998: 7). Generally speaking, the early attempts to use spatial technologies sought first to derive the historical plot patterns, considering them the smallest and most fundamental units of the historical spatial arrangement (Conzen, 1960; Whitehand, 1990; Whitehand, 2001): then, spatial techniques, especially geographic information systems (GIS) and image processing, were employed to document the historical plot patterns (Koster, 1998). The strengths of GIS as a documentation tool stem from its incorporation of the three principal town-plan elements – the street network, the blocks and parcels and the building footprints (Koster, 1998). Therefore, GIS facilitates an understanding of the contemporary and the historic associations among these elements and, by consequence, the historic and the contemporary factors that influence the historic urban landscape (McCarthy, 2004). GIS may also be combined with other types of information technologies, such as the global positioning system (GPS) and Space Syntax, which enable the documentation of the morphological changes over time, for example by digitizing historic maps

and then comparing them to contemporary conditions (Karimi, 2000; Lo and Yeung, 2002). As an example, in their study of the medieval built form of Winchelsea in England, Lilley et al. (2005) used GPS to survey and map the visible medieval remains and, thus, provided accurate data that complemented previous metrological analyses. They then incorporated the data in ArcGIS, reconstructed the medieval town and were even able to generate three-dimensional morphological analyses (Lilley et al., 2005). These and other studies corroborate the potential of GIS to facilitate an analysis of the three principal town-plan elements: the street networks, blocks and parcels and building footprints (Koster, 1998), and, by consequence, to facilitate an analysis of the associations among the various factors that influence the historic urban landscape (McCarthy, 2004). GIS and the other spatial techniques such as space syntax can also document morphological changes over time by comparing digitized historic maps to contemporary ones (Karimi, 2000; Lo, 2007). The proponents of GIS have also claimed that it promotes broader participation in urban preservation through applications such as Internet mapping, which allow the dissemination of information to a larger audience (McCarthy, 2004). GIS has been criticized, however, for being too broad and for not recording details at the building level (Ford et al., 1999) – a weakness that, some have argued, may be overcome by combining GIS with other methods that augment its spatial-recording abilities by providing descriptive data, such as by using traditional methods like field drawings, or by deploying CAD applications (Elkadi and Pendlebury, 2001; Ford et al., 1999; Nichols, 1997).

Lastly, the socio-cultural discourse demands interdisciplinary, grounded and inclusive value assessment methods that address values from the perspective of the general public, such as spiritual values (Mason, 2002: 15), aesthetic preferences and historical associations (Tyler, 2000). Dolores Hayden (1999), for example, used story-telling – an ethnographic method that documents oral traditions – to elucidate, through social memory, the local perceptions toward historic urban landscapes: such methods that incorporate perspectives other than the experts' reveal the value and significance of unlikely elements in the historic urban landscape (Hayden, 1999). Indeed, the local inhabitants of York, England, considered the ordinary and the mundane elements in their historic urban landscape as significant as the monumental, and, hence, prompted Lord Esher to incorporate these ordinary and mundane elements in his urban conservation plans (Pendlebury, 2009). Unconventional methods such as oral traditions may also provide a wealth of information on the practical values of the historic urban landscape, especially its value as a capital resource (Olsson, 2008). The values that emerge from a grounded approach thus unravel qualities that contribute to the distinctive identity of the historic urban landscape and to its sense of place while simultaneously offering an opportunity for future economic development (Nasser, 2003).

More recently, the emphasis on 'change' in historic urban landscapes has also permeated the value assessment methods, whereby rather than separating the documentation of the physical changes and the values, it is currently 'the relationship between change and value' that attains importance (Taylor and Cassar, 2008: 7). Given the capricious nature of heritage values, especially in historic urban landscapes, it is the documentation that establishes the links between change and value. In addition to guiding the intervention strategies, such links also facilitate an interpretation of past and present changes and of the values through the historic urban landscape. Accordingly, intervention necessitates – and also, simultaneously occurs through – the representation of all the possible interpretations of this landscape (Ibid.). Therefore, interdisciplinary methods – through participatory and inclusive value assessments – advance the documentation of the varying perspectives on the values of the historic urban landscape (Tonkin, 2006: 551). Such a combination of diverse perspectives and of interdisciplinary methods stand in stark contrast to the 'static models of significance' that depend on pre-set typologies that 'capture' rather than 'identify' values (Stephenson, 2008: 129; Herlin, 2004: 400). This approach presents a direct criticism of the world heritage criteria whose imposed typologies may – notwithstanding their seemingly all-encompassing nature – fail to grasp the local perspective toward the significance of the historic urban landscape (Stephenson, 2008: 128). The absence of such a local perspective yields a superficial and a fragmented understanding of this landscape's significance (Dakin, 2003: 190).

Notwithstanding this socio-cultural discourse, the implications on the future of the historic urban landscape warrant that the documentation methods transcend data collection to become an 'information strategy' – one that is 'accessible, effective, efficient, replicable, and accurate' (MacLean, 1996: 12–13). So how were the historic urban landscapes of Aleppo, al-Salt and Acre documented? How were the valuable and the significant urban elements assessed? How did the documentation and the assessments impact the setting of intervention

priorities in each city's planning initiatives? And how do the findings of the documentation relate to each city's inscription criteria and outstanding universal value?

Aleppo: A Spatial Approach

Urban planning in Aleppo during the first half of the twentieth century prioritized the automobile traffic as evident in the Gutan proposal and the Banchoya plan (Bianca et al., 1980; Windelberg et al., 2001). Stefano Bianca and his team of experts criticized these earlier plans in their 1980 report for UNESCO (see Chapter 2) because they emphasized vehicular movement, isolated the historic monuments and fragmented Aleppo's historic landscape (Bianca et al., 1980). This report, which heralded Aleppo's inscription on the World Heritage List, stressed in an opening statement that:

> Experience has shown that the individual monuments should not be isolated from the urban context to which they are related. This is particularly true in the case of Islamic towns, where each single element is usually integrated into larger units of the urban fabric in such a way as to form a complex, closely knit architectural cluster. Conserving the monuments of an Islamic town therefore also implies the protection and reinforcement of the urban pattern as a whole (Bianca et al., 1980: 6).

Notwithstanding this recommendation, criteria iii and iv, which justified Aleppo's inscription on the World Heritage List (Table 2.1), underscored the monuments of past eras. According to criterion (iii):

> The old city of Aleppo reflects the rich and diverse cultures of its successive occupants. Many periods of history have left their influence in the architectural fabric of the city. Remains of Hittite, Hellenistic, Roman, Byzantine and Ayyubid structures and elements are incorporated in the massive surviving Citadel. The diverse mixture of buildings including the Great Mosque founded under the Umayyads and rebuilt in the 12th century; the 12th century Madrasa Halawiye, which incorporates remains of Aleppo's Christian cathedral, together with other mosques and madrasas, suqs and khans represents an exceptional reflection of the social, cultural and economic aspects of what was once one of the richest cities of all humanity (UNESCO, 1992–2014c).

Simultaneously, criterion (iv) stipulated that:

> Aleppo is an outstanding example of an Ayyubid 12th century city with its military fortifications constructed as its focal point following the success of Salah El-Din against the Crusaders. The encircling ditch and defensive wall above a massive, sloping, stone-faced glacis, and the great gateway with its machicolations comprise a major ensemble of military architecture at the height of Arab dominance. Works of the 13th–14th centuries including the great towers and the stone entry bridge reinforce the architectural quality of this ensemble. Surrounding the citadel within the city are numerous mosques from the same period including the Madrasah al Firdows, constructed by Daifa Khatoun in 1235 (UNESCO, 1992–2014c).

These two criteria led to Aleppo's statement of outstanding universal value, which naturally underscored Aleppo's monuments:

> The Citadel, the 12th-century Great Mosque and various 16th and 17th-centuries madrasas, residences, khans and public baths, all form part of the city's cohesive, unique urban fabric […] The monumental Citadel of Aleppo, rising above the suqs, mosques and madrasas of the old walled city, is testament to Arab military might from the 12th to the 14th centuries' (UNESCO, 1992–2014c).

By recognizing only fragmented monuments, Aleppo's inscription criteria and statement of outstanding universal value overlooked the other elements of urban form including the path network, the residential districts (that is, the ordinary and the mundane in the city's townscape), the major nodes and the city's edges (Lynch 1960) – all of which had contributed to Aleppo's distinctive character. For example, these criteria

disregarded the links between the *sūq*, the Great Mosque and the other civic structures that had formed a monumental corridor to the Citadel (Figures 2.1 and 2.2). Further, Aleppo's statement of outstanding universal value overlooked the fundamental factors that contributed to Aleppo's townscape, particularly the combination of the town plan and the patterns of both the building form and the land use (Conzen, 1960: 3). Most importantly, this statement discounted the local perspective toward the values and significance of Aleppo's landscape. It also offered a museum-like perception of Aleppo's historic landscape from which conspicuously absent were Aleppo's historic and contemporary socio-economic, cultural and political conditions that had contributed to shaping it in its current form:

> The walled city that grew up around the citadel bears evidence of the early Graeco-Roman street layout and contains remnants of 6th-century Christian buildings, medieval walls and gates, mosques and madrasas relating to the Ayyubid and Mameluke development of the city, and later mosques and palaces of the Ottoman period. Outside the walls, the Bab al-Faraj quarter to the North-West, the Jdeide area to the north and other areas to the south and west, contemporary with these periods of occupation of the walled city contain important religious buildings and residences [...] the surviving ensemble of major buildings as well as the coherence of the urban character of the suqs and residential streets and lanes all contribute to the Outstanding Universal Value (UNESCO, 1992–2014c).

This museum-like perception of Aleppo in its statement of outstanding universal value in fact contradicted with Bianca et al'.s recommendation to steer away from a policy that 'advocates the transformation of large urban areas into a museum' (Bianca et al., 1980: 6).

Probably due to Aleppo's history of spatial planning that prioritized vehicular circulation, Bianca et al'.s report also deployed spatial analyses that recommended the zoning of land uses and the management of vehicular traffic. Accordingly, it proposed several zones that would gradually traverse from the New City into the Old City of Aleppo and that were paralleled by vehicular traffic that also gradually diminished with the transition from the New to the Old City until only pedestrians were allowed within the historic core (Ibid., 1980). Completely absent from these spatial recommendations, however, were the urban conservation and rehabilitation strategies. Certainly, this absence persisted since Aleppo's registration as an historic monument in 1978 until 1990 when a new act finally regulated the building practices in Aleppo. The Building Control Code Decision of the Aleppo City Council-1990, which was shortened to Decision 39/1990 was based on a pre-existing law[10] and which regulated the building practices through – mostly – spatial planning tools like plot divisions, building and land use and optimal interior open space. While Decision 39/1990 built mostly on these spatial tools, it also regulated the building heights and controlled the issuing of building permits and construction procedures (OIKOS et al., 2005).

This propensity toward spatial planning persisted through the Project for the Rehabilitation of the Old City of Aleppo, which commenced in 1992. The use of GIS constituted part of the technical cooperation agreement between the Syrian government and the then GTZ; however, the Syrian planners were initially reluctant to incorporate GIS into the project due to their concerns about a hitherto untried method in Syria – raising uncertainties about the nature of its outcomes and its abilities to link the needs to the desired outcomes. But after a brief period of conducting manual surveys that yielded large amounts of fragmented and incompatible data sets, the team conceded to deploy GIS.[11] The data from the manual surveys, which had primarily documented Aleppo's physical elements, constituted the foundations of the newly formed database and was later augmented with data on the technical infrastructure and general census data about Aleppo's inhabitants.

Aleppo's planners lauded the benefits of GIS for documenting and managing Aleppo's historic landscape. From an analytical point of view, these planners emphasized how GIS emancipated them from the confines of romanticized perceptions of the courtyard houses and from the reductionist theories on the Islamic city as a homogeneous urban landscape. Instead, they shared how the analytical tools of GIS facilitated an alternate understanding, and by consequence different values, for these courtyard houses – ones that are based on

10 This older law was known as the Law of Local Administration number 15 and dates back to 1971.
11 The Arab Development Fund provided funding to support the acquisition of the necessary hardware and software (Ramadan, 2001).

spatial distribution and typologies rather than on monumentality and architectural aesthetic. Indeed, Ramadan (2003: 5) asserted that four distinct layers were generated from the base map, namely: the streets, parcels, patios and plot layers. These had supposedly advanced the town-plan analyses by revealing new findings about Aleppo's morphological formation that refuted earlier assumptions about the homogeneity of its plots, about the relationship between the public and private open spaces and about the neighbourhood structure among others (Ramadan, 2001). Most importantly, and in accordance with town-plan studies, GIS also promoted an understanding of 'change' in Aleppo's historic landscape through comparisons between the historic and the contemporary conditions, hence facilitated the detection of the shifts in the land use and in the street structure over the decades (Ramadan, 2001; also see Conzen, 1961 and Vernez Moudon, 1997 on the notion of change). Indeed, this monitoring of change led to another round of data collection in 2005–06. A planner explained:

> It was plot by plot. We had forty seven thousand questionnaires to fill in, and to feed all the data in GIS. A huge work, which cost us a lot of money, but it was worth it. But they have done such a survey, not as comprehensive as this one but they have made quite a bit of survey [sic] in 1994 on the base of which they had made the Development Plan. Now we can compare and see the trends after ten years, after eleven years (interview on 2 June 2005).

The Syrian planners in particular praised the adoption of GIS for building local capacity and for instituting a centralized yet compatible database for all the agencies involved in planning for Aleppo. From the outset, GTZ had trained a group of public sector Syrian architects and engineers in the use of GIS and its applications. Other planners however relayed that these public sector planners had founded a private architectural firm[12] and were henceforth sub-contracted as local consultants on all issues related to the collection and the management of the data. Moreover, the planners extolled the benefits of the compatibility of the GIS database across multiple agencies as well as its combination of visual and statistical components. Such qualities, in their opinion, had promoted communication among the planners, lessened inconsistencies and fragmentations in the decisions across all the involved agencies, encouraged collaborative representation of these agencies' needs and generated sustainable data sets (also see Ramadan, 2001; Ramadan et al., 2004).

Once the decision to adopt a GIS database was taken, the planning team sought to define 'the uses and the users of the GIS', and, accordingly, assessed the needs of the project, established the types of analyses to be conducted and, by consequence, the types of data to be collected (Ramadan, 2001: 5). Such an approach, which entailed a priori assumptions about the types of data and analyses, set predeterminations that dictated the ensuing intervention strategies as the discussions in the subsequent chapters on place-making and place experience will reveal. Moreover, a critical analysis of the documentation approach in Aleppo revealed that the dependence on the spatial components of GIS as a 'do-all' tool (Aangeenbrug, 1991) led to disregarding its potential for linking spatial data sets to other descriptive ones (Khirfan, 2010a). Multiple repercussions emerged due to such an approach. To begin with, the spatial focus of the documentation compromised the ability to expose the typologies of the buildings and architectural elements – important aspects of Aleppo's townscape. Additionally, and although the Development Plan, which was the primary outcome of Aleppo's documentation, had broadly recognized the town-plan and its components, it had nevertheless overlooked the socio-economic and cultural conditions of the historic urban landscape, especially the links between the land uses and the livelihoods of the local inhabitants. More specifically, the documentation had disregarded the rationale behind these conditions and how they had actually influenced Aleppo's historic landscape. For example, the data analysis and findings overlooked the role of the traditional *'urf* laws in shaping Aleppo's townscape as well as the social networks and clan affiliations that had shaped the residential quarters or the inheritance laws that had formed the parcels and plot sizes and which later impacted the property ownership – all of which had repercussions on the place-making initiatives in Aleppo as will be discussed in Chapters 4 and 5 (see Hakim, 1986 on *'urf*, and Zeitlian Watenpaugh, 2004 on social networks).

12 This firm was named Suradec, acronym for Sustainable Urban Rehabilitation Architectural Design and Engineering Consortium. The Suradec team assumed the role of a GIS private consultant in the Project for the Rehabilitation of the Old City of Aleppo. It seems that some of the founding members of Suradec had later founded the Loggia Engineering Group.

Furthermore, other planners, mostly external to the Project for the Rehabilitation of the Old City of Aleppo, highlighted the challenges of documenting a complex urban setting as Aleppo's, and also mentioned the centralized control over the data sets (also see Ramadan et al., 2004). Also, while the primary objective of the project was to preserve Aleppo's residential function, the spatial documentation did not capitalize on the opportunity to include the perspectives of Aleppo's inhabitants. Considered primarily the domain of professionals, planning in Aleppo adopted a technocratic approach from the outset that began with dependence on GIS and continued throughout the place-making process. According to this approach, Aleppo's inhabitants were considered strictly as a source of information about the physical infrastructure while the potential of GIS to serve an inclusive or participatory planning process was never capitalized on. A planner shared: 'we had started to build data that is specific to the Old City on the basis of local residents' perceptions to a level you might say 60% and 40% technical analyses'. When probed further, this planner elaborated:

> ... when we built the infrastructure-specific map it was related to the residents themselves and to the information that they are providing because they are the ones living in the Old City and know where the blockage happens and know where all issues are [...] if you do not take this information from them [it] will cost you much more time (interview on 1 June 2005).

It is imperative to mention that in 2008 GTZ established a website titled 'Toolkit for Urban Conservation and Development' that presented the Project for the Rehabilitation of the Old City of Aleppo as an ideal case study[13] (GTZ, 2008). While the detailed information and the downloadable documents on this website disseminated the experience of GTZ, they nonetheless targeted professional conservation experts who would have been fluent in English rather than the Arabic-speaking inhabitants of Aleppo. A planner criticized that: 'It is a lot easier to print brochures than to sit down and really figure out what is happening on the ground, and which is something I fear that the project has gotten a lot more interested in printing brochures and promoting itself than promoting the Old City' (interview on 9 June 2005).

Al-Salt: Architectural Heritage

Sensing the threats that were facing al-Salt during the 1980s, Salt Development Corporation contracted the Royal Scientific Society to study the urban architectural heritage of al-Salt and to propose intervention strategies (see Chapter 2). Consequently, the Royal Scientific Society[14] conducted field surveys and documented al-Salt's entire historic landscape. Two sets of publications emerged from this documentation effort: a one-volume report that documented al-Salt's architectural heritage (Royal Scientific Society, 1990a), and a three-volume report that provided detailed patterns and typological studies. Although the latter did not specifically refer to the townscape of al-Salt, nor did it use the terms 'town-plan' or 'urban morphology', it nonetheless proposed typologies that classified all the townscape elements of al-Salt including the blocks and plots, the street network and the public *'aqabāt* (singular *'aqabe*) and the nearly 900 historic buildings (Royal Scientific Society, 1990b). In addition, the last volume of this report, which was titled 'A Plan for Action', emphasized the collective impact of these components in shaping al-Salt's townscape and their relation to the natural setting. It also contained detailed design and budgetary guidelines for a proposed rehabilitation of the buildings (Royal Scientific Society, 1990b). A lack of funding combined with governmental bureaucracy precluded the implementation of these proposals and, thus, only sporadic renovations of a few of the important buildings ever took place.

During the early 1990s, the Jordanian and Japanese governments signed a series of cooperation agreements that aimed at stimulating the Jordanian economy, one of which involved the Japan International Cooperation Agency (JICA) and targeted the development of heritage tourism (JICA, undated). JICA conducted a study to understand tourism in Jordan, particularly focusing on the demand-supply chain and drawing primarily on

13 This website came down in the wake of the ongoing conflict in the Syrian Arab Republic.

14 The Royal Scientific Society's team was supported by dozens of interning students from the architecture departments from the University of Jordan in Amman and the Jordan University of Science and Technology in Irbid.

the statistical data of the Jordanian Ministry of Tourism and Antiquities.[15] While the resulting multi-volume report from this study concluded that 'the basic character of tourism in Jordan will remain centered around its rich history and culture', it simultaneously criticized the 'Over emphasis on antiquities' (Nippon Koei Co. et al., 1996a: 9). Instead, this report recommended the development of six alternative tourist destinations in Jordan, one of which was the Historic Old Salt Development Project which it foresaw as a pioneer project that would mark the transition 'from Antiquities to Cultural' tourism in Jordan, and would also serve as a model for other Jordanian towns (Nippon Koei Co. et al., 1996a: 40). JICA's project became the first in a series of three tourism development projects in al-Salt; it was followed by the Second and the Third Tourism Development Projects that were funded by the United States Agency for International Development (USAID) and the World Bank (United States Agency for International Development, 2011; World Bank, 2005).

The documentation that preceded JICA's project primarily depended on secondary data sources with minimal in situ involvement. In fact, it seemed that only one expert had actually conducted fieldwork in al-Salt, mainly collecting artefacts for a proposed museum. A planner admitted 'we dispatched one female worker and she was collecting many local artefacts to be displayed from the community' (interview on 24 May 2005). Thus in addition to the statistical tourism data from the Ministry of Tourism and Antiquities, JICA's report primarily extracted maps and budgetary estimates from the reports by the Royal Scientific Society – often without acknowledging the sources of these data. Certainly, the documents corresponded to each other and even contained identical maps, design drawings and budgetary details for the proposed rehabilitation interventions. The planning documents for the subsequent Second and Third Tourism Development Projects in turn cited the already abased information in JICA's reports without referring to, and apparently without consulting, the original Royal Scientific Society volumes (see for example: United States Agency for International Development, 2011; United States Agency for International Development, 2007). Notwithstanding this reliance on the Royal Scientific Society's studies, the ensuing plans differed significantly in their goals and objectives. The Royal Scientific Society's reports had emphasized the social value of al-Salt's historic landscape, including the housing needs and the revitalization of the urban core. In contrast, the reports by JICA, USAID and the World Bank underscored 'product development' anchored in the rationale that 'Jordan must prepare itself to manage its architectural heritage, which has considerable cultural and *commercial value*' (Nippon Koei Co. et al., 1996a: 28, italics mine). Embedded within JICA's report was the assumption that such product development would depend primarily on the visual aesthetic of al-Salt's architectural heritage in order to attract new tourist segments to Jordan. Principally then, these projects have emphasized, as evident in their nomenclature, tourism – an emphasis that the subsequent chapters on place-making and place experience argue has prevailed through policies and intervention strategies that prioritized the visual experience of potential tourists.

These factors combined induced a negligence of al-Salt's townscape, especially an understanding of its urban morphology and town-plan. Several other factors exacerbated this oversight including the absence in Jordan of urban planning both as a profession and as a discipline. Until very recently, almost all the Jordanian heritage conservation experts and professional planners have been trained primarily as architects who inevitably continue to underscore the architectural values of al-Salt's stone façades at the expense of its urban morphology. For instance, even the local architectural historians sanction this view such as the studies on al-Salt by al-Zoabi and by Daher, both of which underscored building façades and isolated architectural elements of singular buildings disassociated from their surrounding urban fabric. Al-Zoabi's methodology depended primarily on static snapshots of only the main façades of select buildings rather than their three-dimensional form or their situation within the urban context (Al-Zoabi, 2004). Not differently, and although Daher acknowledged that the urban rehabilitation in al-Salt had depended primarily on 'shock treatments and urban cosmetics', he nevertheless claimed that the rehabilitation of a single building, the *Abū Jābar* mansion, would counter all the weaknesses in the urban rehabilitation once it was converted into the Historic Old

15 These are basic annual data that typically feature the primary tourist destinations in Jordan, the numbers of tourists at each of these destinations and the length of stay and spending patterns of these tourists. These data are publically accessible and can be downloaded from: http://www.mota.gov.jo/ar/Default.aspx?tabid=120

Salt Museum[16] (Daher, 2005: 299). Not surprisingly then that the cultural significance of al-Salt's historic landscape in general, and from the perspective of the three tourism development projects in particular, 'was reduced to the facile emphasis on the architectural aesthetics of isolated façades at the expense of the more fundamental aspects of its urban morphology' (Khirfan, 2013: 313).

These shortcomings were reflected in al-Salt's nomination package for the World Heritage List when criterion (iv) underscored fragmented architectural elements:

> The transformation of Salt from a rural settlement into an urban center, the evolution of the five types of architectural styles within a very short period of time, the use of yellow soft stone, the elegant elevations, decorative gateways and elaborate carvings, the stairs connecting the different neighbourhoods within the city, are all testimony to an exquisite architecture worthy of protection and preservation (Abu Salim, 2003: 3).

This emphasis on architectural styles was furthered in criterion (v), which centred around al-Salt's architectural rather than urban value:

> In the second half of the nineteenth century, Salt became the administrative and economic center for the whole region. The architectural style was thus transformed from rural to urban in character passing through five different stages of evolution (Abu Salim, 2003: 3).

Absent from the values and significance assessments of al-Salt's urban landscape were the socio-cultural and economic aspects of its local inhabitants and, particularly, these aspects' influence on the morphology of the city through land use, mobility and circulation and through the patterns of building forms and masses. Moreover, while the documentation evoked the significance of the architecture of singular buildings, the absence of a local narrative in the documentation processes resulted in the omission of the culturally significant stories behind some of these buildings, especially al-Salt Secondary School, the first in the kingdom and whose alumni continue to this day to prevail the upper echelons of the Jordanian government. Thus, in the absence of a local narrative in al-Salt's documentation, a national perspective emerged – a typical propensity of representation in Jordan (Massad, 2001). Instead of linking the architectural styles to the history of al-Salt's inhabitants, especially the different migration waves that arrived from Nablus, Damascus and other Levantine cities, these architectural styles were associated with the history of the Hashemite Kingdom of Jordan and its foundation in the 1920s. Indeed, in al-Salt's nomination package, criterion (iii) highlighted al-Salt's national significance as:

> ... the only example that can wholly represent the culture and history of modern Jordan. It has been the first capital for it. At the same time, it contains the most intact piece of urban fabric related to Jordanian culture which is represented in the interlocking urban fabric of the city, the old markets selling traditional goods, the old buildings narrating the history and traditions of the area, and the closeness and warmth of its inhabitants (Abu Salim, 2003: 2–3).

Collectively, these inscription criteria based al-Salt's outstanding universal value around the political-economic role that the city had played at the turn of the twentieth century:

> Salt is the oldest and most important city in the history of modern Jordan; it has played a great role in the creation of the Hashemite Kingdom of Jordan and was its first capital. In the late nineteenth century, it was the centre of government, business and commerce, which attracted the money and skilled craftsmen (Abu Salim, 2003: 1).

According to al-Salt's statement of outstanding universal value, this political-economic flourishing led to al-Salt's unique townscape and elaborate architectural styles:

16 It is worth mentioning that in his article Daher acknowledges his personal role as the architect commissioned to adapt the *Abū Jāber* mansion to a museum (Daher, 2005).

> As a result, Salt was transformed from a rural settlement into a rich city with a unique townscape and elaborate architecture [...]. The influx of various influences led to a change in the architectural style passing through 5 periods in 100 years. With the development of architectural styles, construction methods also developed. The architectural development in Salt had a great influence on the development of architectural styles in the region (Abu Salim, 2003: 1–2).

Although this statement rightfully respected the heritage value of al-Salt's architectural styles and mentioned its unique townscape, it nonetheless completely overlooked the factors that led to this townscape. This statement especially overlooked al-Salt's town-plan and the three-dimensional building forms that had emerged from the combination of its natural setting and its socio-economic and cultural networks. In particular, it was the clan and tribal networks, the location of the water springs and the topography that had strongly influenced al-Salt's spatial distribution and urban morphology. Furthermore, this statement neglected the significance of the cultural fusion that ensued from the arrival of merchant families from other cities in Bilād ash-Shām, especially from Nablus to al-Salt, and also from the missionaries who collectively enriched the local culture and generated a local vernacular. The diagrams in Figures 2.4 and 2.5 and Plates 2–5 (Chapter 2) convey the combined outcome of these factors that manifested, firstly, in the arrangement of the terraces along the mountainsides; secondly, in the network of the movement along the horizontal streets and the vertical *'aqabāt*; and, thirdly, in the relationship between the public, semi-public and private spaces. While cognizant of the distinctiveness of al-Salt's townscape, during their interviews, the local planners seemed unable to identify the specific physiognomy as defined by Conzen (1960) nor did they seem to be aware of the role of the traditional *'urf* rules (Hakim, 1986) nor of how these two concepts applied to al-Salt's townscape – as in Figure 2.5. This is probably due to the fact that, as architects, they focused solely on the architectural elements – namely, façades in this instance. Indeed, the statement of outstanding universal value alluded to, but did not directly address the townscape and the *'urf* laws:

> In summary, the city of Salt is unique in Jordan, and probably in the whole of the Near East. The golden stone houses clustered on the slopes of the hills without obstructing the view or intruding into the privacy of surrounding buildings reflects the social relations that prevailed between the inhabitants, the unity and historic significance of the architecture dating from the city's 'Golden Age' between 1890 and 1920, and the centre's survival as the last bustling traditional market-town. This mixture of heritage, charm and tourism potential is of great value to the region (Abu Salim, 2003: 1–2).

Acre: A Layered City

After nearly four decades, Old Acre Development Company eventually acceded to explore alternatives other than transferring Acre's inhabitants to *al-Makr*. A planner shared: 'So today, the authorities and the government finally got into their head and comprehended that Acre's inhabitants will not leave' (interview on 6 January 2006). This coincided in 1990 with *'Atiqot*'s nomination, and UNESCO's eventual selection, of Acre among 100 sites worldwide that best represented the medieval Crusader heritage (Torstrick, 2000) (see Chapter 2). Simultaneously, Old Acre Development Company was keen to take action in Acre, motivated by the necessity to accommodate the needs of the nearly one million national and international tourists who visit Acre annually (Rahamimoff, 1997), and also by the forecasts that anticipated an influx of Christian pilgrims to the Holy Land in 2000 (interviews with several planners, also see Hecht, 1997). Thus in 1992 Old Acre Development Company, in its capacity as a representative of the coalition of public agencies involved in Acre, entrusted architects Arie Rahamimoff and Saadia Mendel with proposing a comprehensive development plan for Acre and specifically requested that they 'make Acre into a City of Tourism' (Kesten, 1993: 4). One source relayed how, as the leading architects, Rahamimoff and Mendel 'proposed a one-year plan during which they wanted to study as many aspects as possible of Acre'. This source shared how 'It was very clear that if you do not deal with all aspects of life of the city, it will be impossible to develop sustainable tourism'. Accordingly, 'Rahamimoff and Mendel established an interdisciplinary team that included a consultant on social issues, an economist, conservation expert, traffic engineer, infrastructure engineer [sic]'. And this source confirmed

that 'The first thing [the planning team] realized is that it is impossible to prepare a plan for tourism without dealing with the whole city' (interview on 10 January 2006).

Consequently, these various experts concentrated their documentation efforts on the triad of: surveys of the socio-economic conditions of Acre's inhabitants; architectural surveys; and surveys of tourism activities. Several of the planners in Acre highlighted the role of the social expert on their planning team and stressed that a combination of her academic expertise and Palestinian Arab background granted her access to Acre's Palestinian Arab inhabitants. A planner shared: 'we had a social consultant, a sociologist [...] she was born in Acre. She was born in the Old City, and she knew everyone' (interview on 26 December 2005). Most importantly, this expert's presence on the planning team triggered a positive participatory process as one planner relayed: 'In the master plan there was a multidisciplinary team and one of the team was [...] a social worker[17] and she was the link between the team and the inhabitants of the Old City, and she also carried out a survey of the people's wishes – the inhabitants wishes' (interview on 29 December 2005). The data from this social survey provided the planning team with in-depth insights – hitherto unbeknown to planners – about the strong place attachment among Acre's inhabitants, their dire housing needs and their desire to be integrated in the tourism development plans (interviews on 26 December 2005 and 10 January 2006). In particular, this social survey revealed that the successful implementation of any urban rehabilitation and historic conservation policies warrants a solution to the complications of property ownership that are particular to Acre.

Simultaneous to the social surveys, 'Atiqot was sub-contracted as a consultant on historic conservation and commenced with field surveys that documented all the architectural and spatial features of Acre's historic landscape including structures, architectural elements and public open spaces. From these data 'Atiqot identified four levels of cultural significance where Level A represented the most significant structures – monuments and sacred buildings whose authenticity was considered paramount. Level B included all the archaeological buildings and ruins that preceded AD 1700.[18] Levels C and D referred to the ordinary and the mundane in the historic urban landscape whereby Level C included those structures deemed of medium significance – mostly, residential and commercial buildings whose façades and exteriors contained features that warranted conservation. Level D hence encompassed all the remaining residential and commercial buildings in Acre whose architectural significance was judged as minimal.

Lastly, Old Acre Development Company conducted its own surveys of tourism activities and identified the numbers of tourists, their origins (whether national or international) and their length of stay. By linking the local statistics to national and regional ones, the planners discovered that Acre was the second most visited tourist attraction by international tourists after Jerusalem. These analyses also revealed that, for the most part, the tourists, regardless of their origins, were day-trippers – that is, tourists who visit Acre for one day only without staying overnight. In addition, Old Acre Development Company surveyed the movement of the tourists inside Acre and hence was able to identify their primary and secondary attractions and their spatial distribution. Noteworthy of mention here are the academic studies that were conducted independently from Old Acre Development Company and from the planning team, but which nonetheless added to the knowledgebase on tourism in Acre and informed the planning process. Of particular interest were the studies that tracked the spatial and the temporal behavioural patterns of the tourists in Acre using GPS devices (see for example: Tchetchik et al., 2009; Shoval and Isaacson, 2007a and 2007b; Shoval, 2007).

Thus by the end of this year-long documentation of Acre's conditions, the interdisciplinary planning team was able to identify eight primary problems that warranted planning interventions (Kesten, 1993: 4). Therefore, the place-making strategies for Acre included: infrastructure; population and housing; economic development; archaeology; tourism services; garbage collection; marketing and promotion; and, lastly,

17 When this social worker was contacted for the purposes of this study she refused to be interviewed or share any information. Other planners and members of the local community relayed how, after her contribution to Rachamimoff and Mendel's team, the local residents became suspicious of her. One senior planner compared her situation to another Palestinian Arab's situation who also worked with Old Acre Development Company. This senior planner said: 'I know now that there is another gentleman named [...]. He works for the [Old Acre Development Company], and I am not sure they [local inhabitants] trust him 100% because he is working for the establishment but he is doing a serious effort over many years to understand the issues' (interview on 6 January 2006).

18 Similar to Jordan, Israel's antiquities laws build on those from the British Mandate era and encompass all sites, structures and ruins that precede AD 1700.

the planning, management, control and maintenance of Acre's urban landscape (Rahamimoff, 1997). The successful implementation of these place-making initiatives, which is discussed in detail in Chapters 4 and 5, led to Acre's nomination to, and eventual inscription on, the World Heritage List in 2000. Interestingly however, the rigorous documentation did not imbue Acre's nomination criteria or its statement of outstanding universal. The latter underscored the overlaid Crusader and Ottoman cities:

> Acre is exceptional in that beneath its present-day appearance as a typical Moslem fortified city lie the remains of an almost intact medieval city on the European model. It bears exceptional material testimony to the Crusader kingdom established in the Holy Land in the 12th–14th centuries, and also to the Ottoman Empire in the 18th and 19th centuries (ICOMOS, 2002: 6).

Thus Acre's statement of outstanding universal value justified its inscription by how it had been:

> Continuously settled from Phoenician times, was of major significance during the Crusader period in the Holy Land. Because of its position, located on a peninsula encompassing a natural bay, the city gained international significance from 1104 to 1291 as the capital of the Crusader kingdom of Jerusalem following its development as the Crusaders main port in the Holy Land [sic]. Whilst this strategically located port enabled it to become a centre for international trade, its physical boundaries, delineated by surrounding walls and sea, created a characteristic densely built mediaeval city (UNESCO, 1992–2014d).

While this statement emphasized Acre's natural setting and its influence on the formation of the Crusader layer, it nonetheless overlooked the Crusader political-economic arrangements that yielded Acre's distinctive physiognomy, particularly its semi-autonomous historic quarters. The statement of outstanding universal value stressed that the Ottoman city's:

> … unique character is in the substantial remains of the Crusader city that are preserved virtually intact beneath the typical Ottoman city preserved till the present day, and have in recent years been revealed by scientific excavation. The present townscape of the walled port-town is characteristic of Moslem perceptions of urban design, with narrow winding streets and fine public buildings and houses. Demonstrating the interchange of mediaeval European and Middle-Eastern architecture, the city has some exceptional edifices, including a citadel, mosques, khans and baths (UNESCO, 1992–2014d).

Not surprisingly then, the adaptations of criteria (ii), (iii) and (v) to Acre disregarded the strong links between the Crusader and the Ottoman layers, particularly in terms of the morphology and urban form, the building materials and the relationship to the natural setting. According to criterion (ii): 'Acre is an exceptional historic town in that it preserves the substantial remains of its medieval Crusader buildings beneath the existing Moslem fortified town dating from the 18th and 19th centuries' (UNESCO, 1992–2014d). The absence of links between the two layers is further manifested in criterion (iii), which overlooked Acre's urban palimpsest when it failed to link the layouts of its Crusader and Ottoman layers: 'The remains of the Crusader town of Acre, both above and below the present-day street level, provide an exceptional picture of the layout and structures of the capital of the medieval Crusader Kingdom of Jerusalem' (UNESCO, 1992–2014d). Furthermore, criterion (v) focused solely on the Ottoman layer: 'Present-day Acre is an important example of an Ottoman walled town', and continued to highlight individual monuments: 'with typical urban components such as the citadel, mosques, khans, and baths well preserved, partly built on top of the underlying Crusader structures' (Ibid.). This criterion thus failed to link these monuments morphologically, or to connect them spatially and functionally to Acre's residential quarters.

Most importantly, by presenting only the Crusader and the Ottoman narratives, the inscription criteria disregarded the other subtle – yet equally significant – narratives in Acre's historic landscape. Of particular significance is the *Bahá'í* cultural heritage such as *Qasr Abbūd* – an important pilgrimage site for the followers of the *Bahá'í* faith (Plate 9). Also, the inscription criteria ignored the continuity in Acre's historic urban landscape and especially, the current life within it.

Table 3.1 The inscription criteria for Aleppo, al-Salt and Acre

Criterion number	Criterion details	Aleppo, Syria	Al-Salt, Jordan	Acre, Israel
i	represent a masterpiece of human creative genius;			
ii	exhibit an important interchange of human values, over a span of time or within a cultural area of the world, on developments in architecture or technology, monumental arts, town-planning or landscape design;			X
iii	bear a unique or at least exceptional testimony to a cultural tradition or to a civilization which is living or which has disappeared;	X	X	X
iv	be an outstanding example of a type of building, architectural or technological ensemble or landscape which illustrates (a) significant stage(s) in human history;	X	X	
v	be an outstanding example of a traditional human settlement, land-use, or sea-use which is representative of a culture (or cultures), or human interaction with the environment especially when it has become vulnerable under the impact of irreversible change;		X	X
vi	be directly or tangibly associated with events or living traditions, with ideas, or with beliefs, with artistic and literary works of outstanding universal significance;[1]			
ii	contain superlative natural phenomena or areas of exceptional natural beauty and aesthetic importance;			
viii	be outstanding examples representing major stages of earth's history, including the record of life, significant ongoing geological processes in the development of landforms, or significant geomorphic or physiographic features;			
ix	be outstanding examples representing significant ongoing ecological and biological processes in the evolution and development of terrestrial, fresh water, coastal and marine ecosystems and communities of plants and animals;			
x	contain the most important and significant natural habitats for in situ conservation of biological diversity, including those containing threatened species of outstanding universal value from the point of view of science or conservation.			

Source: Adapted from (UNESCO, 2005a: Articles 77.i–77.x; UNESCO, 2011c).

Note: [1] The Committee considers that this criterion should preferably be used in conjunction with other criteria.

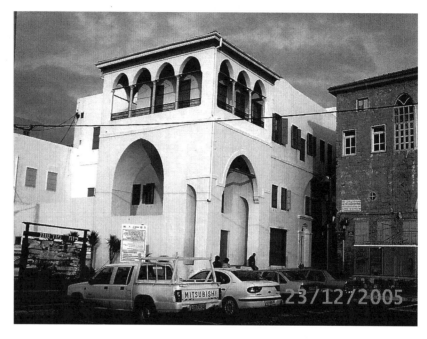

Plate 9 The *Bahá'í* Palace or *Qasr 'Abbūd* in Acre
Source: The author.

The Future Implications of the Documentation and Value Assessments

The discussion in this chapter revealed that meeting the criteria for the outstanding universal value that is associated with the world heritage status bears implications on the future place-making initiatives of world heritage sites in general and world heritage cities in particular. These implications, as distilled from the case study cities, Aleppo, al-Salt and Acre, centre around four tensions: the monuments versus the urban landscape; the layers versus the palimpsest of the historic urban landscape; the outstanding universal value versus the local values; and the static snapshot versus the continuity of the historic urban landscape. But most importantly, these tensions influence the place-making processes in the historic urban landscape.

To begin with, the monumental in the historic landscapes of Aleppo, al-Salt and Acre clearly gained prominence in the adaptation of the inscription criteria for each. Aleppo's inscription criteria highlighted its Citadel, the Great Mosque and other monuments like the *madāris* (singular: *madrasah*), *khānāt* (singular: *khān*) and *ḥammāmāt* (singular: *ḥammām*) among others (see UNESCO, 1992–2014c). Likewise, in al-Salt, the inscription criteria emphasized not only the architectural styles of individual structures, but also, one element therein contained, namely, their main façades – that is, frontal view (see Abu Salim, 2003). Further, Acre's inscription criteria underscored its 'Crusader buildings' underneath the 'Ottoman urban components such as the citadel, mosques, khans, and baths' (UNESCO, 1992–2014d). This emphasis on the monuments in the inscription criteria came at the expense of the coherent image of Christopher Alexander's notion of the wholeness of the historic urban landscape as Chapter 6 will reveal (Alexander, 1979). Such wholeness accounts for the townscape or the physiognomy of the urban form that combines the town-plan, the pattern of building forms and the pattern of land use (Conzen, 1960: 3) – morphological elements that the world heritage inscription criteria continue to overlook. Subsequently, catering only for singular monuments in the ensuing management plans jeopardizes the integrity of the historic urban landscape's townscape as Chapters 4 and 6 will reveal.

The second tension arises between the emphasis on detached layers of the historic urban landscape as opposed to a conceptualization of this landscape as a palimpsest which stems from the morphological

acceptance of change whereby cities' urban forms continuously evolve and acquire new meanings and functions over time (Vernez Moudon, 1997; also see Kostof, 1991). Therefore, the historic urban landscape resembles a palimpsest whose text is effaced and thus can be reused multiple times; however, 'as each era is overtaken by the next, it leaves traces and redundancies, obsolescence and irrationalities' all of which may 'remain as a mark: the burden of the past or an inheritance' (Crang, 1996: 430). AlSayyad has observed, as discussed in Chapter 1, that through 'a series of linked hereditary successions', this inheritance becomes a heritage urban landscape (AlSayyad, 2001: 2). Surely, absent from the statements of outstanding universal value and inscription criteria for Aleppo, al-Salt and Acre were the associations between the various historic periods of their urban landscapes. While Aleppo's statement of outstanding universal value and inscription criteria listed its successive historic periods and the monuments that were considered representative of each, they nonetheless failed to tackle the associations between these periods nor how they had collectively shaped Aleppo's historic urban landscape. Similarly, by virtue of focusing on architectural styles, al-Salt's statement of outstanding universal value and inscription criteria discounted its urban layers, especially the relationship between its initially rural, and eventually urban, forms. These discrepancies in the historic layers are more prominent in Acre's statement of outstanding universal value and inscription criteria that disregarded the strong associations between the Crusader and Ottoman palimpsests. In fact, the conceptualization of historic urban landscapes as palimpsests facilitates a stronger comprehension of their morphological evolution in a manner that precludes prioritizing the traces of one period over another, and, by consequence, one that refrains from museum-like and nostalgic perceptions that freeze the historic urban landscape at one point in time.

The global-local tensions in the assessment and identification of the outstanding universal value are typical of world heritage sites. As discussed earlier in this chapter, mostly, the statement of significance and the interpretation of the inscription criteria conveyed the state's official rhetoric, representing a national perspective of the significance for each of Aleppo, al-Salt and Acre and did not necessarily reflect the outlook of their inhabitants. The forthcoming discussion on place experience (Chapter 6) will reveal the interesting contrasts between these two perspectives and will also incorporate the perspectives of the international tourists in Aleppo and Acre. Essentially, neither the perspectives of Aleppo's nor al-Salt's inhabitants regarding the values of their cities have been documented and thus neither have been incorporated in the initial nomination nor in the eventual inscription in Aleppo's case. Further, although the documentation in Acre eventually included its inhabitants' perspectives, the capturing – as opposed to the identifying (Stephenson, 2008; Herlin, 2004) – nature of the inscription criteria precluded incorporating these perspectives in Acre's nomination and subsequent inscription on the World Heritage List. The subsequent chapters in this book will discuss the representation of the local inhabitants in the place-making initiatives and their experience of the historic urban landscape, but I emphasize here that the values that the local inhabitants attributed to their historic landscapes in Aleppo, al-Salt and Acre had not been incorporated in the nomination, inscription or planning processes. This exclusion yielded a superficial and a fragmented understanding of the significance of these historic urban landscapes (Dakin, 2003: 190). For example, the Jewish community in Aleppo is considered one of the oldest in the world, yet remained completely inconspicuous and obscure in the historic urban landscape (Cobb, 2010). This cultural heritage and the fact that in Aleppo the Jewish community had occupied an entire intramural residential quarter were indeed not addressed in the inscription criteria or in the statement of outstanding universal value and certainly not in the subsequent place-making initiatives. Not differently from the Jewish community in Aleppo, the nomination criteria and the statement of significance for al-Salt overlooked its *aghrāb* in reference to the Levantine families in general, and the Nabulsi families in particular whose arrival had borne a profound enriching impact on al-Salt's architectural and urban design vocabulary. In a similar vein, Acre's values – whether in the world heritage inscription documents or in the planning documents – prioritized the Crusader narrative over all else and also overlooked the fact that what has been dubbed as Ottoman is in fact part of Acre's Palestinian Arab heritage, for it was Palestinian Arab rulers like *Zāhir al-'Omar al-Zeidāni*, not Turkic Ottomans, who brought Acre to flourish (Philipp, 2001). Furthermore, the criteria and the statement of significance also disregarded that Arab Acre was the first city to defy Napoleon Bonaparte after his siege of it failed due to its wall fortifications – that is, *aswār* – that *Zāhir al-'Omar al-Zeidāni* had built, and which were strengthened later by *Ahmad al-Jazzār* (Philipp, 2001). Additionally, the narratives of the world heritage inscription and the development plans completely disregarded the *Bahá'í* cultural heritage, of which two are intramural in Acre, namely: *Qasr 'Abbūd* or the

palace of *'Abbūd* where *Bahā'ullāh* and his family had lived (Plate 9), and the prison cell in the Citadel of Acre where *Bahā'ullāh* was imprisoned.

Lastly, and building on the previous point, by disregarding the contemporary life, the statement of outstanding universal value and the inscription criteria for Aleppo, al-Salt and Acre presented static snapshots that inherently precluded the notion of continuity in these historic urban landscapes. Nowhere in Aleppo's or Acre's nomination and inscription documents was there a mention of their contemporary life while al-Salt's statement of outstanding universal value highlighted only the contemporary challenges. In Acre's case, particularly, ICOMOS's evaluation of the nomination package and the website of the World Heritage Centre mentioned the need for a socio-economic agenda for the contemporary inhabitants of Acre – which they considered crucial for the continuity of the historic urban landscape as 'a living city' (UNESCO, 1992–2014d). Although this attention to the life within Acre's historic landscape seemed positive in principle, a careful reading of the evaluation report by ICOMOS revealed substantive inaccuracies particularly when this report claimed that:

> The most serious problem confronting those responsible for the conservation and maintenance of the old city is a social one. There is an almost total absence of pride of place. Few of the present-day inhabitants have any family ties with the city and so there is a lack of identification with it. Furthermore, many of the inhabitants are unemployed or poorly remunerated and so cannot afford to live elsewhere. If and when their personal fortunes change, they will immediately seek housing outside the walled city. As a result, they do not feel themselves under obligation to respect the appearance of what is to them no more than a transitory place of residence (ICOMOS, 2002: 6).

This statement uncritically echoed the rhetoric of the officials in the government of Israel who for decades have attempted to transfer Acre's Palestinian Arab inhabitants to *al-Makr* (see Chapter 2). The resistance of Acre's inhabitants to these transfer attempts contest both the claim that Acre's inhabitants lack a sense of place attachment and the contention that they are transitory inhabitants. The forthcoming discussions on place-making and place experience (Chapters 4–6) will reveal – through primary data – the presence of a strong sense of place attachment among Acre's Palestinian Arab inhabitants. In fact, the findings reveal that the dilapidation of Acre's historic landscape is attributed not to negligence on the part of its current inhabitants, but rather to several decades of purposeful neglect on behalf of the official institutions specifically, the Municipality of Acre, Old Acre Development Company and *'Amidār*. The upcoming analysis will illustrate how these agencies' collective policies have deprived Acre from basic infrastructure until as recently as the mid-1990s and – compounded by the complexity of the property ownership situation that was discussed in Chapter 2 – prohibited Acre's inhabitants from maintaining their residences. Notwithstanding this critique of the inscription criteria and ICOMOS' report, credit should be given to the 2002 World Heritage Report that documented the decision to inscribe Acre, and which recognized the need for a more 'accurate' representation of the history of the city by stressing the importance of the lived city and its contemporary history:

> A number of delegates commented that the texts contained in the ICOMOS evaluation report needed revision to accurately reflect the history of the site. ICOMOS agreed to Report of the World Heritage Committee discuss appropriate amendments with the delegations concerned to reflect the history of the social and economic situation of the site and the inhabitants of the Old City. The Committee recommended that the State Party incorporate into its management plan a coherent policy for the improvement of the economic and social condition of local residents of the Old City of Acre and to ensure that it remains a living city (World Heritage Committee, 2002: 43–4).

Chapter 4
Place-making Strategies

The Statement of Outstanding Universal Value, UNESCO declared, 'shall be the basis for the future protection and management of the property' (UNESCO, 2008: Article 37.155). Therefore, the nomination package should include 'an adequate protection and management system' that ensures the protection of the authenticity of every nominated property (UNESCO, 2013: Article 78). The bundle of place-making procedures for protecting and managing historic urban landscapes may include legislation, regulations, institutional measures, management plans and implementation tools as well as monitoring systems that collectively would ensure a cyclical process of evaluation and assessment (UNESCO, 2008: Articles 129 and 132). Accordingly, the discussion in this chapter highlights the place-making initiatives in Aleppo, al-Salt and Acre. The discussion firstly situates the various choices of place-making strategies within the heritage debates in general and the world heritage debates in particular. The argument stipulates that these intervention procedures evolved from strategies that had initially prioritized the visual aesthetic values of singular monuments to ones that have accounted for the spatial and morphological characteristics as well as the socio-cultural ones. These visual, morphological and socio-cultural priorities are then linked to another dimension of place-making in historic urban landscapes, namely, tourism development. As the case study cities unfold, the discussion highlights the impacts of the documentation (Chapter 3) on the development of the place-making strategies.

The Perceived and Physical: Conserving the Architectural Aesthetic and Integrity

The Grand Tour, which flourished during the eighteenth century, enhanced the appreciation of the Classical architectural monuments thus prompted the emergence of historic conservation as we know it today (Nasser, 2003: 467). Therefore, when the Athens Charter was drafted in 1931, it gave prominence to the visual appreciation of cultural heritage by restricting the latter to 'artistic and historic monuments' and by limiting historic conservation primarily to 'aesthetic enhancements' that entailed either restoration – that is, the consolidation of monuments – or anastylosis – that is, the reassembling of original pieces (ICOMOS, 1931: Article VI). This charter also recommended a 'picturesque perspective treatment' for the contemporary urban developments that occur in the vicinity of historic monuments (Ibid.: Article VI). The Athens Charter's emphasis on the conservation – visually that is – of the 'aspect and character of the restored monument' went as far as encouraging the deployment of 'modern materials' and 'modern technique', especially 'reinforced concrete' in the restoration of monuments, and also concealing all evidence of consolidation (ICOMOS, 1931: Article IV) – recommendations that counter contemporary conservation norms.

Although the Venice Charter of 1964 – also known as the Restoration Charter – extended the definition of cultural heritage to incorporate 'sites', it limited these sites to the immediate surroundings of monuments (ICOMOS, 1964: Article 14). In addition to consolidation and anastylosis, the Venice charter distinguished between conservation and restoration (ICOMOS, 1964: Articles 4 and 9), but persevered in accentuating the visual aesthetic qualities of monuments by stating that 'The intention in conserving and restoring monuments is to safeguard them no less as works of art than as historical evidence' (ICOMOS, 1964: Article 3). Australia ICOMOS issued in 1979 the Burra Charter[1] which introduced the concept of 'place' in reference to cultural heritage, whereby place could be a 'site, area, building or other work, group of buildings or other works of cultural significance' and included all its 'pertinent contents and surroundings' (Australia ICOMOS, 1979: Article 1). According to this charter, the cultural significance of a place informs the intervention procedures,

1 This charter is also known as the Australia ICOMOS Charter for the Conservation of Places of Cultural Significance.

and it distinguished among five such procedures, whereby conservation[2] remained a 'general term' that referred to all 'the processes of looking after a place' in order to 'retain its culturally significant qualities' (Australia ICOMOS, 1979: Articles 1 and 2). The least invasive among these five procedures is maintenance, which offers the continuous care for the place and was followed by preservation that impedes future deterioration by maintaining the current conditions through minimal interference. Both restoration and reconstruction endeavour to return the existing fabric of a place to a known earlier condition, but where reconstruction introduces new material, restoration simply removes accretions or reassembles existing components. Lastly, adaptation entails reversible interventions that modify the historic fabric to suit contemporary uses and may incorporate one or more of the previous procedures (Australia ICOMOS, 1979). Notwithstanding these pioneering contributions, this first iteration of Australia ICOMOS's charter upheld the emphasis on the visual values, firstly by stating that 'Conservation requires the maintenance of an appropriate visual setting e.g. form, scale, colour, texture and materials', and secondly by ruling out any intervention procedure and intrusion that may 'adversely affect' this visual setting or the 'appreciation or enjoyment of the place' (Australia ICOMOS, 1979: Article 8).

These entrenched values of the 'authorised heritage discourse' (Smith, 2006) by the conservation experts that underscored the physical and intrinsic qualities continued to prevail in the subsequent charters. The Washington Charter of 1987[3] stated that it is 'the historic character of the town or urban area and all those material and spiritual elements that express this character' that warrant conservation, and concluded by stressing that 'Any threat to these qualities would compromise the authenticity of the historic town or urban area' (ICOMOS, 1987: Article 2). Thus, authenticity emerged at the centre of the debates with regards to the appropriate choice of intervention procedures and the incorporation of new structures in the historic fabric. These debates culminated in the drafting of the Nara Document on Authenticity in 1994 according to which 'The understanding of authenticity plays a fundamental role in all scientific studies of the cultural heritage, in conservation and restoration planning, as well as within the inscription procedures used for the World Heritage Convention and other cultural heritage inventories' (ICOMOS, 1994: Article 10). These attempts at truth, credibility and objectivity hence stipulated the *sine qua non* of architectural conservation, namely, drawing clear distinctions between what is contemporary and what is historic in a place (Wells, 2010). Criticized for propagating 'bad' design that destroys 'the organic unity of ancient buildings' (Krier, 1998: 81), these pedantic views were challenged with a more flexible approach to authenticity that has since emerged. This recent approach placed the emphasis on the intentions and aims of the conservation effort (Lowenthal, 2002), which must be truthful and avoid deception by clearly stating the objectives of conservation, such as whether they revolve around authentic physical conservation or heritage development for commercial gain (Jivén and Larkham, 2003: 76–8). In contrast to this emphasis on a place that is frozen in time, the more recent official documentation on world heritage has in fact acknowledged that the historic urban landscape 'incorporates a capacity for change' which led to a new set of questions about the extent and nature of change (van Oers, 2010: 10).

In order to preserve the visual experience of the historic urban landscape, one aspect of urban conservation built on Gordon Cullen's 'townscape' notion that underscored the 'serial vision' – the kinaesthetic visual experience of this landscape that is grounded in how pedestrians navigate it (Cullen, 1971). Accordingly, in addition to the conservation of historic structures, contextual designs were adopted for new urban developments (Larkham, 1996). Contextualism 'yields contemporary architecture that is sensitive to and compatible with the context surrounding it' (Tyler, 2000: 139). Indeed, the Vienna Declaration of 2005 'emphasizes the need to properly contextualize contemporary architecture in the historic urban landscape' by 'undertaking studies to analyze the impact on cultural, visual or other values' (UNESCO, 2005c: Article c). Contextualism may be achieved either through matching or compatible designs. Matching entails that new design styles imitate historic ones by using the same materials, details and massing (Tyler, 2000). For example, the New Urbanist notions of place identify archetypes and typologies whose various compositions shape the townscape. These archetypes and typologies are then transformed into building codes that are regulated by construction manuals in order to maintain the – typically historic – visual impact of the urban landscape (Arefi and

2 In North America, preservation refers to intervention in historic buildings and sites while conservation refers to nature conservation. This book adopts the international terminology and uses historic conservation to refer to the five conservation procedures: maintenance, preservation, restoration, reconstruction and adaptive reuse.

3 This charter is also known as the Charter for the Conservation of Historic Towns and Urban Areas.

Triantafillou, 2005). Matching has been criticized as historicist because it eliminates the distinctive artistic values that distinguish each era and its culture (Ellin, 1999; Jokilehto, 1999). Other criticisms of historicism emerged whether those that claimed it represented a nostalgic rejection of the present by idealizing the past (Lowenthal, 2002), or that it emphasized the visual aesthetic to cater for the commercial heritage industry (Zukin, 1996: 44). This led to the evolution of compatible designs that deploy purely contemporary design elements albeit with sensitivity to the historic composition in terms of spatial arrangements, size, scale and massing (Tyler, 2000).

The Morphological and Spatial: Conserving the Townscape

By highlighting the sensitivity of the composition, compatible designs have in fact underscored the conservation of the townscape's physiognomy, particularly its morphological and spatial characteristics. The 1987 Washington Charter was the first among the world heritage documents and doctrinal texts to address these characteristics. Among the qualities that influence the 'historic character', the Washington Charter prioritized the 'urban patterns as defined by lots and streets' and 'the relationships between buildings and green and open spaces' (ICOMOS, 1987: Articles 2.a and 2.b). This charter also endorsed an important trait of urban morphology, namely, change over time in the functions and land uses, which it considered a contributor to the historic character (ICOMOS, 1987: Article 2.e). By considering change a natural process in historic urban landscapes, this charter endorsed regulated contemporary development in historic towns 'When it is necessary to construct new buildings or adapt existing ones, the existing spatial layout should be respected, especially in terms of scale and lot size' (ICOMOS, 1987: Article 10). Unfortunately, though, the subsequent international charters and doctrinal texts like the 2005 Vienna Declaration (UNESCO, 2005c) and the proposed Recommendation on the Historic Urban Landscape (UNESCO, 2011b) do not build on these valuable morphological contributions.

These debates on the spatial arrangements and the morphological dimension of historic urban landscapes had emerged among geographers since the late nineteenth century, but culminated in the middle of the twentieth century as a result of M.R.G. Conzen's work. Through his study of medieval Alnwick, M.R.G Conzen identified three components for the physiognomy of the townscape: the 'town-plan' or the urban ground plan that highlights the street network, the plots and the building footprints; the 'building fabric' or the three-dimensional form of the buildings; and the land and building uses (Conzen, 1960: 4). Therefore, and in order to maintain the 'serial vision' (Cullen, 1971) and the spatial spirit, urban conservation must transcend the physical conservation of individual buildings and spaces and account for the town-plan, the building fabric and the land and building uses (see for example, Samuels, 1990; Whitehand, 1990; Vernez Moudon, 1997: 7). Indeed, contemporary methodological approaches support such arguments; for example, technologies like space syntax have revealed how massive spatial transformations negatively impact the urban structure but, in contrast, how moderate transformations are more sympathetic to historic spatial organization and hence allow historic cores to survive (Karimi, 2000). Consequently, akin to architectural contextualization, calls for morphological contextualization have similarly emerged through innovative spatial interventions that account for historic arrangements (see: Gospodini, 2004 and Khirfan, 2010b), or through conserving the plot patterns (Samuels, 2009: 861; Whitehand, 2009: 860).

Indeed, the most recent definition of the historic urban landscape has embraced these morphological debates whereby it is considered 'an understanding of the city, or parts of the city, as an outcome of natural, cultural and socio-economic processes that construct it spatially, temporally, and experientially' but most importantly 'it incorporates a capacity for change' (van Oers, 2010: 12, UNESCO, 2011b). Moreover, the wider context of the historic urban landscape encompasses:

> … the site's topography, geomorphology and natural features; its built environment, both historic and contemporary; its infrastructures above and below ground; its open spaces and gardens; its land use patterns and spatial organization; its visual relationships; and all other elements of the urban structure. It also includes social and cultural practices and values, economic processes, and the intangible dimensions of heritage as related to diversity and identity (UNESCO, 2011b: Article 10).

The Socio-cultural and Economic: Conserving the Life within

This recent definition has underscored the socio-economic processes that contribute to the spatial, temporal and experiential formations of the historic urban landscape. Indeed, while historic conservation may sustain the physical and the morphological attributes, other issues arise about conservation's ability to meet the contemporary needs of the local inhabitants of a historic urban landscape. Theoretical and empirical research had long argued that conservation often transforms a historic urban landscape into a liability for its inhabitants.[4] Oftentimes, the high costs associated with urban historic conservation lead to inflating property prices and rent costs and hence trigger displacement and eventually gentrification (Lees et al., 2008). Consequently, many advocated for urban historic conservation that encompasses the socio-economic aspects, and, especially, one that accounts for the needs of the local inhabitants and their own perceptions of what is valuable and significant (see Nasser, 2003; Hayden, 1999; Serageldin, 1997). For example, when Lord Esher put forward his plan for York in the 1960s, he sought to preserve its spirit and character, thus his plan valued York as a living space and bestowed significance on the ordinary and the mundane on a par with the monumental (Pendlebury, 2009; Orbaşli, 2000: 68–74).

Empirical studies have shown how morphological conservation, especially conserving plot sizes and land use patterns, links the socio-economic processes and the physical and spatial qualities (Conzen, 1981: 84, 2009: 864). In the context of Arab-Islamic cities, Besim Hakim (1986: 102) revealed that two concurrent decision-making processes have shaped these cities, whereby the ruler or higher authority governed urban planning and design at the macro level, while the ordinary citizens made the decisions at the micro level. Specifically at the micro level, Hakim explained how the urban fabric assumed its form through the local inhabitants' combining of *sharī'a* (Islamic law) and *'urf* (traditional law) (Ibid.). Later colonial and post-colonial periods brought changes to these cities' formation, decision-making processes, functioning and social structures (Bianca, 2000; Mitchell, 1991). The clash between the traditional and the contemporary westernized planning methods continue to exacerbate the conservation and rehabilitation challenges in these cities (Bianca, 2000).

Furthermore, the complexity of historic urban landscapes triggers conservation challenges that pertain to the need to consider the multiplicity of stakeholders, to balance development and conservation and to conserve the character or sense of place (see for example: Larkham, 1996; Pendlebury, 2009; Tiesdell et al., 1996; Jivén and Larkham, 2003: 74–5). The 1987 Washington Charter emphasized the 'historic character' and underscored the spatial and socio-economic values of the historic urban landscape (ICOMOS, 1987: Article 1). There is indeed a scarcity in theoretical and empirical research that discusses how to conserve the socio-cultural aspects of a place. Such research has called for an approach to historic conservation that, firstly, transcends a static conservation of physical urban components to engage the local inhabitants in the production of place (Lynch, 1981; Hayden, 1999); secondly, empowers the local inhabitants to define and represent their history (Hayden, 1999; Serageldin, 1997); thirdly, allows the urban traditions to continuously evolve and adapt according to the local inhabitants' contemporary needs (Rowe, 1997); and lastly results in an historic urban landscape that meets the needs of the local inhabitants while simultaneously fulfills the needs and expectations of the international tourists (Hayden, 1999; Serageldin, 1997).

Nouha Nasser summed these debates in addressing the objectives of urban conservation whereas, 'Physically, [it] is linked to building preservation … Spatially, it is viewing the townscape as a holistic entity, with its relationships between spaces and their use, as well as circulation and traffic … [Socially, it] concerns the users, local community, and the urban population' (Nasser, 2003: 469). The complexity of urban conservation is more often than not exacerbated with the pressures of tourism development in historic urban landscapes. Building on the discussion in Chapter 1,[5] the following sections discuss the official plans and their associated intervention strategies in each of Aleppo, al-Salt and Acre and place these discussions vis-à-vis the complexities of tourism development.

4 See for example Herzfeld's work in Rethemnos in Crete (Herzfeld, 1991), Mitchell's work in Upper Egypt (Mitchell, 1995, 2001) and Orbaşli's studies of Granada in Spain and the Medina in Malta among others (Orbaşli, 2000).

5 See Chapter 1: The Contradictions of Tourism and the Historic Urban Landscape.

Aleppo: a Delivery Gap?

Immediately following its inscription on the World Heritage List in 1986, the Syrian government issued a regulation that was specific to Aleppo and which came to be known as Decision 39/1990. This three-page document was designed to deter deterioration, to preserve the status quo and to control future development through land use and zoning regulations and through building legislation and codes. Decision 39/9 was amended in 1998 to elaborate on the restoration and renovation guidelines, and to address the preparation of master plans (Windelberg et al., 2001: appendices 2.12 and 2.13). By 2001, the collaboration between GTZ and the Syrian authorities on the Project for the Rehabilitation of the Old City of Aleppo culminated in the publication of a new plan that came to be known as the Development Plan. The latter included nine development fields and their associated strategies that encompassed: spatial development; housing and social development; economic development; traffic and transportation development; environmental development; social development; historical building preservation; and participation (Windelberg et al., 2001). Conspicuously absent from these development fields and their strategies was tourism planning – apart from deploying land use and zoning strategies to limit tourism activities to the area around the Citadel, known as the Citadel Circle. Furthermore, the Old City Directorate lacked a department or a division dedicated for tourism while none of its staff were assigned to attend to matters pertaining to tourism development.[6] One planner admitted that:

> The project, in its very early inception, somehow regarded tourism in a rather nonchalant way – for lack of a better word – in that the main attention of the project was still, and to a certain extent still is, the preservation of the residential function of the city. In that sense working too much in the favour of tourism was seen as somehow endangering the probability of a continuous residential function in the city, so it was mostly an idea of mitigating tourists' presence rather than opening up the city for tourism (interview on 9 June 2005).

Given the large expanse of Aleppo, it was divided into Action Areas (AA) that constituted of demarcated neighbourhoods in an attempt to facilitate a manageable and comprehensive implementation of the plan. Furthermore, according to the Development Plan, such a division sought to convey the project's locations to the local inhabitants and to potential investors and, also, to enable the implementation of an 'intensive policy of control and regulation' (Windelberg et al., 2001: 13). In particular, the Development Plan identified three Action Areas, namely *Bāb Qinnasrīn*, *al-Farāfra* and *al-Jdēide*, which became known as AA-1, AA-2 and AA-3 consecutively (Windelberg et al., 2001). When *Bāb Qinnasrīn*'s Action Plan received an award from the Arab League and, also, when the Development Plan and the Project for the Rehabilitation of the Old City of Aleppo received the Eighth Veronica Rudge Green Prize in Urban Design from Harvard's Graduate School of Design (Busquets, 2005), Aleppo together with the project and the Development Plan were placed at the forefront of a positive media campaign both nationally and internationally. In addition, the several international exhibitions that were curated to raise funds for the Project for the Rehabilitation of the Old City of Aleppo further contributed to this international marketing campaign. A planner explained:

> The project participated in various international events like the World Expo in Nuremberg, and in exhibitions at some museums in Germany that travelled around Germany. Substantial funds were allocated at the time to make this promotion but it was not tourism that was promoted, it was the city in general and more primarily, the rationale of investing in such as city, primarily on the part of donor institutions (interview on 9 June 2005).

The media campaign drew attention to Aleppo's potential for tourism investment, prompting tourism entrepreneurs to purchase traditional courtyard houses and to convert them into catering and accommodation services. One planner relayed how:

> When we entered *Bāb Qinnasrīn*, people didn't even know what it was and where this neighbourhood was. So this big interest and the pouring of activities were in truth as a result of our interest in the area. Unfortunately, the issue of tourism came as an unassigned and unexpected result [...] we walked through the path of

6 Also, see the discussion in Chapter 2 under The Evolution of Aleppo's Urban Form.

rehabilitation from a perspective of rehabilitation and preservation and conservation [but] tourism came in their place (interview on 1 June 2005).

Several sources admitted that *Jdēide* neighbourhood in particular became susceptible to the pressures of tourism development because its primarily Christian inhabitants were deemed less socially conservative. A planner shared:

> What helped in its quick openness is the fact that the majority of its residents are, you know, [Christian] [...] Many told me that *Jdēide* opened up quickly and that the local inhabitants did not give the matter any importance (interview on 7 June 2005).

Striving to counter these tourism development pressures, the senior planners decided to forward *Jdēide* to become the second Action Area (AA-2) and postponed the intervention in *Farāfra* by making it AA-3. Although a relatively small neighbourhood, by 2006 *Jdēide* had boasted well over a dozen hotels and restaurants considered among the best in Aleppo. This rapid tourism development came in spite of the planners' attempts to curb it through their control over land use and zoning. Their stance stemmed from their objective to preserve Aleppo's residential function and from their assumption that tourism development contradicted with the best interests of the local inhabitants. During the workshop that was held on 6 June 2005, the then Mayor of Aleppo, Dr *Ma'an Shiblī*, declared his intent to curb tourism development through his control over the licensing of new tourism establishments, such as retail, catering and accommodation services. One of the planners shared:

> *Jdēide* was a private sector driven process, in that it was chosen as an action area primarily because that was where the private sector has undertaken a process of gentrification work [...] the project had to cope with the presence of the tourist activities in *Jdēide* [...] containing tourism rather than developing it (interview on 9 June 2005).

Once it began, the implementation was limited to two of the proposed nine areas of development, namely, land use and technical infrastructure. The following discussion attributes this limitation to the inability of the new plans to emancipate from the Syrian planning system – a system that is based on planning programs, master plans and building codes (Windelberg et al., 2001). The discussion revolves around the aforementioned triad of conservation: the perceived and physical; the morphological and spatial; and the socio-cultural and economic.

Aleppo: Conserving the Architectural Aesthetic and Integrity

Since Bianca et al'.s 1983 report, several detailed architectural surveys were carried out in Aleppo; however, there were no attempts to develop mechanisms to link these descriptive data to the GIS database[7] which precluded associating Aleppo's spatial survey with descriptive information about the singular buildings whether it was their architectural and façade details, their altered or authentic condition or their conservation needs. The absence of such descriptive data from the GIS database precluded the derivation of effective conservation policies and strategies and led to a delivery gap between the documentation, planning and implementation (Khirfan, 2010a; also see Miele, 2005). Consequently, the planners reverted to Decision 39/1990 and added a few more articles to this legislation with the ultimate objective of deterring deterioration, preserving the status quo and controlling future development. Brief and vague, Decision 39/1990 was used to regulate the building codes, including heights, façade details and construction materials. In enacting these codes, Decision 39/1990 advocated a 'policy of control and regulation', such as the stipulation to demolish any unapproved additions to historic structures (Windelberg et al., 2001: Appendices 2.12 and 2.13). One of the local inhabitants complained during an interview:

> There is stringency in the laws. We cannot restore. Wood is not allowed. We are not allowed to remove it [the existing wood]; and we do not have the ability to maintain it. That's why we sold [our house]. We could

7 See for example Ford et al., 1999 and Elkadi and Pendelbury, 2001 on the descriptive component of GIS and its relevance to the management and conservation of vernacular and historic architecture.

not take it anymore: the dilapidation, the walls, the humidity in winter is very difficult and [the house] needs maintenance. We are sad to leave the area, but there is nothing we can do.

This emphasis on the conservation of the physical fabric in its authentic state shifted the project's focus from urban rehabilitation that allows change and adaptation to architectural conservation that prohibits change (Tiesdell et al., 1996). For centuries, the inhabitants of Aleppo had continuously adapted their urban fabric to fit their needs whether through expansion, addition or subdivision (Khechen, 2005). Indeed, one of the planners in Aleppo admitted that 'continuous negotiation' marked the traditional relationship between the local inhabitants and their built environment – alluding to Hakim's micro-scale interventions through *sharī'a* and *'urf* (interview on 9 June 2005, also see Hakim, 1986) (Plate 10). The regulations of Decision 39/1990 inverted this centuries-old relationship and obliged the local inhabitants to adapt their contemporary living conditions for the sake of conserving architectural authenticity.

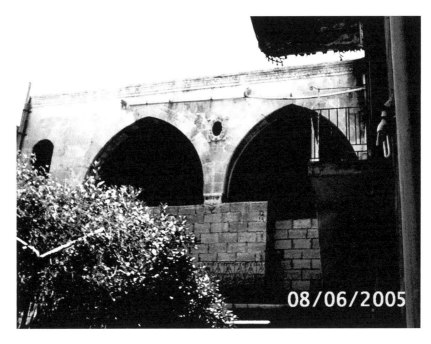

Plate 10 An example of the additions and modifications in the courtyard houses of Aleppo
Source: The author.

Furthermore, several local inhabitants complained about the vagueness and obscurity of Decision 39/1990 with regards to the specifics of the possible intervention strategies through historic conservation. This was particularly problematic given that the hiring of a professional historic conservation firm was well beyond their financial means. Although according to the Development Plan's conservation strategies the staff of the Old City Directorate would provide free technical advice on conservation and rehabilitation, this service incorporated only advice on the supervision of the construction but not on the actual design process. Additionally, the Development Plan's conservation strategies provided an interest-free loan; however, this loan contributed a meagre amount compared to the prohibitive costs of conservation. In fact, this loan had evolved from an emergency loan of nearly US $760 to be used for deterring deterioration, to one that ranged between US $570 and US $2,850 in order to include aesthetic improvements. One of the planners explained:

The rehabilitation loan gives, in addition to the emergency loan, a grant that is not refunded which should be used to restore the architectural elements of the house. This is the condition of the funding: that the property owner does

not really care about the conservation of certain elements because they are issues of appearance or aesthetics. But for us, we care that there is appearance and elegance more than him[8] (interview on 30 May 2005).

Plate 11 **The dilapidated houses in Aleppo**
Source: The author.

Unable to invest large sums in hiring professional conservation experts, many of the local inhabitants shared their inability to maintain their houses (Plate 11). Further, the complexity of the property ownership in Aleppo posed administrative and logistical challenges that further hindered an effective implementation of historic conservation strategies. One of the planners shared the frustration that:

> One of the most important things that local inhabitants suffer from is the issue of ownership itself [...] And you will see one property owned by twenty or more individuals, among them that who is deceased, who is living, who has his own heirs ... etc. This issue deters any operation from a legal aspect (interview on 31 May 2005).

These factors combined generated a gradual process of displacement, whereby the local inhabitants began to abandon their houses in the Old City of Aleppo. Some of the empty houses, especially those on the fringes of the Project for the Rehabilitation of the Old City of Aleppo in areas that were off the tourism track, were converted into storage facilities for small industries (Plate 12). Many of the local inhabitants who were surveyed either confirmed already selling their residences or expressed interest in selling them in the near future, while signs advertising these traditional houses for sale could be seen everywhere (Plate 13). Interestingly, some of the

8 In 2005, at the time of this interview, 40,000 Syrian pounds was equivalent to US $760. According to this exchange rate, the increased range of the loan from 30,000 to 150,000 Syrian pounds paralleled US $570–2,850.

Plate 12 **The courtyard houses in Aleppo became storage facilities for small industries**
Source: The author.

Plate 13 **Signs advertising the traditional courtyard houses for sale can be seen around Aleppo**
Note: Khirfan 2010a. This plate, along with some other plates and some quotes that appear in subsequent chapters have been published in *Traditional Dwellings and Settlements Review*, Spring 2010, volume XXI, Issue II, pages 35–54. The article was titled: From Documentation to Policy-Making: Management of Built Heritage in Old Aleppo and Old Acre.

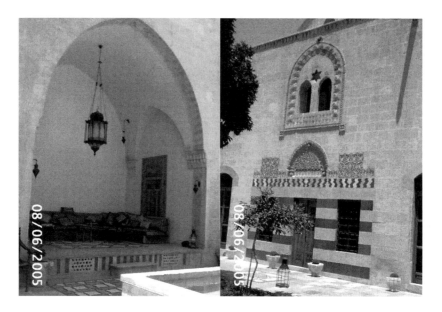

Plate 14 **The courtyard of the Mansouriya Palace Hotel in *Bāb Qinnasrīn* in Aleppo**
Source: The author.

planners distinguished between residential gentrification, which entails social mobility and the replacement of the local inhabitants with new, more affluent ones and tourism gentrification, which involves the penetration of tourism services in the residential areas (Lees et al., 2008). One planner acceded to the former by providing the rationale that the local inhabitants:

> ... don't have the means to maintain their own houses. So how can this built-up structure be maintained if we don't [allow residential gentrification]? So we would have to bring in richer people who have the money to maintain [this structure]. The more people come in and invest, the more people come back – and this is presently happening, that people come back from outside Aleppo, even from foreign countries, investing in the Old City, in these courtyard houses, renewing them to modern living standards (interview on 2 June 2005).

This planner admitted though that this residential gentrification was getting out of hand causing the displacement of the local inhabitants:

> Once you have grown over a certain critical mass – and I think that we are arriving at this critical mass now – we are also somehow worried about this. It is not yet dangerous, but it may become dangerous [...] I am not sure if we can stop this, if we can prevent this, but first of all we need to know how much it is [...] I don't know where the limit is [...] we hear from the *mukhtārs*[9] that, in particular in *Bāb Qinnasrīn* and in *Jdēide*, houses are bought (Ibid.).

In fact, during the fieldwork in *Bāb Qinnasrīn*, the semi-random sampling led to the door of what seemed like a regular residential unit at the end of a long cul-de-sac alley but it turned out to be a courtyard house that had been converted into a boutique hotel called Mansouriya Palace Hotel where the manager offered me a tour[10] (Plate 14). One of the planners later shared:

9 A *mukhtār* is a local neighbourhood leader.
10 The website for this hotel is: www.mansouriya.com

In *Bāb Qinnasrīn* a Swiss person came, and spent millions on a huge project. It is not huge [in size], but a very good project for special customers, which means in one week you can get a whole courtyard house for US $10,000. Mario Botta was there, and the top visited the project: *Suleimān Franjiyye*[11] came to it, and Dr. *Bashār al-Asad*[12] (interview on 7 June 2005).

Aleppo: Conserving the Townscape

The planners had wrongly assumed that GIS was a 'do-all' tool (Aangeenbrug, 1991) in the documentation of Aleppo's landscape, which eventually limited the implementation and the management to land use and zoning policies and to infrastructure rehabilitation with minimal interventions to conserve the townscape. Notwithstanding that the GIS analysis of the land uses revealed that Aleppo's landscape had traditionally lacked any clear separation of uses, the Development Plan proposed separate land uses, probably in an attempt o establish spatial order (Figure 4.1). These new policies overlooked the fact that land uses manifest the links between the spatial and the socio-cultural and economic (Conzen, 1981). Absent from the GIS database, and by consequence from the planning initiatives, were information on the socio-economic rationale behind the mixed land uses as well as *sharī'a* and *'urf* processes that would have elucidated the micro-scale interventions (Hakim, 1986). These new land use and zoning policies also sought to remove all the activities that were deemed unwelcome from Aleppo including, the traditional small workshops, the industrial and commercial warehouses and certain commercial and community facilities (Windelberg et al., 2001) (Plate 15). While some of these facilities – especially, the warehouses – had only recently penetrated Aleppo's landscape, others – especially, goldsmiths and soap-makers – had existed for centuries and even had their own dedicated section in the *sūq* (Vincent and Sergie, 2005). Therefore, the obliteration of these traditional activities would eventually disrupt the centuries-old socio-economic structure of Aleppo.

The rehabilitation of what the planners had dubbed 'technical infrastructure' seemed to be the only aspect of the Development Plan that was actually implemented in Aleppo. Technical infrastructure referred to the sewerage and the water lines while the local inhabitants complained, and planners later confirmed, that telephone and electricity lines were excluded from these upgrades. One of the local inhabitants criticized how:

> They changed the sewerage, then after a while changed the water, and what a mess! They kept the old network which could impact the bases of the old buildings. They did not remove the old and put [the new] on top of it and there was no coordination with institutions, for example the telephone [company]. There are no [telephone] lines [...] They will have to repeat the digging. They should have coordinated all the infrastructure services together.

Two of the planners admitted that the focus on infrastructure rehabilitation was a direct result of the nature of the documentation process that was limited to technical data. Another planner also claimed that the architectural and engineering backgrounds of the local Syrian staff prejudiced the technical orientation of the documentation and implementation: 'It also is expected in the fact that the majority of the [local] people who worked on the project were architects and engineers. This is a project that was technical by its very interests' (interview on 9 June 2005). Several other planners also shared that the rehabilitation of the sewerage and the water lines was provided as a supply-side service at no, or very low, cost to the local inhabitants and the property owners because it was thought to extend the lifespan of Aleppo's historic landscape. One planner explicated:

> Public infrastructure is the easiest way of spending the money in what the state considers a transparent way. And to a certain extent this was the dominant thinking – that the state is a catalyst for change. By investing its share it encourages others to invest their shares. And by providing also the framework for space investment – that is, land use regulations, clear building codes, clear definition of what is permissible and not permissible in the Old City – then people would feel secure and move ahead in their investments (interview on 9 June 2005).

11 The former president of Lebanon.
12 The current president of Syria.

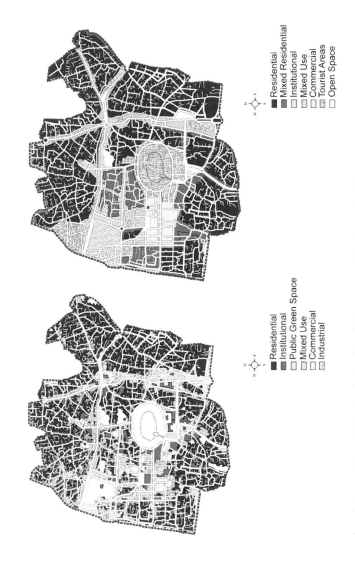

Figure 4.1 A comparison between the existing traditional and the proposed land uses in Aleppo
Source: Khirfan 2010a.

Plate 15 A worker unloads material into a small industry workshop in an historic house in Aleppo

Source: The author.

The project itself contributed little in terms of urban design interventions that were almost limited to one local plaza in *Jdēide* called *Sāḥet al-Ḥaṭab* whereby the originally small plaza was significantly enlarged, beautified and furnished (Plate 16). As discussed in Chapter 2, the traditional cities of *Bilād ash-Shām* in general, and in Aleppo in particular, lacked this type of large public open space. One of the planners conveyed the struggles of attempting to understand the typologies of open space in Aleppo notwithstanding the usefulness of the GIS documentation for exactly such analyses:

> ... one of the problems that surfaced, the issue of open space in the Old City is one of the issues [sic]. You saw the urban fabric of the Old City which is a bit constrained, so where is the open space actually? It is the courtyard of the building itself? (interview on 31 May 2005).

Furthermore, Decision 39/1990 was deployed to regulate urban design standards, especially throughout *Jdēide* whereby all the shop owners were obliged to comply to new building codes that standardized the façades of their shops, including the doors, signage and awnings (Plates 17 and 18). Most of the shop owners criticized these regulations; one complained that 'also the doors that they made us install have flaps that do not suit the nature of the narrow alleys. There is no space for them between shops because the spaces are tight'. Most importantly, the enforcement of these standardization measures, in the name of establishing quality control, spurred homogenization in *Jdēide* (Boniface and Fowler, 1993).

Plate 16 The urban design interventions in *Sāḥet al-Ḥaṭab* in *Jdēide* in Aleppo
Source: The author.

Plate 17 The shop facades in *al-Farāfra* quarter in Aleppo, which have not yet been subjected to the new standardization regulations
Source: The author.

Plate 18 **The standardized shop façades in *al-Jdēide* quarter in Aleppo yield a homogenized urban landscape**
Source: The author.

Aleppo: Conserving the Life Within

The emphasis on the technical infrastructure came at the expense of other areas of the social infrastructure. The Development Plan identified a severe lack of social services in Aleppo, especially health and educational services as well as vocational training and literacy services (Windelberg et al., 2001: 72–3). The project's policy and implementation response to these needs however had been minimal and only included very sporadic initiatives such as one kindergarten, one health unit run by a clinician and one cultural centre at the *Shībani* Church. The latter was an archaeological ruin until it was renovated through the project to serve as an art gallery and a cultural centre that hosted a variety of events, including exhibitions, lectures, conferences and musical concerts (Plate 19). While all of the events that I attended there during the fieldwork were open to the public, it was obvious that most of the attendees were upper class Aleppians. One of the local inhabitants whose house abutted the *Shībani* Church disclosed:

> I usually dress in a *jallābiyye*[13] not pants. I entered the *Shībani* [Church] to have a look around and there was a concert. And they offered me, and I accepted, a glass of pop soda and I looked around. Parties there are so-and-so. I did not recognize [what] the tiny foods [were]. I tasted them, they are neat and look nice, but I did not like them.

The technical tendencies in Aleppo's project also precluded devising policies that address the complexities of private ownership. The Development Plan offered an overly normative approach that documented and identified the ownership patterns, linked them to the population densities and then contrasted the existing situations with a desired ideal; however the Development Plan failed to provide any means – whether in terms of policies or planning strategies – for achieving this ideal (Windelberg et al., 2001).

13 A *jallābiyye* is a traditional long dress worn by generally the local non-westernized men around the Middle East.

Plate 19 **An art exhibition at the gallery of the *Shībani* Church in Aleppo**
Source: The author.

Al-Salt: Is Place a Tourism Product?

The three Tourism Development Projects in al-Salt that were spearheaded by JICA's project claimed to pay particular attention to the development and marketing of a new tourism product. Not only did the nomenclature of these projects underscore this, but also nearly all the planning documents referred to al-Salt as a 'product' in lieu of a 'city'. One of the earliest reports stipulated that the project endeavoured:

> ... to create a wholly new tourism product from a neglected urban resource i.e. cultural, historical and folklore life; to broaden and diversify the product profile of Jordanian tourism from archaeology based to the culture based tourism; to introduce a new perspective in the tourism product development in Jordan; and eventually to enhance the appeal and attractiveness of Jordan as a tourist destination in the world tourist market (Nippon Koei Co. et al., 1996b: 4.56).

Chapter 1 revealed that in the development of place-as-product, a triad of strategies is deployed that includes image marketing, the development of tourism infrastructure and urban rehabilitation (Gold and Gold, 1995). The following discussion addresses how the tourism development projects in al-Salt had approached each of these strategies.

To begin with, image marketing assumes particular significance for a product like al-Salt that is still at the introduction stage in its lifecycle because it targets potential tourists by highlighting the unique selling preposition (USP) of the destination – that is, its distinctive identity (Holloway and Robinson, 1995; Kotler et al., 1993). But the Jordan Tourism Board – the national body in charge of Jordan's official tourism marketing – maintained that:

> ... [al-Salt] does not have a product [...] it is a beautiful old town and contains old buildings, and everything original about an old city, but if you want a selling point, when you are selling abroad, you want something unique [...] in Salt there is no [uniqueness]. It is beautiful, and historically, it is important to us, but it does

not have a [unique] selling point that you can sell abroad [...]. Based on this we do not focus much on al-Salt' (interview with a senior planner at the Jordan Tourism Board on 26 June 2005).

Further still, place marketing strategies were absent from the planning documents of the three Development Projects in al-Salt. The planners, who confirmed this absence, blamed the Jordan Tourism Board for excluding al-Salt from its print media that primarily market the archaeological and natural sites (Jordan Tourism Board, 2011). Other planners implied that the insignificant numbers of tourists and the unfeasibility of extracting entry fees from tourists to al-Salt contributed to this exclusion:

> The reason, according to [the Jordan Tourism Board] is that what they put on the [tourist] map and in their statistics is only based on the numbers of tourists. They give priority to places where tourists' numbers are high. And since al-Salt does not get that many tourists, so it is not prioritized [...] So we told them OK, let us put it on the map, so that the tourists would start coming to it and their numbers would increase, and they said that that is not the way in which they work (interview on 14 May 2005).

In fact, this quote reflects the lack of coordination among the planning agencies since the Minister of Tourism and Antiquities, a partner in the three tourism development projects, serves as a board member for the Jordan Tourism Board.

Most importantly, the documentation of the historic urban landscape failed to register the sentiments of al-Salt's inhabitants toward tourism development. Thus, while the planners boasted that 'our concept was [an] eco museum. The whole city is a museum of course with emphasis on *Abū Jāber* building, [which will] contain the history of al-Salt dating back to the Golden Era of the Kingdom. And the population of al-Salt [are] what we call the precious possessions', the local inhabitants harboured different views. Al-Salt's inhabitants, who are known as *Salṭiyye*, are part of the *Balgā* region whose inhabitants are known as *Balgāwiyye* and both groups are renowned for their *karam wa ḍiyāfe*, which literally translate into generosity and hospitality. Their honour code precludes monetary exchange for their *karam wa ḍiyāfe* (Shryock, 2009), and considers catering to guests a duty (Shryock and Howell, 2001) – something that I had experienced first-hand during the fieldwork. In fact al-Salt's inhabitants boasted the absence of tourist services, especially accommodation and catering, from their region as a demonstration of their *karam wa ḍiyāfe*. According to the *Salṭiyye*'s honour code, any stranger in their city is considered a guest who should be invited into their homes but with the twist that, simultaneously, the guest becomes a captive of the host and, thus, the cultural norms constrict this guest's access to the intimate sphere (Joseph, 1999; Shryock, 2004b). Consequently, the *Salṭiyye* have been renowned for their conservative attitudes toward outsiders entering their intimate sphere. To give an example, in the 1990s the *Qāqīsh* family, a Christian family from al-Salt, restored one of its traditional residences and converted it into a café-restaurant and named it *al-Salṭ Zamān* – literally, the Olden al-Salt. Enticed by its location and unique setting, patrons from Amman as well as international tourists flocked to *al-Salṭ Zamān* to the chagrin of the local inhabitants who considered this a violation of their honour code and a mass mediation of their cultural intimacy, and thus forced its closure.[14] Therefore, as I have argued elsewhere (Khirfan, 2013: 317–8) 'the project's fixation on tourism development and on the perception of the historic urban landscape as a product starkly contradicts the local inhabitants' traditions and norms'.

Al-Salt: Developing Tourism Infrastructure

JICA's reports emphasized the need to develop tourism infrastructure in al-Salt and proposed a three-way strategy to achieve this goal: tourism services, human resources and urban design (Nippon Koei Co. et al., 1996a; Nippon Koei Co. et al., 1996b). This section addresses the first two, while the next section will focus on urban design.

Firstly, the original plan proposed several components for tourism services including a visitor centre, a local museum, a handicraft shop and tourist amenities (Nippon Koei Co. et al., 1996a; Nippon Koei

14　The *Qāqīsh* house remained closed until the family recently donated it to the Municipality of al-Salt, which uses it as offices primarily for its architectural staff.

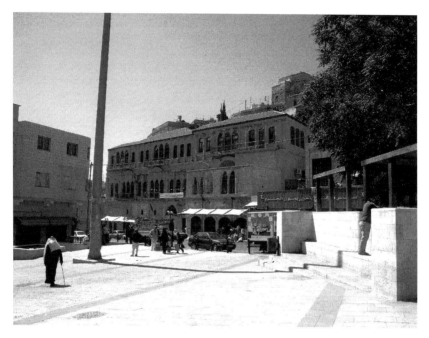

Plate 20 The Historic Old Salt Museum was housed in the *Abū Jāber* mansion in the centre of al-Salt with the plaza or *sāḥa* in the forefront
Source: The author.

Co. et al., 1996b). These were eventually reduced to only the Historic Old Salt Museum, which was housed in the historic *Abū Jāber* mansion in the centre of al-Salt by the *sāḥa*. It was foreseen that this museum would double as a visitor centre and would contain some handicraft shops (plate 20).

Controversies abounded around this building. Initially, the owners, the *Abū Jāber* family,[15] supposedly donated the house to the government in order to convert it into the Historic Old Salt Museum – as maintained by several planners during their interviews. One of the senior planners even claimed to have advocated for acknowledging this donation in the nomenclature of the museum as: 'The Historic House Museum of *Abū Jāber* […] because I want to emphasize the fact that it is the *Abū Jābers*, the owners, who actually granted the house as a gift to the government' (interview on 10 May 2005).

But several sources confirmed that the *Abū Jāber* family had requested and received a hefty compensation that was discounted from the project's budget. A planner shared how:

> The *Abū Jāber* mansion created a problem […] The truth is that there was a huge sum in return and that amount was paid from the budget, and that compensation was taken and the Ministry of Tourism and Antiquities would not have been able to start the conservation until that money was taken. It started as donation but then there was a payment' (interview on 15 May 2005).

The local inhabitants of al-Salt did not relate to the privately owned *Abū Jāber* mansion and actually lamented the disregard of the culturally significant civic structures like al-Salt's Secondary School (see Chapter 6). Such disregard stemmed from the weaknesses of the documentation that underscored the visually aesthetic at the expense of the locally significant. Such an omission was evident in the discussions with the planners who themselves seemed unaware of the elements that contribute to the cultural significance of al-Salt's historic landscape. One of the planners justified the choice to invest in the *Abū Jāber* mansion by stating that 'the reason to preserve this building [is] honestly there is nothing in Salt to attract tourists' (interview

15 A wealthy Christian family whose roots originate in Nazareth in Palestine.

on 7 May 2005). Another planner unrealistically claimed that the museum will 'grant a voice to local Salti history (the social history of everyday life)' (Daher, 2005: 304) – a claim that I address in Chapter 5.

Secondly, in order to ensure the future sustainability of the project's initiatives, a human resource development component was included so as to build local capacity. According to the initial proposals, several workshops were planned both in Japan and in Jordan that would offer training on 'urban facility planning; museum management; tourist service management; tourist marketing; [and] tourist service practices' (Nippon Koei Co. et al., 1996a: 46; Nippon Koei Co. et al., 1996b: 4.58). These were eventually reduced to museum curatorship and included sending only two professionals from the Greater Salt Municipality on a two-month training trip to Japan. One of JICA's planners admitted to the limited benefits of the outcomes: 'two personnel from al-Salt have been selected to go to Japan to do museum training [...] for two months and I think they learned a lot. They came back and their perception, concepts and views were completely enhanced. They were not changed but they were enhanced' (interview on 7 May 2005). Surely, their training did not include the areas of expertise that the local institutions needed in order to guarantee the future sustainability of the historic urban landscape such as site management, urban rehabilitation or historic conservation (Daher, 2005). Nor did this training incorporate the skills needed for developing al-Salt as a tourism product, like tourist site management and tourism promotion, as was initially planned.

Al-Salt: Urban Rehabilitation Versus Cosmetic Treatments

The discussion in Chapter 3 revealed how the cultural significance of al-Salt's urban landscape was reduced to the facile emphasis on the architectural aesthetics of isolated façades at the expense of the more fundamental aspects of its town plan and urban morphology. Moreover, although the tourism development plans listed urban design and urban rehabilitation among the tourism development strategies, the fixation on the visual experience of the potential tourists relegated urban rehabilitation to the mere 'Beautification of Public Spaces and Sign Posting' (Nippon Koei Co. et al., 1996a: 46). This component of the project entailed: the selection of model tourist trails along the *'aqabāt*; the construction of tourist nodes and panoramic lookouts on the hilltops; and the creation of open plazas (Figure 4.2). It also included the provision of aesthetic treatments such as pavement improvements, lighting, street furniture like benches and shelters, public art works and signboards for all the tourist trails and the rest facilities. The planning documents also stipulated that this component would also include services such as the provision of garbage collection; the resolution of the automobile circulation and parking problems; and the rehabilitation of infrastructure (Nippon Koei Co. et al., 1996b: 4.58) – all of which were eventually deemed unnecessary and accordingly, discarded. In rationalizing the abandonment of the infrastructure rehabilitation, a planner claimed that 'Unfortunately, only [sewerage] along our path because we cannot do too much as the design intends and the loan agreement [...]'. When probed further however, this planner admitted:

> No we didn't change the water and sewerage, we only changed the manhole covers, because honestly the sewer lines are still in very good position. We have checked. And it is not possible for us to dig up the whole city, we just want to be practical approach [sic] and if it is not necessary, why reinvent the wheel? (interview on 7 May 2005).

In reality, the project's beautification consisted mostly of repaving some *'aqabāt* and paths by superimposing a new layer of stone over the original one. This naturally cast doubts on the claims that the infrastructure was inspected before the new pavement was laid. Surely, the local inhabitants expressed their concern, and sometimes cynicism, toward what they dubbed 'surface treatments' that would complicate any future attempts to rehabilitate the infrastructure since henceforth digging would have to traverse two layers of stone pavement instead of one. Indeed, Daher had acknowledged that the urban rehabilitation in al-Salt depended primarily on 'shock treatments and urban cosmetics' (Daher, 2005: 299).

Also, the planning documents stipulated that the selection of the 'model' trails that underwent the 'beautification' was based on their potential for serving the anticipated tourists. One of the planners explained that the choice took into account 'the best *'aqabāt* that could connect a plaza with a panoramic

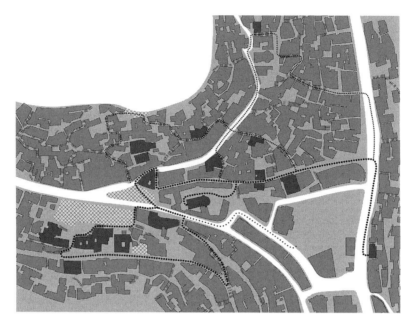

Figure 4.2 The proposed tourist trails along the *'aqabāt* of al-Salt
Source: The author.

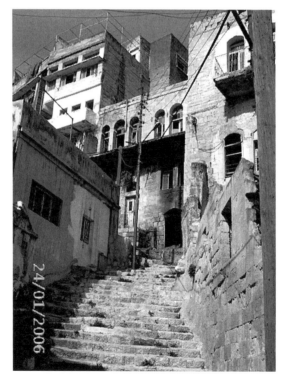

Plate 21 Some of the *'aqabāt* in al-Salt had been excluded from the rehabilitation
Source: The author.

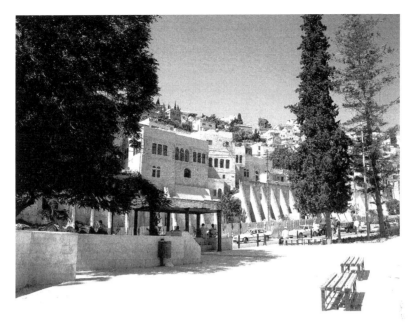

Plate 22 *Sāḥet al-'Ain* (the Spring Plaza) in al-Salt became a wide stretch of glaring white stone pavement

Source: The author.

Plate 23 A newly introduced plaza and water fountain along one of the *'aqabāt* in *al-Jad'a* in al-Salt

Source: The author.

point, and how many buildings can be introduced to tourists along the way'[16] (interview on 14 May 2005; also see Khirfan, 2013: 313) (Figure 4.2). This meant that numerous other *'aqabāt* were excluded from the rehabilitation notwithstanding the needs of the local inhabitants (Plate 21).

To exacerbate matters, the rehabilitation measures in al-Salt had disregarded the basic norms of historic conservation as spelled out in internationally endorsed charters and resolutions. For example, the restoration of the *'aqabāt* did not return them 'to a known earlier state' (Australia ICOMOS, 1999), but, on the contrary, irreversibly changed them by introducing hitherto extraneous urban elements like the extensive paved expanses in *al-sāḥa* that obliterated the three water springs (Plates 20 and 22) and the new small plazas that were introduced along the *'aqabāt* (Plate 23); the latter even included water fountains that contradicted the obliteration of the main spring in *al-sāḥa*, and also defied the semi-private nature of the *ḥūsh* along the *'aqabāt* (see Chapter 2 and Figure 2.5). In the same vein, the placement of the 'panoramic lookouts' at the higher end of the *'aqabāt* defied the local *'urf* that ensured, through regulating the building typologies, the privacy of the residences on the lower terraces by prohibiting their exposure from the upper terraces.

Plate 24 **The mix of new materials in al-Salt included black basalt and white limestone which contrast with the local yellow stone**
Source: The author.

16 This quote, along with some other quotes that appear in subsequent chapters have been published in the *International Journal of Islamic Architecture*, 2, 307–25. The article was titled: 'Ornamented Facades and Panoramic Views: The Impact of Tourism Development on al-Salt's Historic Urban Landscape'.

The irreversible rehabilitation measures also introduced new building materials that were not part of the original vernacular repertoire of al-Salt like the use of the white limestone and the black basalt stone instead of the traditional and distinctive mustard-yellow stone (Plate 24) – a practice that the local inhabitants strongly criticized. Admitting to this criticism, one planner proposed: 'once the project is over, and we get to the finishing stage, all the white limestone will be sprayed with acid and its colour will change into yellow' (interview on 14 May 2005). Other fundamental problems persisted, like the levels of the new pavement compared to the original one that resulted in draining the rainwater from the *'aqabāt* inside their houses (Plate 25). One resident shared how 'I warned them and told them that when they put the [new] pavement that the level of the path becomes higher than the level of my house, and this becomes troublesome when it rains'. This problem was exacerbated by the smooth stone surfaces that become slippery with rain, and by the absence of drainage systems along these *'aqabāt* although the original study by the Royal Scientific Society had recommended such systems. A local planner lamented: 'paved the alleys and stairs not according to [the RSS] detailed recommendations and plans where [there was] a trench in the middle – you see the same in Europe and other parts of the world. It is a shame that they did them like this – with a smooth surface. That's dangerous' (interview on 30 June 2005).

Plate 25 The pavements of the *'aqabāt* in al-Salt were built to the same level as some of the houses, creating drainage problems for the local inhabitants
Source: The author.

The tourism development projects also imposed new urban design regulations that have led to the homogenization of al-Salt's historic landscape whereby all the shops façades in al-Salt had to comply with new standardization measures for the doors and signage (Plates 26 and 27). While all these superficial treatments are pursued, the three projects put aside the fundamental concerns like the regulation of the building types that would maintain the historic townscape. Surely, the building masses for almost all the new structures – most notably, the civic structures such as the Directorate of Education and the Police Headquarters – are disproportionate to al-Salt's townscape (Plate 28).

Lastly, an initial estimated cost of US $7.6 million was allocated for the First Tourism Development Project by JICA to be distributed as follows: US $2.3 million for tourism infrastructure, US $0.3 million

Plate 26 The newly standardized signage in al-Salt yields a homogenized urban landscape
Source: The author.

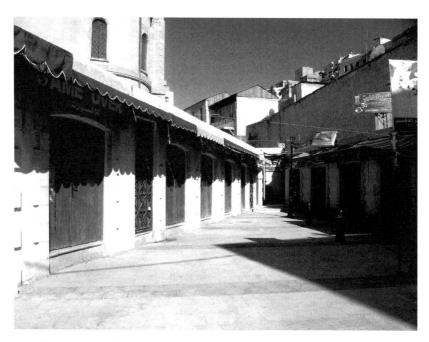

Plate 27 The newly standardized shop façades in al-Salt yield a homogenized urban landscape
Source: The author.

Plate 28 **The contemporary civic structures (the Directorate of Education and the Police Headquarters) are disproportionate to the townscape of al-Salt**

Source: The author.

for human resources and US $5 million for urban design interventions (Nippon Koei Co. et al., 1996a; Nippon Koei Co. et al., 1996b). These costs developed into significantly higher figures with the Second and Third Tourism Development Projects – the latter alone received US $70 million from the World Bank (Dalgamouni, 2010). Considering these costs vis-à-vis the actual tourist demand on al-Salt as a 'tourism product' on the one hand, and the needs of the local inhabitants on the other hand raise many questions. Firstly, the number of tourists to al-Salt remains minimal to this day, whereby according to the statistics of the Ministry of Tourism and Antiquities, only 1,574 visitors arrived at the Historic Old Salt Museum during 2009 and 2,424 visitors arrived during 2010 – an average of 4.3 and 6.6 visitors per day consecutively. Over half of the visitors in 2010 (56 per cent) were Jordanian visitors (Ministry of Tourism and Antiquities, 2009–10) who – according to one museum administrator who was interviewed in July 2011 – were school children from nearby towns who were bussed to the museum on school field trips. On average, the museum received 2.9 local and 3.7 foreign visitors per day in 2010 (Ministry of Tourism and Antiquities, 2009–10). These statistics certainly challenge the three projects' aspirations to transform al-Salt into a tourism product en par with the major attractions in Jordan, let alone into a revenue-generating initiative for al-Salt. Weighing the costs and the modest aspiration to attract '30 local and 20 foreign tourists per day' (United States Agency for International Development, 2007; Luck, 2009), then the current figures are indeed disappointing. Surely, local newspapers reported that the Third Tourism Development Project had 'been listed as "unsatisfactory" by the World Bank' (Dalgamouni, 2010). Also, during conversations with the local inhabitants in 2011, they questioned the rationale behind prioritizing the expenditure of tens of millions of dollars for what they considered to be surface treatments that supposedly catered to potential tourists who might – or might not – one day materialize. Simultaneously, these inhabitants asserted that these projects had disregarded their fundamental physical, socio-cultural, political-economic and ecological needs. Not surprisingly then, some of the youth in al-Salt vented their frustrations against these exuberantly costly projects through vandalizing the light posts and street furniture installed by these projects (Plate 29).

Plate 29 Vandalism and littering along the *'aqabāt* of al-Salt
Source: The author.

Acre: a Shift in Planning Strategies?

Old Acre Development Company, functioning under the auspices of the Ministry of Tourism in Israel, declared early on that its primary goal was to 'develop the Old City and make it an international tourist city' (Old Acre Development Company, 2013). With tourism as its primary goal, it sought since its founding in 1967 to implement similar policies to those adopted by Old Jaffa Development Company.[17] The latter's plan for Old Jaffa 'stipulated that the only people entitled to live in the area are artists' (Old Jaffa Development Company, 2014). Thus it transformed Jaffa into a 'museum city' through transferring its predominantly Palestinian Arab and poor population and by replacing its residential functions with tourist attractions and services like galleries, museums, hotels, souvenir shops, cafés and restaurants. One of Acre's planners mocked Old Jaffa's development by dubbing it 'a plastic fantastic' (interview on 10 January 2006). Old Acre Development Company also prioritized archaeological excavations in order to unearth more of the Crusader city underneath the Ottoman one (Kesten, 1993: 6,8 and 9). Regarding the local Arab inhabitants as deterrents to its plans, Old Acre Development Company had, until the early 1990s, persistently attempted to transfer them to *al-Makr* (see Chapter 2). One of the planners recalled the reaction of these Palestinian Arab inhabitants: 'The moment you tell somebody that we want to relocate you, they will not agree', and reflected: 'In fact, I think it is offensive, and I don't think it is good' (interview on 10 January 2006). When architects Arie Rahamimoff and Saadia Mendel were entrusted in 1992 with proposing a comprehensive development plan, Old Acre Development Company specifically requested that these plans 'make Acre into a City of Tourism' (Kesten, 1993: 4), this time by diverting the tourists away from the various residential quarters of Acre, and by consequence from its Arab inhabitants, to the marina. One planner recalled:

> Old Acre Development Company, the Municipality of Acre, the Ministry of Interior and the Land Development Authority, together with the National Company for Tourism, approached Arie Rahamimoff and asked him to submit a proposal for the plan for the Old City of Acre. They worked together, and they wanted to prepare a plan for Acre basically from the point of view of tourism. [Their] point of view was mainly developing tourism.

17 The Old Jaffa Development Company was founded in 1960.

Basically, the way they viewed tourism in 1993 was to improve the waterfront and the marina (interview on 10 January 2006).

The findings of the documentation process in Acre, which depended on a triad of socio-economic, architectural and tourism studies (see Chapter 3) elicited unanticipated – yet positive – shifts in the tourism development project. In particular, the socio-economic surveys that revealed the strong place attachment and the dire housing needs among Acre's Arab inhabitants have informed the formation of new property ownership policies. These surveys also exposed the desire of Acre's inhabitants to be integrated in the development of tourism. The next sections address these findings and their impact on the new policies and intervention strategies.

Acre: The Conservation of the Life Within

The majority of Acre's Arab inhabitants are leasing their property from *'Amidār*[18] which, since 1953 has been administering the property on behalf of the Custodian of Absentee Property (see Chapter 2). By the early 1990s, decades of neglect by *'Amidār*, the Municipality of Acre and Old Acre Development Company, had led to the dilapidation of the majority of Acre's residences (Plate 30). The situation was exacerbated with the difficulties that Acre's Arab residents had faced in obtaining loans to purchase their property. A planner explicated:

> … we started to see that dozens of the houses were falling down and people were moving out. They were obliged to evacuate because they did not have the financial ability to restore and there was no authority to support [the restoration]. And even in the past ten or fifteen years, the [authorities] stopped the assistance: all the housing loans that used to help the Arabs to buy or restore the houses. The [authorities] stopped even those (interview on 6 January 2006).

Plate 30 A dilapidated residence in Acre
Source: The author.

18 Also known as the Israel National Housing Company for Immigrants, Ltd.

Only when the dilapidated residences were on the verge of collapse did Old Acre Development Company intervene through the Elimination of Danger Act that tackled only crucial structural repairs and required the tenants to pay 50 per cent of their costs. A planner from Old Acre Development Company explained:

> If the [inhabitants] want to have interior work they pay for it. And also lawfully, if there is a danger to the infrastructure of the house and you have to repair it, we ask the house owner and he has to pay on that section fifty-fifty, the charge is not being charged [as] 'ok if you cannot afford it [then] we won't do it'. We cannot afford such a measure because if the house will collapse on their heads, you have done nothing. We do the repairs and the [inhabitants'] fifty per cent is being paid through future payments [...]. And of course our money comes from *'Amidār* who pay us [sic]. It is not our private property, it is government property so we are only a means to do the work (interview on 25 December 2005).

Once the documentation revealed that solving the complicated property-ownership situation was pivotal for the successful implementation of any historic conservation and urban rehabilitation polices, *'Amidār* and Old Acre Development Company collaborated on devising new ownership policies according to which the local inhabitants were provided with long-term loans toward the rehabilitation of their property that they had been leasing from *'Amidār*. *'Amidār* would then transfer the property to these individuals upon the repayment of these loans. One senior planner explained:

> Because Acre was abandoned by its original dwellers, all the houses, all the properties went to the government. Now the government has leased the houses to dwellers [...] they pay only sixty per cent, and forty per cent is [paid by] the government. Now, we are in the midst of a process to sell the houses to the dwellers. From the forty per cent they have to pay only fifty per cent to be the owners of the houses (interview on 29 December 2005).

The implementation of this new ownership policy began with a pilot project in Block 10, which is an administrative unit located at the north-eastern corner of Acre along *HaHagana* Street – known among the locals as *al-Fākhūra*. The gradual implementation in this pilot project began on a case-by-case basis and represented a first step toward urban rehabilitation that meets the housing needs while simultaneously solves the ownership complications. The inhabitants of *Fākhūra* confirmed the implementation of these new policies – although one commented that 'it will take me two lifetimes to pay my loan'. Others wanted the policy to account for the rent that they had already paid over the past decades. A planner echoed these sentiments:

> The Arabs whose houses are being repaired, they thought that their houses will be repaired, but they do not have any money to pay for it. They have been paying for fifty years now, so why don't [the authorities] take that into account? [...] [Why not] consider those fifty years of paying by converting their houses to humane places for living? Seriously, people do not have the money to pay, not that they have the money and do not want to [pay] (interview on 6 January 2006).

Another planner[19] was sceptical about the legality of the new policy:

> *'Amidār* is in a difficult position because it is managing the property of those who are absent – who left in 1948. So in reality it is not the owner of the property, but a manager of it. So now it is in a dilemma that it has no authority to resell those houses, but in reality should give them back to the refugees, who are in the West Bank and all over the Arab world, particularly in Jordan, Syria and Lebanon (interview on 26 December 2005).

19 Before making this statement, this planner requested that the recording device be turned off but allowed note-taking.

Acre: the Conservation of the Townscape

The historic conservation policies in Acre were influenced by the documentation methods and their findings and corresponded to the four levels of architectural significance that *'Atiqot* had identified (see Chapter 3). Accordingly, Level A represented the most significant structures whose authentic state the new policies sought to conserve. Level B included all the archaeological buildings and ruins predating AD 1700, which fell under *'Atiqot*'s auspices, hence the antiquities laws regulated their conservation. Level C referred to the mostly residential and commercial buildings whose exterior façades were considered significant, thus the new building regulations preserved their structural integrity and exterior façades (Plate 31). Level D encompassed all the remaining buildings in Acre, whose significance was considered minimal, nevertheless the new building regulations acknowledged their compositional significance to Acre's townscape (Plate 32). Therefore, while the regulations allowed more leeway in modifying Level D properties, they simultaneously established design guidelines that would maintain their compositional contribution to the townscape of Old Acre.

Plate 31 A level C house in Acre where the façade is significant
Source: The author.

The analysis of the visual documentation also led to typological classifications akin to Alexander's patterns (Alexander et al., 1977). For example these classifications included – among many others – all the types of windows, doors, ceilings and metalwork as well as the building typologies – that is, building footprints, building heights and building masses. The planners explained how these typological classifications led to building guidelines and design manuals that described the appropriate construction and conservation techniques (also see Cohen et al., 2000). Collectively, the building guidelines and the design manuals

Plate 32 A level D housing complex in Acre where the composition is significant
Source: The author.

facilitated the rehabilitation of existing structures and the contextualization of new ones while retaining Acre's townscape and serial vision (Cullen, 1971) (Plates 33 and 34). Copies of these manuals and guidelines were kept at the offices of Old Acre Development Company inside Acre although during informal discussions with the local inhabitants, they seemed unaware of their presence.

The rehabilitation of the individual buildings proceeded in tandem with the urban rehabilitation of Acre, especially the rehabilitation of the physical infrastructure which was seen as important for extending the lifespan of the historic fabric and for deterring further deterioration. A senior planner shared that 'More than ninety five per cent of the old wet and dry infrastructure was changed in the city and we hope within the next six months to finish all the infrastructure' (interview on 29 December 2005). Another elaborated on the complexity of infrastructure rehabilitation in Acre: 'Wherever you dig in the Old City, whenever you turn out the street just to put canalization, you have underneath archaeological facts [sic], so you have to stop the work and everything has to be monitored, and so on, and so on' (interview on 25 December 2005).

Simultaneously, urban design interventions in the public realm included repaving all Acre's paths and alleyways using the local stone but with improvements, such as for channelling rainwater (Plate 35). The urban design interventions also included the practical components such as signage, street furniture and garbage collection bins among others, as well as the creative ones such as the adaptive reuse of the historic moat or *khandaq* in the northern edge of the city as a sports field (Plate 36).

Acre: the Development of Tourism

The tourism surveys offered insights on tourism activities and on the spatial distribution of tourists in Acre, hence led to policies and plans for product development, visitor management and tourism services. In terms of product development, the data revealed which attractions warranted de-marketing due to the large tourists' numbers and which required further marketing to place them on the tourist map. The plan also recommended further archaeological excavations in order to reveal more of the Crusader city; for example, *'Atiqot*'s archaeologists took me on a tour of Crusader tunnels that later became among the new tourist attractions in Acre (Plate 37).

Place-making Strategies

Plate 33 Illegal additions to the residences in Acre
Source: Khirfan 2010a.

Plate 34 Legal additions to the residences in Acre following the new design guidelines
Source: Khirfan 2010a.

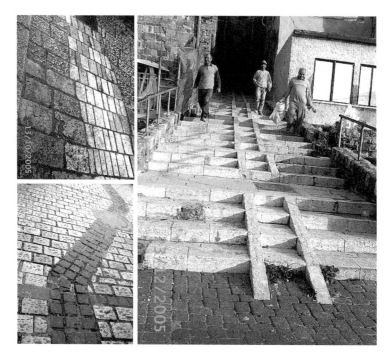

Plate 35 **New street pavements in Acre**
Source: The author.

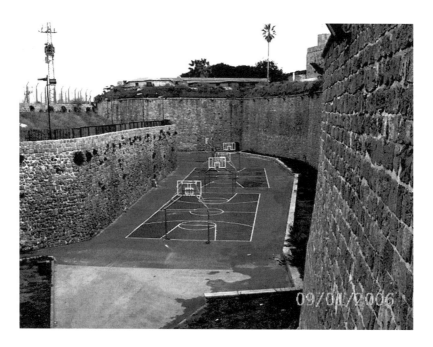

Plate 36 **The moat or *khandaq* in Acre had been adapted into a sports field for the local community**
Source: The author.

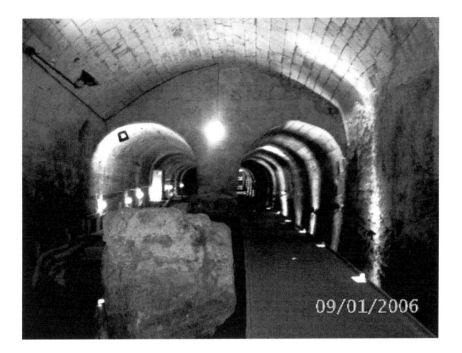

Plate 37 The Templar tunnel in Acre
Source: The author.

In addition, the data on the movement patterns and the spatial distribution of the tourists informed the derivation of new visitor management and land use policies. The latter confined tourism activities around the attractions and diverted them from the residential quarters so as to protect these quarters' privacy and to shield them from tourism gentrification. Simultaneously, the visitor management strategies included two drop-off areas and two sets of trails that ran north–south and east–west. A northern drop-off area by the Citadel led to a walking tour through the *khānāt*, *sūq* and *aswār*, and another drop-off area by the lighthouse at the south-west edge led to walking tours that ran east–west (Figure 4.3). These trails highlighted the major attractions and brought the tourists to the *sūq* (Plate 38), the harbour and the *aswār*[20] where they could contribute to the local economy. By passing by, but not traversing the residential quarters, the trails offered the tourists a glimpse of the life within Acre while respecting the privacy of the local inhabitants.

Furthermore, the data revealed that while Acre ranked second to Jerusalem in attracting foreign tourists, these tourists were day-trippers; in other words, their visits to Acre were limited to a day's excursion. Accordingly, Old Acre Development Company pursued an aggressive marketing strategy to promote Acre nationally and internationally. This marketing strategy focused on the Crusader history and avoided tackling Acre's image in the popular media as a city rampart with violence, substance abuse and unemployment: 'The beautiful, historic city has in recent years become a hotbed of poverty, crime, and narcotics. The number of drug addicts has grown to about 800 in a population estimated at about 7,000. It is a magnet of drug dealing for the entire north' (Galili and Nir, 2001: 99).

The development of tourism services posed challenges for the protection of Acre's townscape. A planner shared how 'we were afraid of big hotels. We thought they were inappropriate' (interview on 10 January 2006), while another cautioned 'when we are talking about big projects we have to be careful, because there is no space in Acre for big projects' (interview on 10 January 2006). Several planners relayed that lengthy debates took place with the economic advisor, who was pushing for larger hotels and for additional hotel rooms. Eventually, the tourism development plans proposed the creation of 1,000 hotel rooms albeit dispersed over

20 Several locally owned restaurants were located inside Acre's walls or *aswār*.

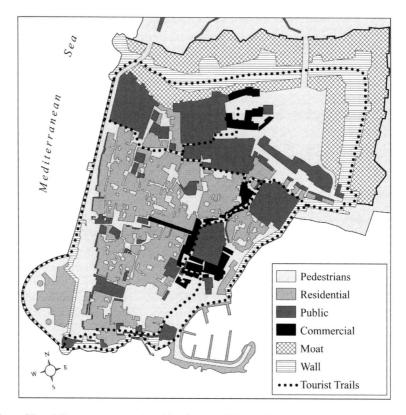

Figure 4.3 The visitor management and land use policies in Acre
Source: Khirfan 2010a.

a multitude of small-scale forms instead of a few large-scale structures. Accordingly, the plans recommended the conservation and the adaptive reuse of three historic structures as medium-sized hotels, two of which were *khānāt* and the other was the lighthouse or *manāra* that would have collectively provided 160 hotel rooms. One of the planners shared the challenges pertaining to adapting such historic buildings, especially in world heritage cities:

> We recommended three hotels […] *Khān al-'Umdān* and *Khān al-Shūna*, the two khans together, this is the second one. And the third was going to be in the Laguna next to the lighthouse [… which] was by now suspended, because UNESCO did not [approve …] the Antiquities Authority changed its mind and UNESCO also did not like [the idea] (interview on 10 January 2006).

The plan also recommended the rehabilitation of some of the larger mansions in Acre to serve as smaller hotels and pensions while additional hotel rooms would be housed in some of the ordinary residences in a traditional interpretation of the bed and breakfast services through what the planners dubbed *ḍiyāfe* – Arabic for hospitality. One senior planner explained that these *ḍiyāfe* sought to integrate the local inhabitants in the development of tourism: 'we thought that tourism is very important for the environment, and if we want to get the population to support our efforts there should be a viable income for them as well' (interview on 10 January 2006). This approach, therefore, appreciated the 'cultural, human, and historic value of the city' (Rahamimoff, 1997: 14) and marked the onset of a positive shift toward including Acre's Arab inhabitants in its unique selling preposition. Certainly, one of the initiatives that targeted the national market and promoted

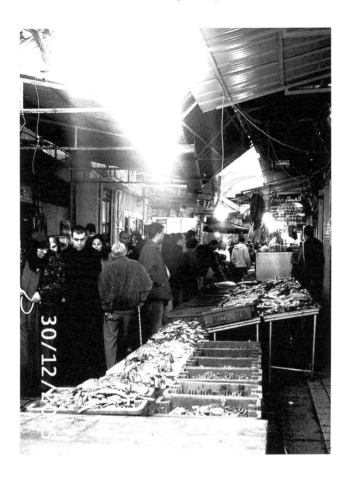

Plate 38 **A fresh fish shop in Acre's** *sūq*
Source: The author.

cross-cultural understanding between the Arab and the Jewish citizens of Israel was known as *Shukran*[21] in a play on words in Arabic, Hebrew and English. *Shukran* means thank you in Arabic, but also if written '*shūk run*' it mixes Hebrew and English and translates to: running through the market. This initiative brought Jewish Israeli families on Saturdays inside the homes of Arab families in Acre for a taste of Arab culture through gastronomy, handicrafts and arts (Plate 39). Some researchers have been critical of such initiatives claiming that their combination with historic conservation not only commodified the Palestinian Arabs for tourism consumption but, also, were part of a larger spatial fixing process of the Palestinian Arabs that occurred within Israel during the 1990s that presented them as one of several Israeli interiors (Stein, 1995).

From Documentation and Value Assessments to Place-making Strategies

The discussion in this chapter focused on the place-making strategies that ensue from the documentation and the value assessments of cultural heritage. Theoretically, the discussion traced the evolution of the conservation paradigm from an emphasis on monuments to one that currently addresses the historic urban landscape (Veldpaus et al., 2013). Simultaneously, the intervention – that is, place-making – strategies evolved

21 This initiative was funded by the Jewish Agency for Israel and took place the Western Galilee Consortium.

Plate 39 *Shukran*, or *shūk run*, **at *Emm Mḥammad*'s home in Acre**
Source: The author.

from only restoration that prioritized the visual experience of cultural heritage to a gradient of five procedures that supposedly now account for the values and the significance of this cultural heritage. These evolutions prompted a paradigm shift that morphed the authorized heritage discourse into one that equally accounts for the physical and visual; the morphological and spatial; and the socio-cultural and economic aspects of the historic urban landscape, while concurrently endorsing change as an inherent morphological quality of such a landscape. Practically, however, the place-making strategies in the historic urban landscapes of Aleppo, al-Salt and Acre presented tensions between these three components – tensions that resembled those that arose from the documentation and the value assessments (see the last section in Chapter 3). In particular, tensions that pertained to architectural conservation versus urban rehabilitation arose and entailed implications on the perception of continuity in the historic urban landscape versus freezing this landscape in a particular timeframe. In the same vein, tourism development presented tensions vis-à-vis urban rehabilitation and the needs of the local inhabitants.

In the first place, Aleppo's stringent architectural conservation legislation underscored the physical authenticity of individual structures and overlooked the historically symbiotic association between the local inhabitants and their urban landscape. Such an association entailed change and adaptation whereby the local inhabitants adapted their urban landscape to suit their continuously evolving lives. By reversing this relationship, the building regulations in Aleppo sought to freeze the historic urban landscape in a static snapshot that failed to account for a fundamental morphological characteristic, namely, change. This failure contradicted the spatial documentation of Aleppo's town-plan but concurrently resulted from overlooking, in particular, one of the morphological elements of its physiognomy: the three-dimensional form of the buildings. Surely, the documentation in Aleppo considered the land and building uses but the approach to this documentation was to register the existing conditions rather than to investigate the rationale behind them. Not surprisingly then, the ensuing place-making policies were oblivious to the significance of these mixed land uses, hence proposed to eliminate them (Figure 4.1). The weak documentation in al-Salt yielded a cosmetic place-making strategy whose superficial interventions failed to address the fundamental architectural conservation and urban rehabilitation needs of the historic urban landscape and its inhabitants. The imposition of visual order in both Aleppo and al-Salt, through the standardization of shop façades and signage, catalysed homogenization: such imposed order

was certainly not justified through sound documentation but instead assumed that international – specifically Western – tourists preferred this visual order. The discussion in Chapter 6 on place experience will refute these assumptions based on empirical data, but suffice it to mention here that these assumptions represented an extension of colonial era perceptions of these Middle Eastern historic cities as unorganized (Mitchell, 1991). Conversely, Acre's place-making strategies combined both architectural conservation and urban rehabilitation but, most importantly, these strategies ensued directly from the documentation and the value assessments. Instead of freezing Acre's historic landscape at one point in history, these strategies accounted for change and evolution by providing choices for contemporary intervention that were grounded in the levels of significance, in the building typologies and in the classifications of architectural and urban elements.

Furthermore, the development of tourism in Aleppo, al-Salt and Acre presented tensions vis-à-vis urban rehabilitation and the needs of the local inhabitants. Such tensions manifested in the three-way relationship between the needs of the historic urban landscape, the needs of the local inhabitants and the needs of the tourism industry[22] (Middleton and Hawkins, 1998). The place-making strategies in Aleppo sought to contain rather than embrace tourism while in al-Salt they sought to impose tourism. The reactionary approach toward tourism development in Aleppo's place-making strategies failed to contain tourism, and instead countered the original objective of preserving the residential function by instigating a private-sector-led tourism gentrification process that coerced Aleppo's inhabitants into abandoning their historic neighbourhoods. Not only were the place-making strategies in Aleppo oblivious of tourism's strong presence in the Old City, but they were also exclusionary of the needs of the local inhabitants who saw tourism's potential for local economic development as will be revealed in Chapter 5. Conversely, al-Salt's place-making strategies sought to impose tourism against the needs and preferences of the local inhabitants and oftentimes against the integrity of the conservation of the historic urban landscape through cosmetic and irreversible treatments. In addition, the exuberantly high costs of such cosmetic treatments in al-Salt challenged their justification with respect to the fundamental needs of the local inhabitants, especially relating to housing, social infrastructure and local economic development. Here again, Acre's place-making strategies, grounded in sound documentation, balanced the urban rehabilitation needs with the needs for tourism development. Simultaneously, these strategies maintained Acre's residential function and integrated its inhabitants in the development of tourism. The discussion of public participation in Chapter 5 will delve further into the local needs and their integration in the place-making processes.

22 This three-way relationship was first identified by the English Tourist Board which changed in 1999 to the English Tourism Council. The latter changed in 2009 to VisitEngland.

Chapter 5
Public Participation in World Heritage Planning: From Evolution to Implementation

Paul Davidoff's 1965 landmark article 'Advocacy and Pluralism in Planning' (Davidoff, 1965) ignited the debate in urban planning on inclusiveness, public engagement and participation (Checkoway, 1994). The discussion in this chapter traces the evolution of inclusive and participatory planning through a longitudinal content analysis of the documents and doctrinal texts on world heritage and then, more generally, on heritage planning. The analysis juxtaposes the development of inclusive and participatory heritage planning in these documents against their development and applications in the field of urban planning. The analyses reveal that UNESCO's documents, ICOMOS' charters and other doctrinal texts on world heritage have significantly lagged behind urban planning theories and practices when it comes to introducing and operationalizing inclusive and participatory measures. These analyses are then linked to the specifics of Aleppo, al-Salt and Acre.

Public Engagement and Participation in the Planning Literature

When Paul Davidoff introduced his theory of advocacy planning (Davidoff, 1965), he did not explicitly call for the active participation of the local communities that are affected by the planning decisions, but he urged the professional planner to become an advocate who represents the interests of constituencies. Davidoff also emphasized the need to provide choices and transparency: 'great care must be taken [so] that choices remain in the area of public view and participation' (Davidoff, 1965: 332). Inspired by marketing tactics, David Godschalk and William Mills (1966) introduced their collaborative planning theory that drew on the idea of marketing experts as 'skilled counsellors' who help consumers define their desires and who work 'with rather than for' the various sub-communities (Godschalk and Mills, 1966: 86). Unlike advocacy planning, collaborative planning underscored the representation of the needs and interests of the stakeholders rather than the representation of the constituencies themselves (Godschalk and Mills, 1966). Collaborative planning thus shifted the emphasis from 'who is representing' to 'what is being represented'. Accordingly, the representation of the various sub-communities occurs either through the election of representatives or through direct self-representation, such as during public meetings. In contrast to these views, Edmund Burke (1968) considered the needs and objectives of the planning organization as the point of departure for any participatory planning process. Citizen participation, according to Burke, entailed five strategies, beginning with the education-therapy of constituencies in order to promote their self-confidence and self-reliance. This strategy of behavioural change supposedly induced change among select individuals who would then influence the behaviour of their own respective groups. The selection of skilled volunteers from the constituencies would also serve as a strategy to supplement the staff of the planning organization, which, in particular cases, might be elevated to cooptation so as to 'prevent anticipated obstructionism' (Burke, 1968: 291). Lastly, the planning organization could utilize the strategy of community power by identifying influential individuals or groups who, in turn, would exercise their will 'over the opposition of others' in order to achieve the objectives of the planning organization (Ibid.).

A major shift occurred during 1969 with the publication, in the *Journal of the American Institute of Planners*, of Sherry Arnstein's 'A Ladder of Citizen Participation'. Arnstein (1969) defined three primary levels of participation, namely, non-participation, tokenism and citizen power. Non-participation occurs when planners use manipulation and therapy tactics to appease their constituencies while tokenism results when planners seek merely to inform, consult or placate constituencies. Citizen empowerment occurs only when the planners create genuine partnerships with their constituencies, delegate power to them and/or allow them to assume control over the planning process (Arnstein, 1969). As the debates on engagement and participation evolved

over the subsequent decades, Arnstein's theoretical concepts developed into operational tools that became institutionalized within the planning process. Yet, it was John Friedmann's (1993) distinction between the expert and the experiential knowledge that re-established the significance of participatory planning. According to Friedmann, although planners possess the expert knowledge, it is the constituencies' 'uncodified knowledge' of their living conditions, or what Friedmann dubs the 'experiential knowledge', that complements and enhances the expert knowledge, hence it is rendered indispensable to the planning process (Friedmann, 1993: 484).

What these discussions had implied, but failed to directly address, were the temporal relationships between public participation and engagement on the one hand, and the planning and implementation processes on the other. Thus it was not until Nabeel Hamdi and Reinhard Goethert (1997) introduced this notion of 'timing' in their five-stage model that these relationships received the attention in the planning discipline. The initiation stage marks the beginning of the process when the problems and needs are identified and the basic goals, objectives and scope are defined. This is followed by the planning stage that determines specific activities, such as the budget. Then the design stage involves the development of the technical details, while the implementation stage witnesses the execution of the various aspects of the plan. The process ends with the maintenance stage, which entails the long-term maintenance of the activities initiated during the implementation stage (Hamdi and Goethert, 1997: 72). Although participation supposedly occurs throughout all these stages, Hamdi and Goethert observed that, typically, participation manifests strongly during the initiation and planning stages, but tapers off to occur rather indirectly during the design and implementation stages and even non-formally during the maintenance stage (Ibid.: 72). Accordingly, they proposed a participation model that elicited shared control between the planners and the constituencies whereby the latter assume full control of the planning process at the initiation stage, shared control at the planning stage and either shared control or consultative involvement at the design, implementation and maintenance stages (Hamdi and Goethert, 1997: 72). Indeed, today's notions of inclusiveness, engagement and involvement have become the norm in the planning practice. But how have these notions evolved in the debates on planning for sites on the World Heritage List?

Public Participation in World Heritage Planning

UNESCO and ICOMOS have been instrumental in the development of conservation principles and planning guidelines for heritage in general, and for World Heritage Sites in particular. In its capacity as an advisory body for UNESCO, ICOMOS was employed to operationalize the Convention following its adoption – an arrangement that yielded a series of operational guidelines (see Chapter 2). Along with its advisory role on world heritage, ICOMOS has been actively engaged in the regulation of heritage resource management worldwide through its international charters and the doctrinal texts of other international organizations that ICOMOS endorsed (ICOMOS, 2011a). The discussion in this chapter analyses the content of these documents in order to investigate the evolution of the concepts of inclusiveness, public engagement and participatory planning in them.

Public Participation and World Heritage: The Convention and the Operational Guidelines

The 1972 Convention *emphasized* international cooperation in the protection and management of World Heritage Sites. This emphasis on the international perspective came at the expense of the local one. Indeed, absent from the Convention is the voice of the local communities at World Heritage Sites except when recommended that such sites must become part of the daily lives of their local communities: 'to adopt a general policy which aims to give the cultural and natural heritage a function in the life of the community and to integrate the protection of that heritage into comprehensive planning programmes' (UNESCO, 1972: Article 5.a).

The first five revisions of the operational guidelines between 1977 and 1984 made no reference to the local communities in planning for World Heritage Sites. In 1987, the sixth revision recommended 'informing' the local inhabitants about the conservation and protection decisions and, also, recommended 'Informed awareness on the part of the population concerned, without whose active participation any conservation scheme would be impractical, is also essential' (UNESCO, 1987: Article C.31). Interestingly, the 1988 revision included a

new article that actually recommended withholding information about the nomination of any property from the public:

> In all cases so as to maintain the objectivity of the evaluation process and to avoid possible embarrassment to those concerned, States Parties should refrain from giving undue publicity to the fact that a property has been nominated for inscription pending the final decision of the Committee on the nomination in question (UNESCO, 1988: Article B.14).

These articles remained in the 1992 revision (UNESCO, 1992: Article B.14). A small yet significant breakthrough for local engagement in the world heritage documents occurred in 1994 when, in addition to the need for 'informed awareness' (UNESCO, 1994: Article C.34), the revised operational guidelines also called for the 'participation' of 'local people' during the primary phase of the nomination to the World Heritage List by stating that the 'Participation of local people in the nomination process is essential to make them feel a shared responsibility with the State Party in the maintenance of the site' (UNESCO, 1994: Article B.14). Another article further emphasized participation by stating that 'The nominations should be prepared in collaboration with and the full approval of local communities' (UNESCO, 1994: Article C.41). Thus, by including the term 'participation' and by replacing the phrase 'concerned populations' with the more inclusive 'local communities', the 1994 operational guidelines shifted toward inclusiveness.

Henceforth, the concepts of participation and engagement appeared more saliently in the operational guidelines. For example, the 1995 revision stated that the 'Participation of local people in the nomination process is essential' (UNESCO, 1995: Article A.2.1). It seems, however, that rather than incorporating the local perspective in the decision-making process, the rationale guiding this change was driven by the desire to allow the local inhabitants to 'feel a shared responsibility with the State Party in the maintenance of the site' (UNESCO, 1995: Article A.2.1). This is further confirmed by the recurring caveat that participation 'should not prejudice future decision-making by the Committee' (Ibid., UNESCO, 1994: Article B14).

The 2005 revision of the operational guidelines marked a major turning point when, for the first time, they introduced the need for participatory planning throughout the management process: 'Partners in the protection and conservation of World Heritage can be those individuals and other stakeholders, especially local communities, governmental, nongovernmental and private organizations and owners who have an interest and involvement in the conservation and management of a World Heritage property' (UNESCO, 2005a: Article I.I.40). Indeed, these 2005 operational guidelines took significant steps forward by referring to the participation of the local communities in several articles. Subsequent revisions of the operational guidelines in 2008, 2011 and 2013 preserved these inclusive and participatory concepts.

Public Participation in ICOMOS Charters and Doctrinal Texts

The first mention of participation in any of ICOMOS' charters appeared for the first time only in the 1987 Washington Charter which emphasized the participation of the inhabitants of historic towns as key for the success of conservation programs (ICOMOS, 1987: Articles 3 and 15). This charter, which coincided with the 1987 operational guidelines that called for merely 'informing' the local inhabitants about the conservation and protection decisions for World Heritage Sites (UNESCO, 1987: Article C-31), had proposed the need for 'a general information program' – one that ensures the involvement of the general public – including school children – in all the aspects of heritage planning (ICOMOS, 1987: Articles 3 and 15). Following that, the Charter for the Protection and Management of the Archaeological Heritage Sites was adopted in 1990 and explicitly recognized that the 'Active participation by the general public must form part of policies for the protection of the archaeological heritage' (ICOMOS, 1990: Article 2). This charter also stressed that the 'Local commitment and participation should be actively sought and encouraged [by heritage planners]' (ICOMOS, 1990: Article 6), and considered this engagement vital, especially during the later stages of heritage planning (Ibid.). This charter also asserted that local participation becomes 'especially important when dealing with the heritage of indigenous peoples or local cultural groups', and went further to actually empower these groups by stating that 'In some cases it may be appropriate to entrust responsibility for the protection and management of sites and monuments to indigenous peoples' (ICOMOS, 1990: Article 6). In 19999, nearly a decade later, ICOMOS International

Cultural Tourism Charter (ICOMOS, 1999a) endorsed collaborative planning through 'the involvement and co-operation of local and/or indigenous community representatives' in the planning process. Such representation would serve the need to 'achieve a sustainable tourism industry', and to 'enhance the protection of heritage resources for future generations' (Ibid.). This charter further recommended involving the 'host communities and indigenous people' in the management of heritage tourism, especially in the cases of 'conflicting interests, responsibilities, and obligations' (ICOMOS, 1999a).

Although the subsequent charters addressed the technical aspects of cultural heritage (such as structures, timbers and wall paintings) some, including the 1999 ICOMOS Charter on the Built Vernacular Heritage, nonetheless underscored community involvement in the protection and conservation of vernacular heritage (ICOMOS, 1999b). Some of the more recent ICOMOS charters further emphasized local engagement; for example, the 2008 ICOMOS Charter on the Interpretation and Presentation of Cultural Heritage Sites alluded to public participation by referring to 'inclusiveness' (ICOMOS, 2008a: Article 6). But there have been other charters that have specifically referred to participation, including the 2008 Charter on Cultural Routes (ICOMOS, 2008b); the 2011 joint ICOMOS-TICCHI[1] Charter on the Principles for the Conservation of Industrial Heritage Sites, Structures, Areas and Landscapes – also known as the Dublin Principles (ICOMOS, 2011b); and the 2011 Valetta Principles for the Safeguarding and Management of Historic Cities, Towns and Urban Areas (ICOMOS, 2011c).

Interestingly, a review of the other doctrinal texts – that is, resolutions and declarations – reveals that several of these had pondered the inclusion of local communities in the conservation and protection of cultural heritage. The earliest occurrence dates back to 1975, when the General Assembly of ICOMOS endorsed a set of resolutions that emerged from the International Symposium on the Conservation of Smaller Historic Towns. While these resolutions gave credit to local conservation initiatives, they simultaneously claimed that 'The problems of urban conservation are, however, growing too complex for private action and purely local initiative'. Therefore these resolutions advocated for national and regional policies 'The future must see stronger and more comprehensive national and regional legislation to encourage the conservation of smaller historic towns, and to protect them from the threat of property speculation' (ICOMOS, 1975: Article 6). A more positive shift however occurred in the 1982 Tlaxcala Declaration on the Revitalization of Small Settlements, which prioritized the input of the inhabitants of such settlements and even went as far as advocating their empowerment by stating that they must 'have a right to share in the making of decisions on the conservation of their town or village and to take part directly in the work of carrying them out' (ICOMOS, 1982: Article 2.a). Unfortunately however, these steps toward more of a participatory and inclusive heritage planning approach subsided throughout the subsequent years. In the 1982 Declaration of Dresden and the 1983 Declaration of Rome, for example, there was hardly any mention of the local communities. But the subject of inclusion and participation resurfaced again – albeit briefly – in the 1993 Guidelines for Education and Training in the Conservation of Monuments, Ensembles and Sites. These guidelines stipulated that education and training should enable conservation professionals 'to work with inhabitants, administrators and planners to resolve conflicts and to develop conservation strategies appropriate to local needs, abilities and resources' (ICOMOS, 1993: Article 5.n).

The 1996 Declaration of San Antonio[2] criticized the 1994 Nara Document on Authenticity for excluding the local communities because it had only mentioned in the appendices the need for community consensus during the process of attributing heritage values (ICOMOS, 1994). Thus in its very first article, the Declaration of San Antonio underscored the temporal dimension of local engagement by stating that 'the concept of participation by the local community and stakeholders needs to be stronger than the [Nara] text implies' and that all the stakeholders should 'be involved in all processes from the beginning' (ICOMOS, 1996a: Article 1). This declaration explicitly criticized the Nara Document for 'identifying the stages for such involvement', which led to 'exclud[ing] the local community, for instance, from the identification process' (Ibid.). Concurrently, the 1996 Principles for the Recording of Monuments, Groups of Buildings and Sites also stressed the need to involve the local communities during the documentation stage of cultural heritage planning, given that this early stage influences the ensuing conservation decisions (ICOMOS, 1996b). This notion of 'involvement' developed further into active 'participation' in the 1998 Stockholm Declaration of ICOMOS marking the 50th

1 TICCIH is The International Committee for the Conservation of the Industrial Heritage.
2 The Declaration of San Antonio is also known as the InterAmerican Symposium on Authenticity in the Conservation and Management of the Cultural Heritage.

Anniversary of the Universal Declaration of Human Rights. This declaration stipulated 'The right [of the community] to participate in decisions affecting heritage and the cultural values it embodies' (ICOMOS, 1998). But it was not until a decade later that the 2008 Québec Declaration on the Preservation of the Spirit of Place harkened back to the earlier rhetoric of actually empowering the local communities:

> Given that local communities are generally in the best position to comprehend the spirit of place, especially in the case of traditional cultural groups, we maintain that they are also best equipped to safeguard it and should be intimately associated in all endeavours to preserve and transmit the spirit of place (ICOMOS, 2008c: Article 9).

The notion of inclusive heritage planning took hold in the 2010 Lima Declarations and the subsequent 2011 Paris Declaration. In its 'Background and Statements' section, the Lima Declaration advocated 'involv[ing] local communities in the preparation and implementation of risk management plans, and all stages of disaster recovery' (ICOMOS, 2010: Article 5). Also, in its 'Action and Recommendations' section, it recommended to 'Undertake awareness-raising initiatives to involve decision-makers and local communities in the development and implementation of disaster risk reduction strategies for cultural heritage' (ICOMOS, 2010: Article 1). This inclusive language became stronger in the 2011 Paris Declaration where one encounters a clear and consistent message about local involvement, participation and even empowerment in the decision-making processes of heritage planning. The Paris Declaration on Heritage as a Driver of Development seeks 'To involve all stakeholders in the creation of management plans' (ICOMOS, 2011d: Article 3). In an even more forceful language, this declaration sought 'To help local communities take ownership of their heritage', and through such ownership 'To encourage their empowerment and their participation in heritage conservation, in the planning process and in decision making' (ICOMOS, 2011d: Article 3). The Paris declaration went further to assert that 'Local participation, drawing on local perspectives, priorities and knowledge, is a pre-condition of sustainable tourism development' (Ibid.). Under the subheading dedicated for 'Promoting the Long Term Impacts of Heritage on Economic Development and Social Cohesion', the Paris declaration 'Place[s] people at the heart of policies and projects; emphasise[s] that ownership of heritage strengthens the social fabric and enhances social well-being; involve[s] local communities at a very early stage in development and enhancement proposals; raise[s] awareness, particularly among young people' (ICOMOS, 2011d: Article 4). The declaration ended with calls for capacity building among the stakeholders and underscored 'The role of local communities and raising stakeholder awareness' (Ibid.: Article 5).

In addition, several national ICOMOS committees drafted their own charters, principles and guidelines, some of which had addressed local engagement and public participation. Of particular note is ICOMOS Canada, whose 1982 Deschambault Declaration[3] and its 1983 Appleton Charter[4] had both incorporated a strong inclusive and participatory planning component. As early as 1982, the Deschambault Declaration had emphasized the significance of empowered local communities for the long-term sustainability of cultural heritage. In fact, this Deschambault Declaration revealed that:

> ... even before [the 1972 Cultural Properties] Act was passed, the community had organized itself into groups that differed in structure, but shared a common desire to become involved in safeguarding their environment and culture, and to develop strategies that would make the different levels of government aware of the issue (ICOMOS Canada, 1982).

The Deschambault Declaration also stipulated heritage as 'a possession of the community', one that 'invites our recognition and our participation' (Ibid.). This declaration consistently referred to citizen participation and empowerment – for instance, according to one article 'the public has a legitimate right to participate in any decision in regard to actions to preserve the national heritage' (ICOMOS Canada, 1982: Article VII). Similarly, the 1983 Appleton Charter stressed the need for establishing a 'legitimate consensus', which could only be achieved through 'public participation' (ICOMOS Canada, 1983: Article B). Indeed, no other national

3 The 1982 Deschambault Declaration is also known as the Charter for the Preservation of Quebec's Heritage.
4 The Appleton Charter is also known as: the Appleton Charter for the Protection and Enhancement of the Built Environment.

ICOMOS charters matched the degree of commitment to local engagement as in ICOMOS Canada's charters. In comparison, the tone of the widely acclaimed 1999 Burra Charter[5] seemed modest as it limited local participation in the assessment of cultural significance to 'Groups and individuals with associations with a place as well as those involved in its management' who 'should be provided with opportunities to contribute to and participate in understanding the cultural significance of the place' (Australia ICOMOS, 1999: Article 26.3). Beyond this initial stage, the Burra Charter gingerly admitted that 'Where appropriate they should also have opportunities to participate in its conservation and management' (Australia ICOMOS, 1999: Article 26.3). Researchers like Barry Rowney (2004: 110) criticized the Burra Charter for failing to examine socio-cultural or economic links to the local communities in great depth. Similarly, and although the 1987 First Brazilian Seminar about the Preservation and Revitalization of Historic Centers directly tackled inhabited historic centres, it nonetheless failed to even mention the subject of local engagement. Rather, the conservation experts were entrusted with paying 'special attention' to 'the permanence of residents and of traditional activities in urban historical sites' so long as such permanence and activities remained 'compatible with those sites' (ICOMOS Brazilian Committee, 1987: Article V).

As for the doctrinal texts, only two that were issued by the Council of Europe in 1975 mentioned the local communities. The 1975 Declaration of Amsterdam stipulated that 'Integrated conservation involves the responsibility of local authorities and calls for citizens' participation' (The Council of Europe, 1975a). But the subsequent paragraphs revealed that such participation was limited to 'informing' the local communities who would be 'given the facts necessary to understand the situation' in order to raise their awareness of the planning decisions (The Council of Europe, 1975a). The 1975 European Charter of Architectural Heritage is notable for how it attempted to transcend informing by engaging the local communities in the decision-making processes when it prescribed that 'The public should be properly informed because citizens are entitled to participate in decisions affecting their environment' (The Council of Europe, 1975b: Article 9).

The Participation Debate: From World Heritage to Urban Planning

Up until 1994, the Convention and the various revisions of the operational guidelines had actively sought to counter the inclusive and participatory notions through their emphasis on secrecy and exclusionary measures in order to avoid undue publicity about the nomination of any particular site for inscription on the World Heritage List. It was not until the 2005 revision that the operational guidelines fully embraced inclusive and participatory planning – nearly four decades after such concepts had been introduced in the urban planning debates. Similarly, with the exception of the 1982 Tlaxcala Declaration, which advocated the empowerment of the local communities, it took ICOMOS Charters more than 20 years to address inclusive and participatory planning. Interestingly, this delayed introduction of inclusive and participatory heritage planning in UNESCO's and ICOMOS' documents on world heritage contrasted with how these notions were introduced much earlier in the other doctrinal texts on heritage planning such as those of the Council of Europe (1975) and ICOMOS Canada (1982 and 1983) which had advocated for public participation and for local empowerment.

It is noteworthy to highlight that the debates on inclusiveness and participation in the urban planning literature have focused on three aspects, namely, the representation of local communities, the level of participation and the timing of public engagement. While timing was addressed in 1997 – relatively later in the urban planning literature – it seems that it was a key consideration in both UNESCO and the various ICOMOS documents on world heritage. The few mentions of local engagement in the operational guidelines during the 1990s specified that such involvement should occur during the early nomination phase of the cultural heritage for inscription on the World Heritage List. The 2005 revision of the operational guidelines represented a turning point since, for the first time, they recommended the participation of all the stakeholders in all the heritage planning and implementation phases. While significant, these more recent shifts in the world heritage debates on participation have yet to clearly address the three aspects of participatory planning: the representation of stakeholders, the level of participation and integration and the timing of engagement. In fact, in their discussion of participation and engagement in Aleppo's, al-Salt's and Acre's projects, the following sections argue that failure to provide better guidance for sites on the World Heritage List negatively influences the representation of the needs, interests and

5 The Burra Charter is also known as the Charter for Places of Cultural Significance.

choices of these sites' local communities and results in misconception of the appropriate levels of participation. These arguments parallel other empirical studies. Luisa de Marco's (2009) study of the Burra Charter and the Getty Conservation Institute's documents concluded that these documents had recommended stakeholders' involvement during the early stage of value assessment. In a similar vein, Neel Kamal Chapagain's (2007) study of heritage sites in Nepal concluded that international charters must 'recognize the active role of the local inhabitants in value assessment, decision making, and strategic planning of conservation' (Chapagain, 2007: 55). The following discussion investigates, firstly, the representation of the needs and interests of the local communities in the ongoing projects and by consequence evaluates the level of local integration in the tourism planning processes. Secondly, the discussion explores how the representation of the local identities manifested within the three historic urban landscapes vis-à-vis the three projects. Lastly, throughout the discussion the timing of participation and local engagement in the projects is also addressed.

Aleppo: Physical Rehabilitation or Social Integration?

The Project for the Rehabilitation of the Old City of Aleppo sought to preserve the residential function of Aleppo. The project's documents thus emphasized how it had stemmed from, and had sought to respond to, the needs of Aleppo's inhabitants (Windelberg et al., 2001). Some of the planners insisted during their interviews on the presence of a strong participatory component throughout the project's phases. But, discussions with the local inhabitants and, also, observations during the workshops and public meetings in Aleppo offered a different perspective – one that reflected a lack of genuine integration and an absence of participation.

To begin with, the accounts from the planners varied as to whether the notion of local integration enticed the contribution of, or that it responded to the pressure from, the German donors. According to one planner: 'the reason [this project] was included under German funding was primarily not because of the historic town but because of this participatory component in urban development' (interview on 9 June 2005). But according to another: 'In the beginning there was nothing called public participation in the project. It is the Germans. The Germans tried to feature this idea in the project. And the Syrians, as a result of the reactions of the inhabitants and the way they behaved with the project also noticed that this issue is very important' (interview on 1 June 2005). The latter scenario seemed more plausible given the hierarchy in the Syrian administrative system, which precludes public participation (also see Busquets, 2005).

In the early stages of the project, the planners identified three types of representation: primary, secondary and tertiary groups. The primary groups included the individuals who either lived or worked in Aleppo, while the secondary groups included those institutions or organizations that represented the primary groups. As for the tertiary groups, these included all the administrative bodies that might have been involved either in the planning or in the implementation of any of the aspects of the project in the designated Action Areas (Windelberg et al., 2001). The information obtained from the planners revealed that during the early years of the project, the planners experimented with different forms of participation for these different groups before settling on final formulae for each.

The planners relayed throughout their interviews that they sought to inform the primary groups about the project through various means, including house visits, surveys, public meetings, meetings with the local leaders and a printed brochure. It is noteworthy to mention that these planners shared how they were sensitive to the local culture hence held gender-specific meetings. Other initiatives with the primary groups included establishing a health unit that was founded as part of the project's deliverables in Aleppo that doubled as a field office for the project's planners where residents could also leave their comments and complaints. The Old City Directorate's offices were located inside the Old City of Aleppo in one of the adapted courtyard houses which placed it within reach of the local inhabitants. All these steps sought to dissolve the traditional barriers between the project's planners and the local inhabitants and to encourage the latter to voice their needs and opinions. In the words of one planner:

> After the first few meetings, [the local inhabitants] started to come to the meetings prepared with what they want […]. They became more prepared. Plus at the same time we made – in one of the Action Areas – a medical unit that offers services to them and which also had offices for the project where we received their suggestions.

So they no more entered this department as a centre for the Municipality, but entered it as an institution that offers them services. In addition to services, they also submitted complaints and that's how the process of interaction took place. And the truth is that this was very productive and effective and helped in that they began to support the ideas of the project (interview on 31 May 2005).

After the initial phase of experimentation, the planners decided that only two types of local engagement functioned efficiently: household surveys and subject-specific meetings. By using the term 'surveys', however, the planners were actually referring to architectural surveys of the physical attributes combined with basic census data that were inputted in the GIS database: 'The surveys were very general. We had a printed survey that we, the project's team, filled out, and which gave a general idea about the general nature of the area, that is the most prominent problems in the area, the most important keys, but in very general terms' (interview with a planner on 1 June 2005). The subject-specific meetings were held during the implementation phase only in response to specific complaints that the local inhabitants had. A planner explained how:

Public meetings have in a sense changed their content considerably from ones of sitting with a community to identify needs and have the community come to a collective understanding of their daily needs to focused meetings on particular subjects. And this seems to be the most positive and fruitful type of communication. The community has a problem with a particular feature of the project, the project organizes a public meeting, they discuss it, but it is very focused on that particular one issue. Almost everything else either failed or was stopped because it was being not too useful (interview on 9 June 2005).

Eventually, the engagement of the local inhabitants became limited to a selected group of representatives who were invited to meet with the project's 'high ranking decision makers' who might respond through 'ad hoc interventions' (Windelberg et al., 2001: 79). Observations confirm that local participation was indeed minimal; for example representatives of the local communities were conspicuously absent from workshops that were held at the Old City Directorate in June 2005 to discuss tourism development. Interestingly, the Development Plan claimed that the needs' assessments for the female and male residents of *Bāb Qinnasrīn* (Action Area – 1) had succeeded and used two criteria as bases for this judgement: the inhabitants' participation in the meetings and the realistic development goals that were formulated. In the same breath, however, the Development Plan admitted that 'Active Participation in planning is still not to be expected', and acknowledged that dialogue 'has not yet been established and seems to be idealistic for the near future' (Windelberg et al., 2001: 79). According to the Development Plan, these shortcomings were attributed to the planning methods that had been inherited from the French period which did not incorporate a participatory component (Windelberg et al., 2001: 79). Some planners however attributed this shortcoming to the project's emphasis on infrastructure. In reference to the participatory component, one planner admitted:

Unfortunately, the Syrian side was not quite willing to develop this particular component any further. And the overwhelming need for technical intervention at first. Providing the necessary infrastructure. Providing the necessary political guarantees that have to come with the investment of infrastructure. In a sense it was, and it still is a highly supply side development [that] caused many of the technicians of the project to see participation only in the most rudimentary (interview on 9 June 2005).

The interviews with the local inhabitants certainly confirmed this shortcoming. When asked about authority sharing in the planning process, a majority of Aleppo's inhabitants who participated in this study (79 per cent) did not think that they had participated in the project in any way. This indicated the limited empowerment of Aleppo's inhabitants in defining their shared experiences in the historic urban landscape. When probed, these participants' comments ranged between passivity, which they attributed to their trust in the planning authorities, to criticism of the technical aspects of the rehabilitation such as the new façade regulations that had been imposed on the shop owners. Furthermore, the majority of the study participants among Aleppo's inhabitants (91 per cent) did not believe that they could include their needs in the project. According to one of the planners, the project's heavy investment in the supply of infrastructure not only minimized the input of the local inhabitants in the planning and implementation processes, but also came at the expense of meeting their

socio-cultural and economic needs (personal interview on 9 June 2005). In fact, this project had provided only one kindergarten and the aforementioned health centre for the entire population of the Old City of Aleppo, which according to the planning documents exceeded 120,000 inhabitants (Windelberg et al., 2001). The local inhabitants shared their concerns about the conditions of the elementary schools in Aleppo, highlighting their inadequate supply and their mixed nature[6] – problematic for the conservative inhabitants of Aleppo, many of whom admitted that, because of this, they had prevented their daughters from going to school altogether. The local inhabitants also complained about the lack of nurseries, playgrounds for the children, clinics and health units, parks and recreational facilities, libraries and social centres for women, to name but a few. Notwithstanding these limitations, the majority of the study participants among Aleppo's inhabitants (76 per cent) believed that the project struck a balance between their needs and the needs of the international tourists. These study participants thought positively of the attention that the planning authorities were bestowing on their city. Also, the majority of the study participants (81.5 per cent) thought that the project balanced beautification and a genuine representation of their contemporary life.

As for the secondary groups, these included the institutions and organizations that represented the local inhabitants. According to the planning documents, these were limited to organizations that constituted part of the Ba'ath ruling party such as scout, youth, women, professional syndicates, neighbourhood and trade chambers in which all the positions 'are granted by appointment' with the exclusion of the trade chambers (Windelberg et al., 2001 78). These groups' engagement followed a similar pattern to that of the primary groups – in other words, it became limited to specific issues that arose during the implementation phase, such as when representatives from the trade unions mediated with the planning officials with regards to the implementation of the new regulations for the shop façades. Interestingly, the planning documents blamed these groups for their limited engagement, claiming that 'as participatory agents [they] are not yet using their full potential' (Windelberg et al., 2001: 79). But interviews and observations during a workshop in June 2005 that discussed the future of tourism in Aleppo revealed that the planners excluded the representatives of the local inhabitants although these discussions specifically considered the local inhabitants as part of the 'tourism product' (Plate 40).

Plate 40 **The notes made by the planners and the tourism entrepreneurs during a workshop specifically mentioned the local inhabitants as part of the tourism product**

Source: The author

6 As a secular party, the ruling Ba'ath Party had institutionalized gender-mixed elementary schools throughout Syria.

Moreover, and while poverty constitutes a major problem in Aleppo, the project's documents lacked any measures for local economic development. A planner shared that:

> ... there was something like a 'survey' that had a relation to the issue of women and their labour force, and it included some training and support [...] Some training took place so that [women] would be suitable to enter in some small income-generating projects (interview on 31 May 2005).

Actually, some of the proposed land use policies that relocated traditional crafts and industries like soap manufacturers and goldsmiths outside the Old City of Aleppo – simply because they were seen as unfitting to the historic fabric – would further decrease employment opportunities, disrupt the centuries-old economic structure and negatively impact Aleppo's status as an economic centre. Further, the genuine interest in tourism development among the local inhabitants and tourism entrepreneurs starkly contrasted with the reservations of the planners. During the aforementioned workshop in June 2005, a heated debate took place between the planning officials and the representatives of the Chamber of Tourism who demanded flexibility in licensing tourism businesses in Aleppo. A member of the Chamber of Tourism criticized the lack of local engagement and participation:

> But there should be a dialogue. The most important thing is that we should have a dialogue, that there exists a committee, a dialogue. And gather this neighbourhood around you [...] raise awareness among the people, invite them to lunch or to dinner and tell them that 'you are part of [Old Aleppo], you are part of us. We have come to you, but let's be a team'. This feeling does not exist [...] but without doubt you should involve them a bit. Of course you won't be able to involve all of them, I think this is a key thing that you actually come to residents and tell them 'we are not strangers, we never came to abuse the place. We came to work with you guys'. And I put forward a suggestion that we bring men and women to work with you. Women would be more difficult, but men, they would buy your vegetables and prepare it at their homes. Simple things that you invest their time and at the same time they receive financial returns and they feel that they are part of the job, part of the teamwork (interview on 7 June 2005).

From the outset, the project's planners foresaw that their interactions with the tertiary groups – that is, the administrative bodies involved in Aleppo – would witness the most intensive forms of participation, hence defined it as a 'sharing participation approach' (Windelberg et al., 2001: 15). The planning documents reflected an optimism that this level would experience the 'sole and most effective kind of participation' (Windelberg et al., 2001: 79) – indirectly admitting in the process that the project fell in the trap of the Syrian planning system that precluded bottom-up approaches. The planning documents, however, admitted that the engagement at this level became limited to 'selective participatory groups who are motivated to enter into a dialogue with the project' (Windelberg et al., 2001: 98). Observations and discussions with several planners also revealed that the key institutions that harboured perspectives different from those of the project's objectives were excluded from the planning process such as the Directorate of Tourism – the local arm of the Ministry of Tourism.

In general, the data revealed that three major obstacles had hindered the ability of the project's planners to fully seek and achieve local participation. Firstly, the Syrian governance system with its highly stratified and hierarchical structure deemed 'parity participation in public discourse simply not possible' (Busquets, 2005: 64). Secondly, the project's planners had to deal with the legacy of previous planning practices in Aleppo that were marred by neglect over decades and which cultivated mistrust among the local inhabitants toward government institutions in general and urban planners in particular. This history also triggered the suspicion and scepticism of the local inhabitants toward the project, which manifested in various ways, such as in refusing to participate in the surveys, but sometimes even more actively. One of the planners relayed that once the digging for the infrastructure rehabilitation commenced, 'the reactions of the local inhabitants were too extreme', admitting that it was due to the fact that 'they wake up in the morning and find a huge dig outside their houses and they didn't know when it will close'. Consequently, this planner shared how 'vandalism started; throwing garbage inside the digs started; and harassment of construction workers started' (interview on 1 June 2005). And, thirdly, it was the unbalanced emphasis of the project on the technical aspects of infrastructure at the expense

of local socio-economic and cultural needs that limited the possibilities of genuine local engagement in the planning process.

Therefore, local engagement in Aleppo mutated into one of four types – none of which extended beyond informing according to Arnstein's ladder of citizen participation. At the outset of the project during the documentation phase, the local inhabitants became a vital source of information about hitherto undocumented infrastructure in Aleppo which saved the planners time, effort and resources. One of the planners explained:

> The data was taken from the people living in the Old City [...] when we built the infrastructure specific map [...] it was related to the residents themselves and to the information that they are providing because they are the ones living in the Old City and know where the blockage happens and know where all the issues are [...]. And you are unable to build data, that is if you do not take this information from them, [it] will cost you much more time (interview on 1 June 2005).

Also, and in particular when it came to the secondary groups such as the Chamber of Commerce and the Chamber of Tourism, the engagement morphed into a tool for regulating the implementation process such as the new laws that required all the shop façades in *al-Jdēide* (AA-2) to comply with new design standards (Plate 18). Additionally, participation became ad hoc, based only on emergency situations during the implementation phase, whereby the local representatives advocated on behalf of their groups' interests. And lastly, participation – according to the planners – became synonymous with 'informing' by disseminating information about the implementation procedures. Surely, the contents of the planning documents confirmed this perception: 'participation in our context consists mainly of a proper information management on the practical measures directly affecting them' (Windelberg et al., 2001: 31). The planning documents actually justified this approach by falling back onto the Syrian governance system, according to which 'Participation for purposes of urban planning is currently fixed by law. Thereby, the plan is announced in the newspaper and opened to the public for one month at the City Hall. Basically, this is a process to inform the beneficiaries on the plan' (Windelberg et al., 2001: 78).

Al-Salt: Local Engagement in Hindsight

The nomenclature of the three Tourism Development Projects in al-Salt reflected these projects' priority, namely, tourism development. The initial JICA reports lacked any census data about the local inhabitants or any information about their needs or their socio-economic conditions. Only the following brief mention of al-Salt's inhabitants appeared in JICA's report: 'Community Considerations: The project will have a major effect on the community' (Nippon Koei Co. et al., 1996a: 46) without elaborating on the nature of this effect or how the then proposed project would counteract it. Indeed, when asked about authority sharing in the planning process and the extent to which they were empowered to define their shared experiences within the historic urban landscape, the majority of the study participants among al-Salt's inhabitants (81 per cent) did not think that they had participated in the project in any way.

In 2000, and at the outset of the implementation phase, JICA issued a new report, which added a new project objective: 'To serve for providing convenience to the tourists and people in Salt; and revitalizing community development and participation in Salt' (Pacific Consultants International and Yamashita Sekkei Inc., 2000: Article 1.2). No further elaboration on these participation methods was offered but the last chapter of this report included a list of 'particular issues' that the Jordanian counterparts were expected to solve. These included the coordination and agreement with the tenants who owned the shops in the *Abū Jāber* mansion, admitting that: 'The construction of the tourist trails, including restoration of Abu Jaber Building, cannot conduct [sic] without co-operation of the residents and shop owners for disturbance of their daily activities such as entry/exits, stopping the operation, etc. [sic]' (Pacific Consultants International and Yamashita Sekkei Inc., 2000: Article 9.1). Thus it was deemed necessary to inform the affected constituencies and obtaining their approval:

Because the sub-project situated in town center may cause socio-economic impacts to disturb or stop economic activities of the tenants/shop owners and disturb the daily life of residents as well as customer in/along/adjacent to the sub-project sites. It is essential to provide adequate notice and information on the development, and to obtain their acceptance in order to achieve a smooth implementation of the sub-project. It is also important to take it in consideration to co-ordinate with their daily activities and conveniences during the construction [sic] (Ibid.: Article 9.1).

Al-Salt's inhabitants, however, offered a contrasting perspective. The majority of the study participants among al-Salt's inhabitants (74 per cent) did not believe that they could include their needs in the project. These study participants criticized the exclusion of their needs and emphasized that the project sought to cater only for the needs of the tourists. They also criticized their exclusion from employment during the project's implementation.

Further, al-Salt's inhabitants observed the gradual marginalization of the role their city's municipality and by consequence their mayor, and their confidence in the project diminished in tandem with the extensive delays in the project's implementation. In 1998, at a later stage during the implementation phase, JICA eventually hired two sociology professors from the University of Jordan to conduct a survey with al-Salt's inhabitants. That survey solicited the opinions of al-Salt's inhabitants about JICA's project, tourism development in general, their perceived benefits from tourism development and their needs in particular. The findings of that survey revealed al-Salt's inhabitants' strong opposition to tourism development – starkly deviating from the planners' expectations. Probably those negative views explain why, of the 12 planners who were interviewed for the purposes of this research, only two had mentioned that sociological study, although all were specifically asked about any surveys that were conducted with the local inhabitants. A planner defiantly shared:

What ended up happening is that these two professors recruited students to talk to the local inhabitants and ask them 'do you want tourism or not' the questions were very naïve and very stupid and the result of the survey came out that [the local inhabitants] do not want tourism in al-Salt (interview on 10 May 2005).

Indeed, al-Salt's inhabitants opposed tourism development in their city. Their conservative nature dictated their reactions to local tourism development initiatives, such as with the *Qāqīsh* house (see Chapter 4). But they also expressed concerns about their city's capacity to accommodate the potential increase in tourists' numbers.

The extensive delays in the commencement of the project's implementation led to the circulation of rumours that the project would ever materialize. One of the planners relayed:

Frankly they [local inhabitants] were not convinced that the project will actually take place. Because if you want to trace back the history of the project it is ten years old, and the local inhabitants have been hearing for the past ten years about a Japanese project, a museum and the like. Up until a year ago if you talked to them their stance was 'talk as much as you want, because nothing will ever take place' (interview on 15 May 2005).

Moreover, the absence of communication exacerbated the rift between the planners and the local inhabitants. The latter consistently asserted that rumours constituted their only source of information about the project. In response to an inquiry about the museum in the *Abū Jāber* mansion, a resident replied: 'I didn't hear that they want to tell about the history of al-Salt. But now the rumours are that there will be a hotel there'. Others complained about the hiring of foreign construction workers – mostly Egyptians – during the construction instead of local inhabitants among whom unemployment was rampant.

By 2004, JICA's approach to its international initiatives had witnessed a shift toward the integration of the local communities in the planning initiatives. This shift impacted new and ongoing projects around the world, hence JICA published a 'Community Based Tourism Development'[7] report in 2004 (Ishimori et al., 2004). Consequently, the Japanese planners pressured their Jordanian counterparts to respond to this shift. One senior Jordanian planner, who insisted that hitherto there had not been any studies involving the local inhabitants –

7 This report responded to three of the then most recent JICA projects that focused on tourism development in areas of civil war, including Lebanon, the Kyrgyz Republic and Bosnia and Herzegovina.

either denying or ignoring the 1998 sociological surveys – admitted that 'we are planning to do a survey in al-Salt as the Japanese are requiring this' (interview on 10 May 2005). This same planner however explained that that these surveys, once held, would serve two purposes:

> We are trying to do [the survey] as a two way. That is to have some questionnaire for people to know about traffic circulation inside al-Salt, and to ask people about the Japanese project. We are intending to do it. It is not done yet.

Thus, the Jordanian planners contemplated introducing participatory measures in hindsight – after all the designs had been finalized, and over a year after the actual construction had already commenced. To this day, the Jordanian urban governance system lacks any policies that govern public participation and local integration in the planning process and, by consequence, faces a dearth of any relevant expertise. Therefore, the Ministry of Tourism and Antiquities, together with the Project Management Unit that it had assigned to foresee the implementation of al-Salt's three tourism development projects, hired a private company to engage al-Salt's inhabitants through public meetings dubbed *mushāwara* – Arabic for consultation. In an attempt to send a sign of goodwill to the local inhabitants, the private consultants invited the mayor of al-Salt to facilitate these *mushāwara* meetings. But given the limited involvement of the Greater Salt Municipality – and by consequence its mayor – in the project, the mayor's role relegated to merely informing al-Salt's inhabitants of the current construction activities. Thus although dubbed *mushāwara*, these meetings were far from consultative. A planner admitted:

> These general meetings introduced the project, and aimed to convince people about it but not to inquire with them about the project. In other words the meetings were 'we intend to convert this building, and make these trails, and these lookouts'. The meetings were not for consultation or the reception of the local inhabitants' ideas and suggestions, but the idea was an introduction to the project, and let's say, convincing the people (interview on 15 May 2005).

Not surprisingly then, these meetings failed to garner the support of al-Salt's inhabitants for the tourism development project. On the contrary, the residents became more wary of the project and intensified their opposition to tourism development in their city. A planner recalled:

> I remember that it did not go really well. They [local inhabitants] said they did not want to have what happened before at the *Qāqīsh* house: that here we are a conservative society, and we do not want you to bring strange things to us, and we do not want you to insert cafés and we do not want you to bring foreigners, and we do not want noise among the houses at night (interview on 30 June 2005).

Again, like the 1998 sociological surveys, only two of the planners who were interviewed mentioned these *mushāwara* meetings when asked about any initiatives to engage al-Salt's inhabitants – again, probably due to their controversial outcomes. One of the Japanese planners who referred to these *mushāwara* meetings claimed that the local inhabitants supported the project:

> During the construction, we get people, strangers, total strangers come up to kiss us. They will kiss me in public. I am in the middle of the plaza or the square and they come to you and they tell you in Arabic thank you for this and they kiss you all over. You get the shopkeepers inviting you to the shop for a cup of coffee, the restaurant owners calling you in for lunch, and they refuse payment no matter what you do, and sometimes we put the money down and they say 'no you are insulting me' (interview on 7 May 2005).

While there is no doubt that such encounters between the Japanese planners and al-Salt's inhabitants had indeed occurred, the Japanese planners had in fact misconstrued them for support for the project. Such actions by the local inhabitants were merely expressions of local *karam wa ḍiyāfe* – generosity and hospitality (Chapter 4). These traits distinguish the Jordanians in general and the tribes and clans of al-Salt's *Balga* region in particular. Part of these tribal host-guest interactions entail that the host fears the guest's ability to spread

information about the host's lack of *karam wa ḍiyāfe*, hence imposing on the hosts an overly conspicuous display of *karam wa ḍiyāfe* (Shryock, 2004a: 36). Thus, despite their objections to the project, the honour code of al-Salt's inhabitants prescribes that they welcome the Japanese planners as guests, invite them to share their food and to – naturally – refuse their offers of payment. In fact, these *karam wa ḍiyāfe* traits explain the restrained reactions of al-Salt's inhabitants against the project in the presence of the Japanese planners to the extent of apathy. In discussing why al-Salt's inhabitants did not express their discontent, a Jordanian planner explained that 'they are shy and ashamed from the Japanese' (interview on 15 May 2005).

The urban design measures of the First Tourism Development Project, which were funded by JICA, standardized the appearance of the public spaces and *'aqabāt*. The Third Tourism Development Project, which was funded by the World Bank introduced new regulations that standardized the façades and the signage of all the shops in the downtown core (Plates 26 and 27). Collectively, such regulations homogenized and legitimized al-Salt's historic landscape because their standardization measures eliminated the local self-representations that had shaped the distinctiveness of this landscape. For example, the white limestone used for repaving the *'aqabāt* or stairways and the public paths clashed visually and technically with the traditional mustard-yellow stone, despite the planners' admission that this yellow stone was 'the most distinctive element in al-Salt. Moreover, instead of water management solutions that would have reinstated the water spring in *Sāḥet al-'Ain* (the Spring Plaza) to its original status as a major feature of al-Salt's historic landscape, the plaza became a wide stretch of glaring white stone pavement (Plates 20 and 22). Simultaneously, the new urban design interventions installed water fountains along the *'aqabāt* where they had never existed (Chapter 4) (Plate 23).

Furthermore, the exhibitions of the Old Salt Historic Museum in *Abū Jāber*'s mansion sought to highlight al-Salt's history between 1847 and 1918, which the planners dubbed 'the Golden Age of Salt' (interviews on 7 and 10 May 2005). The museum's exhibits however, failed to represent a-Salt's socio-economic and political history, because devoid from these exhibitions were the stories of al-Salt's economic prosperity, its local tribes and the various clans that had arrived from Nablus and Damascus and which had contributed to this prosperity. Irene Maffi (Maffi, 2002: 210) lamented 'Salt history, has, instead, been transformed into a folkloric tableau, where the local political and historical distinctiveness disappear behind the integrative uniformity of official discourse. This folkloric approach is certainly a powerful tool for creating a sense of unity and erasing local differences'. Thus, legitimization in the place-making of al-Salt occurred through the official discourse's promotion of a single collective identity – a collective universalism – as opposed to the distinctive particularisms of the various identities that co-existed in al-Salt. These selected representations that constituted only one variant of the reality and were approved by the nation-state, were produced for national and international – rather than for local – consumption. In producing these representations, the distinctively local self-representations were in fact obliterated. The interviews with al-Salt's inhabitants confirmed these findings. When asked whether they thought the project represented to foreign tourists the histories of the various sub-communities of al-Salt, the responses were divided where 43 per cent of the study participants thought that the project had failed in this regard. Al-Salt's inhabitants emphasized the need for interpretive tools, such as tour guides, to compensate the tourists for the project's disregard for their local history. They also speculated about the contents of the museum at the *Abū Jāber* mansion, which was under rehabilitation at the time. Such speculations certainly reflected their exclusion from the planning process and their reliance on rumours as a source of information about the museum's exhibits. Likewise, al-Salt's inhabitants were almost equally divided in their opinions of whether the project balanced beautification and a genuine representation of their contemporary life. One of the local inhabitants confirmed that: 'There is a difference in our daily life, and the scene became a bit more beautiful', but then immediately questioned: 'Beautiful *'aqabāt*, but shambles exist in front of them, what's the difference? Conservation must include everything so that the neighbourhood will become tidy. It is all ruins and garbage. What did we benefit?'

Acre: Establishing Rapport

The representation and the level of engagement of Acre's inhabitants in the tourism development plan varied throughout the various phases of the planning and implementation processes. The first year, which

was dedicated to the documentation of the historic urban landscape, witnessed the most intensive levels of engagement during which the local representation occurred through one or a combination of: survey questionnaires, a community committee and public meetings. The interdisciplinary team that Rachamimoff and Mendel formed had included a social worker, who was an Arab who grew up in Acre, which advantaged her accessibility to the local communities (see Chapter 3). This social worker conducted detailed surveys with Acre's inhabitants in which she documented their socio-economic conditions like housing, employment and education. One of the planners shared how this survey had positively impacted the perceptions of Acre's inhabitants toward the project: 'it also gave them some sort of a confidence that they were part of the plan' (interview on 29 December 2005).

As soon as the plan was finalized, it became public and senior planners insisted during their interviews that any interested person was able to review it (interview on 25 December 2005). My several attempts to view these planning documents, however, were never successful. Old Acre Development Company finally directed me to the lead architect – Arie Rachamimoff – who, in turn, conveyed that only Old Acre Development Company was authorized to share these documents and, instead, he generously shared two publications that contained very brief information about the plan.

The planners shared that a couple of public meetings were held during which the planning team presented the plan to the local inhabitants. Several sources relayed how the local inhabitants had participated actively in these meetings and had shared their points of view. When asked about the attendance of Acre's inhabitants at these meetings, a planner laughingly responded 'Yeah, yeah, a lot. And they shout and everything. It was very colourful' (interview on 26 December 2005). Apparently, during those meetings, the objections of Acre's inhabitants to the proposed plan and its sub-plans revolved around its emphasis on tourism:

> The major struggle that existed there is that the primary investment is made in stones and buildings and tourism while the local inhabitants themselves who have been neglected for 50 years, and who are supposed to be the target of primary investment so that the things that are planned for can be preserved, because what is the benefit for a child to have 10 hotels in Acre when there is not a playground to play in? And when there is not a suitable school that meets the need of children or youth? (interview on 6 January 2006).

In fact, throughout the fieldwork, Acre's inhabitants consistently repeated one phrase as if it were a mantra: *'yistathmerū bil hajar mish bil bashar'*, which translates into: 'they are investing in stones rather than in people'.

In addition to these meetings, and once the plan's first implementation strategies were formed, a community committee that included eight representatives from Acre's different neighbourhoods was established to review them with the planning team. A source at Old Acre Development Company shared that, since the implementation commenced: 'there is a subcommittee that consists of some of the inhabitants [who] still work together with us', and emphasized that 'we have a social worker with us here also' (interview on 29 December 2005). The accounts varied however with regards to the level of local representation on this committee. Some planners completely dismissed any local representation: 'As far as I know, no, there is nothing in terms of neighbourhood or quarter representation' (interview on 10 January 2006). According to this planner, the interactions between Old Acre Development Company and Acre's inhabitants were limited only to those whose residences were located in Block 10 where the Pilot Project was being implemented (see Chapter 4). Indeed, the majority of the study participants among Acre's inhabitants (97 per cent) did not believe that they participated in the project in any way. They were critical of their exclusion from the planning process and asserted that their so called 'representatives' on the committee that Old Acre Development Company had formed were in fact appointed by the company rather than elected by Acre's inhabitants. One of Acre's inhabitants shared how:

> There are neighbourhood committees in *'Akkā*. Each neighbourhood has its own committee, but Old Acre Development Company holds an antagonistic preposition toward *'Akkā*'s inhabitants, so that even if they form any [participatory] framework, there is no reflection [of it]. They select one person so that he would stamp and agree to all their demands.

True to this claim, three of Acre's inhabitants who had served on this committee waved aside any election in their appointment process. According to one of them: 'The institution that plans for the city, Old Acre Development Company, invited us to be on the community committee'.

Notwithstanding the attempts to integrate them into the planning process, Acre's Palestinian Arab inhabitants harboured mistrust toward the authorities, as one planner asserted: 'They do not trust. They do not trust the government' (interview on 26 December 2005). Several of the planners attributed this mistrust to the nearly 40 years of neglect that Acre's historic landscape and its inhabitants had endured. Further, the memories of previous attempts to transfer them to *al-Makr* remained with Acre's inhabitants, and they always compared their situation to that of Old Jaffa's Palestinian Arab population (see Chapter 4). The recollections of Old Jaffa's development had been particularly profound for Acre's inhabitants given that Saadia Mendel, one of the two leading architects involved in Acre's new development plan, was the same architect responsible for Old Jaffa's development (Torstrick, 2000: 176). Therefore, not surprisingly, Acre's inhabitants were wary of the proposals of Old Acre Development Company and *'Amidār*. Actually, throughout the interviews, instead of *'Sharekat Tatwīr 'Akkā'*, Acre's inhabitants sarcastically referred to Old Acre Development Company as: *'Sharekat Tatyīr 'Akkā'* which translates into: 'Old Acre Demolishment Company'. From their part, and after over 40 years of neglect, combined with several transfer attempts, Acre's Palestinian Arab inhabitants were circumspect of the sudden interest in improving their housing conditions and viewed the Pilot Project in Block 10 with suspicion tinged with interest. One planner summed it up as follows:

> So when we started the project there was great suspicion. We were not very supported. I think we reversed the policy. We said we want to work with you. And I think it is not only right from the humanistic point of view [...] But [Acre's inhabitants] remembered that a few years ago the policy was different. So there was suspicion from the beginning, and we kept arriving at suspicion, and quite bitter. And I am not absolutely sure that the suspicion is gone. I'm not sure. In fact I think that you may still find it (interview on 10 January 2006).

The emphasis that the Pilot Project placed on the restoration of the skeletons of the buildings and, especially, on the façades in order to protect the townscape's serial vision exacerbated the local residents' scepticism. By focusing only on the skeletons and the shells of the buildings, the Pilot Project's funding did not include any interior works because of the regulations of the Israel Land Administration or *Minḥāl* and its implementation arm *'Amidār* (as discussed in Chapter 2) and this eventually limited the ability of Old Acre Development Company to modify the interior of the property. An Old Acre Development Company planner attempted to explain: 'the Municipality issues the order of danger, which means that the house is dangerous, so [architects] go and do an elimination of danger. So if you had something inside that is not working we, Old Acre Development Company will not touch it' (interview on 6 January 2006). Several planners confirmed that in the cases where an elimination of danger was approved, the property's tenant was required to pay half of the costs of the repairs – a hefty amount for the low-income inhabitants of Acre (see Chapter 4).

In spite of all the criticism, the discussion in Chapter 4 revealed how Acre's project veered from an emphasis on tourism development toward an incorporation of the needs of the local inhabitants. This change of direction was in line with the demands from Acre's inhabitants a majority of whom (91.4 per cent) believed that they could not include their needs in the development plan. These local inhabitants insisted that the plan prioritized the tourists' needs and preferences when, in their opinions, it should prioritize services at the harbour for the fishermen as well as education and health services. Simultaneously, many among Acre's inhabitants conceded that the later phases of the project did witness positive change in local engagement. Various planning and implementation strategies reflected these shifts, including the rehabilitation of the urban infrastructure, the provision of social infrastructure, the preparation of the conservation manuals and the initiation of the Pilot Project in Block 10 – the very issues that the local residents had identified as their most urgent needs. In particular, it was the inclusion of the social infrastructure – feats that do not generate any revenue – that reflected the planning team's commitment to address the needs of Acre's Palestinian Arab inhabitants, especially given that the project was funded by the Ministry of Tourism and the fact that Old Acre Development Company is a for-profit company. One of the planners explained the rationale:

I'll give you an example: I mentioned before the three kindergartens, and we used the Ministry of Tourism's money to build kindergartens. The government was not happy. They said that money from the Ministry of Tourism should go to tourism not to kindergartens, and of course I am sure you realize that a kindergarten in the Old City is much more expensive than a hotel. But we thought that if there is no better way than expressing an attitude than to build a kindergarten for the kids. If you build a kindergarten then you would want them to stay, to be part of this place. So I think this is a major issue (interview on 26 December 2005).

This perspective, which certainly was not unique to one planner, reflected the personal commitment on behalf of the planning team to respond to the needs of the local inhabitants due to their genuine appreciation of Acre's human and cultural values equally as its historic and architectural values: 'A Preservation and Development Process of a historic city is perpetually incomplete by definition. It is only through professional care and personal involvement of many organizations and individuals that the cultural, human, and historic value of the city can be cherished' (Rahamimoff, 1997: 14). When probed about whether the development plan balanced their needs and the needs of the tourists, the reaction among the local inhabitants offered a relatively more optimistic view than other questions about their engagement in the process whereby over a third (38 per cent) thought that the project succeeded in striking this balance. Moreover, many of Acre's inhabitants admitted that although they thought that the project sought to serve the tourists, they had also benefitted as a consequence.

Additionally, the combination of the Pilot Project and the conservation manuals offered a genuine opportunity for Old Acre Development Company and Acre's inhabitants to tread new collaborative territory. Notwithstanding the criticism of the Pilot Project, it offered the policy-makers and the planners an opportunity to reflect on what had worked, what had not worked and why and to draw lessons accordingly. In particular, the planners realized that the lack of communication with Acre's inhabitants had negatively impacted the image of the development plan for, apart from the efforts by the Rachamimoff and Mendel's team in the early 1990s and at the onset of the implementation, very few subsequent attempts to engage the local inhabitants ever took place. Mostly, these later attempts limited participation to the owners of the property that was included the Pilot Project. Certainly, with the rest of Acre's inhabitants, there seemed to be a gap in the communication between the strategy formation and the implementation phases. One of the planners admitted: 'Yes there was citizen participation. I don't think it was full. I think more can be done. And I think more can be done over a longer period of time. But I think there was serious effort to collaborate with the local inhabitants [sic]' (interview on 10 January 2006).

Lastly, while *'Atiqot*'s conservation team exerted commendable efforts to prepare the building and architectural classifications and to produce the building guidelines and design manuals, it was clear during the interviews that the local inhabitants were unaware of these documents or of their availability to the public. But, most importantly, although these building guidelines and design manuals adhered to the international guidelines of historic conservation and urban rehabilitation, their non-prescriptive nature nonetheless offered enough flexibility to allow local self-representations to emerge in historic conservation, and, thus, they eliminated the threat of homogenizing Acre's historic landscape (see Chapter 4). Instead, the threat of suppressing the local self-representations was brought about through the emphasis on the Crusader narrative that also incurred the legitimization of Acre for tourism consumption. This legitimization in place-making came as a direct consequence of a discourse that sought, for political and nationalistic reasons, to promote one particular narrative – the Crusader in this case – while supressing the – rather contentious – contemporary ones. Certainly, Acre's inhabitants almost unanimously agreed that the plan did not incorporate or represent Acre's various sub-communities or their histories in the tourism development plans. They highlighted for example how the interpretive signage around the city presented the Crusader history at the expense of other periods, including the Ottoman and, especially, the Palestinian Arab histories. One of Acre's local inhabitants commented that 'This [project] is not a true reflection of the [local] residents and their lives. And their goal is not to repair and preserve for the sake of the local inhabitants. They only preserve the palaces and monuments'. Indeed, all the streets and plazas have been given either Crusader or Hebrew names that were completely different from those common among Acre's Palestinian Arab inhabitants and that had been in use since the Ottoman period. According to Rebecca Torstick (Torstrick, 2000: 176):

> The Crusader ruins in the city are one of its tourist attractions, and municipal official have acted to preserve and reinforce this part of its heritage. Thus, squares in the Old City were renamed Pisa, Venice, and Genoa, while streets

were named after Marco Polo and Benjamin of Tudela. The Arab names of Old City quarters do not appear on municipal maps ... The Crusader heritage of the city is remembered so as to emphasize connections to the Christian West rather than the Muslim East. Thus, the Crusader remains are also used to obliterate the city's Arab heritage.

Generally, the planners and policy-makers excluded Acre's Palestinian Arab inhabitants from tourism activities in their city as evident in denying them access to heritage sites that were, until very recently, part of their public and civic domains. In reference to Acre's walls or *aswār*, one resident said 'these *aswār* are ours. And the museums. Why aren't we allowed to enter them? They lie if they tell you we are allowed in'. Some of the planners agreed that *Ḥammām al-Bāsha* – the bathhouse – should have continued to function and to serve the local inhabitants. One of the planners shared that 'Acre is a living city, and the first thing they make are worrying me because of the interaction [sic]. For example they took the Turkish bath and instead of making it function and keep the atmosphere of the Old City, they made out a Luna Park which is completely unnecessary' (interview on 5 January 2006). In fact, this *ḥammām*, which was still in use until recently, became a closed area to the local inhabitants with prison-like fencing in an attempt to prevent the local inhabitants from entering it (Plate 41).

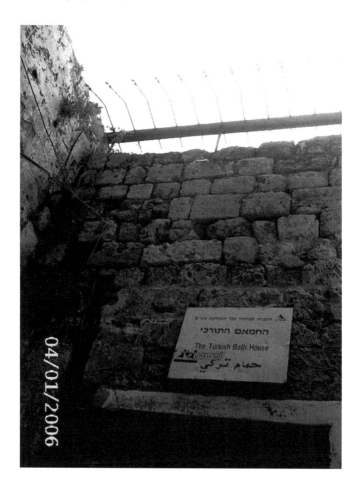

Plate 41 **The fencing of *Ḥammām al-Bāsha* in Acre**
Source: The author

Local Engagement and Place Distinctiveness

The world heritage notion inherently implies the primacy of the global over the local, hence triggering tensions between these two perspectives (see Chapter 3). Bianchi and Boniface (2002) exposed the strong links between world heritage status and global tourism. The latter engenders the contradictory global-local nexus of global demand for distinctively local products – products that are commodified and homogenized to cater for this global demand (see Chapter 1) (Nuryanti, 1996). Dolores Hayden (1999) had also argued that the exclusion of the local self-representations suppresses the local identities from the historic urban landscape and thus detracts from this landscape's distinctively local qualities. Building on Hayden's approach, I argue that public engagement in the place-making processes in historic urban landscape alleviates the global-local tension by balancing the global and the local values and needs. Unfortunately, however, the participatory and inclusive notions in UNESCO's and ICOMOS' documents that pertain to world heritage in particular had lagged behind the urban planning debates. Such debates, which emerged in the second half of the 1960s, appeared in the operational guidelines only in 1994, and did not take hold until 2005.

Three components for local engagement take prominence in urban planning, namely: the representation of the constituencies; the level of engagement; and the timing of engagement. The representation of the constituencies considers the mechanisms by which the voices of the local inhabitants of Aleppo, al-Salt and Acre were considered in the planning process. This entailed three tiers of indirect representation in Aleppo through the primary, secondary and tertiary groups. Conversely, in both al-Salt and Acre representation occurred directly through public meetings where the local inhabitants represented themselves. In Acre, the neighbourhood representatives also played a crucial role in the representation albeit Old Acre Development Company had assigned these positions rather than allowing the candidates to be elected by Acre's inhabitants.

Arnstein's (1969) ladder of participation determined the level of local engagement in the place-making processes, whereby the three case study cities had experienced some form of constrained participation.[8] In other words, each of Aleppo, al-Salt and Acre had attempted – to varying degrees – to incorporate some level of public participation. In Aleppo and al-Salt, the local inhabitants were merely informed of the planning decisions after they were made. Further, Aleppo witnessed some level of informing about the project and its aims during the initial data collection phase when the local inhabitants were solicited for information about the infrastructure. Notwithstanding its nomenclature, what took place in al-Salt was far from a *mushāwara* or a consultation since the decisions had already been made, hence the purpose of these *mushāwara* meetings was solely to inform al-Salt's inhabitants of the project's implementation and to alleviate their mounting concerns due to the circulation of rumours. Likewise, the survey questionnaires that were conducted by the professors from the University of Jordan also happened after the implementation had already commenced. Consistently throughout the project, local institutions like Greater Salt Municipality and Salt Development Corporation were purposefully marginalized in the place-making processes. In contrast, Acre's place-making approach witnessed the highest level of participation through the various inclusive and engaging initiatives; however, several factors detracted from the positive push toward a genuine partnership. Among these was the exclusion of the local Arab Palestinian narrative while highlighting the Crusader one in the historic urban landscape. These factors also included the method of assigning the neighbourhood representatives rather than allowing their appointment to occur through a more democratic and representative process such as elections.

As for the timing of local engagement in the place-making processes, I considered Hamdi and Goethert's (1997) five stages: initiation, planning, design, implementation and maintenance. Accordingly, the three case study cities varied in their timing of engagement whereby al-Salt witnessed the least frequent engagement with only the survey questionnaires and the *mushāwara* taking place after the implementation stage had started. Aleppo witnessed local engagement at the initiation and then later at the implementation stages while Acre experienced the highest frequency of engagement occurrences during the initiation, planning, implementation and maintenance stages. Table 5.1 summarizes these components for Aleppo, al-Salt and Acre.

8 I thank my colleague Pierre Filion for concocting this term after he had read draft of this book's manuscript.

Table 5.1 A summary of the participatory processes in Aleppo, al-Salt and Acre

	Representation of constituencies	Level of engagement	Timing of engagement
Aleppo	Primary, secondary and tertiary groups none of which were direct with Aleppo's inhabitants	Informing	• Initiation stage • Implementation stage
Al-Salt	• Public meetings directly with al-Salt's inhabitants • One local institution: Greater Salt Municipality	Claims of consulting, but informing in actuality since decisions were already taken	• Implementation stage
Acre	• Public meetings directly with Acre's inhabitants • Neighbourhood representatives but they were assigned rather than elected	Above placation but not yet genuine partnership	• Initiation stage • Planning stage • Implementation stage • Maintenance

Source: The author.

Furthermore, Hayden (1999) identified several factors that contribute to the emergence of local self-representations in the historic urban landscape including the consideration of the perspectives of the various local sub-communities in: the research and definition of a collective past; mapping urban space; urban conservation and rehabilitation; and in the interpretation of the historic urban landscape. The absence of such considerations suppresses the self-representation of the local identities from the historic urban landscape hence negatively impacts this landscape's local distinctiveness – the very quality that attracts international tourists in the first place (see Chapter 1). Therefore, the discussion in this chapter paid particular attention to the representation of the needs and interests of the local inhabitants in Aleppo, al-Salt and Acre by assessing these inhabitants' perceptions of: a) the inclusion of their needs in the plans; b) the balance between their needs and the needs of the tourists; c) the level of their interest in tourism; and lastly d) the level of authority sharing in the planning process. The findings revealed that Acre's place-making achieved almost all of these – with the exception of authority sharing, a challenge that planners generally grapple with, but especially so in the authorized discourse of cultural heritage conservation (see Smith, 2006: 11, 300). Conversely, the needs of al-Salt's inhabitants particularly assumed little to no prominence in the place-making processes whether their needs for social infrastructure, their rejection of tourism development in their town or their need to be included in the place-making processes. Similarly, the needs of Aleppo's inhabitants were also disregarded albeit for different reasons. Primarily in Aleppo, and rather than directly soliciting the local inhabitants' opinions about their needs, the planners– in a typical authorized heritage discourse approach – made their own assumptions, based on their own expertise, regarding the needs of the local inhabitants. In the process, Aleppo's planners overlooked the local interest in tourism development and the local needs for social infrastructure.

Lastly, local self-representations emerge in the historic urban landscape in various forms, including vernacular architectural and urban design elements (Ellin, 1999) and contemporary popular cultural expressions and their various forms of symbolism, such as graffiti, signage and even lighting (Jacobs, 1961; Venturi et al., 1977). The various standardization measures that led to the homogenization and the legitimization of the historic urban landscapes especially in Aleppo and al-Salt have also restrained the local self-representations and prevented them from emerging in the historic urban landscape.

The discussion in this chapter addressed the formation of such local self-representations, but the next chapter – Chapter 6 – will discuss these representations' impacts on the sensory experience of the place (see Pearce and Fagence, 1996), whether through the hanging laundry, the graffiti, the smells of the food and the local plants or through the sounds in the marketplaces.

PART III
Place Experience

Chapter 6
Place Experience

Tourism inherently includes an experiential component; however in contrast to the typical forms of mass tourism in which tourists are herded – en masse – to specific tourist attractions, other modes of tourism have emerged. Drawing on the structural-functionalist theories, Cohen (1979: 183) distinguished between five different modes of touristic experiences, namely, the Recreational, the Diversionary, the Experiential, the Experimental and the Existential. The Recreational and Diversionary modes typify mass tourism where tourists originate 'from modern, industrial urban societies' (Cohen, 1979: 186) and are similar in that, through them, a tourist merely seeks pleasure (Ibid.: 184). The Experiential and the Experimental modes similarly entail an experience of the lives and livelihoods of others (Cohen, 1979: 189), but while in the Experiential mode a tourist is 'content merely to observe the authentic life of others' through gazing, in the Experimental mode, a tourist 'engages in that authentic life, but refuses fully to commit himself to it' (Ibid.: 189; also see Urry, 1990 on the tourist gaze). Lastly, the Existential mode encompasses tourists who seek a 'spiritual' experience through which they, in the words of Cohen 'desire to "go native"' not differently from 'Hindu recluses, Israeli kibbuz members, Pacific Islanders' (Cohen, 1979: 190). The Experiential and Experimental modes, in which tourists seek an individualized and distinctive cultural experience of the historic urban landscape, are the focus of this book. These modes are akin to 'Community-based tourism' that 'adopt[s] an ecosystem approach, where visitors interact with local living (hosts, services) and non-living (landscape, sunshine) to experience a tourism product' (Jamal and Getz, 1995: 188), albeit set in an historic urban landscape. For the most part, in the Experiential and Experimental modes, tourists also originate from the West and endeavour for an 'authentic' experience of the 'other' culture (MacCannell, 1999). Such individualized experiences mark the shift from mass tourism back to earlier forms of travel. As opposed to tourists, travellers pursue 'self-transformation' and 'close contact and interaction with the landscapes and the cultures they visit' (Galani-Moutafi, 2000: 216). Indeed, technological advancements, especially in telecommunications and, more recently, in social media, have accelerated this shift by facilitating the availability and the accessibility of information on destinations (Bosselman et al., 1999).

In historic urban landscapes, the Experiential and Experimental modes drive tourists to pursue places ascribed under the 'myth of the unchanged' because of the rich repertoire of their heritage, and their perception as 'timeless' and 'static utopias' stuck in past times (Echtner and Prasad, 2003: 669 and 674). Tourists, hence, seek to experience and experiment with these distinctive lifestyles and how these lifestyles manifest through spatial organizations. For example, such tourists may experience the links between the distinctive local architecture, urban form (spatial organizations) and the natural setting of the urban settlement. Or they may experience the links between the social organizations that represent the different human relationships and their associated urban distribution, such as tribal and clan-based urban quarters. Importantly for these 'authentic' experiences, that the destinations possess a distinctive identity (see for example: Ashworth and Tunbridge, 1990; Chang et al., 1996; Nuryanti, 1996; Sternberg, 1997). Surely, 'image marketing' is deployed to portray the distinctiveness of the historic urban landscape through the Unique Selling Preposition and, in response to the tourists' experiential and experimental needs, to promote this landscape 'also as a vibrant and attractive living urban environment' (Graham, 2002: 1009).

Unfortunately, as Orbaşli (2000) had pointed out, the rich repertoire of mostly anthropological research that discusses the motivations for the Experiential and Experimental modes of tourism has not been matched by empirical research that identifies and assesses the components of their experiences of the historic urban landscape. Most importantly, there is a dearth in research that juxtaposes the tourists' vis-à-vis the local communities' experiences of the historic urban landscape, and how they may impact each other. Similarly, there is a dearth of research that investigates the impacts of the historic urban landscape – that is, the physical and spatial context – on the lives and livelihoods of its inhabitants whether through wealth, prosperity,

lifestyle or empowerment among others (English Heritage, 2000). Indeed, the complexity of the historic urban landscape and its characteristics as a tourism product – for example complimentarity, duality, inseparability and heterogeneity – hinder any efforts to isolate and measure its components:

> The environment of the city is complex and dependent on many circumstances that are constantly changing and acting simultaneously. Ultimately, life in a city is too complicated to be objectively defined or engineered: it has to be experienced holistically. When people live in a city and experience its quality of life day and night, across seasons, years, and decades, the populace makes the urban environment a fit place in which to exist. When a city is inhabited, its inhabitants have a stake in the character of the urban continuum (Tung, 2001: 339).

In order to identify the elements of a distinctive place experience and to facilitate their assessment by transforming them into measurable variables, the discussion in this chapter draws upon the theoretical and empirical work in humanistic geography, architecture and urban design and environmental psychology. To begin with, humanistic geographers have generally considered place as the meaning of lived experience – that is, a sense of identity – and a sense of belonging and attachment (Relph, 1976; Tuan, 1990). They thus put less emphasis on the physical elements of place and more on the relation between people and their environment. According to Tuan (1977), a realistic place experience combines both emotions and thought, which he represented as a continuum at the centre of which lies perception flanked by sensation and conception. In subsequent work, Tuan coined the term 'topophilia' to refer to 'the affective bond between people and place' (Tuan, 1990: 4, 93).

Grounded in existential phenomenology, which underscores the human cognitive experience, the architectural theorist Christian Norberg-Schulz (1980) established strong ties between the 'distinctive sense of place' and 'genius loci' which is also known as the spirit of place. Genius loci then stems from a combination of physical and symbolic values that result from 'space plus character' (Norberg-Schulz, 1980: 23). Aldo Rossi (1984: 130) furthered this idea, especially for historic urban landscapes, when he equated the city's distinctive spirit – its 'soul' – with its history and the collective memory of this history (Rossi, 1984: 130). Kevin Lynch (1960) linked the physical attributes of place to both the cognition – that is, the orientation within the place – and the image – that is, the identification of the self and the place (Lynch, 1960). This distinctiveness 'implies that local features of the built and natural environment characterize a physical identity', and includes the place's continuity from the past (Kim and Kaplan, 2004: 315–16).

The theories of environmental psychology further balance the physical and the non-physical attributes of place. In particular, Canter (1977: 158) proposed a theory that located place at the intersection of three circles that represented the physical attributes of the place, the activities of people within the place and the conception of the place. By equally emphasizing these three elements, Canter's theory offered a more neutral and less subjective approach toward understanding place (Groat, 1995). Punter (1991) sought to operationalize this theory in an attempt to facilitate an objective assessment of the experience of place. He positioned 'the sense of place' at the centre and proposed variables for each of the three elements, such as the townscape, the built form and its permeability for the physical setting; the land use, the pedestrian and vehicle flow and the behavioural patterns for the activities; and the legibility, the cultural associations and the perceived functions and attractions for the meanings and conceptions. Montgomery (1998) further refined Punter's variables. Subsequent theoretical and empirical studies supported the argument that a sense of place stems from a combination of the physical elements and the experiences of the users of the urban landscape (Jivén and Larkham, 2003). Others took this argument further and claimed that people hold the ability to transform their living environment and, in the process, are able to transform place-making from a people-place relationship to a people-people relationship within the place (Schneekloth and Shibley, 1995). In the same vein, others have argued that it is the activities and the events involved in the process of place-making that actually create a place with a distinctive sense of identity (Buchanan, 1988). Indeed, Christopher Alexander (1979) had long advocated for place as a process. Alexander spoke of 'the quality without a name' that stands behind place distinctiveness. This quality resembles human qualities that encompass characteristics such as existing as a whole, possessing passion, being free and alive and even, experiencing death whereby this resemblance 'is not just an analogy, or similarity the fact is that each one creates the other' (Alexander, 1979: 53). Accordingly, series of patterns for the various typologies of

the physical attributes of place serve to link the quality without a name to human experience (Alexander et al., 1977). While Alexander and his colleagues highlighted the physical attributes, they nonetheless underscored '*the process of interacting rules [that] can work to generate a town*' (Alexander, 1979: 499, italics original, underline mine).

Stemming from this emphasis on process whether in the emergence of a town or in its experience, I propose a reinterpretation of Canter's theory of place according to Kevin Lynch's definition of the experience of a sense of place as:

> ... the clarity with which it [place] can be perceived and identified [i.e. the legibility], and the ease with which its elements can be linked with other events and places in a coherent mental representation of time and space [i.e. the symbolic significance] and that representation can be connected with nonspatial concepts and values [i.e. the compatibility and transparency]. This is the join between the form of the environment and the human processes of perception and cognition (Lynch, 1981: 131, underline and square brackets mine).

Therefore, and by building on the premise that the non-physical constructs of place and their interactions with the physical ones are important aspects of place making and experience (Arefi and Triantafillou, 2005: 79), I propose to combine Canter's theory of place and Kevin Lynch's sense of place (Figure 6.1), which yield spatial, cultural and social processes in line with Alexander's views. The distinctive experience of place is situated at the core of these processes, and refers to 'the extent to which a person can recognize or recall a place as being distinct from other places – as having a vivid, or unique, or at least a particular, character of its own' (Lynch, 1981:131). The social processes in particular incorporate the perspective of humanistic geographers on emotion and thought in the perception of place as a lived experience – that is, a sense of identity, belonging and attachment. This is important in light of the fact that the social dimension of historic urban landscapes is often overlooked in historic conservation and in tourism planning (Nasser, 2003). Further, the emerging framework transforms place into the interface between the tourists and the local inhabitants, thus by identifying variables for each process, this framework facilitates a comparative assessment of the experience of the historic city as a tourist destination and as a living place. Therefore, by capturing such complex interactions, this framework accounts for Alexander's emphasis on the 'wholeness' characteristic of the quality without a name (Alexander, 1979). This framework also responds to calls for capitalizing on the conceptual and methodological potential of Kevin Lynch's work for tourism research (Pearce and Fagence, 1996). Further, this proposed framework tackles the concern that the empiricist-positivist paradigm of historic conservation (Tainter and Lucas, 1983) had overlooked the interpretive paradigm that encompasses the social, cultural and experiential meanings of the historic urban landscape (Wells, 2010: 467). Furthermore, this framework's emphasis on the distinctive sense of place responds to a crucial need in urban conservation and rehabilitation practices. Indeed, stemming from this particular need, ICOMOS held a meeting in Montreal, Québec, in 2008, the outcome of which came to be known as the 'Québec Declaration on the Preservation of the Spirit of Place', which declared that:

> Recognizing that the spirit of place is made up of tangible (sites, buildings, landscapes, routes, objects) as well as intangible elements (memories, narratives, written documents, festivals, commemorations, rituals, traditional knowledge, values, textures, colors, odors, etc.), which all significantly contribute to making place and to giving it spirit, we declare that intangible cultural heritage gives a richer and more complete meaning to heritage as a whole and it must be taken into account in all legislation concerning cultural heritage, and in all conservation and restoration projects for monuments, sites, landscapes, routes and collections of objects (ICOMOS, 2008c: Article 1).

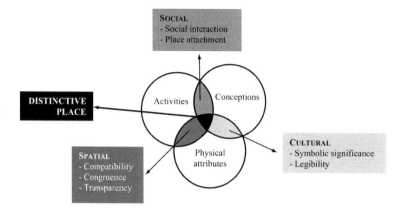

Figure 6.1 **The proposed framework and its three processes for a distinctive place experience: cultural, social and spatial and their measurable elements**
Source: The author.

Figure 6.1 explains the proposed theoretical framework: starting from the *cultural processes* that result from the intersection of the physical attributes of the historic urban landscape and their meaning and conception, and, hence, include symbolic significance, legibility and aesthetics. *Symbolic significance* refers to the holistic comprehension of all the complex processes and their relation to the physical elements of the historic urban landscape (Lynch, 1981), and parallels the contemporary shifts toward the Experiential and Experimental forms of tourism. Thus, a decreased understanding of the relationship between the physical elements of the historic urban landscape and the historic events that had occurred within it actually indicates indistinctiveness. Further, a decreased understanding of the relationship between the historic urban landscape and events in other places reflects a lack of understanding of the relation between time and the historic urban landscape. For example, do the local inhabitants perceive the symbolic significance of a religious complex similarly or differently from the international tourists? And why?

Legibility reflects an understanding of the distinctive elements of the historic urban landscape and refers to the ability to mentally represent the physical attributes of this landscape – that is, the monuments, nodes, paths, districts and edges. Accordingly, legibility reflects the ability of individuals – both tourists and inhabitants – to mentally represent, communicate and interpret the physical attributes of the place (Lynch, 1981). Finally, *aesthetics* constitute an often overlooked part of Abraham Maslow's hierarchy of human needs[1] and assess the need to experience beautiful surroundings (Maslow, 1954: 51). The distinctiveness of the historic urban landscape can be evaluated through the respondents' ability to distinguish the aesthetically appealing elements of this landscape: what physical attributes and/or intangible elements do the individuals consider as beautiful? And why?

Moving on to the *spatial processes* that result from the interaction between the activities of people and the physical attributes of the historic urban landscape and which include two empirical constructs: compatibility and congruence. On the one hand, *compatibility* captures the fit between the individual users – local inhabitants or international tourists – and the built environment and specifically refers to the suitability of the urban form for the functions and the activities undertaken by each of these user segments (Lynch, 1981). Incompatibility occurs when the urban form suits the needs of the international tourists more than the needs of the local inhabitants. On the other hand, *congruence* assesses the extent to which the perceived image of the historic urban landscape represents societal processes, such as the balance between the city as a living place and as a tourist destination (Lynch, 1981). A lack of congruence entails legitimization, which transforms the local representations in the historic urban landscape into the comprehensible and acceptable images that are marketed for the consumption of the international tourists who hail from diverse backgrounds (Dahles, 2001).

[1] He identified a five-tiered hierarchy that starts with the basic physiological needs and includes safety, belonging, esteem and the need for self-actualization (Maslow, 1954).

According to Kavaratzis (2004), the primary – yet unintentional – level to communicate this image occurs through the city's physical attributes, hence the importance of urban design interventions in forming the image of the city. Intentional marketing, Kavaratzis argued, is only the secondary level for communicating the image of the historic city (Kavaratzis, 2004: 67–9). Congruence is challenged when the balance tips in the favour of conserving monumental buildings at the expense of ordinary ones. Likewise, congruence is also tested when individuals form the perception that tourism activities exist at the expense of social infrastructure and traditional societal activities.

Lastly, referring back to Figure 6.1, the *social processes* bridge the actions that occur within the historic urban landscape and their meanings and conception and include *place attachment* and *social interaction*. In advocating for inclusive heritage values – ones that extend beyond the values of the conservation experts – Mason (2002) emphasized the social values of heritage which he linked to people's activities in the historic urban landscape through 'the use of a site for social gatherings such as celebrations, markets, picnics, or ball games – activities that do not necessarily capitalize directly on the historical values of the site but, rather, on the public-space, shared-space qualities' (Mason, 2002: 12). Mason further argued that the social value 'also includes the "*place attachment*" aspects of heritage value' and defined it as 'the social cohesion, community identity, or other feelings of affiliation that social groups (whether very small and local, or national in scale) derive from the specific heritage and environment characteristics of their "home" territory' (Ibid.: 12, italics mine). Indeed, Wells (2010: 468) has argued that 'place attachment can be best thought of as defining particular meanings and experiences that occur in the interaction of people with places'. Interestingly, these notions of social interaction and place attachment have been at the core of the place debates in humanistic geography and in environmental psychology. *Social interaction* represents the formal – for example active, planned – or informal – for example casual, unplanned – social opportunity in which the users of the historic urban landscape, whether international tourists or local inhabitants, interact together (Kim and Kaplan, 2004). Place attachment refers to Yi Fu Tuan's (1990: 4, 93) topophilia that describes 'the affective bond between people and place'. Place attachment can be assessed through various qualitative and quantitative measures at different place scales that range from the home to the continent (Lewicka, 2011). This cognitive bond extends beyond a responsive reaction to surroundings to encompass the active production and/or the reproduction of places (Lynch, 1960; Jacobs, 1961). In this context, the indicators used for place attachment include the local communities' sense of rootedness to their historic urban landscape (Kim and Kaplan, 2004: 315), their identification with the historic urban landscape (Proshansky et al., 1983), their sense of ownership of their cultural heritage (Harris, 1996) and their active participation in place-making (Lynch, 1960).

The proposed model is able to capture and to compare the experience of the historic urban landscape for the international tourists and for the local inhabitants. It links this complex experience to the historic urban landscape's socio-economic, cultural and physical conditions (Tung, 2001). In other words, this model links place experience to the various place-making processes that extend beyond the emphasis of historic conservation on authenticity (Pendlebury, 2009: 22), to incorporate contemporary development. It also parallels the shift toward the Experience and Experiential modes of tourism – that is, the shift from visiting monuments and sites toward a sensory experience of the historic urban landscape. The 1987 Washington Charter (ICOMOS, 1987) was the first to recognize – as per Alexander's (1979) recommendation – the significance of the wholeness of the historic urban landscape in any conservation initiative. Therefore, this charter accounted for the socio-economic and the cultural processes and for involving the local inhabitants in any such initiatives.

The next sections of this chapter apply this proposed model and its variables to the historic urban landscapes of Aleppo, al-Salt and Acre. In particular, the application offers a twofold comparison; firstly, between the perspectives of the local inhabitants and the tourists when applicable[2] and, secondly, between these perspectives and the planning approach in each city. The objective is to identify the similarities and the differences between the place experience for the local inhabitants and for the international tourists, and, also, to compare these place experiences to the objectives of the ongoing planning initiatives.

2 As was discussed in Chapter 4, the number of international tourists in al-Salt remains to this day minimal (also see Khirfan, 2013).

Place Experience in Aleppo

Cultural Processes: the Synonymous Perceptions of the Inhabitants and the Tourists

Almost everyone among Aleppo's inhabitants oriented their movement in relation to the Citadel. Therefore, it was not surprising when the majority of Aleppo's inhabitants who partook in this study (88 per cent) chose the Citadel as the most significant urban element. Several of the study participants indicated the Citadel's scale and visual dominance, and referred to it as a symbol of Aleppo: 'Giant. [It] parallels the Pyramids of Cairo'. While very few were able to elaborate on the history of Aleppo's Citadel, those who did were certainly articulate. One of them explained that it is 'One of the largest citadels in the world, and has lots of historic stories [like] the presence of our Lord Abraham on a hill there milking his cow. It was occupied throughout history: Byzantines, Romans, Saladin and *Ghāzi*'.

Second to the Citadel, Aleppo's inhabitants were divided between the old *sūq* and the Umayyad Mosque. Many of those who selected the *sūq* actually linked it to the Citadel and to the various *khānāt*, especially *Khān al-Shūneh*, while others highlighted its division into specializations, commenting that the *sūq* was: 'like an exhibition of traditional industries'. Similarly, those who selected the Umayyad Mosque made reference to the tomb of the prophet *Zakariyyā*. A few of Aleppo's inhabitants listed the 10 gates of Aleppo and its walls (16 per cent), elaborated on their location in relation to the historic neighbourhoods and demanded their excavation and renovation.

When asked about the most distinctive intangible elements in Aleppo, the majority of Aleppo's inhabitants (61 per cent) chose their own culture, expounding: 'Aleppo is neat in its food and drink and people. There is no discrimination in it'. Others selected the vibrant aura of the *sūq*, commenting that 'Its' distinctiveness stems from the specializations. Copper in one *sūq*, *Tilal* for shoes, *Mwāzīn* only for scales, leather in one *sūq*'.

The international tourists in Aleppo harboured similar opinions to its inhabitants whereby most of those who participated in this study (47 per cent) considered the *sūq* the most distinctive urban element in Aleppo. Aleppo's Citadel came second to the *sūq*. These tourists also mentioned the entire historic urban landscape, the city's mosques and its traditional food. Regardless of their choices, the tourists' comments emphasized the importance of the local culture to their experience of distinctiveness: 'It is the real Syria. The life here gives you the feeling of the country as it is naturally, in positive and negative way [sic]'. Similarly, when asked about the most distinctive intangible elements in Aleppo, the majority of the international tourists who partook in this study (68 per cent) selected Aleppo's aura, especially in the *sūq* commenting that it offered: 'City life. Observing the day-to-day activities of the locals'. Other comments underscored the 'otherness' of Aleppo's *sūq*: '[It is] very representative of another way of life than European. Very alive'.

Surely, the similarities between the perspectives of the local inhabitants and the international tourists regarding the most significant elements in Aleppo were in tandem with the objectives of the Project for the Rehabilitation of the Old City of Aleppo and with the personal opinions of the planners. By underscoring the conservation of the historic fabric and the preservation of its residential function, the project sought to demonstrate sensitivity to the local culture vis-à-vis tourism development. According to one of the planning documents:

> It is of vital importance to find the right balance between 'marketing the city for tourism', and the privacy of inhabitants and the authenticity of life there. 'Tourists feel comfortable where inhabitants feel at home' is the central guideline for a long term policy of tourism development in Old Aleppo. This vision is borrowed from the German city of Heidelberg (Nakhal and Spiekermann, 2004: 22).

Six of the nine planners selected Aleppo's Citadel as the most distinctive element while all nine of them underscored the entire historic urban landscape including its socio-cultural experience:

> I could draw you a face: the *Mukhtār* of the [*Bāb*] *Qinnasrīn* area, because this face is for me the authenticity. The citadel. It is the citadel. That is not all. The traffic. The people. It is the people. *Bāb Qinnasrīn* because I pass through here on my way to work and I like it. Voila! *Bāb Qinnasrīn*. It is the face that is more important, more important than this. The people are truly [significant]. When you walk at seven o'clock in the evening –

walk through the *Bāb Qinnasrīn* street, you can see them sitting there, kids running around (interview on 2 June 2005).

Interestingly, some of the personal perceptions of the planners matched the orientalist perceptions of the international tourists:

[imagine] to really live for one night in such a house. It is a bit imaginary but is a beautiful one. This is something I dream of, to enter an Arab house that is not a hotel, to spend a night there at a guest house. It is not built as a hotel but built as a dream Arab courtyard house (interview on 7 June 2005).

Interestingly, though, while Aleppo's inhabitants were able to list individual urban elements, their legibility of Aleppo was weak since they were unable to link these elements spatially, to represent them mentally or to communicate them structurally and coherently. Of the 36 inhabitants who were interviewed in Aleppo only one was able to describe and, also, sketch the relationship between the Citadel (monument), the quarters and the *sūq* (districts), the main roads (paths), the city's walls (edges) and the 10 gates (nodes) (Plate 42).

Plate 42 **A sketch of Aleppo's urban elements by one of its inhabitants**
Source: The author.

Conversely, all the planners who were interviewed expressed a genuine understanding of Aleppo's historic urban landscape and the spatial and historic relationship among its various elements – with the exception of the gates, which no one referred to. One of the planners described:

So apart from the heart of the city, which is the Citadel, no matter how you move you will see archaeological remains, and each area has its different charm, although you will see that the western area has more weight from an archaeology point of view. However, and generally no matter how you walked, you will see mosques, religious schools, some hotels that recently entered the Old City and some restaurants and cafés. Apart from all that, there is the old *sūq* which just as you enter it, you will see how it is divided according to themes. This means that you will find a gold *sūq*, a women's *sūq* … etc. And you will see that as you enter each *sūq*, it

transforms you from one atmosphere into another, even the noise that people make in their daily lives, that in itself is a charm of the Old City (interview on 31 May 2005).

As the last measure of the cultural processes, place distinctiveness was evaluated through distinguishing Aleppo's aesthetically appealing elements. Over a third of the interviewees among the local inhabitants selected Aleppo's Citadel (35 per cent) because of its domination, beauty and symbolism. Others chose Aleppo's entire historic landscape and the *sūq* (19 per cent and 16 per cent consecutively). Further, nearly a quarter of the interviewees among Aleppo's inhabitants (22 per cent) chose intangibles as the most beautiful about Aleppo (see Table 6.1) – most dominantly, the religious co-existence:

> Its atmosphere is good, and it is liveable [for] the rich, middle, and *Darwīsh* or poor. And religion; each one [following] his own religion and this is a blessing from God. The Great Pope Bishop [sic], he entered *Yahiā*'s [John the Baptist] grave and visited him. That was beautiful. And our sheikhs go to churches. There is love, cordiality and understanding. Each one [follows] his own religion, and God judges. My trade master was Armenian. God bless him and give him strength. He used to take me to his home.

Table 6.1 Some of the comments by the local inhabitants of Aleppo on the most beautiful elements of their city

The choice of a beautiful element	Comments
Citadel	Cleaner than other cities. Cleaner than Damascus or Homs.
	The food in Aleppo.
	I love the motion in the *Mdīneh*, seeing huge numbers of people. Old Aleppo is beautiful with its motion.
	All of it, on top of itself. I love it. It smells differently.
	Its people are hospitable and helpful to strangers. They love foreigners. Its summers. Its winters are not too cold. Religious coexistence between Islam and Christianity is rooted among the people. This is a strong characteristic.
	It is more organized than other cities, the organization of the *sūqs* in the *Mdīneh*. Each of the *sūqs* specializes in one item.
	Its atmosphere is good, and it is liveable [for] the rich, middle, and *Darwīsh* or poor. And religion; each one [following] his own religion and this is a blessing from God. The Great Pope Bishop [sic], he entered *Yahiā*'s grave and visited him. That was beautiful. And our sheikhs go to churches. There is love, cordiality and understanding. Each one [follows] his own religion, and God judges. My trade master was Armenian. God bless him and give him strength. He used to take me to his home.
Sūq or *el-Mdīneh*	The *sūq* is an *el-Mdīneh* on its own: spices, carpets. [It is] a huge supermarket that spreads twelve kilometers and the most important element.
	The city is its markets. The *sūq* and the khans because they are archaeological and very historic and are all old floors and stairs. The old *sūqs*: *Sūq al-Zarb*, *Sūq al-Jūkh*.

Source: The author.

The international tourists who partook in this study were again almost equally divided between the Citadel and the *sūq* in their choice of the most beautiful element in Aleppo (42 per cent and 38 per cent of the interviewees consecutively). Others mentioned Aleppo's historic landscape and its skyline, and like Aleppo's inhabitants, the international tourists commented on the hospitality, kindness, friendliness, peacefulness and co-existence among Aleppo's inhabitants. A tourist shared:

It is history and culture and it reminds me of the Arabian past, not only Syrian, but a larger context. A link between our own histories. Lots of things we have in Europe came from here through caravans – a big part of our civilization came from here. It is nice to see it here when we have lost it.

Spatial Processes: the Challenge of Maintaining the Residential Functions

In terms of compatibility, the majority of Aleppo's inhabitants who participated in this study (83 per cent) considered their city's historic landscape suitable for tourism activities, while a smaller majority among them (56 per cent) found it unsuitable for their own activities. These opinions somewhat corresponded to those of the international tourists who partook in this study the majority of whom (77 per cent) considered Aleppo suitable for tourism, but a smaller majority (51 per cent) chose to remain neutral regarding its suitability for its inhabitants – explaining that they were unable to judge, citing their lack of knowledge about the living conditions of Aleppo's inhabitants. From their part, the planners agreed that Aleppo's historic landscape posed significant compatibility challenges with the daily lives and livelihoods of its inhabitants. From the planners' perspective, Aleppo's problems pertained to adapting the courtyard houses to contemporary life; the multiple ownership of the one property; an increase in the non-residential functions; auto accessibility and congestion; infrastructure; and, admittedly, the stringent conservation regulations. The planners particularly found the courtyard houses challenging: 'These courtyard houses are built for certain social contexts. They are made for multigenerational families, for big families. And in addition they do not fit the modern ways of living. They have kitchens and bathrooms separated from the sleeping rooms. And the access by cars and so on' (interview on 2 June 2005). While the combination of observations and interactions with Aleppo's inhabitants confirmed some of these challenges, the planners' perceptions of the courtyard houses were influenced by their own socio-economic backgrounds. Admittedly, some of the female interviewees indeed complained of the difficulty of the daily chores required to maintain the courtyard houses and expressed their desire to move to contemporary apartments in New Aleppo. Speaking of her house, one female respondent said, 'Sometimes I get mad at it', but she immediately continued that 'it is open and airy, and good. Beautiful in the summer, and [offers] privacy'. For the most part, the inhabitants of these courtyard houses were satisfied with them but also criticized the building regulations that prevented them from continuing their centuries-old traditions of dividing the property among the heirs and of expanding and adding to the structures so as to cater for the expansion of the families. They also complained about their inability, due to these regulations, to modify and upgrade their houses to meet their contemporary needs. In particular, these regulations set high standards for rehabilitation that are beyond their financial capacity (see Chapter 4). In fact, the majority of Aleppo's inhabitants who partook in this study (77 per cent) thought that the level of care for the monuments was good but, in comparison, only a minority (12 per cent of them) thought that the level of care of the ordinary buildings was comparable to that of the monuments. The international tourists who participated in this study shared these views whereby 49 per cent of them thought that the care of the ordinary buildings was unacceptable.

Surely, one of the planners admitted that the stringent implementation of building regulations negatively impacted the ability of the local inhabitants to adapt their traditional houses to their contemporary needs. This planner firstly explained the traditional way of life of the local inhabitants: 'These [inhabitants] are poor. They do not have much income. So if someone's son gets married, they construct for him a room on the roof. This is well known', and then went on to explain that the new building regulations ordered them to 'Stop. You are not allowed'. This planner then suggested a different planning approach:

> Either you make things easier, or he will leave the Old City. There is no middle ground solution, so you must find him one [solution] that allows him to construct the room but under your supervision, where it would have a bathroom with technical assistance from you, and you should even draw it for him, in order to allow him to stay in the Old City and continue the process of life in it (interview on 7 June 2005).

Undoubtedly, the multiple ownership of the one property posed complications for the conservation initiatives, especially with regards to the applications for loans. Further, and because Aleppo's affluent inhabitants had moved to the newer parts of the city in the mid-twentieth century, the authorities focused their planning

efforts there, neglecting, in the process, the Old City of Aleppo. This eventually led to an almost dysfunctional infrastructure by the end of the twentieth century. Simultaneously, several workshops for small industries started to move into the residential quarters of the Old City of Aleppo and to occupy the empty houses. The concentration of these workshops, along with other public services, caused severe traffic congestion and noise pollution. One planner summed:

> In the fifties, outward migration increased from the Old City because people wanted something new and more modern areas, and the rich left the city centre [...] and the Old City was neglected as usual because they [the planners] follow the new areas and improve them [...] and as long as only poor inhabitants stay in the Old City, then there is neglect. So the balance that maintained the city for hundreds of years was tipped off. While its[3] planning is haphazard it is also rational, and its main streets are served because they are four to five metres wide which made it enough to transform them into automobile streets. This means that there is hierarchy, so it can be comfortable, but when it was abandoned, the erosion started, the electrical, water and other services that were installed in the early twentieth century were all eroded and the streets as well. And the old houses that were abandoned were converted into workshops, so workshops entered the residential neighbourhoods, and there were swamps and poor people cannot preserve their own houses. So that became the problem actually (interview on 30 May 2005).

Moving on to the congruence of the historic urban landscape, the majority of Aleppo's inhabitants who partook in this study (62 per cent) believed that the image of their city's historic landscape realistically represented their lives to the international tourists. Further, a larger majority among Aleppo's inhabitants (89 per cent) believed that the project represented their history to the international tourists. These views paralleled the international tourists', a majority of whom (61 per cent) found that Aleppo's historic landscape realistically represented the contemporary lives of Aleppo's inhabitants. The planners in turn agreed that the international tourists were pleasantly surprised by the hospitality of the local inhabitants and by the vibrant life on Aleppo's streets. In the words of one planner:

> I know that most Europeans are very much astonished and are pleasantly surprised about Syria in general and very much Aleppo. I do not know any other case. I know only people who are positively surprised because they expected something dark, something backward, something Islamic fundamentalist, and so on. That's what they show on TV. They are also surprised here to see that people are very nice, very kind [and] very helpful. It is one of the safest countries you can find in the world, at least with small criminality. Very small criminality. They see Christians and Muslims living together. They see women more modern than they can ever see in Europe so they are surprised. For me it is a fun [sic], it is a pleasure to show that this image is reality, one of the realities at least (interview on 5 June 2005).

Other planners harboured different views and considered that the private form of the courtyard houses precluded a genuine understanding of the societal processes that occurred within – that is, unless the international tourists gained access to these houses. One planner actually distinguished between mass tourism and the Experiential and Experimental modes of tourism, stating that:

> ... for the tourist who comes with a group, the movement with a group may not allow him [access] because he has a set program, and in this situation the abilities of the tour guide and his level of culture and education play a big role, because when he shows them around he also explains to them. Of course not all of [tour guides] are able to offer such interpretation. And there are the tourists who come individually, and they enter people's homes and eat with them and people invite them in, and so on. These are the ones who possibly would benefit more (interview on 30 May 2005).

3 In reference to the Old City of Aleppo.

Social Processes: The Challenges of Tourism Gentrification and Cultural Clashes

In the wake of the project, Aleppo faced tourism gentrification due to its inhabitants' lack of place attachment, for many families began to sell their property to tourism entrepreneurs and to move outside the Old City. Over half of the interviewees among Aleppo's inhabitants (55 per cent) thought that the houses that were rehabilitated through the project shifted hands. They also relayed how they were witnessing a systematic loss of the residential function whether to tourism-related services in the Action Areas, or to warehouses and small industry workshops beyond the project's boundary. Aleppo's inhabitants were also concerned about the rising rents and property prices in the Action Areas, especially in *al-Jdēide*. Signs advertising the sale of traditional courtyard houses can be found in every neighbourhood (Plate 13). Most of the planners confirmed:

> Unfortunately, in some neighbourhoods especially, those that became active at the tourism level, a big change occurred. The nature of the change was that several of the houses were transformed from residences to tourism-related services like hotels, restaurants, guesthouses and the like. And all this also in addition to the fact that some ownership is transferring to foreigners, people who are entirely from outside Aleppo. I don't know what will happen in the future since lately, a new rule allows foreigners to own property. Previously this was not allowed so there existed some manipulation in the form of commissioning a lawyer or delegating a Syrian to buy the house on their behalf (interview on 1 June 2005).

Furthermore, the apathy among Aleppo's inhabitants was certainly noticeable – a sign of a lack of place attachment. They rarely seized the initiative to upkeep their neighbourhoods where littered alleys were a common sight, even the areas close to the main attractions such as the Citadel and the *sūq*. One of Aleppo's inhabitants shared her frustration:

> May God help us to maintain the cleanliness of Aleppo. Its inhabitants are neglectful. The inhabitants must take notice of cleanliness. There are gnats and midges. They should spray to kill the insects. *Al-Jallūm*[4] used to be so clean. Where should the garbage containers be put? In the past who would have dared to litter the streets? We had never had gnats and midges. Lots of garbage [now], [although] the streets have been repaved and have become beautiful.

Not surprisingly then, Aleppo's inhabitants lacked a sense of ownership over their cultural heritage, notwithstanding their sense of pride in the Citadel's prominence and the *sūq*'s vibrancy. This pride did not extend to the ordinary and the mundane in the historic urban landscape. Generally, very few of Aleppo's inhabitants appreciated the aesthetic and historical values of the ordinary and the mundane in their historic urban landscape. One commented: 'the old *ḥarāt* [neighbourhoods] are not beautiful', but credited the project for increasing the aesthetic appeal: 'but *Bāb Qinnasrīn* around the mosque was rehabilitated, and they [the authorities] paved it and tiled it, though it still needs some greening'. Instead, Aleppo's inhabitants perceived their houses either as a burden due to the high costs of rehabilitation or as a financial asset as a consequence of the project.

Lastly, it was important to shed light on the nature of the social interactions between Aleppo's inhabitants and its international tourists. The majority of the international tourists who partook in this study (72 per cent) believed that these interactions constituted an important part of their experience of Aleppo. Likewise, a majority of the interviewees among Aleppo's inhabitants (59 per cent) thought that they benefited from tourism whether economically or culturally. It was noticeable, however, that the female interviewees among Aleppo's inhabitants dominated the 41 per cent who thought they did not benefit from tourism. One such interviewee relayed how 'Every time they [the international tourists] see me they laugh', and she questioned: 'I do not know. Do they laugh at my black clothes?' Another interviewee articulated the concerns repeated by many others about the exposure of what Herzfeld dubbed the 'culturally intimate' (1997):

> What they photograph is telling. Sometimes they see things that are not good and they photograph them so that they would go back to their countries and say 'look at the Arabs'.

4 *Al-Jallūm* is one of the neighbourhoods in Aleppo.

These were not one-sided cultural misunderstandings, for one of the male tourists complained that:

> Yes. We would like to go inside the mosque but we cannot because we do not like that anyone tells us how we have to dress us [sic] and put a chador around us. And what we do not like also is that in the streets you nearly see no women in the streets. Maybe not the normal life?

Surely, male tourists are not required to wear a chador, thus, if anything, such a comment indicated the need for educating both the international tourists about the local culture as well as the local inhabitants about tourism. In fact, one of Aleppo's inhabitants emphasized:

> Tourists must be treated well and should form a good opinion of us. There is an improvement from before. Slowly, slowly [...] Start with the kids, prepare the [younger] generation to be respectful and that this is our guest. For me, the most important āthār[5] are the individual and how he behaves.

From their part, the planners highlighted the importance of raising awareness among the local inhabitants toward tourism development in general and toward better interactions with the international tourists in particular. Referring to Aleppo's inhabitants, one planner said:

> I think now they are a liability, but they should be assets. How? We have to educate them. For example, you bring the cream of their crop, or their leaders and actually raise their awareness, and make them understand what is it that you are exactly doing and that it is for their own benefit [...] You distribute small brochures among them, that Old Aleppo is so and so, and they would give it to their children. In my opinion the new generation is very important [...] and sorry for stating this bluntly, but that you [as a tourist] provide them with their income so they must respect you. A tourist is a support for me and for my business and creates jobs for me and my country, therefore I must respect him, pamper him and take care of him (interview on 7 June 2005).

Place Experience in Al-Salt

Cultural Processes: The Divergent Views of the Local Inhabitants and the Planners

Al-Salt's inhabitants were divided in their perceptions of the most significant element in their city, between al-Salt Secondary School and the superimposing composition of al-Salt's historic landscape. Those who chose the former elaborated on its historic and symbolic significance and one of them lamented:

> Al-Salt Secondary School produced generations of distinguished alumni [including] ministers and important men. Only if the inhabitants of al-Salt would return back to their history, and if they would revive it [through] collections dedicated to the history and the distinctive sons of this city: leaders, poets, writers.

Al-Salt's inhabitants also mentioned *Ḥammām* Street (Plate 2) among the most significant urban elements but very few of them associated it with the Nabulsi families who had built it in the late eighteenth and early twentieth centuries. But most interestingly, only a fraction of al-Salt's inhabitants who partook in this study (6 per cent) chose *Abū Jāber*'s mansion (Plate 20) as their first choice. This was at odds with this building's preeminence in the tourism development projects that singled it out for rehabilitation. But, the prominence of the *'aqabāt* and the panoramic lookouts in the projects were in accordance with the local inhabitants' selection of al-Salt's historic landscape. In fact, one of these trails led to al-Salt Secondary School. The personal opinions of the planners varied considerably and they spoke candidly about the lack of distinctive elements in al-Salt's historic landscape. Actually, in justifying the decision behind the rehabilitation of the *Abū Jāber* mansion, one senior planner admitted that 'the reason to preserve this building [is] honestly there is nothing in al-

5 The word āthār in Arabic has two meanings: either archaeological remains and/or remaining impacts.

Salt to attract tourists, although there are some attractions in al-Salt but they are not good enough for the sustainability of tourism' (interview on 7 May 2005).

Many of al-Salt's inhabitants (39 per cent) considered their own culture the most distinctive intangible element. Their comments highlighted aspects such as their strong tribal and clan affiliations, their continuity of traditions and their *karam wa ḍiyāfe*. When asked, one of the local inhabitants exclaimed 'The generosity of al-Salt!' and bragged: 'At one point they [the authorities] wanted to build a hotel in al-Salt, but the inhabitants refused because they keep their houses open for foreign visitors'. Others thought al-Salt's natural setting and its relationship to its hinterland, especially the orchards, significant. Some even elaborated on the historic links between these orchards and the caravan trade routes, revealing an understanding of al-Salt's historically significant economic role.

The legibility of al-Salt's inhabitants was weak as they were unable to mentally represent or to communicate the physical elements of their historic city – that is, the relationship between the streets, *'aqabāt*, *sāḥa*, *mahallāt* and buildings. But it was the lack of legibility among the planners who were involved directly in the projects that was striking with the exception of one who described:

> The entrance of the city is distinctive from other cities. You enter it through a mountainous area. We had a foreign group once, and when they entered the city, they thought that *al-Jad'a*[6] area on the opposite mountain is all one big hotel. For me, the entrance to al-Salt is very distinctive. It gives the indication of something mysterious inside the old city. This thing is the ensemble of buildings. Now, the individual buildings on their own are not very beautiful, but the whole area and approaching it, and how to link the building to the adjacent ones and to the urban space near it, and how to link all the elements together, that's what I find important. The urban spaces and the branches off of them, which are the stairs, then the buildings. The buildings are located originally in the areas on the sides of the mountains and are linked together through a specific concept (interview on 14 May 2005).

The attention that al-Salt had received over the past decades had positively impacted its inhabitants' appreciation of its aesthetics. In response to a question that asked the study participants to list the most beautiful elements in their city, the majority of al-Salt's inhabitants (67 per cent) thought all of al-Salt was beautiful, highlighting its combination of mountains and buildings, and over a quarter of them (26 per cent) chose their own culture. Apart from the direct questions, other indicators signalled their awareness of the aesthetic value of their historic town. During their interviews, al-Salt's inhabitants voiced their disapproval of the quality of craftsmanship and the choice of materials in the projects and of their negative impact on al-Salt's appearance. From their part, several planners chose the entrance to the city and especially, the *sūq* in *Ḥammām* Street. Some of them singled out buildings like the Ecclesiastic Complex; the Mosque; and residences including the *Tūqan*, *Khreisāt* and *Sukkar* houses.

Spatial Processes: How Well Do the Planners Know Al-Salt?

Al-Salt's inhabitants thought that their historic urban landscape lacked compatibility with their contemporary needs, where a majority among the interviewees (69 per cent) thought that their city's historic landscape suited tourism activities while a similar majority (64 per cent) thought that this landscape did not suit their own activities. Simultaneously, a majority of al-Salt's inhabitants (71 per cent) found the level of care for monuments good while a similar majority (72 per cent) found the level of care for ordinary buildings unacceptable.

The planners agreed that while the historic urban landscape in general and the houses in particular have the potential to be adapted to contemporary life, such adaption would also be an expensive feat. These planners admitted that in their current status, the houses and the historic urban landscape posed multiple challenges for their inhabitants. One planner explained:

> The whole idea is that these houses were built when the requirements of life were so different from what they are now, especially, some of the things that were not important are now essential. I visit these houses but do not

6 *Al-Jad'a* is one of the *mahallāt* or neighbourhoods of al-Salt.

live in them, so I do not suffer like them [inhabitants], but I know how they feel. These buildings are difficult as residences. Although it is possible to adapt them but it is difficult. Firstly, it is very costly and secondly, they require continuous maintenance. And the services. Not all the basic services can be provided in them like modern bathrooms, restrooms and kitchens (interview on 14 May 2005).

Furthermore, over half of the interviewees among al-Salt's inhabitants (54 per cent) believed that their town's image did not realistically represent their contemporary lives. The exact same ratio also thought that the tourism development projects failed to represent their contemporary lives. The planners certainly concurred, and there was consensus among them for the need of interpretive tools to aid the international tourists in their understanding of the local culture. A planner suggested:

Tourists must realize that there are people behind these houses. There are people who think, and did a courtyard, behind a courtyard, behind a courtyard to suck air in so as to allow fresh breeze always in. These things are very important. Also for example, to know that this was a merchant's house, and each shop had a house above it, and to know that throughout, *Hammām* Street had such merchant houses as we call them (interview on 30 June 2005).

Other planners put the onus on al-Salt's inhabitants to represent their culture to the international tourists by allowing these tourists to observe their normal day-to-day lives, thus becoming the subject of the tourists' gaze (Urry, 1990). One of the planners said: 'Now it is up to the […] locals: how do they want to project themselves to the foreigners? "Hey, this is my city, this is how we used to live, and this is how I am living now"' (interview on 7 May 2005). Another planner recommended involving al-Salt's inhabitants in staging events for tourists at the Historic Old Salt Museum:

When the tourist comes for only a couple of hours, he does not have the time to sit down with one of the elderly people to take information from him. What we [planners] do then is to specify a room for example for medicine, and how the school was, and how popular life was; even the shapes of dances and *dabkāt*.[7] Actually, one of the proposed ideas, but not confirmed, is to have a *dabkeh* band at the entrance for welcoming, and at the same time it indicates to tourists that they have entered into the atmosphere of the Old City. And there could possibly be a model wearing the traditional dress – the *thōb*. Possibly one among the *dabkeh* would wear it. This is the idea (interview on 10 May 2005).

Such a suggestion typified the commodification of the local culture for tourism consumption. But more profoundly, it reflected how some of these planners, who were directly involved in al-Salt's projects and who were mostly from Amman, seemed oblivious about the local culture. As outsiders, these planners lacked the nuanced knowledge of both al-Salt's local culture and its planning culture (Mintzberg, 1994). In a town that rejected a café because it was deemed culturally inappropriate, such ideas of local women dancing for international tourists – male tourists included – would simply be inconceivable. Needless to say that none of these ideas came to fruition. Further, other planners seemed sceptical of this approach and even questioned the authenticity of the messages conveyed through the Historic Old Salt Museum. They were particularly critical of the representations offered within the museum:

I am not certain whether it [the museum] tells the history of the city of al-Salt specifically or the traditional history of the country. I know for example that there is a *hakawāti* – a storyteller. Was there really a storyteller in al-Salt? All these things that they are talking about are extinct now. And [so] how did they [the planners] know that they existed in al-Salt? And how did they confirm how these things exactly were? (interview on 30 June 2005).

Social Processes: Trepidation about Tourism Development

Al-Salt faced a systematic loss of inhabitants from its historic core that led to dilapidation (Plate 43). The affluent families had moved either to the capital Amman or to the newer areas of al-Salt, while poorer locals and foreign

7 *Dabkeh*, plural *dabkāt*, is a form of a traditional line dance.

Plate 43 Dilapidated buildings in the core of al-Salt
Source: The author.

workers – mostly single males – replaced them. In addition, al-Salt's inhabitants complained about the inadequacy of the municipal services, the challenge of navigating the *'aqabāt* daily and the dilapidation of the infrastructure. Most of those who remained in the historic core expressed their desire to move out. One planner confirmed:

> It is a phenomenon, and you can also notice for example that in some of the traditional areas such as *al-Jad'a*, because families expanded, people spread out and left al-Salt which is now occupied by Egyptian and immigrant labourers and this is a somewhat negative aspect. Now I go back in my memory and pass through *al-Jad'a* and wish to see some of the people I used to know previously. There aren't any. You only would encounter one, two or three families at the most, and the rest are either immigrant workers or outsiders who live there because of the very cheap rent of these buildings (interview on 30 June 2005).

Notwithstanding their strong sense of pride in al-Salt, apathy among its inhabitants toward its upkeep was conspicuous, for the same inhabitants whose residences were immaculately clean deemed it acceptable to litter the *'aqabāt* surrounding their own residences while vandalism was rampant (Plate 29). They also refrained from participating in any initiatives to enhance their physical environment such as when, in the summer of 2005, a professor and his graduate students from the Development Planning Unit at the University College of London collaborated with the Greater Salt Municipality to initiate an in situ design charrette. They invited those who lived along the *'aqabāt* to share their needs, problems and visions and, considerate of the local culture, had arranged two charrettes, one for women during the day and another for men during the evening. But apart from a few children, no one attended.

This apathy contrasted starkly with the strong sense of ownership that al-Salt's inhabitants displayed toward their cultural heritage, which they demonstrated, for example, through their sense of pride in their town's historic landscape and in al-Salt Secondary School. This strong sense of ownership even existed at the institutional level, for despite their exclusion from the planning process, the Greater Salt Municipality and Salt Development Corporation relentlessly pursued the curatorial management of al-Salt's historic landscape. For example, Greater Salt Municipality collaborated with the Royal Scientific Society and jointly submitted in 2005 a nomination package to inscribe al-Salt on UNESCO's World Heritage List. These efforts yielded al-Salt's inscription on the Tentative List. Greater Salt Municipality, the Royal Scientific Society and Salt Development Corporation also initiated an award for the best conservation effort in al-Salt (interviews with several planners, also see: Al-Kāyed, 2005; Jel'ad, 2005). Most importantly, while JICA's reports claimed that al-Salt's historic landscape was 'a

neglected urban resource' (Nippon Koei Co. et al., 1996b: 4.56), other possible scenarios existed. If anything, the combined efforts of Salt Development Corporation and the Royal Scientific Society had galvanized the public's attention toward al-Salt's historic landscape and toward other similar landscapes in Jordan, which until 2004 had lacked the necessary legislative protection because the Jordanian Antiquities Law only safeguarded cultural heritage that post-dated AD 1700. Consequently, 'Salt Development Corporation prepared the Heritage Law proposal and raised it to the government and the government adopted this project, and finally this law was issued as the temporary law that you have a copy of now'[8] (interview with a planner on 30 June 2005). Moreover, when a lack of government funding forced the Royal Scientific Society and Salt Development Corporation to halt their rehabilitation efforts, the latter actively sought alternative sources, until, as one planner shared, in 1992, 'Salt Development Corporation received funding from USAID that amounted to US $150,000 for Ḥammām Street, which was rehabilitated and returned to its former old state. [Salt Development Corporation] repaved Ḥammām Street, reinstalled infrastructure and prevented automobile traffic on it' (interview on 30 June 2005). Greater Salt Municipality also fully funded an initiative to place signage for some of the distinguished buildings and trails. Dubbed 'The Naming Project', a planner explained that this initiative 'used the common name used by the local inhabitants and not the registered names', and then 'prepared a sign for each of the buildings to guide people'. This planner shared how 'the local inhabitants became interested in the building in their area, and also the visitors' (interview on 14 May 2005). In addition, Greater Salt Municipality provided ingenious yet pragmatic solutions to some of the challenges of curating al-Salt's historic landscape such as by procuring a fleet of donkeys to collect the garbage along the *'aqabāt* that are inaccessible for garbage trucks (Plate 44).

Plate 44 Donkeys are used for garbage collection along the winding *'aqabāt* of al-Salt
Source: Khirfan 2013.

Most importantly, while the projects in al-Salt emphasized tourism, al-Salt's inhabitants were wary of tourism and of international tourists (see Chapters 4 and 5): in general, al-Salt's inhabitants welcomed tourism's contribution to the local economy and its signalling of peace and stability in an otherwise politically volatile region: 'Psychological repose. The feeling that there is [enough] tranquility for tourism', yet, they disapproved

8 This new law is known as the Law for the Protection of Architectural and Urban Heritage, number 5/2005 and protected the post-AD 1700 architectural and urban heritage. It passed as a temporary legislation in 2004 and became permanent in 2005 (Hashemite Kingdom of Jordan, 2005).

of transforming al-Salt's historic landscape into a tourist attraction and almost unanimously attributed their opinions to their conservative culture and oftentimes expressed wariness about the exposure of culturally intimate aspects of their local culture (Herzfeld, 1997). One interviewee summed the local objections to international tourists by firstly disapproving of 'Their clothes. The shorts and the short sleeves', and stated: 'The feeling that the tourists are looking at shambles and photograph dumpsters', but then assured: 'Tourism has not happened yet, but probably these things will happen'. Others talked about the need to educate the local inhabitants prior to bringing in the international tourists, admitting, while speaking of the *Salṭiyye*, that: 'We are *sarsariyye*.[9] Tourism does not suit us'.

Place Experience in Acre

Cultural Processes: Analogous Perceptions

Over a third of Acre's inhabitants who partook in this study (39 per cent) believed that Acre's entire historic landscape was distinctive. They described how Acre's peninsula-like form influenced its relationship to the Mediterranean. Simultaneously, nearly a quarter of the interviewees (24 per cent) considered *al-aswār* – Acre's defensive walls – as the most distinctive urban element and described their relationship to the Mediterranean (Plate 8). Certainly, most of Acre's inhabitants linked their choices to historic events through comments that described Acre as: 'A city in the middle of the sea. A peninsula. And its walls are great and intrinsic. Walls that prevented the great sea from entering the city. Walls that defeated Napoleon'. Half of the interviewees among Acre's inhabitants chose themselves – that is, Acre's inhabitants – as the most distinctive intangible elements about Acre, especially highlighting their kind-heartedness. Some even linked the diversity of the contemporary population to the city's history:

> You'll find an Arab city on top of the Crusader city. It contains archaeological ruins and a Byzantine harbour. Its churches [and] mosques [are] all ancient. [There is] a cultural mixture in *'Akkā*: European, Arab, Turkish and even Roman. Even the walls of *Fakhr al-Dīn* and *Zāhir al-Omar*.[10]

Another group of the interviewees (21 per cent) considered Acre's rich history distinctive: 'its ancient history. All the world tried to occupy it. Its Byzantine harbour was called in history the "window or door to Europe"'. Others also mentioned the local gastronomy, especially seafood and a hummus shop in the *sūq* that attracted patrons from beyond Acre.

The development plan for Acre proposed tourist trails that highlighted the same elements considered distinctive by Acre's inhabitants. Two of the north–south tourist trails ran along the western and eastern *aswār*, and another passed through the *sūq*. The east–west tourist trails ran along the Citadel (north), the harbour (south) and through the city between *Khān al-Shūneh* and *Qaṣr 'Abbūd* – the Bahá'í palace (Figure 4.3 and Plate 9). These trails featured Acre's *aswār* and (Plate 8), its historic landscape and its monuments while maintaining the privacy of the residential quarters. The personal opinions of the planners also paralleled the inhabitants' whereby four of the planners considered Acre's entire historic landscape as the most distinctive while three appreciated the relationship between its *aswār* and the Mediterranean. The other five planners highlighted various monuments like the Templar Tunnel (Santa Anna Tunnel), the Citadel and the *Hospitalier* compound and *Ḥammām al-Bāsha*. For the most part, the planners' choices were influenced by their aspirations to exploit Acre's potential for international tourism:

9 That is, rascals.
10 These are two Arab princes from the eighteenth century who ruled in the region during the Ottoman period. *Fakhr al-Dīn* ruled in the area that spreads over what is now southern Lebanon and *Zāhir al-Omar al-Zeidānī* ruled over Acre. They were rivals (Makhkhul, 1979, also see Chapter 2).

Everything that makes you sigh as a tourist. [Acre] consists of a revival of ancient culture, ancient religion. It does not matter which, but if it makes you sigh as a tourist, then it is distinctive. The whole city of Acre is a tourist site. You do not have to pay to enjoy it (interview on 29 December 2005).

Almost all the planners referred to Acre's rich socio-cultural mix whether historic or contemporary:

It is a peninsula. A walled peninsula. I think one of the only cities remaining with intact walls on the Mediterranean coast. It is a combination between east and west. [It] has all cultures. It represents all cultures I think. We have all the faiths. We have Muslims, Druze, Christians, Jews and *Bahá'ís*. It is the holiest place for *Bahá'ís*. It is a most unique place and you can come a hundred times and always find a new corner. You can always find a new thing to see though it is very old (interview on 25 December 2005).

Probably this richness of Acre's cultural heritage explains the variety in the opinions of the international tourists who partook in this study, nearly a quarter of whom (24 per cent) thought that the *sūq* was the most distinctive in Acre (Plate 37). Others chose the Citadel and the Hospitalier compound, while others selected Acre's *aswār* and its archaeological remains. But regardless of their choice, most of the international tourists referred to Acre's inhabitants (Table 6.2). A tourist who admitted to her inability to make a choice opted to share:

I do not know how to answer. '*Akkō* will be on my heart [sic] for a long time. The arriving at night by bicycle, the cardamom coffee, the kindness of people, the house near where I was drinking coffee. There is no number one or two or three. Every experience I had was different. Everything is distinctive. Everything is different from my place [...]. What makes it different and interesting is that there is not too many souvenir shops and things like that, just a few on the port [sic].

This same tourist pleaded with the planners: 'Please, do not change this city in a big Walt Disney [sic]. Do not try to make it better for tourists! We [i.e. tourists] are the distinctive things here, if there is something to change for us, do not do it'. Another tourist considered the lack of commodification distinctive in Acre: 'Walking along the streets of the old city. Very few tourists there and good for seeing how the locals live. Observing children playing in the streets, locals going in and out of their houses, neighbours chatting'. In a manner that exemplified Alexander's notion of wholeness (Alexander, 1979), this same tourist further elaborated:

Table 6.2 The comments offered by the international tourists as they made their choices regarding the most distinctive urban elements of Acre

The choice of a distinctive element	Comments
Sūq	Local food, craft, atmosphere
	Walking around the market gives a sense of the inhabitants lives
	Interesting aspect of contemporary life and culture
	Real life and people
	Real life of people
	It is more relaxed than Jerusalem's but still interesting
	Traditional atmosphere
	Interactivity with local inhabitants
	The Oriental smell
	Pulse of life
	Colourful markets, street sellers, shops for locals and tourists, Arabic music, great ambience as long as people don't try to force you into buying things. The market place is a multi-purpose central place for locals and tourists alike: post office, bank, entrance to the mosque, shops for tourists, museums ... etc.

The choice of a distinctive element	Comments
Citadel	Incredible edifice lots to see with the visit
	Well-preserved historic site
People	Arab population
	Arabs with Jews, to show that it is possible [to live together]
Houses	The houses show how people live
	Still a lot of inhabitants in old houses
The harbour and fishermen	Fishing nets on the roads, observing individual fishermen or groups of men working together on a boat. I had the feeling that fishing is an important source of revenue for locals and the experience felt very real.
Historic remains and Acre	Reconstructed Crusader city, nothing similar in my country/region
	Layers of history throughout the city
	Gives an overall feeling of the city life in the past
	Walking along the streets of the old city. Very few tourists there and good for seeing how the locals live. Observing children playing in the streets, locals going in and out of their houses, neighbours chatting.
	Acre offers a wide range of experiences for different tastes: walking along the streets of the old city, the harbour, colourful markets and local craft shops – seeing how the locals live and getting a taste of the culture. Historical buildings and well-organized tourist services to visit these – for those interested in history and archaeology. Arabic music playing in the streets and prayer songs from the mosque – great ambience! What also made my experience of this city very distinctive was the friendly welcome from the hotel owner and the discussions we had about local culture and political issues.
Religious buildings	Representative of local customs
	Real life of people
	Continuing life of people
	Distinctive architecture, beautiful gardens and nice decoration inside. Seeing locals going for prayer and hearing prayer songs in the streets taught me about the importance of religion in people's lives.
Turkish Bathhouse - Ḥammām al-Bāsha	Good tourist attraction to learn about how people used to live but it doesn't seem relevant to current living, as [it does] not functions[1] [sic]. It's a shame it's not in use anymore. Maybe one part could be a museum and the other a bath for people to use?

Source: The author.
Note: [1] This respondent is referring to the fact that the Bathhouse, or Ḥammām al-Bāsha is currently inoperative.

Acre offers a wide range of experiences for different tastes: walking along the streets of the old city, the harbour, colourful markets and local craft shops – seeing how the locals live and getting a taste of the culture. Historical buildings and well-organized tourist services to visit these – for those interested in history and archaeology. Arabic music playing in the streets and prayer songs from the mosque – great ambience! What also made my experience of this city very distinctive was the friendly welcome from the hotel owner and the discussions we had about local culture and political issues.

Acre's inhabitants revealed exceptional legibility of their city's form. Almost all of the interviewees referred to Acre's natural peninsular shape and to its relationship to the Mediterranean. Also, whether during the interviews or during personal interactions with them, Acre's inhabitants constantly referred to Acre's urban elements to orient themselves such as 'the Eastern' and 'the Western' sides, and the *khandaq* and harbour for the north and south sides (Plates 36 and 45) and, lastly, the *sūq* as the artery that connects the *khandaq* and harbour.

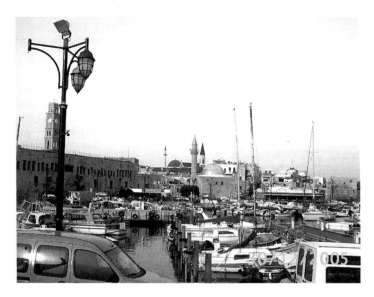

Plate 45 The harbour of Acre
Source: The author.

Similarly, the planners displayed strong legibility, but unlike the residents, underscored the overlaid Crusader and Ottoman cities. One planner shared:

> … archaeological layers and Ottoman layers. They are two very, very amazing layers. The Old City of Acre, the Ottoman city is a beautiful city […] More of it the Crusader city, again very flourished one, lived for 200 years [sic]. It is more or less equivalent to the Ottoman city. And a lot of buildings and a lot of parts of the Crusader city are preserved very nicely below to the Ottoman city [sic] (interview on 27 December 2005).

Acre's inhabitants were divided between two points of view regarding their city's aesthetic appeal; whereby one considered Acre's relationship to the Mediterranean through its *aswār* while the other chose Acre's entire historic landscape (40 per cent and 32 per cent of the interviewees respectively). Others chose *al-Jazzār* Mosque (Plate 7), Acre's inhabitants and even Acre's Arabic name *'Akkā*. Interestingly, the views of the international tourists were very similar whereby they chose either Acre's entire historic landscape (32 per cent) or its walls (27 per cent), while others selected the harbour or the Citadel. Additionally, when asked about the intangible elements, many of the international tourists chose the links between Acre's *Bahá'í* holy sites (Plate 9) and the *Bahá'í* sites in Haifa. Most of the choices however, (40 per cent of the study participants) highlighted Acre's inhabitants and their culture as the most beautiful intangible element. One tourist commented:

> People, they smile. People, their kindness. People, their music. People, their food. I did not feel like a tourist in this town. Everyone was treating me as a person, not as a bank. No 'want to see my shop', no 'take it, take it, for your sister. For your brother. Take it, take it'. Just a 'shalom'. We haven't been aggressed by sellers. That was beautiful.

This same tourist went on to lament however that 'some buildings are run down and the streets can be dirty in places, so it would be good if the streets could be cleaned regularly and the buildings restored while keeping their ancient features'. Mostly, the tourists associated Acre's inhabitants to Acre's historic landscape. One remarked: 'Street sellers, all human in a picturesque presence in historical places', while another reflected 'Calm of [the] narrow streets, children playing, glimpses of [the] lives of ordinary people'.

Across the board, the planners refrained from signalling one beautiful urban element and, instead, several of them considered the historic urban landscape – in its entirety – beautiful, while others referred to the

combination between archaeology and contemporary life: 'I think this combination [and] the connection between the archaeological level between the Crusader and the Ottoman periods and between the living place that is still a living place, and that you can still go around and still feel the place' (interview on 20 December 2005).

Spatial Processes: Reconciling the Needs of the Local Inhabitants and the International Tourists

A large majority of the interviewees among Acre's inhabitants (97 per cent) thought that their historic landscape suited tourism activities; however, another majority among them (82 per cent) thought that this landscape did not suit their own activities. Similarly, a majority of the international tourists (75 per cent) considered Acre suitable for tourism but also a majority of the international tourists (69 per cent) remained neutral about the suitability of Acre's historic landscape for its inhabitants, citing their lack of knowledge of the intimate lives of these locals. Moreover, the majority of Acre's inhabitants (95 per cent) thought that the plan cared for monuments more than for ordinary buildings and another majority (82 per cent) considered the level of care bestowed on ordinary buildings insufficient. The international tourists agreed with Acre's inhabitants that the level of care for monuments was very good (66 per cent of respondents) while nearly half of them considered the care for ordinary buildings insufficient (43 per cent).

For their part, the planners agreed that Acre's historic landscape in general, and its residences in particular, posed daily challenges for Acre's inhabitants – even after, as one shared, a potentially comprehensive rehabilitation: 'Well you have to be committed if you want to live there. I think to give up certain conveniences, like accessibility to cars' (interview on 10 January 2006). In fact, some of the planners insisted that the residences in Acre were not suitable for human habitation. In response to a question about the suitability of Acre for the needs of its inhabitants, a planner vehemently argued:

> Absolutely not [suitable]! I thought all the city in terms of my needs. I mean if I would buy the land and I would like to live there, I would see it from my eyes, and the answer is not [suitable]. I think that a lot of the buildings, the structures, are not fitting appropriate for dwelling [sic]. It is not healthy to live there. They all suffer from high humidity. They are without the circulation of the air. There is thick air within the structures (interview on 10 January 2013).

Another planner echoed: 'some of the houses in Acre are inhumane. Some underground houses in Acre do not get sunshine and are not suitable for human habitation' (interview on 6 January 2013).

As for the congruence of Acre's historic landscape, the inhabitants were almost equally divided with nearly half of the interviewees (46 per cent) believing that Acre's historic landscape reflected to the tourists a genuine representation of their lives. Their opinions were similarly divided with regards to the transparency of the new development plan where nearly half of the interviewees (48 per cent) believed that this plan did not realistically represent their lives. But contrary to the divided opinions of Acre's inhabitants, most of the international tourists (60 per cent) found that Acre's historic landscape realistically represented the contemporary lives of its inhabitants. The planners agreed that more could be done through planning to realistically portray the contemporary lives of the local inhabitants by improving the transparency through the development plan which a planner admitted that it was:

> Reasonable. Not brilliant but reasonable. You can get a little booklet, a little folder that gives narratives. So there are narratives. There is a Crusader narrative. There is a general historic narrative. The *Bahá'í* community has a narrative. The nationalistic Israelis have gotten a narrative. So there are a series of narratives, and for the most part they are OK. But there is room for a lot more improvement, but it is a process. This is a problem of value judgment. For instance if I say that I am interested in the Crusader period then many would say that the Crusaders are not important (interview on 26 December 2005).

Social Processes: A Symbiosis between the Local Inhabitants and the International Tourists

Acre's inhabitants consistently exhibited a strong sense of connectedness to their historic urban landscape. A planner confirmed: 'The inhabitants like the Old City of Acre. They love actually to live in the Old City and they do not want to leave it' (interview on 29 December 2005). The earlier account in Chapter 2 about the attempts to transfer Acre's inhabitants to *al-Makr* and their subsequent return also confirms this strong sense of place connectedness notwithstanding the inadequacy of the residences for habitation as discussed earlier in this chapter. This place connectedness reflected their Palestinian Arab nationalist feelings toward Acre as one of the few remaining historic Arab strongholds within Israel (Galili and Nir, 2001). A planner explained:

> Some of the houses in Acre are inhumane. Some underground houses in Acre do not get sunshine and are not suitable for human habitation, so as an issue, [it is] an issue of clinging only. So nationalism [is] making every hole in Acre inhabited with children and women in inhumane conditions. The idea that each corner must be inhabited even if it does not suit habitation just out of nationalistic logic (interview on 6 January 2013).

Acre's inhabitants also revealed a strong sense of ownership toward their cultural heritage which they expressed through their knowledge of their city's urban elements and their histories. The local cultural institutions also displayed this strong sense of ownership when, for example, a local NGO called *al-Yāṭer* published its annual cultural journal with the same name whose contents highlighted Acre's history, culture and built heritage (Shamali, 2004; Shamali, 2001). *Al-Aswār* was another major local institution whose permanent offices occupied a restored old building close to Acre's harbour and whose name denoted Acre's defensive walls. *Al-Aswār* pursued an active agenda that promoted Acre's culture through events and through a periodical. Similarly, various local ad hoc groups had collaborated to improve the housing conditions over the decades by conserving some of the residences – often successfully securing international funding. Two of Acre's inhabitants relayed how:

> The Neighbourhood Restoration Project took place with international support [from] the Welfare Association. Its' goal was to conserve the houses that are falling apart, when no authority or institutions helped with the conservation of these houses.

Because of its small scale, compact size and overcrowded conditions, it was clear during the various interactions with them that Acre's inhabitants were tightly knit and maintained very strong social links. This inclusive nature extended toward the tourists – both local and international – to whom the local inhabitants were very welcoming. One of the local inhabitants shared:

> *'Akkā* particularly is well known for receiving foreigners and tourists who come to it. Now they roam all *'Akkā* and cannot find a restroom, so they knock on the doors to use the toilets inside the houses. In *'Akkā*, the inhabitants know that the tourists come here because they appreciate the heritage of the city. And the inhabitants benefit from tourism because most have businesses in the *sūq* where they sell tourism products.

This interviewee, however, cautioned about the need to overcome the prevalent negative image of Acre in the media:

> The tourist walks into *'Akkā* and there is a lack of awareness. When the tourist comes in, he should not feel fear from the city. The city is always targeted and the drugs reflect a bad image of it, although drug users and dealers are only four per cent or less of the population.

This same interviewee emphasized the role of the various governmental agencies in mitigating the negative impact of these 4 per cent: 'The authorities should participate to encourage the tourists and keep them and prevent them from harassing female tourists'. In fact, this interviewee's comments summed up all the controversies regarding Acre's social interactions namely, its drug dealing reputation (Galili and Nir, 2001), lack of tourism services and its inhabitants' aspirations and welcoming attitude. As for the international

tourists, nearly half of them (46 per cent) believed that their interactions with Acre's inhabitants constituted an important part of their experience. Indeed, these tourists thought that Acre's inhabitants were polite, welcoming and interesting. In addition to the previous remarks, many also commented on the friendliness of Acre's inhabitants sharing statements, such as 'People are very nice. Helpful with the tourists', and 'The citizens are polite, trying to help, are open minded toward tourists'. Another begged: 'Please do not change this city. Do not bring McDonald to make tourists feel more comfortable [sic]. Please do not let them change!'

But in contrast to this plea, some of the planners, especially the more senior ones, voiced their aspirations to change Acre's social structure, claiming that its local inhabitants were the worst aspect about the historic urban landscape. These planners repeatedly shared opinions such as, 'a pearl in the dirt' or 'so much wasted potential' in reference to Acre being unworthy of its inhabitants. Several of these senior planners spoke candidly of instigating 'controlled gentrification' and when probed one of them elaborated that it entailed the 'use [of] gentrification in a positive way' whereby the municipality or investors would provide 'revolving funds' according to which:

> You say to somebody: 'you can't afford to build it, we the municipality we will do it'. And they say 'where does the municipality get the money back?' When they sell the houses. When the person dies. You see because it is usually the older people who live in these houses. When the person dies, then the houses worth more now, because they are all cleaned up [sic]. Then at the sale, at the realization of the added value, that's when the municipality gets its money back, and then uses it again. So it's a matter of what we call revolving funds which something that could be. It is used in the Jerusalem Municipality in West Jerusalem buildings'.

This planner went on to explain how social mobility will occur through this system:

> I think the problem with gentrification is that people get all changed. That was the historic group of people who suddenly money wise can't afford to pay their taxes. They can't afford to live there. They run into problems. So you open up to that controlled gentrification where you allow certain things. So therefore a certain amount of gentrification means that the first level of gentrification is like architects, art students they are the first level of gentrification, then after the architect, then perhaps come the, I don't know the academia, then come the accountants, then finally come the lawyers then the yuppies. So there's a hierarchy. So start on the lower level of gentrification then move to the upper level (interview on 26 December 2005).

In light of such views, it was not surprising to detect a lack of trust among Acre's inhabitants toward the authorities. One planner insightfully shared how Acre's Palestinian Arab inhabitants:

> Do not trust. They do not trust the government. They think [the] worst, [the] worst. There are forty years [...] and at the end, and of course it is politics, but at the end they know they are Arabs and they will not get money and they will not get the assets, and so on [...] they are not only poor and self-learning, but they are poor Arabs, and the establishment is all Jewish so it is more, they have this untrust [sic] (interview on 26 December 2005).

There were certainly visionaries among the planners who provided a healthy balance to those views that sought relentlessly to transfer Acre's Arab population. A planner shared how, 'The moment that you tell somebody that we want to relocate you they will not agree. In fact I think that it is offensive and I do not think it is good' (interview on 10 January 2006). These visionaries insisted that only by involving the local inhabitants in the place production initiatives would it be possible to overcome their lack of trust toward the authorities and the planning processes. Another planner relayed how, 'So when we started the project there was great suspicion. We were not very supported', but affirmed that, 'I think we reversed the policy' and explained how they had engaged Acre's inhabitants:

> We said we want to work with you. And I think it is not only right from the humanistic point of view, I think it is right from [a] planning point of view and from [an] economic point of view. From [a] humanistic point of view it goes without question, but from [an] economic point of view you want the Old City of Acre to have

fishermen and chefs and hotel manages and tour guides and archaeologists and whatever. That's how cities are supposed to be (interview on 10 January 2006).

For their part, Acre's inhabitants enthusiastically embraced any initiative that involved them in the place-making initiatives through attending the workshops, meetings and other events organized by the planners (see Chapter 5).

From Place-making to Place Experience in Historic Urban Landscapes

The shifts to the Experiential and Experimental modes of tourism centre around place experience, especially the experience of the unique and distinctively local qualities of place, and warrant the investigation of how to assess place experience in general and place distinctiveness in particular. The proposed framework therefore integrates cultural, spatial and social processes and operationalizes them by identifying their measurable elements. Considering place, the interface between the local inhabitants and the international tourists, this proposed framework evaluates the similarities and differences in their experiences with the ultimate objective of informing the place-making process to sustain those qualities of the place that contribute to its distinctiveness.

Starting with the cultural processes that combine legibility and cultural significance, and with regards to legibility, Acre's inhabitants exhibited the highest level of comprehension of the urban form of their historic landscape while al-Salt's planners – mostly outsiders to the city hence lacking the nuanced knowledge of insiders (Mintzberg, 1994) – exhibited the lowest levels of legibility. These findings were consistent with those of the cultural significance whereby al-Salt witnessed the most conspicuous discrepancy between the local inhabitants on the one hand, and the planners and the project on the other hand. Conversely, the experience of the cultural significance of Aleppo's citadel and its *sūq*, also known as *Madīneh*, were shared among Aleppo's inhabitants, international tourists and planners and were also highlighted in the place-making initiatives, especially the Citadel Circle component. In the same vein, Acre's local inhabitants, international tourists and planners also similarly experienced its cultural significance, especially the distinctiveness of its townscape in general and its relationship to the Mediterranean in particular. The interpretation in Acre's development plan, however, was not in tandem with these views and highlighted – for the most part – its Crusader narrative at the expense of the other narratives including the Palestinian Arab, the Ottoman and the *Baha'i*. In particular, both Acre's and al-Salt's plans accentuated an official narrative of the historic urban landscape – one that was detached from the place experience of its local inhabitants, and in Acre's case, its international tourists.

Moving on to the spatial processes that combine compatibility and congruence, it was noticeable in the three case study cities that compatibility posed a challenge for the local inhabitants, which was exacerbated in al-Salt due to its topography. Acre, however, witnessed the only serious attempts to enhance the compatibility of the historic urban landscape through a strong understanding of the building typologies and the architectural classifications that facilitated the derivation of policies that offered choices rather than the prescriptions that manifested in Aleppo. By providing choices as opposed to prescriptions, the development plan in Acre allowed the symbiotic relationship between the local inhabitants and their historic urban landscape to continue according to which adaptation occurred in two ways: on the one hand, the historic physical fabric is adapted without compromising its integrity; and on the other hand, the local inhabitants adapt and adjust their living conditions to suit their historic fabric. The implications of such an approach entail an acceptance of change and an endorsement of continuity in the historic urban landscape's palimpsest – fundamental morphological principles. Conversely, Aleppo's stringent regulations shifted the place-making process from urban rehabilitation to architectural conservation that sought to freeze the historic urban landscape in a snapshot of a past time, in a typical manifestation of the myth of the unchanged (Echtner and Prasad, 2003: 669 and 674). In a different vein, al-Salt's absence of architectural conservation policies failed to curb the abandonment of the historic core and to control the dilapidation of the residential structures.

Congruence posed different challenges whereby the three case study cities grappled with the representation of local particularisms in their historic urban landscapes and leant either toward a national narrative – one that the nation-state approved of and endorsed – or toward a legitimized and Disneyfied historic urban landscape (see Chapter 1). In Aleppo and al-Salt particularly, the place-making initiatives – through historic conservation – presented the monumental and disregarded the ordinary and the mundane. Aleppo's and al-

Salt's place-making initiatives also obliterated local particularisms through the standardization policies that homogenized their historic urban landscapes. Conversely, the absence of such policies from Acre's place-making allowed local particularisms to emerge in the historic urban landscape hence permitted the reduction of spatial concepts to tangible images (Bacon, 1982: 30) (Plates 46, 47 and 48). In fact, in a manifestation of linkages between congruence and symbolic significance, the international tourists in Aleppo and in Acre almost unanimously preferred the local particularisms in both historic urban landscapes (see for example Table 6.2). Interestingly, one of the international tourists in Acre pleaded with the planners to leave Acre as it is, and to avoid Disneyfying its historic landscape. Moreover, these findings indicate the importance of local development in the place-making initiatives in historic urban landscapes as equally as tourism development. In other words, when the high fixed costs of place-making in such landscapes (see Chapter 1) include social infrastructure along with the architectural conservation, urban rehabilitation and tourism infrastructure, then it is possible to sustain the life within the historic urban landscape – an important aspect of place distinctiveness.

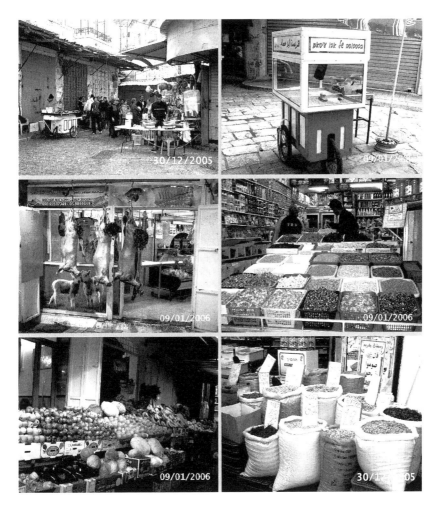

Plate 46 A snippet of local particularisms in Acre's *sūq*
Source: The author.

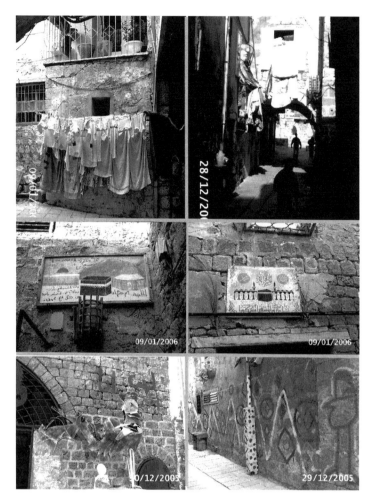

Plate 47 A snippet of local particularisms in Acre's residential *ḥārāt* (singular *ḥāra*)
Source: The author.

Lastly, social processes encompass place attachment and social interaction and yielded findings that were consistent with those of the other processes whereby Acre's inhabitants exhibited the highest levels of place attachment and interest in interacting with the tourists. Conversely, and notwithstanding their claims to a strong sense of ownership over their cultural heritage, Aleppo's and al-Salt's inhabitants demonstrated apathy toward the upkeep of their cities' public spaces and indifference toward relocating from their historic neighbourhoods. Interestingly, some of the planners in Aleppo and Acre advocated what they dubbed 'controlled gentrification' which in Aleppo referred to residential gentrification that would bring higher income inhabitants to the historic core while in Acre it referred to replacing the current inhabitants with one particular segment of the creative class, specifically artists. In addition, Aleppo's and al-Salt's inhabitants were wary, albeit to varying degrees, about the presence of international tourists in their historic urban landscapes. From their part, the international tourists in both Aleppo and Acre considered the local inhabitants an important component of their place experience. Surely, a need to educate all involved – local inhabitants, international tourists and planners – in tourism, and especially toward culturally sensitive social interactions in the context of heritage tourism, arose in all three cities.

The local inhabitants were the recurring theme in these analyses of place experience. As discussed in Chapter 1, rather than an 'outside-in' approach to the local inhabitants (Kotler et al., 1993: 135), the local

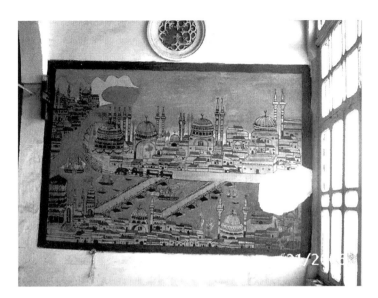

Plate 48 **A fresco representing Acre in one of the houses that exemplifies Bacon's (1982: 30) notion of the representations of local particularisms that became 'the means by which spatial concepts are reduced to tangible images'**
Source: The author.

inhabitants become part of the product by integrating their lives and livelihoods in the place-making processes. Such integration shifts the emphasis from historic conservation and tourism development toward place-making that, firstly, integrates the needs of the local inhabitants, secondly, provides them with choices rather than prescriptions and, thirdly, allows their self-representations to emerge in the historic urban landscape. Acre's case revealed that such a shift in fact complements rather than detracts from the planners' expertise and knowledge. In lieu of an authorized heritage discourse (Smith, 2006: 11, 300), the authority of Acre's planners shifted toward devising the methods for obtaining and distilling knowledge about the historic urban landscape, and especially toward merging their own 'expert' knowledge with the 'experiential' knowledge of constituencies. According to Friedmann (1993: 484), the latter refers to 'the uncodified knowledge of people who will be affected by potential solutions'. Indeed, the positive outsomes of Acre's development plan are attributed to the critical analysis of the uncodified knowledge of Acre's local inhabitants and its international tourists that was combined with the expertise of the planners and the conservation experts. In addition to mapping the movement of tourists in Acre, the planners, especially those who advocated the controlled gentrification, could benefit from gaining further insights on the preferences of tourists in Acre's historic landscape, and, in particular, from their appreciation of the life within this landscape.

Chapter 7
Conclusions

Theoretical, empirical and professional perspectives converge on the essentiality of conserving an historic urban landscape's sense of place, of integrating this landscape's local inhabitants in the planning processes and of offering international tourists a distinctive place experience. This book has investigated these indisputable ideals through the place-making and place experience processes. It identified in Chapter 1 two normative planning implications that arise from tourism development in historic urban landscapes and which entail, firstly, offering the international tourists a distinctive place experience and, secondly, integrating their needs in the place-making processes. Such place-making typically deploys strategies that include the marketing of an historic image; the rehabilitation of urban landscapes and the conservation of architectural structures; and the development of tourism infrastructure. These two normative planning implications lead to four contradictory, mutually exclusive conditions. Throughout this book, the theoretical discussions and the case study cities have offered insights on these four conditions.

The first of these conditions arises from the high fixed costs that are associated with place-making whose externalities are typically borne by the local inhabitants. Indeed, while the rehabilitation of the urban infrastructure in both Aleppo and Acre was provided at very low costs to the local inhabitants, they were nevertheless expected to bear a significant portion of the architectural conservation of historic structures. The place-making initiatives in Aleppo and Acre considered the investment in the rehabilitation of urban infrastructure crucial for extending the lifespan of the historic urban landscape, and particularly for the continuity of their residential function. Failing to capitalize on this opportunity in al-Salt, however, combined with the dysfunctional urban infrastructure, exacerbated the local inhabitants' exodus from the historic core. The place-making initiatives in Aleppo and Acre did not, however, extend similar investment perceptions to the conservation of architectural structures, particularly to the ordinary and the mundane that nonetheless contribute to the historic townscape's visual experience. Instead, and in order to facilitate the conservation of such structures, the senior planners in both cities spoke of controlled gentrification whereby in Aleppo they would supposedly cap the number of sold property to outsiders whereas in Acre they would permit only the creative class to live in the historic urban landscape. These views contrasted with the preferences of the international tourists, the majority of whom considered the 'otherness' of the lives and livelihoods of Aleppo's and Acre's inhabitants a crucial component of their place experience. These planners' views also contradicted the second condition whereby tourism in historic urban landscapes triggers global demand for distinctively local products. This demand instigates the commodification and, by consequence, the legitimization and Disneyfication of historic urban landscapes for tourism consumption both of which, if taken too far, lead to homogenization. The limits of acceptable change (Blockley, 1996) – at least architecturally and visually – have indeed been reached in Aleppo's Action Areas and in al-Salt's historic core (Plates 18 and 27) due, primarily, to the prescriptive building codes and regulations that precluded visual diversity. Interestingly, architectural and visual homogenization did not pose a threat to Acre's historic landscape because the regulations provided choices for architectural conservation rather than prescriptions. These choices stemmed directly from the thorough documentation that had successfully discerned Acre's local particularisms – not only the architectural, but also the morphological and the socio-economic and the cultural. New policies were thus devised that augmented these local particularisms in Acre's historic landscape. In fact, Acre's case revealed that thorough documentation holds the potential to yield new – yet crucial – information about the historic urban landscape's values, these values' complexities and their capricious nature. Therefore, instead of essentially centring on the inscription criteria for the World Heritage List, Acre's place-making accounted for the findings that emerged throughout the documentation process in a direct attempt to overcome the third condition's divergence between the national and the local perspectives in the management of heritage resources.

It is clear that the management of heritage resources in general, and world heritage in particular, leads to the bifurcation of national versus local values and this bifurcation has implications for the place-making, and

by consequence the place experience, processes. The findings from the three case study cities have confirmed that heritage is indeed layered and encompasses different narratives that range from the collective universalism to a multiplicity of local particularisms and whatever lies in between. One only has to consider Aleppo's multifaceted heritage of different historic periods, religions, ethnicities, professions and even quarters; or al-Salt's multifarious narratives of local tribes, *aghrāb* clans, caravan routes and hinterland links; or Acre's multi-layered heritage of Crusader, Ottoman and local Palestinian Arab narratives among others. The complexity of these values also entailed their overlap but simultaneously did not preclude conflict and competition among them. Thus, integrating them in the place-making processes certainly poses significant planning challenges. If anything, Acre's case has revealed that local engagement, while far from being perfect, played a significant role in alleviating some of these challenges. Certainly Aleppo, al-Salt and Acre all demonstrated some form of constrained rather than full participation. The difference in Acre, however, resided in the fact that its place-making initiatives simultaneously incorporated various forms of local inhabitants' representations together with diverse levels of participation both of which occurred at different times throughout the five stages of the place-making process (see Chapter 5). Local engagement in particular poses the most conflicts vis-à-vis world heritage with its inherent promotion of collective universalisms. The tourists in Aleppo and Acre, however, as discussed earlier, almost unanimously preferred the local particularisms and were attracted by them – highlighting in their comments the different other, the myth of the unchanged and a place whose lives and livelihoods are captured in a snapshot of a past time. These findings warrant the recognition of local particularisms within the world heritage debate whereby these particularisms coexist in tandem with – and not necessarily mutually exclusive to – the outstanding universal value associated with the world heritage status. Furthermore, and rather than the classifications and typologies that seek to justify the inscription of an historic urban landscape on the World Heritage List by fitting it to pre-set criteria, the case study cities have all revealed that the documentation process should be rooted in an attempt to understand the historic urban landscape. Therefore, instead of the normative, pre-set typologies and prescribed inscription criteria, accurate documentation adopts a grounded theory approach that allows the resulting data to guide the subsequent place-making processes. This again warrants a paradigm shift in the perception of the role of the conservation experts and their training in order to enable them to determine the types of knowledge required during the documentation of the historic urban landscape and to manage this knowledge once obtained. This shift advocates the fusion of the planners' expert knowledge and the locals' intuitive knowledge – in other words, Friedmann's (1993) expert and experiential knowledge. Such fusion inevitably enables the documentation process to balance the socio-economic and cultural conditions; the spatial and morphological dimensions; and the architectural and visual elements. These shifts that integrate the local conditions in the place-making processes lead to the fourth, and last, of the conditions, namely the perception of the local inhabitants of historic urban landscapes either as assets or as liabilities.

The commodification and the homogenization of historic urban landscapes alienate their local inhabitants. They also negatively impact the carrying capacity of the place and its limits of acceptable change. Herein lay accurate documentation that determines the thresholds (socio-economic and cultural; spatial and morphological; and architectural and visual) for the carrying capacity and the limits of acceptable change, which seem to have been reached in al-Salt in particular. Further, the socio-economic and cultural otherness of the local inhabitants constitutes an important component of the place experience; in other words, the local particularisms, or the 'glimpses of the lives of ordinary people' as one of the tourists had put it, entail far more than the monumental architecture singled out in the world heritage statutes. Chapter 2 diagnosed the contemporary challenges in Aleppo, al-Salt and Acre, firstly, as the conservation of the socio-economic and cultural factors whereby these cities struggled with the challenges of social mobility and demographic change. Here, the findings associated the continuity of the life within the historic urban landscape with the provision of social infrastructure. Secondly, these contemporary challenges raised morphological and spatial concerns that warrant a strong understanding of the historic urban landscape's morphology in order to determine its limits of acceptable change and to allow the natural adaptation processes to continue. Two points are crucial here, namely, that urban morphology is a spatial articulation of the socio-economic and cultural conditions, and that the balance between urban rehabilitation and architectural conservation maintains the symbiotic relationship between the historic urban landscape and its inhabitants. Al-Salt's example in particular has underscored how a profound understanding of the townscape and its distinctive morphological characteristics

were intertwined with the socio-economic and cultural characteristics and were collectively crucial for conserving place distinctiveness. This leads to the third and last of the contemporary challenges faced by Aleppo, al-Salt and Acre, which were the architectural and visual challenges. Acre's case has established that architectural conservation that accounts for the townscape's serial vision in fact emanates from – and is associated with – morphological rehabilitation. In addition, the findings from the case study cities have indicated that the provision of choices permits change and adaptation and supersedes the prescriptive policies that trigger Disneyfication and legitimization. Therefore, the heritage debate in general, and the world heritage debate in particular, needs to address the mechanisms for public engagement through a combination of: the representation of the local inhabitants, the level of their participation and the timing of their engagement. Moreover, such engagement necessitates the empowerment of the local inhabitants to define their experiences through: defining their perception of the values of their heritage; identifying their needs in the historic urban landscape; and contributing to the design of the possible future choices for their lives within this landscape. Aleppo's struggles with balancing tourism development and the conservation of the residential function have demonstrated the need to emancipate from a paternalistic approach to community engagement to an approach that genuinely empowers the local communities to define their choices. In fact, the findings in Acre have asserted that by providing an assortment of choices rather than prescriptive instructions, the place-making initiatives have empowered the local inhabitants and, also, have yielded outcomes that were more conducive to the conservation of the distinctive spirit of the historic urban landscape. Herein lies the advantage of the proposed place experience framework (Chapter 6 and Figure 6.1). This framework's analytical capacity facilitates the identification and the assessment of the experiential elements of place. This framework also maintains place as the interface between the international tourists and the local inhabitants, hence it offers a simultaneous juxtaposition of these two experiences in a manner that allows their comparison. In hindsight, it would be beneficial to introduce this framework during the earlier documentation phase in order to identify the elements that would be considered important constituents of a distinctive place experience for the international tourists and the local inhabitants, and, accordingly, to plan for their conservation. The flexibility of this proposed framework facilitates further additions to the measurable elements of each of the cultural, social and spatial processes that might be similar or different depending on each context's characteristics – a task for future research. But mostly, by situating the distinctive experience of a place at the intersection of that place's social, cultural and spatial conditions, this framework extends beyond the purely physical architectural and visual experience, and its implications for architectural conservation and visual authenticity to encompass Alexander's notion of 'wholeness' (Alexander, 1979) and his 'quality without a name' (Alexander et al., 1977). Indeed, Carmona et al. (2003) identified six interrelated dimensions for urban design: the morphological, the perceptual, the social, the visual, the functional and the temporal dimensions as an indication of the complexity of urban design and urban rehabilitation by consequence. Future research will be needed to further refine the proposed measurable elements of place experience and link them more closely to these six dimensions.

Postscript

Shortly after this book project had commenced in August 2010, the Arab Spring spread to the Syrian Arab Republic on 15 March 2011. While initially peaceful, the situation soon deteriorated until civil war eventually erupted and reached Aleppo by July 2012. In addition to the human suffering from the repercussions of this war, the Old City of Aleppo's historic urban landscape became a target for the various warring factions. In July 2012 both UNESCO and ICOMOS issued statements bringing the attention to the dangers facing Aleppo's historic landscape (UNESCO, 2012, ICOMOS, 2012), and by 2013 the Old City of Aleppo was inscribed on the List of World Heritage in Danger (UNESCO, 1992–2014e). Due to the dearth of in situ correspondents, it has become extremely difficult to verify the extent of the damage to Aleppo's historic landscape, and the various attempts at doing so remotely have yielded confusing outcomes. For example, Emma Cunliffe and the Global Heritage Fund issued a report in 2012 (Cunliffe and Global Heritage Fund, 2012: 35) that cited Arabic newspaper reports and accordingly stated that 'One news report suggests that entire historic neighbourhoods in Aleppo have been bulldozed', but continued to stress that 'but this has not been verified'. When I referred to

the original Arabic newspaper report, however, its contents relayed that such bulldozing of the neighbourhoods had in fact happened during the reign of Bashār al-Asad's father, Ḥāfiẓ, and not recently as misinterpreted in Cunliffe and the Global Heritage Fund's report (As-Sharq Al-Awsat, 2012). By presenting this controversy I am in no means claiming that the historic urban landscape of the Old City of Aleppo has been spared, but I am only presenting one example of the difficulty of obtaining accurate information about Aleppo's historic landscape from reliable sources.

More recently, Francesca Borri, an Italian freelance journalist, who is among the very few remaining journalists in Aleppo, has been providing firsthand accounts of the extent of the damage to the landscape of the Old City of Aleppo. On 1 May 2013, Borri (2013a) posted to twitter a photo of the damage to the *sūq* in the *Mdīneh* in the Old City of Aleppo.[1] Borri followed this photo on 4 June 2013 with a detailed report titled 'Syrian Dust', Borri (2013b) in which she reported more extensively about the damage to the *sūq* in the *Mdīneh*. Then on 1 July 2013, Borri (2013c) reported on her work in Aleppo in general, and specifically spoke of the damage to the Old City of Aleppo. On 20 May 2014 Martin Chulov (2014) reported to the Guardian about a new war technique in which tunnels are being dug under the historic core of the Old City of Aleppo in order to detonate explosives at specific targets. These subterranean tunnels that snake beneath Aleppo's historic core range in length between a few dozen meters and a few hundred meters. The tunnel used to destroy the Carleton Citadel Hotel in May 2014 reached 860 meters in length (Ibid.). Not only would such tunnels compromise the structural integrity of Aleppo's historic fabric, but the amount of explosives reportedly deployed would cause significant damage that would definitely extend beyond the specific targets. Surely, Chulov (2014) reported that the 25 tonnes of explosives that were used in the Carleton Citadel Hotel attack had rumbled and destroyed a 15-kilometre radius encircling the explosion site.

Beyond such intermittent reporting, it has been incredibly difficult to obtain accurate and reliable information about Aleppo's historic landscape. The personal reporting by anonymous bloggers also provides some insights on the level of destruction in Aleppo's historic core. For example, Z.E. is a female blogger who on 15 July 2014[2] reported that 'in April alone activists documented 650 barrel bomb and 100 missile attacks' had hit Aleppo (The Economist, 2014). When giving directions to her home, Z.E. reports that 'I usually say "pass the fully destroyed building with the pink cot hanging from it, to the wreckage with the graffiti saying 'We will remain steadfast!'; then my building is the first on your left"' (Ibid.). Furthermore, contact with friends in Aleppo has been impossible, while those friends who managed to leave Aleppo have also been unable to secure accurate and reliable information from within Aleppo. Friends like Nouha Attar, who was instrumental during my fieldwork in 2005, tried to help but to no avail. All the immediate members of Nouha's family have left Aleppo and she shared that, 'Sadly I do not have any photos since it became too risky to hold a camera anywhere in Syria 3 years ago' (email correspondence on 24 February 2014). I will conclude this postscript and book with Nouha's own words during this same correspondence: 'there is nothing worse than turning our backs to the fact that [war] is happening … I can only hope for the day that we have our home back … or at least the day that our children will realize what a beautiful place Syria used to be'.

1 This photo can be accessed at: https://twitter.com/francescaborri/status/329537986704330754
2 This posting to Z.E.'s blog can be accessed at: http://www.economist.com/blogs/pomegranate/2014/07/syrian-diary

Bibliography

The Hashemite Kingdom of Jordan. 1988. *The Antiquities Law*.
The Hashemite Kingdom of Jordan. 2005. *Law on the Protection of Traditional Architecture and Heritage*.
Aangeenbrug, R.T. 1991. 'A Critique of GIS'. In: Maguire, D.J., Goodchild, M.F. and Rhind, D.W. (eds) *Geographical Information Systems: Principles and Applications*. New York: Wiley.
Abu Salim, L. 2003. 'Salt: Nomination of Properties for Inclusion on the World Heritage List'. Al-Salt: Al-Salt Municipality.
Abu Shanab, M. 2004. *Akhādīd fi al-Thākirah*. Acre: Directorate of Arab Culture, the Israeli Ministry of Education, Culture, and Sports.
Abū Tālib, M., Khuraysāt, M. and Al-Ḥayārī, M. 2000. *Tārīkh madīnat al-Salṭ 'abra al-'uṣūr*. Al-Salt: Mu'assasat I'mār al-Salṭ.
Ahn, B., Lee, B. and Shafer, S. 2002. 'Operationalizing sustainability in regional tourism planning: An application of the limits of acceptable change framework'. *Tourism Management*, 23(1), 1–15.
Al-Asad, M. 2005. 'Rehabilitating old Aleppo'. *The Jordan Times*, Thursday, 5 May 2005.
Al-Kāyed, N. 2005. 'Abniyat al-Salṭ al-Turāthiyya Taḥkī Tārīkhahā wa Tasda'ī Māḍihā'. *Al-Rai*, Saturday, 4 June 2005.
Al-Zoabi, A.Y. 2004. 'The Influence of Building Attributes on Residents' "Images of the Past" in the Architecture of Salt City, Jordan'. *International Journal of Heritage Studies*, 10(3), 253–75.
Alexander, C. 1979. *The Timeless Way of Building*. New York: Oxford University Press.
Alexander, C., Ishikawa, S., Silverstein, M., Jacobson, M., FIksdahl-King, I. and Angel, S. 1977. *A Pattern Language: Towns. Buildings. Construction*. New York: Oxford University Press.
Alsalloum, A. 2011. A New International Instrument: The proposed UNESCO Recommendation on the Historic Urban Landscape (HUL) Remarks and Questions. Available: http://intbau.org/essays.html [Accessed 17 May 2011].
Alsayyad, N. 2001. 'Global Norms and Urban Forms in the Age of Tourism: Manufacturing Heritage, Consuming Tradition'. In: Alsayyad, N. (ed.), *Consuming Tradition, Manufacturing Heritage: Global Norms and Urban Forms in the Age of Tourism*. 1st ed. New York: Routledge and EF & N Spon, 1–33.
Anderson, B. 1991. *Imagined Communities: Reflections on the Origin and Spread of Nationalism*. London and NY: Verso.
ANSAmed. 2013. *Tourism: Jordan, Revenues Reach Usd 2.231 bln in 8 Months* [Online]. Ansa Mediterranean, a section of Agenzia Nazionale Stampa Associata, the Italian news agency. Anna Lindh Foundation – EuroMed. Available: http://www.ansa.it/ansamed/en/news/sections/economics/2013/09/24/Tourism-Jordan-revenues-reach-Usd-2-231-bln-8-months_9353180.html [Accessed 24 July 2014].
Arefi, M. and Triantafillou, M. 2005. 'Reflections on the Pedagogy of Place in Planning and Urban Design'. *Journal of Planning Education and Research*, 25(1), 75–88.
Arnstein, S.R. 1969. 'A Ladder of Citizen Participation'. *Journal of the American Planning Association*, 35(4), 216–24.
Ashworth, G.J. and Tunbridge, J.E. 1990. *The Tourist-Historic City*. London and New York: Belhaven Press.
Ashworth, G.J. and Voogd, H. 1990. *Selling the City: Marketing Approaches in Public Sector Urban Planning*. London: Belhaven Press.
Ashworth, G.J. and Voogd, H. 1994. 'Marketing and place promotion'. In: Gold, J.R. and Ward, S.V. (eds), *Place Promotion: The Use of Publicity and Marketing to Sell Towns and Regions*. New York: John Wiley & Sons, 39–52.
As-Sharq Al-Awsat. 2012. 'Al-Amāken al-Athariyya Tadfa' al-Thaman fī 'amaliyyat Qam' al-Thawrah al-Sūriyyah'. *As-Sharq Al-Awsat*, Thursday, 1 March 2012.

Australia ICOMOS 1979. 'The Australia ICOMOS Charter for the Conservation of Places of Cultural Significance (Burra Charter)'. ICOMOS Australia.

Australia ICOMOS 1999. 'The Burra Charter: The Australia ICOMOS Charter for the Conservation of Places of Cultural Significance'. ICOMOS Australia.

Bacon, E.N. 1982. *Design of Cities*. London, Thames & Hudson.

Beck, W. 2006. 'Narratives of World Heritage in Travel Guidebooks'. *International Journal of Heritage Studies*, 12(6), 521–35.

Beriatos, E. and Gospodini, A. 2004. '"Glocalising" urban landscapes: Athens and the 2004 Olympics'. *Cities*, 21(3), 187–202.

Bianca, S.A. 2000. *Urban From in the Arab World: Past and Present*. London: Thames & Hudson Ltd.

Bianca, S.A., David, J.-C., Rizzardi, G., Beton, Y. and Chauffert-Yvart, B. 1980. 'The Conservation of the Old City of Aleppo'. Restricted technical report prepared for the Government of the Syrian Arab Republic by the United Nations Educational, Scientific and Cultural Organization (UNESCO). Paris: UNESCO.

Bianchi, R. and Boniface, P. 2002. 'Editorial: The politics of World Heritage'. *International Journal of Heritage Studies*, 8(2), 79–80.

Blockley, M. 1996. 'Limits of Acceptable Change (LAC) and Recreational Carrying Capacity'. *Interpretation*, December, 21–3.

Boniface, P. and Fowler, P.J. 1993. *Heritage and Tourism in the Global Village* London: Routledge.

Borri, F. 2013a. #aleppo in the ancient souk, unesco world heritage site pic.twitter.com/XSTi9YczwC.

Borri, F. 2013b. 'Syrian Dust'. *Pressenza*, Tuesday, 4 June 2013.

Borri, F. 2013c. 'Woman's work: The twisted reality of an Italian freelancer in Syria'. *Columbia Journalism Review*, Monday, 1 July 2013.

Bosselman, F.P., Peterson, C.A. and Mccarthy, C. (eds) 1999. *Managing Tourism Growth: Issues and Applications*. Washington, DC: Island Press.

Briuer, F.L. and Mathers, C. 1997. *Trends and Patterns in Cultural Resource Significance: An Historical Perspective and Annotated Bibliography*. US Army Corps of Engineers.

Brundtland, G.H. 1987. *Our Common Future* [Online]. Available: http://www.un-documents.net/ocf-01.htm.

Bryden, D. 1996. 'Capacity Compromised'. *Interpretation*, December, 10–12.

Buchanan, P. 1988. 'What City? A Plea for Place in the Public Realm'. *Architectural Review*, 184(1101), 31–41.

Burke, E.M. 1968. 'Citizen Participation Strategies'. *Journal of the American Institute of Planners*, 34(5), 287–94.

Busquets, J. 2005. 'Why Aleppo?' In: Busquets, J. (ed.), *Aleppo: Rehabilitation of the Old City. The Eighth Veronica Rudge Green Prize in Urban Design*. Cambridge, MA: Harvard University Graduate School of Design, 11–21.

Cameron, C. 2005. 'What is OUV? Defining the Outstanding Universal Value of Cultural World Heritage Properties'. Keynote speech on the occasion of the Expert meeting on the concept of outstanding universal value which took place in Kazan, Russian Federation, from 6 to 9 April 2005 and which was titled 'Evolution of the Application of 'Outstanding Universal Value for Cultural and Natural Heritage'. Paris: The World Heritage Center.

Canter, D. 1977. *The Psychology of Place*. New York: St Martin's Press.

Carmona, M., Heath, T., Oc, T. and Tiesdell, S. 2003. *Public Places Urban Spaces: The Dimensions of Urban Design*. Oxford, UK: Architectural Press, an imprint of Elsevier.

Castells, M. 2002. 'Information Technology, the Restructuring of Capital–Labor Relationships, and the Rise of the Dual City'. In: Susser, I. (ed.), *The Castells Reader on Cities and Social Theory*. 1st ed. New York: Blackwell, 285–313.

Chancey, M.A. 2005. *Greco-Roman Culture and the Galilee of Jesus*. New York: Cambridge University Press.

Chang, T.C., Milne, S., Fallon, D. and Pohlmann, C. 1996. 'Urban heritage tourism: The global-local nexus'. *Annals of Tourism Research*, 23(2), 284–305.

Chapagain, N.K. 2007. 'Revisiting Conservation Charters in Context of Lomanthang, Nepal: Need to Acknowledge Local Inhabitants and Changing Contexts'. *City & Time*, 3(2), 55–65.

Chatterjee, P. 1993. *The Nation and Its Fragments: Colonial and Postcolonial Histories*. Princeton, NJ: Princeton University Press.

Checkoway, B. 1994. 'Paul Davidoff and Advocacy Planning in Retrospect'. *Journal of the American Planning Association*, 60(2), 139–44.

Chulov, M. 2014. 'Aleppo's most wanted man – the rebel leader behind tunnel bombs'. *The Guardian*. Available: http://www.theguardian.com/world/2014/may/20/aleppos-most-wanted-man-rebel-leader-tunnel-bombs [Accessed 24 July 2014].

Cleere, H. 1996. 'The concept of "outstanding universal value" in the World Heritage Convention'. *Conservation and Management of Archaeological Sites*, 1(4), 227–33.

Cobb, E. 2010. *Cultural Heritage in Conflict: World Heritage Cities of the Middle East*. Master of Science in Historic Preservation: University of Pennsylvania.

Cohen, E. 1979. 'A Phenomenology of Tourist Experiences'. *Sociology*, 13(2), 179–201.

Cohen, O., Kislev, R., Forman, Y. and Kitov, A. 2000. 'Nomination of the Old City of Acre for the World Heritage List'. Jerusalem: The Conservation Department of the Israeli Antiquities Authority.

Conzen, M.R.G. 1960. 'Alnwick Northumberland: A Study in Town-Plan Analysis'. *Transactions and Papers (Institute of British Geographers)*, 27, iii+ixxi+1+3–122.

Conzen, M.P. 2009. 'Classics in human geography revisited'. *Progress in Human Geography*, 33(6), 862–4.

Conzen, M.R.G. 1981. 'Geography and townscape preservation'. In: Whitehand, J.W.R. (ed.), *The Urban Landscape: Historical Development and Management, Papers by M.R.G. Conzen*. London: Academic Press, 75–86.

Cooper, P. 1996. 'Carrying Capacity and Visitor Management in Historic Cities'. *Interpretation*, December, 30–33.

Coplans, C. 2009. *Israel: Tel Aviv and Jaffa Twin-centres* [Online]. Available: http://www.travelweekly.co.uk/Articles/PFDetails/31083 [Accessed 27 June 2011].

Crang, M. 1996. 'Envisioning urban histories: Bristol as palimpsest, postcards, and snapshots'. *Environment & Planning A*, 28(3), 429–52.

Creighton, O. 2007. 'Contested Townscapes: The Walled City as World Heritage'. *World Archaeology*, 39(3), 339–54.

Cullen, G. 1971. *The Concise Townscape*. New York: Van Nostrand Reinhold Company.

Cunliffe, E. and Global Heritage Fund 2012. 'Damage to the Soul: Syria's Cultural Heritage in Conflict' Durham: Durham University.

Daher, R.F. 2005. 'Urban Regeneration/Heritage Tourism Endeavours: The Case of Salt, Jordan "Local Actors, International Donors, and the State"'. *International Journal of Heritage Studies*, 11(4), 289–308.

Dahles, H. 2001. *Tourism, Heritage and National Culture in Java: Dilemmas of a Local Community*. Richmond: Curzon Press.

Dakin, S. 2003. 'There's more to landscape than meets the eye: Towards inclusive landscape assessment in resource and environmental management'. *The Canadian Geographer*, 47(2), 185–200.

Dalgamouni, R. 2010. 'Third Tourism Project progress improving'. *The Jordan Times*, Thursday, 4 November 2010.

Davidoff, P. 1965. 'Advocacy and Pluralism in Planning'. *Journal of the American Planning Association*, 31(4), 331–8.

Davis, R. 1967. *Aleppo And Devonshire Square: English Traders in the Levant in the Eighteenth Century*. Toronto: MacMillan.

De Cisari, C. 2010. 'World Heritage and Mosaic Universalism: A view from Palestine'. *Journal of Social Archaeology*, 10(3), 299–324.

De Marco, L. 2009. 'Connecting principles with practice: From charters to guiding case studies'. *City & Time*, 4(2), 13–21.

Deeben, J., Groenewoudt, B.J., Hallewas, D.P. and Willems, W.J.H. 1999. 'Proposals for a Practical System of Significance Evaluation in Archaeological Heritage Management'. *European Journal of Archaeology*, 2(2), 177–99.

Di Giovine, M. 2009. *The Heritage-scape*. Toronto: Lexington Books.

Echtner, C.M. and Prasad, P. 2003. 'The context of third world tourism marketing'. *Annals of Tourism Research*, 30(3), 660–82.

Elkadi, H. and Pendlebury, J. 2001. 'Developing an Information Model to Support Integrating Conservation Strategies in Urban Management'. *Journal of Urban Technology*, 8(2), 75–93.

Ellin, N. 1999. *Postmodern Urbanism*. New York: Princeton University Press.

English Heritage 2000. *Power of Place: The Future of the Historic Environment*. English Heritage.

Ettinghausen, R., Grabar, O. and Jenkins-Madina, M. 2001. *Islamic Art and Architecture 650–1250*. New Haven: Yale University Press.

Fainstein, S.S. and Gladstone, D. 1999. 'Evaluating Urban Tourism'. In: Judd, D.R. and Fainstein, S.S. (eds) *The Tourist City*. New Haven: Yale University Press, 21–34.

Feilden, B.M. and Jokilehto, J. 1998. *Management Guidelines for World Cultural Heritage Sites*. Rome: ICCROM.

Fischbach, M. 2003. *Records of Dispossession: Palestinian Refugee Property and the Arab-Israeli Conflict*. New York: Columbia University Press.

Ford, M., Elkadi, H. and Watson, L. 1999. 'The Relevance of GIS in the Evaluation of Vernacular Architecture'. *Journal of Architectural Conservation*, 5(3), 64–75.

Forester, J., Fischler, R. and Shmueli, D. 2001. *Israeli Planners and Designers: Profiles of Community Builders*. Albany: State University of New York Press.

Frey, B.S. and Steiner, L. 2010. 'World Heritage List: Does it Make Sense?' *CESifo Working Paper No. 3078*, Category 2: Public Choice, 1–24.

Friedmann, J. 1993. 'Toward a Non-Euclidian Mode of Planning'. *Journal of the American Planning Association*, 59(4), 482–5.

Friedmann, J. and Hudson, B. 1974. 'Knowledge and Action: A Guide to Planning Theory'. *Journal of the American Planning Association*, 40(1), 2–16.

Fyall, A. and Rakić, T. 2006. 'The Future Market for World Heritage Sites'. In: Leask, A. and Fyall, A. (eds), *Managing World Heritage Sites*. Oxford: Butterworth-Heinemann, 159–75.

Galani-Moutafi, V. 2000. 'The self and the other: Traveler, ethnographer, tourist'. *Annals of Tourism Research*, 27(1), 203–24.

Galili, L. and Nir, O. 2001. 'From the Hebrew Press'. *Journal of Palestine Studies*, 30(3), 97–106.

Gates, C. 2003. *Ancient Cities: The Archaeology of Urban Life in the Ancient Near East and Egypt, Greece and Rome*. London: Routledge.

Godschalk, D.R. and Mills, W.E. 1966. 'A Collaborative Approach to Planning through Urban Activities'. *Journal of the American Institute of Planners*, 32(2), 86–95.

Gold, J.R. and Gold, M.M. 1995. *Imagining Scotland: Tradition, Representation and Promotion in Scottish Tourism Since 1750*. Brookfield, Vermont: Ashgate Publishing Company.

Gospodini, A. 2004. 'Urban morphology and place identity in European Cities: Built heritage and innovative design'. *Journal of Urban Design*, 9(2), 225–48.

Graham, B. 2002. 'Heritage as Knowledge: Capital or Culture'. *Urban Studies*, 39(5–6), 1003–17.

Graham, B., Ashworth, G.J. and Tunbridge, J.E. 2000. *A Geography of Heritage: Power, Culture and Economy*. New York: Oxford University Press.

Gray, C. 2002. *A Renewal of Faith in Petra: Jordan's Geographical Proximity to Israel and Palestine has Caused Many to Question its Safety as a Holiday Destination* [Online]. Independent Digital (UK) Ltd. Available: http://travel.independent.co.uk/low_res/story.jsp?story=313035&host=2&dir=42 [Accessed 9 August 2004].

Green, P. 1996. *Hellenistic History and Culture*. Berkeley, CA: University of California Press.

Groat, L. 1995. 'Introduction: Place, Aesthetic Evaluation and Home'. In: Groat, L. (ed.), *Giving Places Meaning*. London: Academic Press, 1–26.

Groat, L. and Wang, D. 2002. 'Case Studies and Combined Strategies'. *Architectural Research Methods*. New York: John Wiley & Sons Inc.

Grunewald, R.D.A. 2002. 'Tourism and cultural revival'. *Annals of Tourism Research*, 29(4), 1004–21.

GTZ. 2008. *Toolkit for Urban Conservation and Development* [Online]. Germany. Available: http://www.udp-aleppo.org/toolkit/mod/en/mod0/credits.html [Accessed 28 January 2013].

Hakim, B. 1986. *Arabic-Islamic Cities: Building and Planning Principles*. London: KPI.

Hamdi, N. and Goethert, R. 1997. *Action Planning for Cities: A Guide to Community Practice*. New York: John Wiley & Sons.

Harris, P. 1996. 'Privacy Regulation and Place Attachment: Predicting Attachments to a Student Family Housing Facility'. *Journal of Environmental Psychology*, 16(4), 287–301.

Hartal, M. 1997. 'Excavation of the Courthouse Site at 'Akko: Summary and Historical Discussion'. *'Atiqot*, XXXI, 109–14.

Harvey, D. 2001a. 'The art of rent: Globalization and the commodification of culture'. In: Harvey, D., *Spaces of Capital: Towards a Critical Geography*. 1st ed. New York: Routledge, 394-411.

Harvey, D. 2001b. *Spaces of Capital: Towards a Critical Geography*. New York: Routledge.

Hassan, F.A. 2007. 'The Aswan High Dam and the International Rescue Nubia Campaign'. *African Archaeological Review*, 24(3–4), 73–94.

Hasselquist, F. 1766. *Voyages and Travels in the Levant, in the Years 1749, 50, 51, 52: Containing Observations in Natural History, Physick, Agriculture, and Commerce: Particularly on the Holy Land, and the Natural History of the Scriptures*. London: Printed for L. Davis and C. Reymers.

Hayden, D. 1999. *The Power of Place: Urban Landscapes as Public History*. Cambridge: The MIT Press.

Hecht, E. 1997. 'A Sinking City'. *Jerusalem Post*, Friday, 31 October 1997.

Herlin, I.S. 2004. 'New Challenges in the Field of Spatial Planning: Landscapes'. *Landscape Research*, 29(4), 399–411.

Herzfeld, M. 1991. *A Place in History: Social and Monumental Time in a Cretan Town*. Princeton: Princeton University Press.

Herzfeld, M. 1997. *Cultural Intimacy: Social Poetics in the Nation-State*. New York and London: Routledge.

Herzfeld, M. 2004. *The Body Impolitic: Artisans and Artifice in the Global Hierarchy of Value*. Chicago: The University of Chicago Press.

Holloway, J.C. and Robinson, C. 1995. *Marketing for Tourism*. Singapore: Longman Group Limited.

Horsfield, G. and Conway, A. 1930. 'Historical and Topographical Notes on Edom: With an Account of the First Excavations at Petra'. *The Geographical Journal*, 76(5), 369–88.

Howard, P. 2006. 'Editorial: Valediction and Reflection'. *International Journal of Heritage Studies*, 12(6), 483–8.

ICOMOS 1931. 'The Athens Charter for the Restoration of Historic Monuments'. Adopted at the First International Congress of Architects and Technicians of Historic Monuments, Athens, Greece. Paris: ICOMOS.

ICOMOS 1964. 'International Charter for the Conservation and Restoration of Monuments and Sites (The Venice Charter 1964)'. Adopted at the Second International Congress of Architects and Technicians of Historic Monuments, Venice, Italy. Paris: ICOMOS. Available: http://www.international.icomos.org/charters/venice_e.pdf

ICOMOS 1972. 'Resolutions of the Symposium on the Introduction of Contemporary Architecture into Ancient Groups of Buildings, at the Third General Assembly of ICOMOS in Budapest, Hungary'. Paris: ICOMOS.

ICOMOS 1975. 'Resolutions of International Symposium on the Conservation of Smaller Historic Towns (Bruges Resolutions)'. Fourth General Assembly of ICOMOS in Bruges, Belgium. Paris: ICOMOS.

ICOMOS 1982. 'Tlaxcala Declaration on the Revitalization of Small Settlements'. Adopted at the third Inter-American Symposium on the Conservation of the Building Heritage, organized by the Mexican National Committee of ICOMOS and held in Trinidad, Tlaxcala, from 25 to 28 October 1982. Paris: ICOMOS. Available: http://www.icomos.org/en/charters-and-texts?id=385:tlaxcala

ICOMOS 1987. 'Charter for the Conservation of Historic Towns and Urban Areas (Washington Charter 1987)'. Adopted by ICOMOS General Assembly in Washington, DC, October 1987. Paris: ICOMOS. Available: http://www.international.icomos.org/charters/towns_e.pdf

ICOMOS 1990. 'Charter for the Protection and Management of the Archaeological Heritage'. Prepared by the International Committee for the Management of Archaeological Heritage (ICAHM) an approved by the 9th General Assembly in Lausanne in 1990. Paris: ICOMOS. Available: http://www.international.icomos.org/charters/arch_e.pdf

ICOMOS 1993. 'Guidelines for Education and Training in the Conservation of Monuments, Ensembles and Sites'. Adopted at the General Assembly of the International Council on Monuments and Sites,

ICOMOS, meeting in Colombo, Sri Lanka, at its tenth session from July 30 to August 7, 1993. Paris: ICOMOS. Available: http://www.icomos.org/charters/education-e.pdf

ICOMOS 1994. 'The Nara Document on Authenticity'. Adopted during the Nara Conference held in Nara, Japan in November 1994. Paris: ICOMOS.

ICOMOS 1996a. 'The Declaration of San Antonio'. Adopted by the delegates and members of the ICOMOS National Committees of the Americas, in San Antonio, Texas, United States of America, between 27 and 30 March, 1996, at the InterAmerican Symposium on Authenticity in the Conservation and Management of the Cultural Heritage. Paris: ICOMOS.

ICOMOS 1996b. 'Principles for the Recording of Monuments, Groups of Buildings and Sites'. Ratified by the 11th ICOMOS General Assembly in Sofia, October 1996. Paris: ICOMOS. Available: http://www.icomos.org/charters/archives-e.pdf

ICOMOS 1998. 'Stockholm Declaration of ICOMOS Marking the 50th Anniversary of the Universal Declaration of Human Rights'. Paris: ICOMOS. Available: http://www.icomos.org/charters/Stockholm-e.pdf

ICOMOS 1999a. 'International Cultural Tourism Charter: Managing Tourism at Places of Heritage Significance'. Adopted by ICOMOS at the 12th General Assembly in Mexico, October 1999. Paris: ICOMOS. Available: http://www.international.icomos.org/charters/tourism_e.pdf

ICOMOS 1999b. 'Charter on the Built Vernacular Heritage'. Ratified by the ICOMOS 12th General Assembly, in Mexico, October 1999'. Paris: ICOMOS. Available: http://www.international.icomos.org/charters/vernacular_e.pdf

ICOMOS 2002. 'The Old City of Acre Evaluation Package'. Paris: ICOMOS.

ICOMOS 2008a. 'Charter on the Interpretation and Presentation of Cultural Heritage Sites'. Ratified by the 16th General Assembly of ICOMOS, Québec (Canada), on 4 October 2008. Paris: ICOMOS. Available: http://www.international.icomos.org/charters/interpretation_e.pdf

ICOMOS 2008b. 'The ICOMOS Charter on Cultural Routes'. Ratified by the 16th General Assembly of ICOMOS, Québec (Canada), on 4 October 2008. Paris: ICOMOS. Available: http://www.international.icomos.org/charters/culturalroutes_e.pdf

ICOMOS 2008c. 'Québec Declaration on the Preservation of the Spirit of Place'. Adopted at Québec, Canada, on 4 October 2008. Paris: ICOMOS.

ICOMOS 2010. 'Lima Declaration for Disaster Risk Management of Cultural Heritage'. Adopted at the Symposium on Disaster Risk Management of Cultural Heritage in Lima, Peru on 3 December 2010. Paris: ICOMOS.

ICOMOS. 2011a. *International Council on Monuments and Sites* [Online]. ICOMOS. Available: http://www.icomos.org [Accessed 19 June 2012].

ICOMOS 2011b. 'Joint ICOMOS_TICCIH Principles for the Conservation of Industrial Heritage Sites, Structures, Areas and Landscapes'. Adopted by the 17th ICOMOS General Assembly on 28 November 2011. Paris: ICOMOS. Available: http://www.icomos.org/Paris2011/GA2011_ICOMOS_TICCIH_joint_principles_EN_FR_final_20120110.pdf

ICOMOS 2011c. 'The Valetta Principles for the Safeguarding and Management of Historic Cities, Towns and Urban Areas'. The 17th ICOMOS General Assembly'. Adopted by the 17th ICOMOS General Assembly on 28 November 2011 in Valetta, Malta. Paris: ICOMOS. Available: http://www.international.icomos.org/Paris2011/GA2011_CIVVIH_text_EN_FR_final_20120110.pdf

ICOMOS 2011d. 'The Paris Declaration on heritage as a driver of development'. Adopted at Paris, UNESCO headquarters, on Thursday, 1 December 2011 during the 17th General Assembly of the International Council on Monuments and Sites (ICOMOS). Paris: ICOMOS. Available: http://www.international.icomos.org/Paris2011/GA2011_Declaration_de_Paris_EN_20120109.pdf

ICOMOS. 2012. *ICOMOS warns on Aleppo's cultural heritage* [Online]. Paris: ICOMOS. Available: http://www.icomos.org/en/what-we-do/disseminating-knowledge/newsletters/499-icomos-warns-on-aleppo-s-cultural-heritage [Accessed 9 January 2014].

ICOMOS Brazilian Committee 1987. 'First Brazilian Seminar about the Preservation and Revitalization of Historic Centers'. Adopted at the First Brazilian Seminar about the Preservation and Revitalization of

Historic Centers in Itaipava, Brazil in July 1987. Paris: ICOMOS. Available: http://www.icomos.org/en/charters-and-texts?id=194:first-braz

ICOMOS Canada 1982. 'Deschambault Declaration: Charter for the preservation of Quebec's Heritage'. Adopted by the Conseil des monuments et des sites du Québec, ICOMOS Canada French-Speaking Committee, April 1982. Paris: ICOMOS. Available: http://www.icomos.org/en/charters-and-texts?id=192:the-de

ICOMOS Canada 1983. 'Appleton Charter for the Protection and Enhancement of the Built Environment'. Published by ICOMOS Canada under the auspices of the English-Speaking Committee, Ottawa, Canada, August 1983. Available: http://www.international.icomos.org/charters/appleton.pdf

Ishimori, S., Maita, A. and Seki, Y. 2004. 'Community Based Tourism Development'. Japan International Cooperation Agency (JICA), Social Development Study Department.

Jacobs, J. 1961. *The Death and Life of Great American Cities*. New York: Vintage Books.

Jamal, T.B. and Getz, D. 1995. 'Collaboration theory and community tourism planning'. *Annals of Tourism Research*, 22(1), 186–204.

Japan International Corperation Agency. 2011. *Activities in Jordan* [Online]. Available: http://www.jica.go.jp/jordan/english/activities/activity02.html [Accessed 14 June 2011].

Jeffers, J.S. 2009. *The Greco-Roman World of the New Testament Era: Exploring the Background of Early Christianity*. Downers Grove, IL: InterVarsity Press.

Jel'ad, H. 2005. Ḥafl Ishhār al-Mabāni al-Murammama fil Madīna al-'Atīqa, Abu el-Samen: Nas'ā li Idrāj al-Salṭ 'al ā Qā'imat al-Turāth al-' Ālamī. *Al-Rai*, Tuesday, 15 March 2005.

JICA. 2004. *Japan International Cooperation Agency* [Online]. Japan International Cooperation Agency. Available: http://www.jica.go.jp/jordan/index.html [Accessed 16 November 2004].

Jivén, G. and Larkham, P.J. 2003. 'Sense of Place, Authenticity and Character: A Commentary'. *Journal of Urban Design*, 8(1), 67–81.

Jokilehto, J. 1999. *A History of Architectural Conservation*. Oxford: Butterworth-Heinemann.

Jokilehto, J., Cameron, C., Parent, M. and Petzet, M. 2008. 'What is OUV? Defining the Outstanding Universal Value of Cultural World Heritage Properties'. Berlin: hendrik Bäßler verlag.

Jordan Tourism Board. 2011. *Visit Jordan* [Online]. Amman. Available: http://www.visitjordan.com and http://www.visitjordan.com/Default.aspx [Accessed 4 January 2014].

Jørum, E. 2004. 'European Territorial Legacy: Syrian Policies towards Lebanon and Hatay/liwa' Iskandarunah'. *Sixth Nordic Conference on Middle Eastern Studies, Workshop 5: The Middle East and the Area Studies Controversy*. Copenhagen 8-10 October.

Joseph, S. 1999. *Intimate Selving in Arab Families: Gender, Self, and Identity*. Syracuse: Syracuse University Press.

Judd, D.R. and Fainstein, S.S. 1999. 'Global Forces, Local Strategies and Urban Tourism'. In: Judd, D. R. and Fainstein, S.S. (eds), *The Tourist City*. New Haven: Yale University Press, 1–17.

Karimi, K. 2000. 'Urban conservation and spatial transformation: preserving the fragments or maintaining the "spatial spirit"', *International Journal of Urban Design*, 5(3), 221–31.

Kavaratzis, M. 2004. 'From city marketing to city branding: Towards a theoretical framework for developing city brands'. *Place Branding*, 1(1), 58–73.

Kedar, B.Z. 1997. 'The Outer Walls of Frankish Acre'. *'Atiqot*, XXXI, 157–80.

Kenyon, K.M. 1957. *Digging Up Jericho: The Results of the Jericho Excavations 1952–1956*. New York: Praeger, Fredrick A.

Kesten, A. 1993. 'The Old City of Acre: Re-Examination Report 1993'. Acre: The Old Acre Development Company.

Khechen, M. 2005. 'Spatial Restructuring and Participatory Public Action'. In: Busquets, J. (ed.), *Aleppo: Rehabilitation of the Old City. The Eighth Veronica Rudge Green Prize in Urban Design*. Cambridge, MA: Harvard University Graduate School of Design, 55–67.

Khirfan, L. 2010a. 'From Documentation to Policy-Making: Management of Built Heritage in Old Aleppo and Old Acre'. *Traditional Dwellings and Settlements Review*, XXI(II), 35–54.

Khirfan, L. 2010b. 'Traces on the palimpsest: Heritage and the urban forms of Athens and Alexandria'. *Cities*, 27(5), 315–25.

Khirfan, L. 2013. 'Ornamented Facades and Panoramic Views: The Impact of Tourism Development on al-Salt's Historic Urban Landscape'. *International Journal of Islamic Architecture*, 2(2), 307–25.

Khuraysāt, M.A.A.-Q. 1997. *Dirāsāt fī tārīkh madīnat al-Salṭ*. Amman, Jordan: Ministry of Culture.

Kim, J. and Kaplan, R. 2004. 'Physical and Psychological Factors in Sense of Community: New Urbanist Kentlands and Nearby Orchard Village'. *Environment and Behavior*, 36(3), 313–40.

Kirshenblatt-Gimblett, B. 2004. 'Intangible Heritage as Metacultural Production'. *Museum International*, 56(1–2), 52–65.

Kool, R. 1997. 'The Genoese Quarter in Thirteenth-Century Acre: A Reinterpretation of its Layout'. *'Atiqot*, XXXI, 187–200.

Koster, E. 1998. 'Urban morphology and computers'. *Urban Morphology*, 2(1), 3–7.

Kostof, S. 1991. *The City Shaped: Urban Patterns and Meanings Through History*. NYC, Bulfinch Press: Time Warner Book Group.

Kotler, P., Haider, D.H. and Rein, I. 1993. *Marketing Places: Attracting Investment, Industry, and Tourism to Cities, States and Nations*. New York: The Free Press, Macmillan, Inc.

Krier, L. 1998. *Architecture: Choice or Fate*. Windsor: Andreas Papadakis Publisher.

Kushner, D. 1997. 'Zealous towns in nineteenth-century Palestine'. *Middle Eastern Studies*, 33(3), 597–612.

Larkham, P.J. 1996. *Conservation and the City*. New York: Routledge.

Law, C.M. 1996. 'Tourism in Major Cities: Introduction'. In: Law, C.M. (ed.), *Tourism in Major Cities*. Boston, MA: International Thomson Business Press, 1–22.

Lees, L., Slater, T. and Wyly, E. 2008. *Gentrification*. New York: Routledge.

Lewcock, R. 2002. 'Cities in the Islamic World'. In: Petruccioli, A. and Pirani, K.K. (eds), *Understanding Islamic Architecture*. London and NY: Routledge Curzon, 41–7.

Lewicka, M. 2011. 'Place attachment: How far have we come in the last 40 years?'. *Journal of Environmental Psychology*, 31(3), 207–30.

Lilley, K., Lloyd, C., Trick, S. and Graham, C. 2005. 'Mapping and analysing medieval built form using GPS and GIS'. *Urban Morphology*, 9(1), 5–15.

Lipe, W.D. 1974. 'A Conservation Model for American Archaeology'. *The KIVA*, 39(3/4), 213–45.

Lo, C.P. 2007. 'The application of geospatial technology to urban morphological research'. *Urban Morphology*, 11(2), 81–90.

Lo, C.P. and Yeung, A.K.W. 2002. *Concepts and Techniques of Geographic Information Systems*. Upper Saddle River, NJ: Prentice Hall.

Lowenthal, D. 1998. *The Heritage Crusade and the Spoils of History*. Cambridge, UK: Cambridge University Press.

Lowenthal, D. 2002. *The Past is a Foreign Country*. Cambridge: Cambridge University Press.

Luck, T. 2009. 'Salt poised to give tourists taste of Kingdom's urban heritage'. *The Jordan Times*. Friday, 13 February 2009.

Lynch, K. 1960. *The Image of the City*. Cambridge, MA: Massachusetts Institute of Technology.

Lynch, K. 1981. *Good City Form*. Cambridge, MA: The MIT Press.

Maalouf, A. 1985. *The Crusades Through Arab Eyes*. New York: Schocken Books Inc.

MacCannell, D. 1999. *The Tourist: A New Theory of the Leisure Class*. Berkeley, CA: The University of California Press.

MacLean, M.G.H. 1996. 'Capturing the Past: Documentation & Conservation'. *Conservation, The Getty Conservation Institute Newsletter*, 11(2), 12–13.

Maddern, J. 2004. 'Huddled Masses Yearning to Buy Postcards: The Politics of Producing Heritage at the Statue of Liberty – Ellis Island National Monument'. *Current Issues in Tourism*, 7(4–5), 303–14.

Maffi, I. 2002. 'New Museographic Trends in Jordan'. In: Joffé, G. (ed.), *Jordan in Transition*. New York: Hurst & Co. (Publishers) Ltd, 208–24.

Makhkhūl, N.H. 1979 *'Akkā wa-qurāha: min aqdam al-azminah ilā al-waqt al-hāḍir*. 'Akkā: Al-Aswār.

Mansour, J. 2006. 'The Hijaz-Palestine Railway and the Development of Haifa'. *Jerusalem Quarterly*, Autumn (28), 5–21.

Maslow, A.H. 1954. *Motivations and Personality*. New York: Harper & Row Publishers.

Mason, R.F. 2002. 'Assessing Values in Conservation Planning: Methodological Issues and Choices'. In: De la Torre, M. (ed.), *Assessing the Values of Cultural Heritage*. Los Angeles: The Getty Conservation Institute, 5–30.

Massad, J.A. 2001. *Colonial Effects: The Making of National Identity in Jordan*. New York: Columbia University Press.

Mathers, C., Darvill, T. and Little, B.J. (eds) 2005. *Heritage of Value, Archaeology of Renown: Reshaping Archaeological Assessment and Significance*. Gainesville: University Press of Florida.

Maundrell, H. 1848. *A Journey from Aleppo to Jerusalem at Easter 1697*. London: Printed for C. & J. Rivington. Available: https://archive.org/details/journeyfromalepp00maunrich [Accessed 24 July 2014].

McCarthy, D. 2004. 'Innovative Methods for Documenting Cultural Resources: Integrating GIS and GPS Technologies'. *CRM*, Summer 2004, 86–91.

Meyer, K.E. 2005. 'Syriana, or the Godfather, Part IV'. *World Policy Journal*, 22(4), 87–91.

Middleton, V.T.C. and Hawkins, R. 1998. *Sustainable Tourism, A Marketing Perspective*. Oxford: Butterworth-Heinemann.

Mieczkowski, Z. 1995. *Environmental Issues of Tourism and Recreation*. New York: University Press of America, Inc.

Miele, C. 2005. 'Conservation Plans and the Development Process'. *Journal of Architectural Conservation*, 11(2), 23–39.

Ministry of Tourism and Antiquities. 2009–10. *Table 5.18: Monthly Number of Visitors to Salt Museum by Nationality* [Online]. Amman, Jordan: Ministry of Tourism and Antiquities. Available: http://www.tourism.jo/en/Default.aspx?tabid=121 [Accessed 4 January 2014].

Mintzberg, H. 1994. 'The Fall and Rise of Strategic Planning'. *Harvard Business Review*, January–February 1994, 107–14.

Mitchell, T. 1991. *Colonising Egypt*. Berkeley, CA: University of California Press.

Mitchell, T. 1995. 'Worlds Apart: An Egyptian Village and the International Tourism Industry'. *Middle East Report*, 196, 8–11 and 23.

Mitchell, T. 2001. 'Making the Nation: The Politics of Heritage in Egypt'. In: Alsayyad, N. (ed.), *Consuming Tradition, Manufacturing Heritage: Global Norms and Urban Forms in the Age of Tourism* 1st ed. New York: Routledge and E.F. & N Spon, 212–39.

Montgomery, J. 1998. 'Making and City: Urbanity, Vitality and Urban Design'. *Journal of Urban Design*, 3(1), 93–116.

Moratto, M.J. and Kelly, R.E. 1976. 'Significance in Archaeology'. *The KIVA*, 42(2), 193–202.

Morris, B. 2004. *The Birth of the Palestinian Refugee Problem Revisited*. New York: Cambridge University Press.

Nakhal, R. and Spiekermann, M. 2004. *The Rehabilitation of the Old City of Aleppo: Urban Development in a World Cultural Heritage Site*. Aleppo: GTZ (Deutsche Gesellschaft für Technische Zusammenarbeit) GmbH and the Directorate of the Old City of Aleppo.

Nasser, N. 2003. 'Planning for Urban Heritage Places: Reconciling Conservation, Tourism, and Sustainable Development'. *Journal of Planning Literature*, 17(4), 467–79.

Nichols, T. 1997. 'Computing for Conservation'. *Architect's Journal*, 205, 52–3.

Nippon Koei Co., L., Padeco Co., L. and Regional Planning International Co., L. 1996a. 'The Study on the Tourism Development Plan in the Hashemite Kingdom of Jordan. Executive Summary: National Tourism Development Strategy and Policy (Part I)'. In: *The Study on the Tourism Development Plan in the Hashemite Kingdom of Jordan*. Amman, Jordan: Ministry of Tourism & Antiquities, the Hashemite Kingdom of Jordan and Japan International Cooperation Agency (JICA).

Nippon Koei Co., L., Padeco Co., L. and Regional Planning International Co., L. 1996b. 'The Study on the Tourism Development Plan in the Hashemite Kingdom of Jordan. Development Plans for Priority Areas (Volume 2)'. In: *The Study on the Tourism Development Plan in the Hashemite Kingdom of Jordan*. Amman, Jordan: Ministry of Tourism & Antiquities, the Hashemite Kingdom of Jordan and Japan International Cooperation Agency (JICA).

Norberg-Schulz, C. 1980. *Genius Loci: Towards a Phenomenology of Architecture*. NYC: Rizzoli.

Nuryanti, W. 1996. 'Heritage and postmodern tourism'. *Annals of Tourism Research*, 23(2), 249–60.

Oikos, Herrle, P. and Nebel, S. 2005. 'Old City of Aleppo – Conservation and Development Strategy'. Aleppo: Berlin Project for the Rehabilitation of the Old City of Aleppo.

Old Acre Development Company. 2013. *Old Acre* [Online]. Acre. Available: http://www.akko.org.il/en/About-the-Old-Acre-Development-Company [Accessed 4 January 2014].

Old Jaffa Development Company. 2014. *Old Jaffa* [Online]. Tel Aviv. Available: http://www.oldjaffa.co.il/?CategoryID=212&ArticleID=353 [Accessed 4 January 2014].

Oliphant, L. 1880. *The Land of Gilead, with Excursions in the Lebanon*. Edinburgh & London: William Blackwood & Sons.

Olsson, K. 2008. 'Citizen input in urban heritage management and planning: A quantitative approach to citizen participation'. *TPR*, 79(4), 371–96.

Orbaşli, A. 2000. *Tourists in Historic Towns: Urban Conservation and Heritage Management*. New York: E F & N Spon.

Pacific Consultants International and Yamashita Sekkei Inc. 2000. 'Detailed Design for Tourism Sector Development Project in the Hashemite Kingdom of Jordan. Final Report (Main Report). Volume 7MR. Historic Old Salt Development Sub-Project'. Amman, Jordan: Japan International Cooperation Agency (JICA), the Ministry of Tourism & Antiquities and the Ministry of Planning, the Hashemite Kingdom of Jordan.

Parent, M. 1979. 'Comparative Study of Nominations and Criteria for World Cultural Heritage'. An annex to: UNESCO 1979. Third Session of the World Heritage Committee, Luxor, Arab Republic of Egypt, 23-27 October 1979. Item 6 of the Provisional Agenda: Principles and Criteria for Inclusion of Properties on World Heritage List.. Paris: UNESCO.

Pearce, P.L. and Fagence, M. 1996. 'The legacy of Kevin Lynch: Research Implications'. *Annals of Tourism Research*, 23(3), 576–598.

Pearson, M. and Sullivan, S. 1999. *Looking After Heritage Places: The Basics of Heritage Planning for Manages, Landowners and Administrators*. Melbourne: Melbourne University Press.

Pendlebury, J. 2009. *Conservation in the Age of Consensus*. New York: Routledge.

Perry, C. 1743. *A View of the Levant: Particularly of Constantinople, Syria, Egypt, and Greece*. London, T. Woodward.

Philipp, T. 2001. *Acre: The Rise and Fall of a Palestinian City, 1730–1831*. New York: Columbia University Press.

Pitard, W.T. 1987. *Ancient Damascus: A Historical Study of the Syrian City-state from Earliest Times Until its Fall to the Assyrians in 732 B.C.E.* Winona Lake, IN: Eisenbrauns.

Proshansky, H.M., Fabian, A.K. and Kaminoff, R. 1983. 'Place-Identity: Physical World Socialization of the Self'. *Journal of Environmental Psychology*, 3(1), 57–83.

Punter, J. 1991. 'Participation in the Design of Urban Space'. *Landscape Design*, 200, 24–7.

Raab, L.M. and KLINGER, T.C. 1977. 'A Critical Appraisal of Significance in Contract Archaeology'. *American Antiquity*, 42(4), 629–34.

Rahamimoff, J. (ed.) 1997. *Arie Rahamimoff: Architect & Urbanist*. Jerusalem: A.S.R.

Rakić, T. 2007. 'World Heritage: Issues and Debates'. *Tourism: An International Interdisciplinary Journal*, 55(2), 209–19.

Rakić, T. and Chambers, D. 2007. 'World Heritage: Exploring the tensions between the national and the "universal"'. *Journal of Heritage Tourism*, 2(3), 145–55.

Ramadan, M. 2001. 'GIS in a World Heritage Site – Mapping Urban Development in Old Aleppo'. A paper presented at *Geospatial World*, the Intergraph Geospatial Users Community IGUC Atlanta, Georgia, USA, June 18-20, 2001.

Ramadan, M. 2003. *The GIS of the Old City of Aleppo*. Aleppo, Syria: Suradec.

Ramadan, M., Makdisi, S. and Jouhar, M. 2004. 'Information Technology Final Report 2003'. Aleppo, Syria: Suradec: Sustainable Urban Rehabilitation, Architectural Design and Engineering Consortium.

Read, M. 2005. 'Planning and the Picturesque: A Case Study of the Dunedin District Plan and its Application to the Management of the Landscape of the Otago Peninsula'. *Landscape Research*, 30(3), 337–59.

Relph, E. 1976. *Place and Placelessness*. London: Pion Limited.

Robinson, M. 1999. 'Cultural Conflicts in Tourism: Inevitability and Inequality'. In: Robinson, M. and Boniface, P. (eds), *Tourism and Cultural Conflicts*. 1st ed. Oxon and New York: CABI Publishing, 1–32.

Robinson, M. 2001. 'Tourism Encounters: Inter- and Intra-Cultural Conflicts and the World's Largest Industry'. In: Alsayyad, N. (ed.), *Consuming Tradition, Manufacturing Heritage: Global Norms and Urban Forms in the Age of Tourism*. 1st ed. New York: Routledge, 34–67.

Rogan, E.L. 1996. 'The Making of a Capital: Amman, 1918–1928'. In: Shami, S. and Hannoyer, J. (eds), *Amman: Ville et Société. The City and Its' Society*. Beirut, Lebanon: Centre d'Études et de Recherches sur el Moyen-Orient Contemporain, 89–108.

Rogers, M.E. 1975. 'Acre, the key of Palestine'. In: Wilson, S.C.W. (ed.), *The Land of Galilee & the North: Including Samaria, Haifa, and the Esdraelon Valley*. Jerusalem: Ariel Publishing House, 73–109.

Rossi, A. 1984. *The Architecture of the City*. Cambridge, MA: The MIT Press.

Rowe, P.G. 1997. *Civic Realism*. Cambridge, MA: The MIT Press.

Rowney, B. 2004. *Charters and the Ethics of Conservation: A Cross-Cultural Perspective*. Doctor of Philosophy: The University of Adelaide.

Royal Scientific Society 1990a. *Al-Turāth al-Mi'mārī fil Mamlakah al-Urduniyyah al-Hāshimiyyah: Madīnat al-Salṭ*. Amman: Mu'assasat I'mār al-Salṭ.

Royal Scientific Society 1990b. *Salt: A Plan for Action*. Amman: Royal Scientific Society.

Russo, A.P. 2002. 'The "vicious circle" of tourism development in heritage cities'. *Annals of Tourism Research*, 29(1), 165–82.

Rustum, A.J. 1926. 'Notes on Akka and its defences under Ibrahim Pasha'. *The Archaeological Congress of Syria and Palestine*. Beirut: s.n.

Ryan, C. 1999. 'Some Dimensions of Maori Involvement in Tourism'. In: Robinson, M. and Boniface, P. (eds), *Tourism and Cultural Conflicts*. 1st ed. Oxon and New York: CABI Publishing, 229–45.

Rykwert, J. 1976. *The Idea of a Town: The Anthropology of Urban Form in Rome, Italy and the Ancient World*. London: Faber & Faber Limited.

Salāmah, J.H. 1998. *'Akkā athnā'a al-Hamlah al-Firinjiyah-al-Salībīyah al-Thālithah*. Nablus: Dār al-Fārūq.

Samuels, I. 1990. 'Architectural practice and urban morphology'. In: Slater, T.R. (ed.), *The Built Form of Western Cities: Essays for M.R.G. Conzen on the Occasion of his Eightieth Birthday*. Leicester: Leiscester University Press, 415–35.

Samuels, I. 2009. 'Classics in human geography revisited. Conzen, M.R.G. 1960: Alnwick, Northumberland: A study in town-plan analysis. Institute of British Geographers Publication 27. London: George Philip'. *Progress in Human Geography*, 33(6), 861–2.

Samuels, K.L. 2008. 'Value and significance in archaeology'. *Archaeological Dialogues*, 15(1), 71–97.

Sartori, G. 1994. 'Compare Why and How: Comparing, Miscomparing and the Comparative Method'. In: Dogan, M. and Kazancigil, A. (eds), *Comparing Nations: Concepts, Strategies, Substance*. Oxford: Basil Blackwell Ltd, 14–34.

Säve-Söderberg, T. 1987. *Temples and Tombs of Ancient Nubia*. London: Thames and Hudson.

Schiffer, M.B. and House, J.H. 1977. 'An Approach to Assessing Scientific Significance'. In: Schiffer, M.B. and Gumerman, G.J. (eds), *Conservation Archaeology: A Guide for Cultural Resource Management Studies*. New York: Academic Press, 249–57.

Schneekloth, L. and Shibley, R. 1995. *Placemaking: The Art and Practice of Building Communities*. New York: John Wiley & Sons.

Scholze, M. 2008. 'Arrested Heritage – The Politics of Inscription into the UNESCO World Heritage List: The Case of Agadez in Niger'. *Journal of Material Culture*, 13(2), 215–31.

Serageldin, I. 1997. 'The Architecture of Empowerment: A Survey'. *The Architecture of Empowerment: People, Shelter and Livable Cities*. London: Academy Editions.

Shackley, M.L. (ed.) 2000. *Visitor Management: Case Studies from World Heritage Sites*. Oxford; Boston: Butterworth-Heinemann.

Shamali, N. (ed.) 2001. *Al-Yater*. 'Akkā: Al-Yāṭer, Organization for Cultural and Social Development.

Shamali, N. (ed.) 2004. *Al-Yater*. 'Akkā: Al-Yāṭer, Organization for Cultural and Social Development.

Shorrock, W.I. 1970. 'The Origin of the French Mandate in Syria and Lebanon: The Railroad Question, 1901–1914'. *International Journal of Middle Eastern Studies*, 1(2), 133–53.

Shoval, N. 2007. 'Tracking technologies and urban analysis'. *Cities*, 25(1), 21–8.

Shoval, N. and Isaacson, M. 2007a. 'Sequence Alignment as a Method for Human Activity Analysis in Space and Time'. *Annals of the Association of American Geographers*, 97(2), 282–97.

Shoval, N. and Isaacson, M. 2007b. 'Tracking Tourists in the Digital Age'. *Annals of Tourism Research*, 34(1), 141–59.

Shryock, A. 2004a. 'The New Jordanian Hospitality: House, Host, and Guest in the Culture of Public Display'. *Comparative Studies in Society and History*, 35(1), 35–62.

Shryock, A. 2004b. 'Other Conscious/Self Aware: First Thoughts on Cultural Intimacy and Mass Mediation'. In: Shryock, A. (ed.), *Off Stage on Display: Intimacy and Ethnography in the Age of Public Culture*. Stanford, CA: Stanford University Press, 3–28.

Shryock, A. 2009. 'Hospitality Lessons: Learning the Shared Language of Derrida and the Balga Bedouin'. *Paragraph*, 32(1), 32–50.

Shryock, A. and Howell, S. 2001. '"Ever a Guest in Our House": The Emir Abdullah, Shaykh Majid al-Adwan, and the Practice of Jordanian House Politics, as Remembered by Umm Sultan, the Widow of MajidAuthor'. *International Journal of Middle East Studies*, 33(2), 247–69.

Smith, C.G. 1968. 'The Emergence of the Middle East'. *Journal of Contemporary History*, 3(3), 3–17.

Smith, L. 2006. *Uses of Heritage*. London and New York: Routledge.

Soja, E.W. 2003. *Postmodern Geographies: The Reassertion of Space in Critical Social Theory*. London: Verso Press.

Stanley, N. 1998. *Being Ourselves for You: The Global Display of Cultures*. Middlesex: Middlesex University Press.

Stein, R.L. 1995. 'Remapping Israeli and Palestinian Tourism'. *Middle East Report*, 196, 16–19.

Stephenson, J. 2008. 'The Cultural Values Model: An integrated approach to values in landscapes'. *Landscape and Urban Planning*, 84(2), 127–39.

Sternberg, E. 1997. 'The iconography of the tourism experience'. *Annals of Tourism Research*, 24(4), 951–69.

Sternberg, E. 1999. 'Staging a Natural Wonder'. *The Economy of Icons*. Westport, CT: Praeger Publications.

Sutton, J.A.D. 1979. *Magic Carpet: Aleppo-in-Flatbush; The Story of a Unique Ethnic Jewish Community*. Brooklyn, NY: Thayer-Jacoby.

Swarbrooke, J. 1999. *Sustainable Tourism Management*. New York: CABI.

Tabbaa, Y. 1997. *Constructions of Power and Piety in Medieval Aleppo*. University Park, PA: The Pennsylvania State University Press.

Tainter, J.A. and Lucas, G.J. 1983. 'Epistemology of the significance concept'. *American Antiquity*, 48(4), 707–19.

Taylor, J. and Cassar, M. 2008. 'Representation and Intervention: The Symbiotic Relationship of Conservation and Value'. In: Saunders, D., Townsend, J.H. and Woodcock, S. (eds), *Conservation and Access Contributions to the London IIC Congress*. London: IIC (International Institute for Conservation of Historic and Artistic Works), 7–11.

Taylor, J.P. 2001. 'Authenticity and sincerity in tourism'. *Annals of Tourism Research*, 28(1), 7–26.

Tchetchik, A., Fleischer, A. and Shoval, N. 2009. 'Segmentation of Visitors to a Heritage Site Using High-resolution Time-space Data'. *Journal of Travel Research*, 48(2), 216–29.

The Council of Europe 1975a. 'The Declaration of Amsterdam'. Adopted by the Council of Europe at the Congress on the European Architectural Heritage in Amsterdam, the Netherlands, 21–25 October 1975. Paris: ICOMOS. Available: http://www.icomos.org/en/charters-and-texts?id=169:the-dec

The Council of Europe 1975b. 'European Charter of the Architectural Heritage'. Adopted by the Council of Europe, October 1975 at the Congress on the European Architectural Heritage in Amsterdam, the Netherlands, 21–25 October 1975. Paris: ICOMOS.

The Economist. 2014. Syrian Diary: Life in Aleppo. Pomegranate: The Middle East. Tuesday, 15 July 2014. Available: http://www.economist.com/node/21606828 [Accessed 24 July 2014].

The Organization of World Heritage Cities. 2011. *The Organization of World Heritage Cities (OWHC)* [Online]. Québec City. Available: http://www.ovpm.org/ [Accessed 5 January 2014].

Throsby, D. 2002. 'Cultural Capital and Sustainability Concepts in the Economics of Cultural Heritage'. In: De la Torre, M. (ed.), *Assessing the Values of Cultural Heritage*. Los Angeles: The Getty Conservation Institute, 101–17.

Tiesdell, S., oc, T. and Heath, T. 1996. *Revitalizing Historic Urban Quarters*. Oxford: Architectural Press, an imprint of Butterworth-Heinemann.
Titchen, S.M. 1996. 'On the construction of 'outstanding universal value'. Some comments on the implementation of the 1972 UNESCO World Heritage Convention'. *Conservation and Management of Archaeological Sites*, 1(4), 235–42.
Tonkin, R. 2006. 'Architects Creating a Landscape'. *International Journal of Heritage Studies*, 12(6), 551–568.
Torstrick, R. 2000. *The Limits of Coexistence: Identity Politics in Israel*. Ann Arbor, MI: The University of Michigan.
Tuan, Y.-F. 1990. *Topophilia: A Study of Environmental Perception, Attitudes, and Values*. New York: Columbia University Press.
Tuan, Y.F. 1977. *Space and Place: The Perspective of Experience*. London: Edward Arnold Publishers Ltd.
Tunbridge, J. and Ashworth, G.J. 1996. *Dissonant Heritage: The Management of the Past as a Resource in Conflict*. Chichester: Wiley.
Tung, A.M. 2001. *Preserving the World's Great Cities: The Destruction and Renewal of the Historic Metropolis*. New York: Clarkson Potter.
Tyler, N. 2000. *Historic Preservation: An Introduction to Its History, Principles, and Practice*. New York: W.W. Norton & Company.
UNESCO 1972. 'Convention Concerning the Protection of the World Cultural and Natural Heritage'. Paris: UNESCO.
UNESCO 1977. 'Operational Guidelines for the Implementation of the World Heritage Convention'. Paris: World Heritage Center.
UNESCO 1978. 'Operational Guidelines for the Implementation of the World Heritage Convention'. Paris: World Heritage Center.
UNESCO 1979. 'Third Session of the World Heritage Committee, Luxor, Arab Republic of Egypt, 23-27 October 1979. Item 6 of the Provisional Agenda: Principles and Criteria for Inclusion of Properties on World Heritage List'. Paris: UNESCO.
UNESCO 1983. 'Operational Guidelines for the Implementation of the World Heritage Convention'. Paris: World Heritage Center.
UNESCO 1987. 'Operational Guidelines for the Implementation of the World Heritage Convention'. Paris: World Heritage Center.
UNESCO 1988. 'Operational Guidelines for the Implementation of the World Heritage Convention'. Paris: World Heritage Center.
UNESCO 1992. 'Operational Guidelines for the Implementation of the World Heritage Convention'. Paris: World Heritage Center.
UNESCO 1994. 'Operational Guidelines for the Implementation of the World Heritage Convention'. Paris: World Heritage Center.
UNESCO 1995. 'Convention Concerning the Protection of teh World Cultural and Natural Heritage. Bureau of the World Heritage Committee Nineteenth Session. UNESCO Headquarters, Paris, Room X (Fontenoy), 3-8 July 1995. Item 11 of the Provisional Agenda: Revision of the Operational Guidelines for the Implementation of the World Heritage Convention'. Paris: World Heritage Center.
UNESCO 2005a. 'Operational Guidelines for the Implementation of the World Heritage Convention'. Paris: World Heritage Center.
UNESCO 2005b. 'Convention Concerning the Protection of the World Cultural and Natural Heritage. Twenty-ninth Session, Durban, South Africa, 10-17 July 2005. Item 5 of the Provisional Agenda: Report of the World Heritage Center on its activities and on the implementation of the decisions of the World Heritage Committee'. Paris: World Heritage Center.
UNESCO 2005c. 'The Vienna Declaration: Declaration on the Conservation of Historic Urban Landscapes'. Paris: World Heritage Center.
UNESCO 2008. 'Operational Guidelines for the Implementation of the World Heritage Convention'. Paris: World Heritage Center.
UNESCO 2011a. 'Operational Guidelines for the Implementation of the World Heritage Convention'. Paris: World Heritage Center.

UNESCO 2011b. 'A New International Instrument: The proposed UNESCO Recommendation on the Historic Urban Landscape (HUL)'. Paris: UNESCO.

UNESCO 2011c. 'Records of the General Conference – 36th session'. Volume 1: Resolutions. Paris: UNESCO.

UNESCO. 2012. *The Director-General of UNESCO appeals for the Protection of the World Heritage City of Aleppo* [Online]. Paris: UNESCO. Available: http://www.unesco.org/new/en/culture/themes/single-view/news/the_director_general_of_unesco_appeals_for_the_protection_of_the_world_heritage_city_of_alepo/ – .Us7XmXkg9Jw [Accessed 9 January 2014].

UNESCO 2013. 'Operational Guidelines for the Implementation of the World Heritage Convention'. Paris: World Heritage Center.

UNESCO. 1992–2014a. *The World Heritage Center* [Online]. Paris. Available: http://whc.unesco.org/ [Accessed 3 January 2014].

UNESCO. 1992–2014b. *Old City of Salt* [Online]. Paris. Available: http://whc.unesco.org/en/tentativelists/1855/ [Accessed 3 January 2014].

UNESCO. 1992–2014c. *Ancient City of Aleppo* [Online]. Available: http://whc.unesco.org/en/list/21 [Accessed 4 January 2014].

UNESCO. 1992–2014d. *Old City of Acre* [Online]. Available: http://whc.unesco.org/en/list/1042 [Accessed 4 January 2014].

UNESCO. 1992–2014e. *The List of World Heritage in Danger* [Online]. Paris. Available: http://whc.unesco.org/en/danger/ [Accessed 3 January 2014].

UNESCO World Heritage Center 2008. 'World Heritage Information Kit'. Paris: UNESCO.

United States Agency for International Development 2007. 'Jordan Tourism Development Project (Siyaha): Year 2 planning and documentation. September 2006–August 2007'. Amman, Jordan: United States Agency for International Development (USAID).

United States Agency for International Development 2011. 'Jordan Tourism Development Project (Siyaha): Project Interim Report October 2008–June 2011'. Amman, Jordan: United States Agency for International Development (USAID).

Upton, D. 2001. '"Authentic" Anxieties'. In: Alsayyad, N. (ed.), *Consuming Tradition, Manufacturing Heritage: Global Norms and Urban Forms in the Age of Tourism*. 1st ed. New York: Routledge and E F & N Spon, 298–306.

Urry, J. 1990. *The Tourist Gaze: Leisure and Travel in Contemporary Societies*. London: Sage Publications.

Van Oers, R. 2010. 'Managing Historic Cities and the Conservation of Historic Urban Landscapes – An Introduction'. *Managing Historic Cities*. Paris: World Heritage Papers Series, 7–17.

Veldpaus, L., Pereira Roders, A.R. and Colenbrander, B.J.F. 2013. 'Urban Heritage: Putting the Past into the Future'. *The Historic Environment*, 4(1), 3–18.

Venturi, R., Scott Brown, D. and Izenour, S. 1977. *Learning from Las Vegas: The Forgotten Symbolism of Architectural Form*. Cambridge, MA: The MIT Press.

Vernez Moudon, A. 1997. 'Urban morphology as an emerging interdisciplinary field'. *Urban Morphology*, 1, 3–10.

Vincent, L.H. and Sergie, L. 2005. 'An Urban History of Aleppo'. In: Busquets, J. (ed.), *Aleppo: Rehabilitation of the Old City. The Eighth Veronica Rudge Green Prize in Urban Design*. Cambridge, MA: Harvard University Graduate School of Design, 40–51.

Wahab, S. and Pigram, J.J. (eds), 1997. *Tourism, Development and Growth: The Challenge of Sustainability*. London and New York: Routledge.

Ward, S.V. 1998. *Selling Places: The Marketing and Promotion of Towns and Cities: 1850–2000*. New York: Routledge.

Wass, M. 2010. 'Contents of British Mandate Archaeological Inspection Files Archive (Mandate Antiquities Department)'. Acre, Israel: The International Conservation Center.

Waterton, E., Smith, L. and Campbell, G. 2006. 'The Utility of Discourse Analysis to Heritage Studies: The Burra Charter and Social Inclusion'. *International Journal of Heritage Studies*, 12(4), 339–55.

Wells, J.C. 2010. 'Our history is not false: Perspectives from the revitalisation culture'. *International Journal of Heritage Studies*, 16(6), 464–85.

Wenning, R. 2001. 'The Betyls of Petra'. *Bulletin of the American Schools of Oriental Research*, 324, 79–95.

Whitehand, J. 1990. 'Townscape management: Ideal and reality'. In: Slater, T.R. (ed.), *The Built Form of Western Cities: Essays for M.R.G. Conzen on the Occasion of his Eightieth Birthday*. Leicester: Leicester University Press, 370–93.

Whitehand, J. 2001. 'British urban morphology: The Conzenian tradition'. *Urban Morphology*, 5(2), 103–9.

Whitehand, J. 2009. 'Classics in human geography revisited. Conzen, M.R.G. 1960: Alnwick, Northumberland: A study in town-plan analysis. Institute of British Geographers Publication 27. London: George Philip'. *Progress in Human Geography*, 33(6), 859–60.

Windelberg, J., Hallaj, O.A.A. and Stürzbecher, K. 2001. 'Development Plan'. Deutsche Gesellschaft für Technische Zusammenarbeit (GTZ) & Aleppo's Old City Directorate.

World Bank 2005. *Second Tourism Development Project: Implementation Completion Report*. World Bank.

World Commission on Protected Areas 1998. 'Economic Values of Protected Areas: Guidelines for Protected Area Managers'. In: Phillips, A. (ed.), *Task Force on Economic Benefits of Protected Areas of the World Commission on Protected Areas (WCPA) of IUCN, in collaboration with the Economics Service Unit of IUCN*. Gland, Switzerland and Cambridge, UK: IUCN.

World Heritage Committee 1998. 'Report of the World Heritage Global Strategy Natural and Cultural Heritage Expert Meeting, 25 to 29 March 1998, Theatre Institute, Amsterdam, The Netherlands'. Paris: The World Heritage Center.

World Heritage Committee 2002. 'Convention Concerning the Protection of the World Cultural and Natural Heritage, Twenty-fifth session. Helsinki, Finland 11-16 December 2001'. Paris: The World Heritage Center.

World Heritage Committee 2005. 'Convention Concerning the Protection of the World Cultural and Natural Heritage. Item 9 of the Provisional Agenda: Assessment of the conclusions and recommendations of the special meeting of experts (Kazan, Russian Federation, 6–9 April 2005) established by Decision 28 COM 13.1'. Paris: The World Heritage Center.

World Tourism Organization 1995. 'Tourism Expenditure Statistics 1995'. Madrid: World Tourism Organization.

Yin, R.K. 1994. *Case Study Research Design and Methods*. London: Sage Publications.

Yin, R.K. 2003. *Applications of Case Study Research*. Thousand Oaks, CA: Sage Publications.

Zeitlian Watenpaugh, H. 2004. *The Image of an Ottoman City: Imperial Architecture and Urban Experience in Aleppo in the 16th and 17th Centuries.* Leiden and Boston: Brill.

Zukin, S. 1996. 'Space and Symbols in an Age of Decline'. In: King, A.D. (ed.), *Re-Presenting the City: Ethnicity, Capital and Culture in the 21st-Century Metropolis*. New York: New York University Press, 43–59.

Index

Bold page numbers indicate figures and plates, *italic* numbers indicate tables.

Abū Jāber mansion, al-Salt 52, 53n16, 77, **78**, 78, 109, 110, 112, 132
Acre
　aesthetic appeal **140**, 140–1
　al-Jazzār Mosque 27, **29**, 140
　al-aswār 142
　al-Makr 30, 54, 60, 86, 114, 142
　'Amidār 28, 30, 32, 60, 87, 88, 114
　aswār (defensive walls) 28, **29**, 31, 59, 93, 116, 137, 138, 140
　Atiqot 30, 54, 55, 89, 90–1, 115
　automobiles, adaptation to 32
　Bahá'í 56, 59, 138, 140, 141, 144
　Bahá'í Palace **58**, 59–60, 137
　classification of buildings 89–90, **90**
　compatibility 141
　congruence 141, 145
　contemporary challenges 31
　Crusaders narrative, emphasis on 115–16, 26-7, **27**, 56, 59, 86, 90-1, 93, 115-16, 140-1, 144, 150
　cultural processes 137–41, *138–9*, **140**, 144
　Custodian of Absentee Property 28, 30
　Development Plan 30–1, 33
　dilapidation of residences **87**, 87–8
　distinctive elements of 137–8, *138–9*
　documentation 54–6
　Fākhūra 88
　Ḥammām Street 27, 116, **116**, 137, 139
　ḥārāt 146
　historical periods and events 14–15
　interior work not in project 114
　Kesten Plan 30
　khānāt (caravanserai) 26, 27, 28, 56, 93
　layout of, historical background of 26–31, **27, 29**
　legibility 139–40
　local self-representation 118
　Mendel, S. 54–5, 86, 113, 115
　Minhāl 28, 30, 32, 114
　mistrust towards authorities 114
　moat 90, **92**
　Old Acre Development Company 30, 54, 55, 86, 113–16
　as Ottoman city **27**, 27, 56, 58, 59, 86, 115, 140-1, 144, 150
　outstanding universal value (OUV) 56, 59
　ownership and maintenance of properties 32, 88
　ownership of cultural heritage 142–3
　Palestinian-Arab history, neglect of 59–60, 115–16
　participation levels 117, *118*
　place attachment 142–3
　place experience 137–44, *138–9,* **140**, 144–6, **145, 146, 147**
　place-making strategies 55–6, 86–95, **87, 89, 90, 91, 92, 94, 95**
　public participation in planning 112–16, **116**
　Qasr 'Abbūd **58**, 59–60, 137
　Rahamimoff, J. 54–5, 86, 113, 115
　relocation of inhabitants, attempts in 30, 60, 86
　representation of constituencies 117, *118*
　snapshots v. continuity in documentation 60
　social interaction 143–4
　social processes 142–4, 146
　social surveys of inhabitants 55
　socio-economic conditions 31–2
　spatial processes 141, 145
　symbolic significance 137–8, *138–9*, 144
　sūq 26, 93, **95**, 137, 138, *138,* 139, **145**
　timing of public participation in planning 117, *118*
　tourism as focus 86–7
　tourism development 30–1, 90, **93**, 93–5, **94, 95, 96**
　tourism surveys 55
　townscape conservation 56, 89–90, **89, 90, 91, 92**, 144, 151
　Turkish Bath House 116, **116**
　World Heritage List 56, *57,* 59
　Zāhir al-Omar al-Zeidānī 27, 137n10
'Advocacy and Pluralism in Planning' (Davidoff) 99
advocacy planning 99
　see also public participation in planning
'Akka (or 'Akkā), *see* Acre
al-Jazzār Mosque 27, **29**, 140
al-Makr 30, 54, 60, 86, 114, 142
al-Salt
　Abū Jāber mansion 52, 53n16, 77, **78**, 78, 109, 110, 112, 132
　apathy towards upkeep 135
　'aqabāt 22, **23**, 51, 54, 79, **80, 81**, 82–3, **86**, 112, 132, 133, 135, 136, **136**
　architectural decline 24–5
　architectural focus in 51–4
　automobiles, adaptation to 32
　beautification v. rehabilitation 79, **80, 81**, 82–3

congruence 134, 144–5
contemporary challenges 31
costs compared to tourism figures 83, 85
Crusades 20
cultural processes 132–3, 144
documentation 51–4
emergence of interest in heritage 25–6
Ḥammām Street **21**, 21, **25**, 25, 132, 133, 134, 136
ḥārāt 20, 21,
Historic Old Salt Museum **78**, 78–9, 85, 134
historical periods and events 14–15
honour code of inhabitants 77, 111–12
human resource development 79
ḥūsh 22 , **22, 23**
image marketing 76–7
infrastructure for tourism 77–9, **78, 80, 81, 82,** 82–3, **83, 84,** 85, **85**
Japan International Cooperation Agency (JICA) 26, 26n8, 51–2, 76, 77, 79, 83, 109, 110–12, 135–6
legibility 133
local inhabitants, exclusion from documentation 59
local narrative, absence of 53–4
local self-identity, obliteration of 112
local self-representation 118
morphology of **20,** 20–2, **21, 22, 23,** 24–6
mushāwara (consultation) 111, 117
negligence of townscape 52–3
nomination package for World Heritage List 53
Old Salt Historic Museum 112
opposition to tourism 110, 111–12
as Ottoman city 15, 20
outstanding universal value (OUV) 59
ownership and maintenance of properties 32
ownership of cultural heritage 135–6
participation levels 117, *118*
place experience 132–7, **135, 136,** 144–6
place-making strategies 76–83, **78, 80, 81, 82, 83, 84, 85**
as a product 76
public participation in planning, exclusion of 109–12
Qāqīsh house 77, 77n14, 110, 111
reports on in 1980s 51
representation of constituencies 117, *118*
Sāḥet al-'Ain **81,** 112
significant elements in 132–3
single collective identity, promotion of 112
social processes 134–7, **135, 136,** 146
socio-economic conditions 31–2
socio-economic decline 25
spatial processes 133–4, 144–5
standardization measures 83, **84,** 112
symbolic significance 132–3, 144
timing of public participation in planning 117, *118*
tourism, wariness towards 136–7
townscape 22, 51, 52–4, 83, **85,** 150–1
Tourism Development Projects 26, 33, 52, 76–7, 109–12

World Heritage List 26, *57,* 59
al-Zoabi, A.Y. 52
Aleppo
 Action Areas, (AA) 65, 105, 131, 149, 11,
 aesthetically appealing elements 128
 al-Mdīneh 16,
 architectural aesthetic and integrity 66–71, **67, 68, 69, 70**
 associations between periods, neglect of 59
 automobiles, adaptation to 32, 48
 Bāb Qinnasrīn 11, 65, **70,** 70–1, 106, 126–7, 131
 Banchoya and David Plan 19
 building regulations 129
 change, prohibition of in 66–7
 Citadel 10, 15, 16, **17, 18,** 48–9, 58, 65, 126–8, *128,* 131, 144
 compatibility 129
 congruence 130, 144–5
 contemporary challenges 31
 courtyard houses 129
 Crusades 14
 cultural processes 126–9, **127,** *128,* 144
 Decision 39/1990 49, 65, 66–7, 73
 Development Plan 50, 65, 67, 71, 75
 displacement of inhabitants 68, **69,** 70
 distinctive elements of 126–8, **127,** *128*
 documentation 48–51
 evolution of urban form 15–16, **18,** 19, **19**
 Farāfra 11, 16, 65, 66, **74**
 gentrification **70,** 70–1, 131
 geographic information systems 49–50, 71
 Great Mosque 15, 16, 48–9, 58
 Gutton Proposal 19
 Ḥammām Street 58
 ḥārāt 16, 19, 131
 historical periods and events 14–15
 industrial workshops 130
 infrastructure rehabilitation, focus on 71–2
 Jdēide 11, 49, 65, 66, 70, 73, **74, 75,** 109, 131
 Jewish community 59
 khānāt (caravanserai) 48, 58, 126
 land use and zoning policies 71
 legibility **127,** 127–8
 loans to inhabitants 67–8
 local inhabitant perspectives excluded 51
 local inhabitants, exclusion from documentation 59
 local self-representation 118
 maintenance of properties 67–8
 media campaign 65
 monitoring of change in 50
 morphological and spatial conservation 71, **72,** 73, **73, 74, 75**
 museum-like perception of 48–9
 Old City 10, 19, 48, 49, 50n12, 51, 65, 67, 68, 70, 73, 97, 105, 107, 108, 126, 130, 131, 151–2
 as Ottoman city 14, 16, 49
 outstanding universal value (OUV) statement 48–9

Index

ownership and maintenance of properties 32, 67–8, 129
ownership of cultural heritage, lack of 131
participation levels 117, *118*
place experience 126–32, **127, 128**, 144–6
place-making strategies 65–74, **67, 68, 69, 70, 72, 73, 74, 75, 76, 78**
Project for the Rehabilitation of the Old City of Aleppo 19, 32–3, 49–51, 65, 105–9
public open spaces 73
public participation in planning as limited 105–9, **107**
representation of constituencies 117, *118*
Sāhet al-Ḥaṭab 73, **74**
Shēibāni Church 12
snapshots v. continuity in documentation 60
social interaction 131–2
social processes 131–2, 146
socio-cultural and economic conservation 75, **76**
socio-economic conditions 31
spatial approach 48–51
spatial processes 129–30, 144–5
standardization measures 73, **74, 75**
sūq 14, 16, **17**, 19, 48–9, 71, 126, 127–8, *128*, 131, 144, 152
symbolic significance 126–7, 144
timing of public participation in planning 117, *118*
tourism, desire to curb 19, 66
tourism pressures in 65–6
townscape 48–9, 50, 71, **72, 73**, **73, 74, 75**
World Heritage List 19, *57*
Alexander, Christopher 58, 122–3
alienation of local inhabitants 8
AlSayyad, N. 4, 59
Amsterdam Declaration 104
Appleton Charter 103
architecture
 Acre 89–90, **90**
 al-Salt 51–4, 79, **80, 81**, 82–3
 Aleppo 66–71, **67, 68, 69, 70**
 conservation of 61–3
 discourse of 46
 and sense of place 122
Arnstein, Sherry 99–100
'aqabāt in al-Salt 22, **23**, 51, 54, 79, **80, 81**, 82–3, **86**, 112, 132, 133, 135, 136, **136**
Aswan High Dam, flooding due to 3
Athens Charter 37, 61
'Atiqot 30, 54, 55, 89, 90–1, 115
authenticity 7, 38, 41, 44, 46, 55, 61, 62, 67, 96, 102, 125, 126, 134, 151
automobiles, cities' adaptation to 32, 48

Bahá'í Palace **58**, 137
Banchoya and David Plan, Aleppo 19
Bianca, Stefano 48–9
Bilād ash-Shām
 characteristics of cities in 13–14
 see also Acre; al-Salt; Aleppo
Briuer, F.L. 39
Burke, Edmund 99
Burra Charter 40, 61–2, 104, 104n5, 105
Burra Declaration 105

Cameron, Christina 43
Canter, D. 122
cars, cities' adaptation to 32, 48
case studies
 approach taken to 10
 data collection 10–11
 interviews 11
 selection of cities 9–10
 see also Acre; al-Salt; Aleppo
Castells, Manuel 45
change
 Aleppo, monitoring of in 50
 limits of acceptable 7
 as natural process in urban landscapes 63
 prohibition of in Aleppo 66–7
 and value, relationship with 47
Chapagain, Neel Kamal 105
cities
 automobiles, adaptation to 32, 48
 in *Bilād ash-Shām,* characteristics of 13–14
 ownership and maintenance of properties 32
 socio-economic conditions in 31–2
 tourism as issue in 4–5
 World Heritage List, impact of on 4–5
 see also Acre; al-Salt; Aleppo
citizen participation 99
 see also public participation in planning
Cohen, E. 121
collaborative planning 99
 see also public participation in planning
commodification in tourism 7, 8, 134, 138, 149, 150
comparative assessments 41
computer technologies 46–7, 49–50, 71
conservation triad
 architectural aesthetic and integrity 61–3, 66–71, **67, 68, 69, 70**
 morphological and spatial 63, 64, 71, **72, 73**, **73, 74, 75**
 socio-cultural and economic 64, 75, **76**
 tensions between components 96–7
consultation (*mushāwara*) 111, 117
contextualism 62–3
contextualization, morphological 63
Convention Concerning the Protection of the World Cultural and Natural Heritage 3–4, 37, 100–1
Conzen, M.R.G. 45, 46, 63
courtyard houses in Aleppo 129
Crusades
 Aleppo 14
 Acre 115-16, 26-7, **27**, 56, 59, 86, 90-1, 93, 115-16, 140-1, 144, 150

al-Salt 20
cultural heritage defined 4
Custodian of Absentee Property, Acre 28, 30

Daher, R.F. 52–3
Damascus 13, 15, 20, 53, 112
Davidoff, Paul 99
De Marco, L. 105
Declaration of Amsterdam 104
Declaration of Appleton 103–4
Declaration of Deschambault 103
Declaration of Lima 103
Declaration of Paris 103
Declaration of Québec 103
Declaration of San Antonio 102
Declaration of Stockholm 102–3
Deeben, J. 44
definitions by UNESCO 4
Deschambault Declaration 103
Disneyfication 7, 8, 138, 144, 145, 149, 151
distinctiveness
 Acre 56, 76, 137-9, *138-9*, 150-1
 al-Salt 22, 54, 83, 112, 132-3
 Aleppo 48, 126-8, **127**, *128*
 local engagement 117-18, *118*
 local identity 5-8
 of local products 7, 149
 tourism and place experience 121-4, **124**, 144-5, 151
 value assessments 45, 47
diyāfe (hospitality) 77, 94, 111–12, 133
documentation
 Acre 54–6
 al-Salt 51–4
 Aleppo 48–51
 architectural and visual discourse 46
 computerized technologies 46–7
 criticality of 38
 defined 45
 local inhabitants, exclusion from 59
 role of 46
 secondary sources, use of in al-Salt 52
 snapshots v. continuity 60
 socio-cultural discourse 47
 spatial and morphological values 46–7
 value assessment 37
 Dublin Principles 102

Echtner, C.M. 5–6
economic value 44–5
environmental psychology 122–3
experiential/experimental tourism
 dearth of research into 121–2
 defined 121
 in historic urban landscapes 121
expert/experiential knowledge 100

Fākhūra, Acre 88

Friedman, John 6, 100

generosity (*karam*) 77, 111, 112, 133
genius loci 122
gentrification in Aleppo 70–1, 131
geographic information systems (GIS) 46–7, 49–50, 71
Gesellschaft für Technische Zusammenarbeit (GTZ) 19, 49, 50, 51, 65
global positioning systems (GPS) 46–7
Godschalk, David 99
Goethert, Reinhard 100, 117
Greater Syria, *see* Acre; al-Salt; Aleppo; *Bilad ash-Sham*
groups of buildings defined 4
Gutton Proposal, Aleppo 19

Hakim, Besim 45, 64
Hamdi, Nabeel 100, 117
Ḥammām **21**, 21, **25**, 25, 27, 58, 116, **116**, 132, 133, 134, 136, 137, 139
Harvey, David 45
Hayden, Dolores 47, 117, 118
historic conservation
 Acre, policies in 89
 contemporary, emergence of 61
 needs of local inhabitants 64
 norms of, disregard to 82
 shift of emphasis from 147
historic towns
 conservation of 102
 contemporary development in 63
 in 'groups of buildings' category 4
 in Operational Guidelines 40
historic urban landscape
 definition 63
 documentation of 45-8, 77
 place-making to place experience in 144-7, **145**, **146**, **147**
 tourism, contradictions of 5-8
 World Heritage List 4-5
homogenization 7, 73, **75**, 83, **84**, 97, 112, 115, 117, 118, 145, 149, 150
honour code of al-Salt inhabitants 77, 111–12
hospitality (*diyāfe*) 77, 94, 111–12, 133
House, John H. 41
Hudson, Barclay 6
human resource development in al-Salt 79
humanist geography 122
ḥūsh 22 , **22, 23**

image marketing 6, 76–7
inclusive planning, *see* public participation in planning
information systems 46–7
inscription criteria, *see* World Heritage List
integrity 5, 38, 46, 58, 66, 89, 97, 144, 152
International Centre for the Study of the Preservation and Restoration of Cultural Property (ICCROM) 3

International Council on Monuments and Sites (ICOMOS) 3
 Amsterdam Declaration 104
 Appleton Charter 103
 Appleton Declaration 103–4
 Athens Charter 37, 61
 Burra Charter 40, 61–2, 104, 104n5, 105
 Deschambault Declaration 103
 Dublin Principles 102
 Lima Declaration 103
 Paris Declaration 103
 public participation in planning 100–4
 Québec Declaration ١٠٣
 San Antonio Declaration 102
 Stockholm Declaration 102–3
 Valetta Principles 102
 Venice Charter 37, 61
 Washington Charter 40, 46, 62, 63, 64, 101, 125
International Union for the Conservation of Nature (IUCN) 3, 38
interviews for research 11
intrinsic value 38, 44
Israel Antiquities Authority ('Atiqot) 30, 54, 55, 89, 90–1, 115
Israel National Housing Company for Immigrants, Ltd. 28, 30, 32, 60, 87, 88, 114

Japan International Cooperation Agency (JICA) 26, 26n8, 51–2, 76, 77, 79, 83, 109, 110–12, 135–6
Jewish community in Aleppo 59
Jokilehto, J. 42, 43

karam (generosity) 77, 111, 112, 133
Kazan meeting 42, 43
khānāt (caravanserai) 14, 26, 27, 28, 48, 58, 93, 126
Kelly, Roger E. 39–40, 43
Kesten Plan, Acre 30

'Ladder of Citizen Participation, A' (Arnstein) 99–100
legitimization 7, 8, 27, 44, 112, 115, 118, 124, 144, 149, 151
Levant
 characteristics of cities in 13–14
 see also Acre; al-Salt; Aleppo; Bilād ash-Shām
Lima Declaration 103
limits of acceptable change 7, 149, 150
local inhabitants
 Aleppo, perspectives excluded in 51
 alienation of 8
 displacement of 68, **69,** 70
 and economic value 44–5
 exclusion from defining significance 40
 exclusion from documentation 59
 input of in tourism 7–8
 local narrative, absence of in al-Salt 53–4
 mistrust towards authorities in Acre 114
 movements of 31

OUV, perspective on 42
 relocation of Acre inhabitants, attempts to 30, 60, 86
 social surveys of in Acre 55
 see also public participation in planning
Lowenthal, David 43
Lynch, Kevin 122

MacLean, M.G.H. 45
Maffi, Irene 112
maintenance of properties 32, 67–8
marketing, tourism 6–7, 65, 76–7, 79, 90, 93, 121, 125, 126, 149
Mason, R.F. 125
Mathers, C. 39
Mendel, S. 54–5, 86, 113, 115
methodology of research 9–12
Mills, William 99
Minḥāl 28, 30, 32, 114
moat in Acre 90, **92**
Montgomery, J. 122
monuments defined 4
Moratto, Michael J. 39–40, 43
morphological conservation 63, 64
morphology of cities in Bilād ash-Shām 13–14
mushāwara (consultation) 111, 117 see also public participation in planning

Nablus 15, 19, 20, 21, 53, 54, 112
Nara Document on Authenticity 1994 62
Nasser, Nouha 64
Norberg-Schulz, Christian 122

Old Acre Development Company 30, 54, 55, 86, 113–16
Old Jaffa Development Company 86
Oliphant, Laurence 24
Operational Guidelines for the Implementation of the World Heritage Convention 3–4, 10, 37–9, 40, 42, 43, 100–1, 104, 117
oral traditions 47
Orbaşli, A. 121
Organization for World Heritage Cities 4
otherness and tourism 5–6, 9, 13, 126, 149, 150
Ottoman period
 Acre **27,** 27, 56, 58, 59, 86, 115, 140-1, 144, 150
 al-Salt 15, 20
 Aleppo 14, 16, 49
outstanding universal value (OUV)
 Acre 56, 59
 al-Salt 59
 Aleppo 48–9
 criteria for 37–8, 43
 debate over 41–3
 defined 42
 evolution of 40–1
 as excluding other values 43
 global-local tensions 59
 stakeholder perspective 42

tensions around criteria 58–9
uniqueness and representativeness 42
ownership and maintenance of properties 32, 67–8, 129

palimpsest, historic urban landscape as 56, 58, 59, 144
Parent, Michael 41
Paris Declaration 103
participatory planning, *see* public participation in planning
particularism 7–8, 112, 144–5, **145, 146, 147,** 149, 150
Perry, C. 16
physiognomy 45, 54, 56, 58, 63, 96
place
 concept of 61–2
 as-product 10, 76
 socio-cultural aspects of 64
 theories of 122–3
place experience
 Acre 137–44, *138–9,* **140,** 144–6, **145, 146, 147**
 al-Salt 132–7, **135, 136,** 144–6
 Aleppo 126–32, **127, 128,** 144–6
 compatibility 124, 129, 133–4, 141, 144
 congruence 125, 130, 134, 141, 144–5
 cultural processes 124, 126–9, **127, 128,** 132–3, 137–41, *138–9,* **140,** 144
 experiential/experimental tourism 121–2
 legibility 124, **127,** 127–8, 133, 139–40
 local inhabitants as recurring theme in 146–7
 place attachment 125, 142–3
 social interaction 125, 131–2, 143–4
 social processes 125, 131–2, 134–7, **135, 136,** 142–4, 146
 spatial processes 124, 129–30, 133–4, 141, 144–5
 symbolic significance 17–8, 124, 126–7, 132–3, *138–9,* 144
 theoretical framework for 123–5, **124**
 theories of place 122–3
 visual experience 6, 52, 61–3, 78, 79, 96, 149, 151
place-making strategies
 Acre 55–6, 86–95, **87, 89, 90, 91, 92, 94, 95**
 al-Salt 76–83, **78, 80, 81, 82, 83, 84, 85**
 Aleppo 65–75, **67, 68, 69, 70, 72, 73, 74, 75, 76, 78**
 conservation of architecture 61–3
 conservation triad 61–4
planning for experience-based urban heritage tourism 6
political situation in the Middle East 11–12
Prasad, P. 5–6
Project for the Rehabilitation of the Old City of Aleppo 19, 32–3
public participation in planning
 Acre 112–16, **116**
 advocacy planning 99–100
 al-Salt, exclusion of in 109–12
 Aleppo, as limited 105–9, **107**
 citizen participation 99
 collaborative planning 99
 Convention Concerning the Protection of the World Cultural and Natural Heritage 100–1
 debate over 104–5
 expert/experiential knowledge 100
 ICOMOS Charters and Declarations 100–4
 levels of participation 99–100, 117
 local self-representation 118
 needs and interests of local inhabitants 118
 obstacles to 108–9
 Operational Guidelines for the Implementation of the World Heritage Convention 100–1
 and place distinctiveness 117–18, *118*
 representation of constituencies 117, *118*
 stages in planning 100
 Theories concerning 99–100
 timing of 104, 117, *118*
 types of 109
 see also local inhabitants
Punter, J. 122

Qāqīsh house, al-Salt 77, 77n14, 110, 111
Qasr 'Abbūd, Acre **58,** 59–60, 137
Québec Declaration 103, 123

Rahamimoff, J. 54–5, 86, 113, 115
Ramadan, M. 50
Read, Marion 44–5
Recommendation on the Historic Urban Landscape 5, 40
representation, self- 7, 99, 112, 115, 117, 118, 147
representative samples 41
research design 9–12
Rogers, M.E. 28
Rossi, Aldo 122
Rowe, Peter G. 45
Rowney, Barry 104
Rykwert, Joseph 45

Sāhet al-'Ain, al-Salt **81,** 112
San Antonio Declaration 102
Sharī'a 13, 14, 16, 32, 45, 64, 67, 71
Schiffer, Michael B. 41
self-representation 7, 99, 112, 115, 117, 118, 147
sense of place 122
significance
 alternative conceptions of 43–5
 definitions of 38–9
 evolution of 38–9
 experts-based approach 38–9
 local communities, exclusion of from defining 40
sites defined 4
socio-cultural discourse in documentation 47
socio-economic conditions in cities 31–2
socio-economic processes 64
Soja, Edward W. 45
spatial conservation 63
stakeholders
 multiple, and value/significance 40
 outstanding universal value (OUV) 42
 perceptions of value 44

standardization 7, 118
 Acre, absence from in 145
 al-Salt 83, **84**, 97, 112
 Aleppo 73, **73, 74**
Stockholm Declaration 102–3
story-telling 47
sūq
 Acre 26, 93, **95**, 137, 138, *138,* 139, **145**
 Aleppo 14, 16, **17**, 19, 48–9, 71, 126, 127–8, *128,* 131, 144, 152

technology 46–7
timing of public participation in planning 104, 117, *118*
Torstick, Rebecca 115
tourism
 Acre, development in 30–1, 90, **93**, 93–5, **94, 95, 96**
 al-Salt, opposition to in 110, 111–12
 Aleppo, pressures for in 65–6
 alienation of local inhabitants 8
 commodification in 7, 8, 134, 138, 149, 150
 contradictions of 5–8
 desire to curb in Aleppo 19
 Disneyfication 7, 8, 138, 144, 145, 149, 151
 as focus in Acre 86–7
 in historic urban landscapes 5–6
 image marketing 6
 infrastructure for, costs of 6
 infrastructure for in al-Salt **78**, 79, **80, 81, 82**, 82–3, **83, 84**, 85, **85**
 as issue in cities 4–5
 local inhabitants, input of in 7–8
 marketing 6–7, 65, 76–7, 79, 90, 93, 121, 125, 126, 149
 modes of 121
 and otherness 5–6
 planning for experience-based urban heritage tourism 6
 as revenue source 5
 Tourism Development Projects in al-Salt 26, 33, 52, 76–7, 109–12
 Un-myths 6
 universalisms/particularisms, integration of 7–8, 112, 150
 see also experiential/experimental tourism; place experience
town-plans 46, 47, 50, 51, 52, 54, 58, 63, 96
town-plan analysis 46, 50
townscape
 Acre 56, 89–90, **89, 90**, 144, 151
 al-Salt 22, 51, 52–4, 83, **85**, 150–1
 Aleppo 48–9, 50, 71, **72**, 73, **73, 74, 75**
 character of a town 45
 conserving 63
 as holistic entity 64
 qualities of 46
 and value assessments 58
 visual experience 62, 149

Tuan, Y.F. 122

Un-myths 6
 The myth of the unchanged 13, 121, 144, 150
UNESCO
 Convention Concerning the Protection of the World Cultural and Natural Heritage 3–4, 10, 31, 37, 38, 40, 41, 42, 43, 47, 62, 100, 101, 104
 debate over OUV 41–3
 definitions 4
 General Conference 3, 4, 5
 Operational Guidelines for the Implementation of the World Heritage Convention 3–4, 10, 37–9, 40, 42, 43, 100–1, 104, 117
 Recommendation on the Historic Urban Landscape 5
 State Parties 3, 3n2
 World Heritage Center 3, 5
 World Heritage Committee 3–4, 5, 37, 38, 41, 42, 57, 60
unique selling proposition (USP) 6, 7, 76, 95, 121
universalisms/particularisms, integration of 7–8
urban design
 Acre 90
 al-Salt 79-85, **80, 81, 82, 83, 84. 85, 86**, 112
 dimensions for 151
 image of the city 125
 Sāhet al-Ḥaṭab **74**
 standardization 7, 73, 83
urban morphology
 al-Salt 20-6, **20, 21, 22, 23, 24, 25**, 52-4, 150-1
 cities in *Bilād ash-Shām* 13–14
 factors shaping 14
 IT for documenting 46–7
 physiognomy 45, 54, 56, 58, 63, 96
 Washington Charter 63
'urf 14, 16, 45, 50, 54, 64, 67, 71, 82
use/non-use value 44–5

value assessments
 alternative conceptions of value 43–5
 and change, relationship with 47
 comparative assessments 41
 deduction-oriented perspective 45
 definitions of value 38–9
 dissonance between universal, national and local values 43
 economic value 44–5
 evolution of 38–9
 evolution of OUV 40–1
 experts-based approach 38–9
 intrinsic value 38, 44
 ongoing debate on 40
 OUV, criteria for evaluating 37–8
 representative samples 41
 social construct, value as 39
 socio-cultural values 44
 spatial and morphological values 46–7

stakeholders' perceptions 44
uniqueness and representativeness 42
use/non-use 44–5
see also outstanding universal value (OUV)
vehicular traffic, cities' adaptation to 32, 48
Venice Charter 37, 61
Vienna Memorandum 4–5, 62, 63
visual discourse 46, 61–3
visual experience 6, 52, 61–3, 78, 79, 96, 149, 151

Washington Charter 40, 46, 62, 63, 64, 101, 125
Wells, J.C. 125
world heritage, evolution of 3–4
World Heritage and Contemporary Architecture – Managing the Historic Urban Landscape conference 5
World Heritage Center 3, 5
world heritage cities, *see* Acre, al-Salt, Aleppo
World Heritage Cities Programme 4

World Heritage Committee 3–4, 5, 37, 38, 41, 42, 57, 60
world heritage discourse 9
World Heritage Expert Meeting, Kazan 42, 43
World Heritage List
 Acre 10, 31, 53, 56, *57,* 59
 al-Salt 10, 26, 53, *57,* 59, 135
 Aleppo 10,19, 48, *57*, 65
 inscription criteria 3–4, 37–8, 41, 43, 45, 149, 150
 critique of 7–8
 European Judaeo-Christian over-representation on 41
 and historic urban landscape 4-5
 impact on cities 4–5
 monuments, emphasis on 58
 nomination phase 104
 tentative lists 3, 4, 10, 26, 135
 widening of 41